SCREEN OF KINGS

ROYAL ART AND POWER IN MING CHINA

CRAIG CLUNAS

REAKTION BOOKS

Published by
Reaktion Books Ltd
33 Great Sutton Street
London EC1V 0DX, UK
www.reaktionbooks.co.uk

First published 2013

The publishers gratefully acknowledge support for the publication of this book from the
Chiang Ching-kuo Foundation for International Scholarly Exchange.

Chiang Ching-kuo Foundation for International Scholarly Exchange

This publication was made possible in part by a grant from the James P. Geiss Foundation,
a private, non-profit operating foundation that sponsors original
research on China's Ming dynasty (1368–1644).

Illuminating the Ming

Printed and bound in China by C&C Offset Printing Co., Ltd

British Library Cataloguing in Publication Data
Clunas, Craig.
Screen of kings : royal art and power in Ming China.
1. China — History — Ming dynasty, 1368–1644. 2. Art, Chinese — Ming-Qing dynasties, 1368–1912.
3. Art patronage — China — History. 4. China — Kings and rulers — Art patronage.
5. Aristocracy (Social class) — China — History.
I. Title
709.5'1'09024-dc23

ISBN 978 1 78023 103 7

SCREEN OF KINGS

Contents

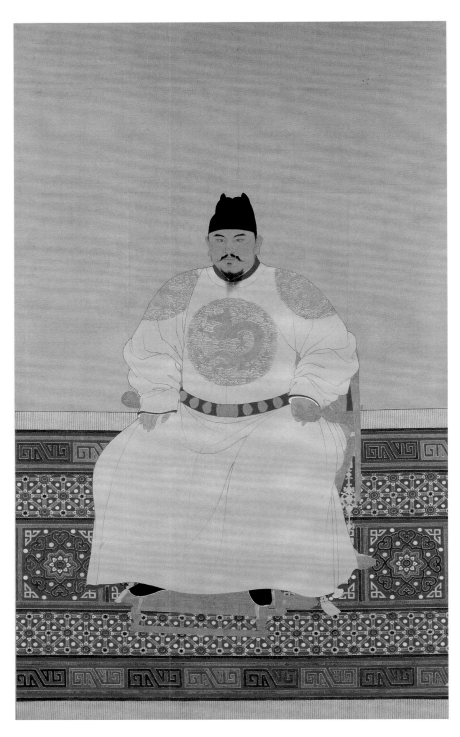

1 *Ming Taizu*, hanging
scroll, 14th century,
ink and colours on silk,
268.8 × 163.8 cm, artist
unknown.

ONE

'A Fence and a Screen'

The most successful act of transcultural communication by the Italian Jesuit missionary to Ming China, Matteo Ricci (1552–1610), was perhaps the composition in 1595 of his essay 'On Friendship' (*Jiao you lun*). Ricci had been living in China from 1583 and had acquired an impressive degree of both linguistic and cultural fluency in pursuit of his project to bring the Christian mission to the Ming empire (1368–1644), then into its third century of rule. 'On Friendship' combined the allure of the exotic, being 100 maxims drawn from the European classics, with another theme of interest to Ming elites, for whom the topic of how right friendship was to be established and maintained against the tug of family, faction and region was of consuming importance. This text has long been known and discussed, although only recently made available outside the Chinese language in a new translation.[1] What has been perhaps underestimated in the past is the significance of the text's dedication, and Ricci's account of how that dedication came into being. For the dedicatee, and hence by implication the 'friend' for whom this account of friendship was written, was not a member of the type of Chinese elite with whom we are most familiar: he was not a 'scholar-official' or 'member of the literati' or 'mandarin', with status deriving from mastery of the classical textual tradition and from success in the imperial examination system. He was an aristocrat.

His personal name was Zhu Duojie, 'a figure about whom we know frustratingly little except that he was enfeoffed in 1573 and died in 1601'.[2] He held a title which Ricci's modern translator renders as 'Prince of Jian'an Commandery' (*Jian'an wang*). The sufficiency of that translation will be addressed shortly, but for now it is only necessary to acknowledge that it identifies him as a member of the imperial clan (*zongshi*), the large number of men and women who by Ricci's day could prove their descent from Zhu Yuanzhang (1328–1398), 'Grand Progenitor' (*Taizu*) and founder of the Ming dynasty (illus. 1). In a decisive break with the practice of previous dynasties, the

26 sons of this man (with the exception of the eldest, installed as Crown Prince) were established in great state in centres across the empire, and in a culture which allowed polygamy some 100,000 people could by 1600 be identified as their descendants, or as the descendants of later imperial sons. It is they, or at least some of them, who form the matter of this book.

They have not received a good press from history. One striking index of this is perhaps the way in which their title is generally translated by modern authors writing in English, as 'prince'. This is done in defiance of the fact that early modern European observers such as Ricci, more familiar with complex hierarchies of rank than we are, were generally happy to call a *wang* a 'king'.[3] It is done despite the fact that the character *wang*, which certainly goes back to the earliest forms of Chinese script in oracle bone inscriptions, is in most other contexts translated as 'king'. Thus, if in the classic text *Mencius* students come across *Liang Hui wang*, they are expected to translate it as 'King Hui of Liang', but an exactly similar locution in a Ming text, for example *Liang Zhuang wang*, is rendered as '*Prince* Zhuang of Liang'. This loses at once the echo of what is in Ming terms one of the most important features of the Ming system of establishments for imperial sons other than the Crown Prince, and that is its deliberate aura of antiquity, its invocation of the Golden Age of the Zhou

dynasty (*c.* 1050–221 BCE), source of so many political and moral exemplars for the men of the Ming. The term *wang* was from the very beginning one of great sacral power, and it would be rash to suggest that this aura had utterly ceased to have meaning by the Ming period, some 2,000 years later. For the Han dynasty philosopher Dong Zhongshu (179–104 BCE), as for the earliest dictionaries of the Chinese language (still consulted in the Ming), the very character *wang*, 王, with its three horizontal lines joined by a single vertical, was an index of the fact that the king is what links and unites the three cosmic levels of Heaven, Earth and Man. The *wang dao*, or 'kingly way', spoke of rulership with a cosmic resonance of benevolence, as a term of moral weight which implied more than force and the power to be obeyed. In later centuries, when supreme rulers invariably used the grander titles of *huang*, *di* or *huangdi* ('emperor'), the ideal of the 'king' as a moral lord still invoked a purer and better relationship between ruler and ruled, as well as the specific past when kings who were kin were 'enfeoffed' by the Zhou in a system known as *feng jian*.[4] By the twentieth century *feng jian* had come to be used to translate the Western political concept of 'feudal', with predictably negative effects on its connotations, connotations of backwardness and repression which it has continued to hold to the present day.[5] Whether the political order of the Zhou period was 'feudal' or not is

a topic for specialists; what is not disputed is that, at least for part of its near millennium of existence, the Zhou polity was imagined as an 'exemplary centre' occupied by an emperor bearing the title 'Son of Heaven' (*Tian zi*), who was surrounded by a multitude of lords, some of them related to him by blood, the most senior of which bore the title of *wang*. This ideal of a surrounded and protected centre is manifested in one of the most ancient of the canonical Confucian texts, which would echo through all Ming discussions of the topic:

> With the honest people as a fence (*fan*), the great armies as a bulwark, the great territorial states as a screen (*bing*), the Major Lineage as a support, love of virtue as a source of peace, and the sons of your lineage as a fortress, nothing will let that fortress fall into decay, and there is nothing to fear about loneliness.[6]

It was as 'a fence and a screen' (*fan bing*) that the role of the sons of Ming Taizu was imagined; collectively they were *zong fan*, 'fence of the [imperial] lineage'. It was as *fan wang*, literally 'fence kings', that they were established in what here will be called, using an anachronistic term consciously but warily drawn from European history, their 'appanages'.[7] Throughout this book they will be referred to as 'kings'; if the effect is a jarring one then that is deliberate, and a way of recalling to our

attention the prominence and centrality of these figures on the Ming social landscape.

A screen can do two things. It can hide things from our view, but it can also act as a surface on which images can appear.[8] And something of this twin aspect of rendering visible and at the same time unseen attaches to the kings of Ming China. So prominent in their own day, as their presence in well-known primary sources attests, their relative oblivion in the account we hold of the Ming today says much about what we wish to see or not see about the past, and arguably masks from us some of that past's most significant features. So this account of Ming China will be a deliberately revisionist one, and revisionist not least of some of the things the present author has put into print about the period before now. An attempt to put kings at the centre of the story is by definition an attempt to rethink in some quite fundamental ways what we have agreed matters about Ming China. And those perceptions matter in *their* turn quite a lot because so many of those ideas are constitutive of the very idea of the 'Western world'. The Ming period of China's history was precisely when, through the agency of men such as Matteo Ricci, sufficient information on 'what China was like' was laid before readers and thinkers in Europe for them to form a series of perceptions of its nature. The importance of those early perceptions, not least in the formation of the very idea of 'the

West' cannot be overestimated, and continue to act upon notions of 'what China is like' today. But what if those perceptions were wrong in some quite fundamental ways?

To construct a revisionist account in this way will not simply be to put the kings of Ming China into the place previously occupied by other elites who have been better studied and celebrated. If a case is made here for their necessary prominence in a fuller account of the period, it was still, unarguably, a prominence which was in inverse proportion to their importance in the running of the machinery of the state. Barred from the examination system until late in the dynasty, in 1595, and progressively stripped of any control they had once had over military forces, Ming imperial relatives have been seen by most writers as the inhabitants of 'lacquered and gilded prisons', consumers of vast amounts of the state's resources, who nevertheless lived lives of pointless banality. Typical perhaps would be the view of Frederic Wakeman, whose magisterial history of the fall of the Ming characterizes the late Ming aristocracy thus: 'Even higher-ranking kinsmen lived in a state of genteel poverty, letting their palaces run down, or frittering away their lives in debauchery and drink.'[9] While not wishing to argue for the stone-cold sobriety of every last member of the imperial clan, it should be stated from the outset that this is a caricature, which owes its tenacity to several different strands of historiography with an interest in denigrating the imperial aristocracy. The contemporary historical record, that written in the Ming dynasty itself, is dominated (although not totally, as we shall see), by the degree-holding elite. It is not only socially limited, but geographically limited as well, in that most of the written record exploited up to now by scholarship emanates from the Jiangnan region, the economically and culturally most highly developed part of the empire on the lower course of the Yangtze river, and the site of the dynasty's original capital.[10] The Ming founder had located none of his sons in this sensitive area, on which the state's political economy rested; there were no appanages in Jiangnan. So the holders of these appanages were unfamiliar to many of the canonical figures of what we think of today as 'Ming culture'. They either ignored them, or were vaguely hostile to them. After the protracted death agony of the dynasty in the middle decades of the seventeenth century, Chinese commentators looking for the causes of that fall, and of the Manchu conquest which precipitated it, lighted on the role, a role seen as less than glorious, of the successive Ming kings who tried to keep the dynasty alive in the south after 1644, and whose weakness and cupidity were seen as contributory factors to the debacle.[11] They lighted too on the drain of state resources to keep up the imperial clan, in the form of the great estates they received (and on which no land tax was paid), as well as the stipends

in grain, silver and other gifts which they received. Such views remained normative throughout the Qing dynasty (1644–1911) and down into the Republican period in the early twentieth century. They were then augmented by Marxist or Marx-influenced Chinese and Japanese historians, for whom the imperial aristocracy were the most vile part of a bloated feudal ruling class, mentioned if at all as the appropriators of the fruits of peasant toil, and as the objects of the righteous wrath of those same peasants, the motive force of Chinese and world history.

What this means is that the hereditary aristocracy are generally either invisible in the literature on the Ming, or else are mere footnotes to the story of some other more interesting object of study. In the standard dynastic history, the *Ming shi*, compiled in 1736 and hence in no strict sense a contemporary source but one which reflects a number of Ming priorities, the kings still occupy the fourth to eighth chapters of the biographies which take up the bulk of this massive work, preceded only by the empresses. There are over 70 main biographies listed there, with many more supplementary entries.[12] However, in the principle modern reference work, the *Dictionary of Ming Biography* (1976) edited by L. Carrington Goodrich and Chaoying Fang, only six members of the Zhu family who did not themselves reign as emperors are afforded entries of their own.[13] The consensus seems to be, in the words of the doyen of Ming historians in the West, Charles Hucker, that 'the nobility in general was an ornament on the Ming social scene, not a factor in government'.[14] This opposition between 'the social scene' and 'government' is one to which we will return, but which will be signalled here as considered to be generally unsafe as a tool for understanding Ming China.

In China too, in contemporary synthetic accounts of the Ming, its kings and their culture are generally invisible, or at best peripheral.[15] Although recent years have seen a much raised level of interest in the imperial court itself, the courts of regional kings are only now beginning to receive more focussed attention by scholars, both within and outside China. There has as yet been no full overview of their role in Ming culture or society, of the kind called for by David Robinson, who draws attention to the fact that although the princes (as he prefers) 'were denied political and military control over the areas where they were invested', their ritual primacy and range of connections to the emperor made them highly significant figures; he argues, 'Thus, although the central node of the Ming court was in Beijing, the secondary court in Nanjing and princely establishments in the provinces meant that the greater court extended throughout much of the empire.'[16] This notion of the 'greater court' is one this book attempts to engage with. Although it is far from being the complete account which we

need of the kingly role in the Ming, it will attempt, from the viewpoint of art history and material culture studies, to draw attention to some of the material as well as some of the textual evidence. It will argue that we ought to take Ming kings seriously. The subsequent historical fame of Matteo Ricci and the relative oblivion of Zhu Duojie, King of Jian'an (for so he shall now be named), reverses absolutely their prominence on the Ming landscape, and if as historians we wish to understand that landscape we have to try and imagine a set of priorities very different from our own.

The stated priority of the Ming founder, victor in the series of wars which expelled the Mongol Yuan dynasty and then established him as the sole contender to inherit the Mandate of Heaven from them, was for security. This is what comes across most strongly in his pronouncements, as recorded in the standard historical sources, and is the reason that he entrusted them with the command of major military forces. Taizu saw one of the causes of the fall of the Song and the Yuan dynasties in a situation where 'the ruler was weak and the officials strong', where the ruler lacked the 'fence and screen' (fan bing) of his family. Hence the first establishment of nine of his sons as kings in the third year of his reign (1370).[17] He is quoted as saying, 'In the Way of ruling the world, you must establish a fence and a screen.'[18] Another issue which all historically literate members of the elite will have been

very conscious of was that of how to deal with the large numbers of sons which a polygamous regime of marriage generated. More than once in the Han (206 BCE–220 CE) and Tang (618–906) dynasties rulers had been challenged from within their own families, and a variety of solutions had been attempted in recent centuries to forestall this.[19] In the Song dynasty (960–1279) the solution was to keep all members of the imperial clan close at hand in the imperial centre, sequestered in their own palaces. At the same time, the Song broke with Han and Tang precedent by greatly expanding the definition of that clan to include all patrilineal descendants of the brothers who were the Song dynastic founders.[20] The Yuan, and the Mongols in the wider Eurasian context, had certainly employed a system of appanage provision for younger sons.[21] The extent to which the Ming polity was an actual heir of Mongol practice, while at the same time rejecting it rhetorically with considerable vehemence, is currently a topic of great interest to historians, and the focus of a forthcoming study by David Robinson. But the *stated* precedents of the appanage system in the Ming were certainly not located in the Yuan period, or in the Song or the Tang, but much further back in antiquity, in the Han period (when *wang* were sent out to territories across the empire), and even more in the Zhou, most venerated source of social, political and cultural models. By the

sixteenth century this connection was taken as a truism, for example in a statement by one high official, to the effect that 'The kings of the blood of today are the feudal lords of antiquity; the commandery kings of today, are the secondary sons of antiquity.'[22] It was in the restoration of the order of antiquity that the importance of Ming kings lay; there is no evidence that the principle of this was challenged at the time.

The institutional framework of the system was laid down in a number of imperial pronouncements at the very beginning of the dynasty. The key text governing the imperial clan was the thirteen-section *Huang Ming zu xun lu*, or 'August Ming Ancestral Instruction', first presented to the throne in 1373 and revised finally in 1397.[23] It regulates a broad range of aspects of the life of the imperial family, both the descendants of the founder and those families who provided them with wives, as well as other nobles rewarded for meritorious service (chiefly in war), and the eunuchs, bodyguards and personnel who served them. It lays down a hierarchy of titles, serving to mark the degree of distance from the imperial body. Thus, sons of emperors (other than his heir) were titled *qin wang* or just *wang*, here rendered as 'king'. The first son of a king retained that title. Other sons were titled *jun wang*, here rendered as 'commandery king', using an archaic title for a territorial division. His eldest son and heir maintained

the same title as his father, as happened throughout the ranks. The titles of younger sons of subsequent generations were then as follows; the younger sons of a commandery king were titled as:

> Defender-general of the State: (*Zhen guo jiang jun*), his sons were titled;
> Bulwark-general of the State: (*Fu guo jiang jun*), his sons were titled;
> Supporter-general of the State: (*Feng guo jiang jun*), his sons were titled;
> Defender-commandant of the State: (*Zhen guo zhong wei*), his sons were titled;
> Bulwark-commandant of the State: (*Fu guo zhong wei*), his sons were titled;
> Supporter-commandant of the State: (*Feng guo zhong wei*).[24]

A parallel system of titles existed for daughters. An emperor's daughters were all Imperial Princesses (*Gong zhu*), their husbands were Commandant-escorts (*Fu ma du wei*), while a king's daughters were Commandery Princesses (*Jun zhu*), and the daughters of a commandery king in turn were District Princesses (*Xian zhu*). And so on down through the ranks of Commandery Mistresses, District Mistresses and Township Mistresses (*Jun jun, Xian jun, Xiang jun*).[25] The niceties of titling and precedence take up a great deal of space in Ming records, and while few would have the patience to take a close interest

in these tedious-seeming matters now, we would be unwise to assume that they were not matters of compelling interest, at least to those most directly affected. A 'Supporter-commandant of the State' or a 'Township Mistress' may seem to us today to be figures of very little import, whose role in the great currents of Ming history is of no account, but they may have looked very different to their neighbours, perhaps far from a major city. The blood of the Son of Heaven was also their blood, and the stipends in grain which they received (even at the lowest ranks) marked them as privileged well beyond the peasant mass.

A king was established in a 'state' (guo). These states took their names from those of the Zhou dynasty, in the remote Bronze Age, and it was this continuity which gave some of the lustre of that idealized society to present arrangements. These ancient names remained meaningful in Ming China (and continue to do so today) as elegant-sounding variations, rather like the way the names of vanished ancient kingdoms might be used in contemporary Britain ('Caledonia', 'Wessex', 'Dalriada'). Thus for example Zhu Gang, third son of the Ming founder, was established at the city of Taiyuan, and became 'King of Jin' (Jin wang). Jin had been one of the greatest of kingdoms in the Bronze Age Spring and Autumn Annals period, created by Tang Shu Yu, son of the Zhou founder, King Wu (d. 1043 BCE), and roughly

contiguous with modern Shanxi province.[26] Known in his lifetime only by the title 'King of Jin', on his decease Zhu Gang received the posthumous 'temple name' Gong, meaning something like 'reverent', and so appears in the historical record as Jin Gong wang; such titles will be rendered here as 'King Gong of Jin'. All of the kings of the blood, whether descended from the Ming founder or from creations for the sons of subsequent emperors, had both states and temple names of a single Chinese character.[27] Commandery kings had titles of two characters (the name of a county, xian, where they had their putative seat), and posthumous names to match; for example, a son of King Gong of Jin could be King Zhuanghui of Qingcheng. This is how we know that Ricci's patron, Jian'an wang or King of Jian'an, was a holder of this slightly lower rank.

Naming was one of the key practices which tied the wider imperial clan to the ritual and political centre of the emperor's court. Each member of the clan received at birth a personal name from the Court of the Imperial Clan (Zong ren fu), and was entered in its records. Each 'state', as it was established, was given a twenty-character phrase in the form of a moral maxim; this determined the first character of a man's personal name (making it easy now to spot members of the same generation).[28] The second character of a name was defined by the cosmic sequence of the 'Five Phases' (wu xing), in the order wood/fire/earth/metal/water. As

the number of members of the clan increased it became more and more difficult to find character combinations which had not been used before, and the names of Ming imperial relatives become more and more arcane throughout the dynasty, to the point where they employ extremely rare characters or variants of characters scarcely found in dictionaries, and well beyond the character sets of modern Chinese language software.

On reaching maturity (usually in his early teens), an imperial son established with the rank of king 'went to his state' (*zhi guo*). At least at the very beginning of the dynasty, it was anticipated that they should also leave it frequently, to visit the imperial capital and do reverence to the emperor. There are elaborate regulations for this preserved in the 'Ancestral Instructions'.[29] But Shen Defu, a late Ming writer deeply interested in the imperial clan, talks of how this custom gradually fell into disuse, to the point where after the mid-fifteenth century, 'no prince of the blood came to court for nearly forty years . . .'.[30]

A king could be spoken of as having 'passed away in his state' (*yu guo zhong xia shi*).[31] This was therefore a physical location, usually a major provincial city, but it was also a conceptual one. A king's *guo* had a centre but no boundaries, or at least there are no maps showing such boundaries, and in Ming cartography the 'State of Jin' (*Jin guo*) has no sharply delineated edges in the way that 'Shanxi' does.

For most of their lives kings were located in and associated with their 'states'. As Shen puts it later in the same passage, 'The precedent is that kings of the blood, save for meeting an imperial progress or the sweeping of graves, are not permitted to depart one pace outside their cities.'[32] And in fact it was the walled city (illus. 2) rather than the arable land beyond it which was the core meaning of *guo*, 國, as the form of the character, with its rectangular enceinte, makes visible. As Tracy Miller has written of the Bronze Age paradigms, 'This scheme has been understood as making the state capital city a ritual centre, thereby linking the whole country within both a ritual and a familial network that would function on temporal and supernatural levels.'[33]

This language of 'centres' perhaps seems to invoke the now deeply rooted model of 'central-places theory', which has been so persuasive, but more recently so challenged, in all sorts of contexts, including those of art history and the history of culture. It is the growing influence of anthropology within the humanities more broadly which has been identified as increasing the importance of cultural factors (over objectively quantifiable indicators such as those of trade and commerce) in defining exactly what *are* the core and the peripheries in any given context.[34] One of the most influential transfers from anthropology on this issue has been the often-cited work of Clifford Geertz, and his notion of an 'exemplary

centre', as applied to the multiple royal courts of Bali, where:

> By the mere act of providing a model, a paragon, a faultless image of civilized existence, the court shapes the world around it into at least a rough approximation of its own excellence. The ritual of the court, and in fact the life of the court, is thus paradigmatic, not merely reflective, of social order.[35]

Certainly the Ming imperial court has been seen as such a centre, but what is only perhaps beginning to be appreciated (and it is the argument of this book, still not to a sufficient degree), is that the Ming empire had *many* such centres. Any educated person would be familiar with passages like that from the canonical *Zhou li*, 'Rites of Zhou':

> The king alone constitutes the kingdom. He determines the four corners and fixes the principal position. He plans the capital and the countryside. He creates the ministries and separates their functions, thus offering norms for the people.[36]

While those educated people were well aware that the kings they saw around them did not 'determine' very much, that is not the same as saying that the ideal of 'norms for the people' was utterly without force. The obvious example (before the eyes of a British author, at any rate), is of an elderly monarch in a splendid crown solemnly reading out annually the managerialist platitudes of what 'my government' will achieve. We would perhaps see her as one of the most powerless of people, for the words she reads out are not even her own, and monarchy in twenty-first-century Britain can thus easily be identified as, in Charles Hucker's words, 'an ornament on the social scene, not a factor in government'. But does that mean that Elizabeth II does not matter, does not occupy a place in the imagination of many, is not thought about and resented and cared about by many? An account of modern Britain which left her (and her family) out would be an insufficient one. The same is true for Ming China. And yet that king-less account of the Ming is what we largely have. Why should this be so?

It is certainly *not* because we lack sources on them. They are a prominent feature of writing by the educated elite. The most prestigious and official forms of historiography afford them a large degree of notice.[37] In this regard, they are rather like another group of significant figures who are arguably very visible in the historical record globally, but little regarded until recently by historians of a number of contexts, namely royal and imperial women. For example, Ruby Lal, in her insightful study of the women of the imperial courts of Mughal India, has deployed the concept (derived from subaltern studies

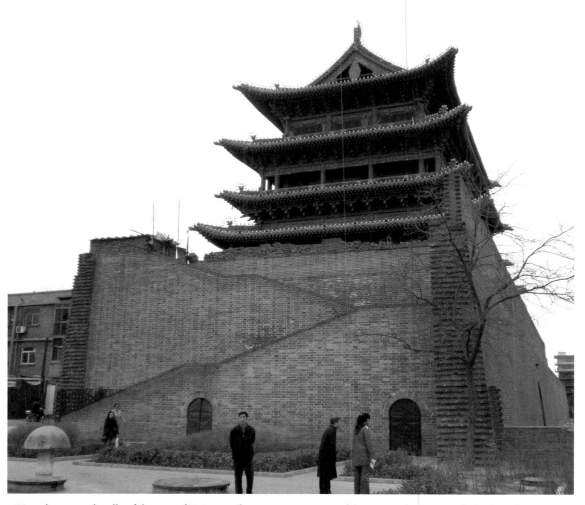

2 Heavily restored walls of the city of Taiyuan, Shanxi province, seat of the Kings of Jin, originally built in the late 14th century.

scholarship) of 'hidden in plain sight' to eluci-date sources which are long known but long neglected, in a way which does not simply reinsert women into the power structures of the imperial centre but challenges what mattered *as* power at that centre.[38] If we want to do something of the same for Ming China, then perhaps we have to start by taking seriously its attachment to a world which certainly had a

centre (the imperial court), but which did not see that centre as absolute. For it to be exem-plary, there had to be something for it to be an example to.

We might start therefore by recognizing the plurality of centres implied by the very term 'king'. The title *wang* was not restricted in the Ming to its holders among the imperial family, and was variously meaningful to the

educated and illiterate alike. It was, for example, part of the title of many deities.[39] One wonders how much confusion there sometimes was in the minds of the humble about some of the various figures, all grand and for much of the time unseen, who peopled their world. Among the better educated, the idea of the sage Confucius as an 'uncrowned king' (*su wang*) had deep roots in the exegetical tradition about him, and from 1308 he actually bore a royal title, conferred by the Mongol emperors.[40] This title was removed during the Ming in 1530, significantly by an emperor who had once borne a kingly title himself, and who was presumably extremely sensitive to its nuances.[41] There were also in the early Ming eight major religious figures of Tibetan Buddhism who were so titled by the imperial court, and the higher appellation of 'dharma king' (*fa wang*) was allowed to three of these.[42] Numerous Mongol leaders throughout the dynasty, 'foreigners who had remained abroad but had recognized themselves to be vassals of the empire', were given the rank of 'king', sometimes with titles that alluded to territories over which they ruled and sometimes with titles suggesting their moral qualities, such as *Zhongyong wang*, 'Loyal and Courageous King'.[43] And there may well have been an awareness of 'kings' in the far reaches of the world, in Korea, in Borneo, in Samarkand.

This very multiplicity may have something quite fundamental to do with the reasons that the kings of Ming China, despite their visibility in a wide range of contemporary sources, are so strangely absent from synthetic accounts of the period constructed in more recent times. For the Ming has long been firmly fixed in the historiographical mind in both the West *and* in China itself (at least from the early twentieth century) as *the* textbook case of 'despotism', the high point of imperial dominance over the whole of society, when no one else counted. This idea was prominent in some of the earliest European writing about China, its certainty in inverse proportion to the writer's actual experience of going there. This was the framework on which Giovanni Botero (1544–1617) composed his survey of the world, *Relationi universali*, in Rome in 1591–6, developing the idea of '*governo despotico*'.[44] His idea that 'in the whole of China there is no other lord but the king' (or emperor), and the non-existence, or at least the invisibility, of the hereditary aristocracy, is thus central from the very beginning to the theory of 'oriental despotism'.[45] On through the Enlightenment and into the nineteenth century, the growing literature on Chinese history in European countries painted the Ming founder as the creator of one of the most despotic of oriental despotisms, a picture into which the 'many kings' of the primary sources could not be made to fit. There was no room for 'other lords'. The contrary fascination on the part of European intellectuals with a society ruled by meritocrats, the literati or

mandarins (and the continuing fascination of this model of a society for *their* heirs, the modern 'academic') served still further to render quaint any interest in those whose status came from the hereditary principle.

But European contemporaries of the Ming, people who lived in a society where heredity mattered a lot, and power was not simply a matter of tax receipts, may well have seen things differently. Those few Europeans who did see a Ming regional king (and who may not have been as schooled in Aristotle as a Ricci or a Botero) had no difficulty fitting them into an aristocratic world view, where power *and* pomp were unproblematically hereditary. Unlike Botero, the Portuguese Galeote Pereira (active *c.* 1545–1565) had actually been in China, and had seen (and been well treated by) the King of Jingjiang, in the southwestern city of Guilin. His account was published in Italian in 1565 and available in English by 1577. He gives this account of the imperial relatives who were such a prominent feature of that city's social landscape:

> They give themselves to eating and drink-
> ing, and be for the most part burly men of
> body, insomuch that espying any one of
> them whom we had not seen before, we
> might know him to be the king his cousin.
> They be nevertheless very pleasant, cour-
> teous, and fair conditioned; neither did
> we find, all the time we were in the city,

so much honour and good entertainment anywhere, as at their hands.[46]

'Courtesy', 'honour' and 'good entertainment' are, it could be argued, at the centre of early modern understandings of power and authority, in China as much as in Europe. The non-clerical Pereira well understood that the aristocracy lived under a degree of imperial suspicion, and that their freedom of movement was constrained, but he also understood their ritual precedence over the degree-holding bureaucratic elite: 'The king . . . letteth not one in all his country to be called lord, except he be of the blood', adding, 'Their festival days, new moons, and full moons, the magistrates go there to make him reverence . . .'. Who bowed to whom mattered to contemporaries more than it perhaps matters to us, who are more inclined to 'follow the money'. But is our understanding thereby increased? One highly influential account which would offer a resounding 'no' to that proposition would again be the work of the anthropologist Clifford Geertz. As well as showing how, in the case of Bali, the influence of an 'oriental despotism' model served to mask understanding of the complex interactions between many lordships, he has in a much-quoted passage insisted that we may have unwittingly inverted the correct relationship between what we have taken in that context to be the forms and the substances of rule:

Court ceremonialism was the driving force of court politics; and mass ritual was not a device for shoring up the state, but rather the state, even in its final gasp, was a device for the enactment of mass ritual. Power served pomp, not pomp power.

He goes on to develop an idea which has already been alluded to, that of the court as the 'exemplary centre', in words that certainly have a ring of truth with regard to the activities of Ming kings to be studied in the rest of this book: 'By the mere act of providing a model, a paragon, a faultless model of civilized existence, the court shapes the world around it into at least a rough approximation of its own excellence.'[47]

Part of the historiographical problem may lie in the fact that aristocracy and heredity came to be seen after the Enlightenment as the opposite of that desirable but ineluctable quality we still keep calling 'modernity'. But more recently, and probably under the impact of anthropologists like Geertz, historians of Europe (and of other parts of Asia) in the centuries contemporary with the Ming have begun to re-evaluate the older teleological accounts which see the aristocratic principle as being 'in crisis', and doomed to terminal decline during these centuries. In one thorough analysis of the role of the aristocracy in Europe, Hamish M. Scott has asserted that at this time,

In contrast to the later modern era, social status still resided in esteem, in the value and therefore the respect and approbation which other members of society felt towards an individual's function and role, and not in the mere possession of wealth.[48]

As the great historical drama of the 'rise of the nation state' no longer seems to be sufficient in a world of multiple and overlapping sovereignties, of states with seemingly very little power and 'non-state actors' with seemingly a great deal of agency, a re-evaluation is taking place of the many contexts where power was dispersed and multiplicity was prized. James Hevia has shown how in the late eighteenth-century Manchu empire, the notion of a 'multitude of lords' was crucial to the constitution of an imperial centre; it was the presence (not the absence, as the theory of 'despotism' would have us believe) of many sovereignties which made the Qianlong emperor great in his own eyes.[49] And Timon Screech has insisted, almost shockingly, on taking the plural rhetoric of Edo period political culture seriously in his study not of 'Japan' but of 'the Japanese states' at the same period.[50] In the case of China, we are still absorbing the implications of Lothar Ledderose's wide-ranging study of the 'ten thousand things'. But it seems safe to say at the very least that it is a philosophical position which underpins valuing the many in

terms of understanding a broad range of aspects of the world; put simply, 'more is more'.[51]

As part of the process whereby an Enlightenment (and emotionally republican, whether French or U.S.) historiography was consigning the aristocracy to the dustbin of history, the settings for these Others of modernity, reified in the notion of 'the court', became equally looked down on and neglected as objects of study by 'real' historians, fit instead 'only for reactionaries and eccentrics'.[52] As one scholar has succinctly written:

> In many places around the globe during the nineteenth and twentieth centuries, the court was conceived as the epitome of all that was backward, corrupt, effete and debased about the *ancien régime*.[53]

It was the work of the émigré German sociologist Norbert Elias (1897–1990), whose volume *The Court Society* (conceived as far back as the 1930s) was published in English only in 1983, which did more than anything to bring courts and court culture back into the fold of respectable historical discourse.[54] Elias took the Versailles of Louis XIV as the paradigmatic court, a site and an institution where the monarch disciplined previously unruly aristocratic elites, a 'gilded cage' where they were designed to 'ruin themselves by conspicuous consumption, to engage in ceremonial squabbles with their rivals at court, and thus to gradually

dissolve into insignificance under his wary eye'.[55] Assailed on both empirical and theoretical grounds, Elias's model has more recently given way among historians of Europe to more detailed case studies, and ones which are more mistrustful of what are seen as its biases towards the study of culture, of 'ritual' and of discourse. The literature on European courts is now vast, and the conclusion to this book will return to some of the implications of what value a comparative approach can have in the study of the 'greater court' of Ming China. Such an approach is (in the words of one historian of pre-modern India's culture) in fact 'imperative', given that if historians do *not* consciously direct attention to the European cases then what happens in practice is:

> The cultural and political theory designed to make sense of the European nation-state is often, and too facilely, applied to the pre-modern world outside of Europe, distorting thinking about language and identity, and identity and politics, and thereby occluding the specificity of the Indian case and its misfit with models designed to explain the European.[56]

In other words, to grasp the specificity of the kings of Ming China, it is a good idea to have a conscious sense of where that specificity was like and unlike other specificities. It is less problematic to borrow a word like 'appanage'

from medieval Europe consciously, than to use one like 'nobility' without thinking it through.

This awareness of comparison is all the more necessary in that this is a study which treats as central areas of art and culture. We need to be alert to the fact that, just as scholars of European history seem to turn away from the 'strong cultural bias' of Elias and the many who followed him, here the turn will still be *towards* the field of culture, which for reasons to do with the entirely independent historiographical traditions of China in the twentieth century has been vastly *under*valued in what thinking has been done on the world of the kings in the Ming dynasty. There is a risk (probably several risks) here, and again the example of work done on pre-modern India is instructive, at least in pointing out what such a turn is *not* meant to do: 'To foreground aesthetics, however, is not to argue with Weber (or Clifford Geertz) that culture is all that constituted polity in the non-modern non-West and that other core issues of power were never addressed.'[57] If aesthetics, or what elsewhere I have called 'visual and material culture', are prominent here too, then it is hoped that this is not totally at the expense of how aesthetics and power acted to make a world, a world in which both could have meaning and force. Arguably the kings of the Ming dynasty have been so undervalued that attention paid to *any* aspect of their presence on the Ming scene represents a necessary rebalancing of our understanding.

Undervalued perhaps, but not totally unnoticed. I would want to stress the extent to which this book draws on the work that has been done in a variety of fields already. While still arguing that the Ming aristocracy has been a neglected part of the total picture, it would be grossly unfair to suggest that absolutely no attention has been paid at all to this social group, and particularly in certain of their cultural aspects. As far back as 1954, in the introductory volume to *Science and Civilisation in China*, Joseph Needham noted that in the Ming, 'As in the Han, imperial princes took part in the flowing tide of learning.'[58] And Ming imperial clan members variously have roles in the volumes on botany, alchemy, geography, physics and printing. Histories of drama also give due weight to kingly creators. The 'prince and dramatist' Zhu Youdun (1379–1439), one of those who *does* enjoy an entry of his own in the *Dictionary of Ming Biography*, is described by another standard reference book as 'the most important dramatist of the first half of the fifteenth century' and has been the subject of monographs in Chinese and English by Ren Zunshi and Wilt Idema.[59] Another figure well known to historians of drama is Zhu Quan (1378–1448), who has been further noticed by several scholars as a writer on various subjects including famine crops, Daoism and music.[60] He is one of several Ming kings cited by Robert van Gulik in his classic monograph on the lore of the *guqin*,

the Chinese zither or lute, an elite instrument with which a number of members of the imperial clan were associated as players or theorists.[61] Zhu Zaiyu (1536–1611) is an important figure in the intersecting histories of both music and mathematics, for his work on pitch.[62] And there has been attention by more than one scholar to the role of the kingly households as important centres of book publishing in the Ming.[63] But what has not been attempted so far is a 'joining of the dots'; work on Ming dynasty kings remains largely specialized and compartmentalized. What will be argued here is that there is a picture to be discerned if some of the work done already by scholars in their own areas is connected, or at the very least assembled into some sort of a pattern. Here it will be a pattern in which what we now call 'art' and 'culture' are most prominent. There is certainly no claim that the present account is final or definitive. No one (and certainly not the present author) possesses the full range of competencies and grasp of sources to produce a full account. But any such full account of the Ming aristocracy will have to take account of their importance as creators and sustainers of cultural projects, a term which is here cast very wide to encompass work in the field of calligraphy and painting, as well as things like the building projects they sponsored and the vast assemblages of material culture which went into their tombs. This study will also choose

to focus on two geographical areas: the modern provinces of Shanxi and Hubei (see map on page 197). The former is northern, and not one of China's richest areas (though rich in mineral resources); the latter is south of the Yangtze and now, as in the Ming, is a region of considerable prosperity. Both were in the Ming period the site of several kingly establishments; indeed, Hubei has a claim to be the most 'kingly' of provinces, with seven lineages of kings of the blood (*qin wang*) sited there in the course of the dynasty. Shanxi by contrast had three.[64] They therefore make a valuable pair of case studies, and so this book will return to these very different landscapes at a number of points. Very different from each other, each is equally different from Jiangnan, the focus of so much attention up to now. It would be tempting to see Jiangnan as the 'core' of the Ming empire, to which Shanxi and Hubei were in their different ways 'peripheries', neglected until now but interesting in their own right. But in doing so, one would merely *seem* to direct attention away from Suzhou and Nanjing, in ways that ended up re-inscribing their centrality even more firmly. What is attempted here instead is a 'devolution' in the sense that this charged word is employed by John Kerrigan: 'To devolve is to shift power in politics or scholarly analysis from a locus that has been disproportionately endowed with influence and documentation to sites that are more dispersed and more

skeletally understood.'[65] In devolving our understanding of Ming China's art and culture from (for example) the literati painters of Jiangnan to the palaces and tombs of Shanxi and Hubei, it will be necessary to draw not only on textual documentation but on the evidence of a range of kinds of material culture, some of it familiar (such as calligraphy in chapter Three and painting in chapter Four) but some of it perhaps less often investigated, such as jewellery (in chapter Five) or bronzes in an archaic style produced in a kingly milieu (chapter Six). We need to start by considering the landscapes in which kingly culture was situated, and the places where it might have been encountered.

TWO

THE KINGLY LANDSCAPE

The visibility of the imperial clan in textual records of the Ming period today would only have been paralleled in their own time by their visibility within the landscape of the empire. Across the provinces where they were established, and especially in and around the great cities which were their homes, their presence was continuous and imposing in the form of palaces they inhabited, temples they built and patronized, estates they owned and from which they drew their wealth, and the great tombs in which they were buried and which dominated great swathes of the countryside. As with the historical record discussed above, this prominence is borne out by the amount of space they take up (and the placing of that space) within a type of Ming text which can serve as a bridge between the printed page and the actual landscape, namely the gazetteer. Gazetteers, whether of the entire empire, of provinces or of smaller units within them (even of single sites such as temples) are a type of Ming text which exists to render space fully part of culture by ordering the natural and human phenomena of a given region in a way which makes it make sense. They are a site on which the imperial clan and the educated degree-holding elite (who composed these texts and formed their primary readership) might figuratively meet and occupy the same space. The Ming gazetteers of Shanxi and Huguang (comprising modern Hubei and Hunan) provinces, the two provinces on which this study will concentrate as case studies, at once demonstrate, by the attention they devote to kingliness, the extent to which kings were a visible part of the Ming landscape in its textual rendition. The 'Comprehensive Gazetteer of Shanxi' (*Shanxi tong zhi*) was edited in 1629 by Li Weizhen (1547–1626), replacing editions of 1474 and 1567 which are now extant only in fragmentary form.[1] The first of these earlier gazetteers, that of 1474, had as a member of its editorial team a certain Yin Hong, who held the office of Administrator of the Right in the palace of the Kings of Jin, showing that there was at least in one case a point of contact between the kingly milieu and a form of textual

production now overwhelmingly associated with the bureaucratic elite.[2]

Of its 30 chapters, chapter Eleven of the early seventeenth-century version of the Shanxi gazetteer is devoted to *feng jian*, 'establishment of appanages', and lists holders of such appointments in Shanxi from the earliest times down to the Ming. It gives the lineages of the Kings of Jin, from the first holder of the title Zhu Gang (third son of the Ming founder), and of the other two lines settled in Shanxi, the Kings of Shen and of Dai, as well as the lineages of all of the founders of lines of *jun wang*, 'commandery kings', the younger sons of the main houses.[3] It also distributes kingly presence across its own textual surface, for example, giving the sacrifices to cosmic powers carried out by kings in their appanages precedence over all other sacrifices except those to Confucius himself, and most significantly giving them precedence over the sacrifices to City Gods carried out by officials.[4] In the chapter on *gu ji*, 'ancient relics', the section of a gazetteer typically devoted to noteworthy objects and places of antiquarian interest, the sites of the tombs of the Kings of Jin, of Shen and of Dai, as well as of the cadet lineages, are all scrupulously recorded, putting them on a par with other traces of ancient rulers and heroes, and the sites of battles which changed the fates of dynasties.[5] And finally, in the section on temples which is part of the chapter on 'miscellaneous treatises' (*za zhi*), the temple which is listed first, and hence

given precedence over all other temples in a province famous for its sacred sites, is the Chongshansi, 'Temple of the Veneration of Goodness' (illus. 3).[6] Built in the early Ming by the first King of Jin, and hence much less venerable than many of Shanxi's Buddhist sites, this great urban temple functioned as the 'family chapel' of the Kings of Jin, and its prominence here stands both for its prominence in the urban landscape of Taiyuan and for their prominence within the province itself.

In the huge 98-chapter gazetteer of Huguang, which was edited by Xu Xuemo (1522–1594) in 1591, the kings are also a prominent feature, though the fact that the material on them is arranged quite differently shows that their inclusion was the result of editorial choices, rather than a matter of unthinking reflex.[7] Chapters Eight and Nine form a two-part 'treatise' (*zhi*) on 'appanage fiefs' (*fan feng*), which begins with biographies of all of the founders of the kingly lines and of the lines of commandery kings. This takes up the whole of the first chapter, the second being devoted to 'palaces' (*fu di*), then to a listing of the salaries received by each holder of a title, and of their retainers, including the entourage to which they were entitled, and the flags, banners, musical instruments and travelling furniture which accompanied them on their movements through their domains.[8]

Texts like the gazetteers made the aristocracy visible to the wider empire, or at least

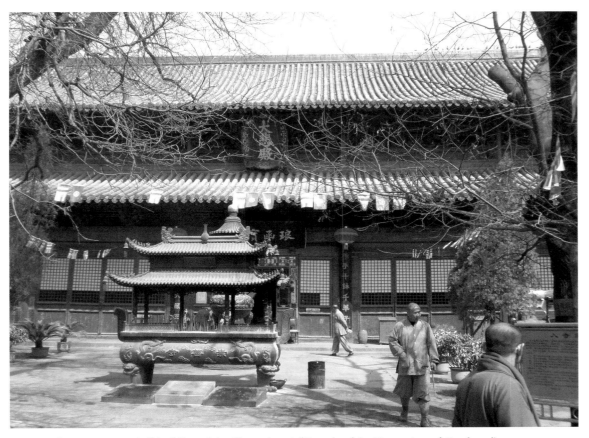

3 Late 14th-century main hall building of the Chongshansi ('Temple of the Veneration of Goodness'), Taiyuan, Shanxi province.

to its literate elites, since they were printed and distributed through the book trade. Although not always produced under state auspices, they form part of the 'official', that is to say prescriptive rather than descriptive, placing of the aristocracy within the landscape. But what made them such an inescapable part of that landscape was as much as anything else their sheer numbers. Different Ming writers had a different sense as to which provinces were most thickly studded with kingly households. Xu Xuemo, editor of the Huguang gazetteer cited above, thought it was Henan, centred on the Northern Song dynasty capital of Kaifeng. Xie Zhaozhe (1567–1624) listed three areas as being most prominent in this regard: Shaanxi, Henan and Huguang. And the modern calculations would seem to bear this out, with seven kingly lineages each having their seats in Huguang and Henan, and five in Shaanxi.[9] Shanxi had only three: the Kings of Jin, with their palace in Taiyuan (still the modern provincial capital), the kings of Shen at Luzhou (the modern Changzhi) and the Kings of Dai

at Datong, in the very north of the province. These three lines were still capable of expanding into impressive numbers of people. That of the Kings of Jin was especially fecund, with nearly 5,000 titled male and female members of the lineage by the middle of the sixteenth century, making it the second-largest such line in the whole empire, after that of the Kings of Zhou at Kaifeng. At the same date there were 9,965 titled individuals in the whole of Shanxi; taking all family members into account (and not just title holders), the figures of 20,000 clan members in the city of Taiyuan and 200,000 imperial clan members for the whole of Shanxi by 1600 seems not wholly implausible.[10] Ming population statistics, like all numbers from the period, are notoriously hard to interpret, but what is incontrovertible is that a Ming inhabitant of Shanxi had a much greater statistical chance of setting eyes on a member of the imperial clan than on a member of the imperial bureaucracy. Holders of the highest level *jinshi* degree were extremely rare birds in the Shanxi landscape by comparison with Supporter-commandants of the State, lowest of the eight grades of nobility, and even much grander title holders were more numerous than county magistrates. Eighteen commandery kings had their residences in the provincial capital of Taiyuan alone.[11]

The density of the kingly presence was if anything even greater in Huguang, and spread across a much greater number of centres. From the work of modern scholars it is possible to construct a list of some nineteen imperial sons who were established in this fertile and prosperous region. These date from Zhu Zhen, sixth son of the Ming founder, who was created King of Chu with his seat at Jiangxia (part of the modern metropolis of Wuhan) in 1370, to Zhu Changying, seventh son of the Wanli emperor (r. 1573–1620), who was created King of Gui at Hengzhou in 1627. Not all of these lines were equally successful or long-lived. Particularly in the early Ming, the notorious suspicion of the Ming founder (and of his equally suspicious heirs the Jianwen and Yongle emperors) could lead to the disgrace of kings and to the extinction of their lines. This happened to the Kings of Tan in 1388, of Xiang in 1399 and of Gu in 1417, while the kings of Liao were finally cashiered for behaviour appalling even by Ming aristocratic standards in 1568. And not all lines were equally prolific breeders, with six dying out for lack of issue, often after only one holder of the title. This was the case for example with the King of Liang (r. 1429–41), whose spectacular tomb will be examined in more detail in chapter Five. This still left nine kingly lines in Huguang which lasted from their creation until they were all swept away, either in the huge peasant wars of the early 1640s which presaged the fall of the Ming, or by the Manchu conquest which finally achieved it. As in the cities of Shanxi, they were a visible feature of the urban scene, with over 5,000 relatives of the Kings of

Liao living within the (still-extant) walls of the city of Jingzhou (illus. 4).[12]

This same picture can be replicated across those regions of the empire where appanages were established, as can the complaints of members of the imperial bureaucracy about the unchecked proliferation of title-holders, and the unbearable strain placed on the provincial fisc by their ever-expanding salaries. However important as the statistics were to the officials making these complaints, the kingly presence in the Ming landscape was established through much more than simple numerical weight. Both their initial positioning within the landscape and their subsequent use of it was designed to create a kingly space which maxi-mized the flow of benefits to the dynasty and its ruling family from cosmic forces. While the Ming founder's choice of places of residence for his sons was governed to a large degree by strategic considerations, in keeping with their role as 'a fence and a screen' for the imperial centre, these considerations were inflected by the desire to harmonize with such forces. The major building campaigns which created the kingly centres of the early Ming were all carried out with this in mind. For example, the city of Yanzhou in Shandong province was designated right at the start of the dynasty as the seat of the appanage of Zhu Tan, Taizu's tenth son, who was created King of Lu at the age of three months in 1370. In 1385 he left

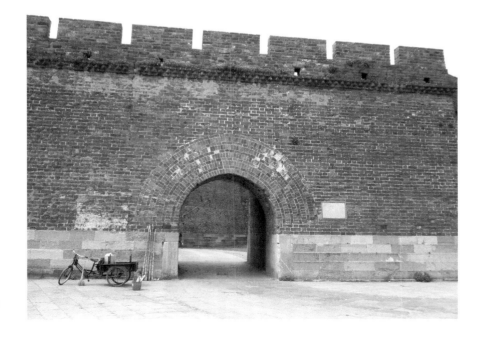

4 Ming dynasty walls of the city of Jingzhou, Hubei province.

Nanjing to proceed to a huge pre-constructed palace, where he died at the age of just nineteen, ostensibly from ingesting an alchemical elixir. At his investiture, Yanzhou was raised in the administrative hierarchy from being the seat of a county (*xian*) to that of a prefecture (*fu*), and this already strategic city became a significantly more important political, economic and cultural centre than hitherto.[13] In the course of this transformation, Yanzhou changed shape significantly; not only did it receive vast new walls, but the building of the royal city within the former Yuan city meant that the remainder was now too small for the enhanced importance of the place, and so it was expanded around the royal core, changing its ground plan from a 'landscape' to a 'portrait' rectangle in the process. For the inhabitants of Yanzhou, and for all who frequented it as a commercial or cultural hub of Shandong province, its new configuration was inescapably bound to its kingly status. A new north–south processional axis was centred on the royal city, with an east–west axis formed by a canalized river, the *fu he* or 'palace river'. The north gate of the city, instead of being situated in the middle of the line of the walls, was now offset to the east, for the specific geomantic reason of preventing the escape of *wang qi*, 'kingly aura'. This was a powerful force both desired and feared at the same time; a lack of it would cause premature death and the extinction of the line, but too much of it created the serious risk of

breeding a rival to the imperial centre; hence the contradictory impulses of both nurturing and controlling *wang qi* as it roiled across and over and through the landscape.[14] This explained the distinctive layouts of royal cities, which often did not conform to the simple concentric rectangles of ideal urban plans derived from classical sources. In Yanzhou, the kingly seat was in the north of the city, while in Taiyuan it was in the east, despite the theoretical desirability of sitting it on a central axis. At least in later Ming memory, there was one case in which a fear of an excess of 'kingly aura' led to modifications being made to a palace or to structures around it. The writer Li Mengyang (1472–1529) records how in Kaifeng, seat of the Kings of Zhou in Henan province, a number of storeys were removed from the pagoda of the Xiangguo Temple for this very purpose of 'uprooting the kingly aura' (*chan wang qi*). A later local history of Kaifeng tells of various modifications ordered by the imperial geomancers to the Zhou palace, including the demolition of some halls, gates and towers, a prohibition on the opening of one particular gate, and the planting of nails in the ground at the four corners, all because 'the kingly aura of the appanage kings of Zhou was too strong'.[15] One factor underlying fears that Kaifeng's aura was such as to support the rise of a claimant to the imperial throne itself is provided by the evidence of modern archaeology, which shows that the palace of the Kings of Zhou was built

precisely on the foundations of the imperial palace of the Song and Jin dynasties.[16] The late Ming collection of imperial clan biographies, *Fan xian ji* ('Offerings from the Appanages', to be introduced in more detail in the next chapter), attributes the first King of Zhou's desire to refurbish the dilapidated imperial palace as his dwelling to his desire to spare 'the people' from labour, but the symbolism of such a move was double-edged.[17] Conversely, the siting of a royal seat in a place lacking in sufficient 'kingly aura' could lead to the premature extinction of that line, as happened in quite a few cases. The late Ming writer Shen Defu was sceptical of this, maintaining that it was fate and not 'the numinosity of the terrain' (*di ling*) which governed the failure or flourishing of lineages, but the terms in which he does so indicate that many held the contrary view.[18]

Not one of these royal palaces survives today. In the far southwestern city of Guilin, the erstwhile site of the mansion of the Kings of Jingjiang (descendants of a nephew of the Ming founder) occupies to a degree its original placement, having been converted into an examination hall in the Qing and subsequently into Guangxi Normal University, though none of the surviving buildings is Ming. Although other kingly traces on the landscape do remain there, in the form of inscriptions carved into the nearby scenic cliffs which make Guilin such a centre of tourism today,[19] it is to archaeology and the rich textual record that we must turn to

derive any sense of the richness and impact of the Ming royal palaces on the cities of the empire. For these (or at least those of the major kings of the blood) were structures on a massive scale, which deployed the full range of architectural symbols of power and authority, in the shape of walls and gates, halls and pavilions and pleasure grounds, to convey the message that those who inhabited them were supremely important. This was not a message lost on the only European to have left an eyewitness account of one of these palaces in its days of glory:

His palace is walled about, the wall is not high but four-square, and in circuit nothing inferior to the walls of Goa. The outside is painted red, in every square a gate, and over each gate a tower, made of timber exceedingly well wrought. Before the principal gate of the four, that openeth into the high street, no Loutea, be he ever so great, may pass on horseback, or be carried in his seat. Amid this quadrangle standeth the palace where that gentleman lieth, doubtless worth the sight, although we came not in to see it. By report the roofs and towers are glazed green, the greater part of the quadrangle set with savage trees, as oaks, chestnuts, cypress, pine-apples, cedars and other such like that we do want, in sort that it forms as fresh and singular a wood as can be seen anywhere, wherein are kept stags, gaxelles, oxen and cows, and

other beasts for that lord his recreation, since he never goeth abroad as I have said.[20]

The observer is the Portuguese Galeote Pereira, who in 1561 passed through the city of Guilin and saw the palace of the Kings of Jingjiang there. The 'Louteas' of his account are the holders of official positions (men who would soon in European tongues come to be called 'mandarins'), and the fact that they dismounted from their horses on passing the royal gate was precisely the sort of visual expression of status which an early modern (minor) European nobleman like Pereira was finely attuned to noticing.

Guilin is not usually prominent as an urban centre in general accounts of Ming history. It is therefore worth pausing at this point to think about how much of our picture of 'the Ming city' is derived from the great conurbations of the Jiangnan region, on the lower Yangtze delta: Suzhou, Hangzhou, Yangzhou, Nanjing and others. From them come the descriptions of urban florescence and excess, from them (or from Beijing) come such visual images as we have of the urban scene.[21] And yet not one of these cities contained a kingly palace, meaning that our model of 'the city' in the Ming period is a seriously skewed one, skewed as in so many other aspects towards the well-documented heartlands of literati culture, where kings were an object of gossip but not of observation.

Central regulations laid down both the dimensions and the names of the halls and palaces which formed the elements of kingly palaces, as well as elements of their decoration like the use of green-glazed tiles for their roofs and dragon motifs for their screens, both established by edict in 1376.[22] Towards the end of the dynasty, the distinctive tiled roofs of 'the palaces of kings of the blood living in the provinces' were still there to be remarked on by the author of the text *Tian gong kai wu* (1637), 'The Marvellous Works of Nature and Man', where the specifics of material culture and its significance in a cosmic balance are equally objects of concern.[23] Certainly the visual appearance of these great complexes was seen as being of significance to the body politic, within an exchange between Taizu and his ministers in that same year striving to achieve a happy medium in decoration between an excessive modesty (seen as vulgar) and over-ostentation (seen as harming the livelihood of the common people). Taizu's son, the Daoist mystic King Xian of Ning, was remarkable for living 'in great simplicity, his palace unornamented with colours or with glazed tiles'.[24]

What buildings were called mattered greatly too. As the Ming founder put it, 'Let all the kings gaze on the names and think on the meaning, that they be sufficient as a hedge and screen for the imperial house, and for ever enjoy much good fortune.'[25] The names of

palace halls all had cosmological significance, drawing in most instances on the classics: in front, the Chengyun Dian, 'Hall of According with the Cosmic Cycle'; in the middle, the Yuan Dian, 'Round Hall'; to the rear, the Cun Xin Dian, 'Hall of Concentrating the Heart-Mind'. The numerological significance of the number nine was everywhere in evidence, with buildings of nine bays in width, and a reported height for the front hall of the Xi'an palace of 9 *zhang*, 9 *chi*, 9 *cun*.[26]

The surviving material evidence for the appearance of Ming kingly palaces is extremely sparse. They survive as phantoms in the ground plans of modern cities, or as sites of memory, their locations preserved in local history and popular memory through the Qing. Only a few substantial artefacts remain. The 'nine-dragon screen' which stood in the palace of the Kings of Dai at Datong survives from the early Ming (illus. 5), and from later in the dynasty there is a similar screen at Xiangfan in Hubei

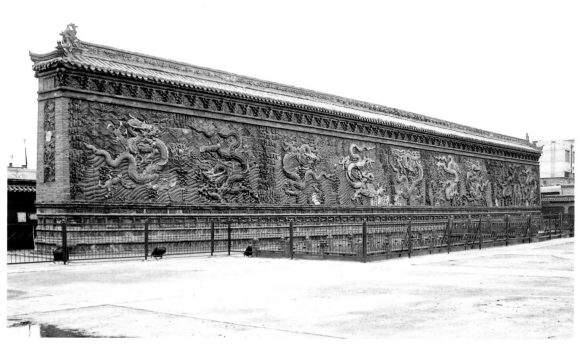

5 Late 14th-century 'nine-dragon screen' of glazed ceramic tiles, formerly part of the palace of the Kings of Dai, Datong, Shanxi province, 45.5 × 8 m.

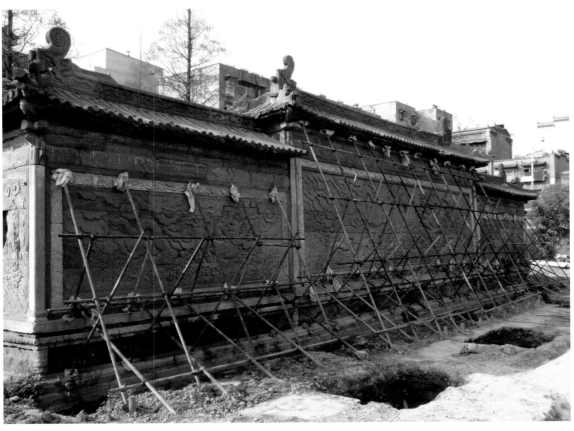

6 Stone screen, formerly part of the palace of the Commandery Kings of Xiangyang, Xiangfan, Hubei province.

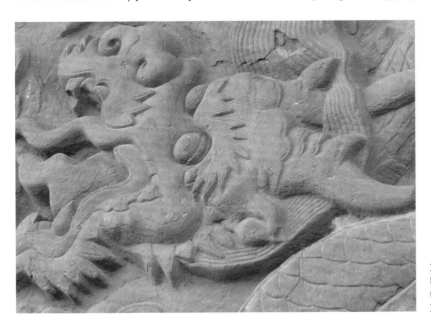

7 Detail of the stone screen, formerly part of the palace of the Commandery Kings of Xiangyang, Xiangfan.

province, once part of the palace of the Kings of Xiangyang (illus. 6, 7).[27] Carved from a distinctive local green stone, its fluent carving and still impressive scale hint at the lavishness of what was by no means the grandest of kingly establishments. Fragments of the palace of the Kings of Heng, in Shandong province, survive today within a public park (illus. 8). Of something like the huge palace of the Kings of Jin at Taiyuan, totally destroyed by fire shortly after the Qing conquest in 1646, we have only odd pairs of cast-iron lions, guardian figures which once stood outside a gate and which attest by

their inscriptions to their date and origin (illus. 9). At least one stone lion in Kaifeng stands similarly forlorn as the only survivor of the threatening and majestic 'kingly aura' of the Kings of Zhou.[28] But only imagination can populate these sherds and fragments of once-great building complexes with the vast staffs they held, including staffs of eunuchs, whose presence marked the kingly palaces out as a particular kind of space of rulership. Eunuchs were forbidden as servants to the populace at large, a prohibition which unlike many seems to have been upheld, and it was for a chance to

8 Stone archways from the site of the palace of the Kings of Heng, Qingzhou, Shandong province.

9 Cast-iron lion, dated 1562, formerly from the palace of the Kings of Jin, now sited at Chunyanggong (Shanxi Art Museum), Taiyuan, Shanxi province.

serve in the households of kings that men took the gruesome path of self-mutilation; after 1529 imperial clan members of the rank of General or even lower were also allowed this mark of privilege.[29]

It therefore takes a considerable effort of will and imagination to see certain Ming cityscapes as royal terrains. Perhaps it is with Xi'an, the great historic metropolis of the north-east, that this effort can most productively be made. An analysis of the dwellings of all members of the imperial aristocracy in that city shows just how thickly studded with them the streets were.[30] In addition to the great palace of

the Kings of Qin themselves, numerous commandery kings (*jun wang*), and holders of such titles as Defender-general of the State, Bulwark-general of the State, down to the bottom rank of Supporter-commandant of the State, had their residences in Xi'an; a total of 38 dwellings in all are recorded. The commandery kings, descended from sons of a king of the blood other than the eldest, took their two-character titles from the names of counties in the administrative geography of the empire; hence King of Bao'an, King of Yongxing, and so on. But this did not mean they were resident in those places. Whether from fear of Mongol raids (in the early Ming) or desire for proximity to higher levels of urban luxury and comfort, most of the collateral branches of the Qin lineage were residents of Xi'an. An analysis of gazetteers, which record their addresses, shows that they were not evenly distributed across the city. Most residences of the higher ranking commandery kings were in its eastern half, newly developed in the early Ming when the city walls were extended, while the western half was crowded with long-established streets containing markets, government offices and temples. By contrast, the residences of the various ranks of general (*jiangjun*) were spread more evenly across the four quarters of the city, with the effect of this being that very few residents of Xi'an did not live in some degree of proximity to (or at the very least were aware of) a member of the imperial aristocracy. Even more noticeable

would have been the continual visiting between these dwellings, as the kingly retinues of guards and musicians filled the streets.

Of their internal layout we get only glimpses. The titles of poems by King Jian of Qin (*d.* 1498) include 'An Inscription Done in the Lanxiu Tower for the Yangxing Studio of My Clan Elder Brother the King of Lintong' and 'Done in the Garden Pond Pavilion after an Excursion to the Shendu Studio in the Company of Third Defender of the State'. Another poem recalls the Qinyou Studio of the King of Qianyang, its cupboards crammed with texts of the Six Classics, and its shelves filled with '30,000 scrolls'.[31] The gardens of the aristocracy were in fact one of the sights of Ming Xi'an, and although we tend to associate 'the Ming garden' with cities of Jiangnan such as Suzhou, there is considerable evidence that royal pleasure parks in areas far from the Yangtze delta could still impress those who came from those climatically more favoured parts. Zhang Han (1511–1593) was a native of the great southern city of Hangzhou, and by 1565 was effectively governor of Shaanxi.[32] In an essay entitled 'Record of a Journey to the West' (*Xi you ji*), this acute observer, who presumably had seen enough of major cities to be beyond too easy impressionability, noted the following:

Over the Jing River is Gaoling, over the Wei River is Fuping, and between the Jing

and the Wei is the provincial capital of
Shaanxi, the Chang'an of antiquity. There
is the Qin palace, known widely as 'First
Appanage Under Heaven' (*tian xia di yi
fan feng*). Whenever visiting the King of
Qin, after the formal banquet in the palace,
there was a private banquet in his study,
with a chance to enjoy the splendours of
the terraces and ponds, the fish and birds.
Behind the study canal, water was led in to
make two ponds, a great swathe of white
lotuses, the ponds stocked with golden
fish, and willows growing over it, so that
the fish would jump out and would eat
titbits thrown for them, making a noise
in their struggle for the food. Behind
the ponds earth and stones were heaped
up into a mountain, with a dozen or so
terraces and pavilions on it, where a
number of tables would be set up, for the
spreading of paintings and histories, and
the enjoyment of rare treasures dazzling to
the eye. Among the rocks were planted
rare flowers and strange trees, the red of
the spring crab-apples, the white of the
pear blossom, the green of the tender buds,
the purple of old *huai* trees, but most out-
standing the thousand-branch cypress,
its roots and branches convoluted and
gnarled in a particularly delightful way.
In the rear garden were planted several
mu of tree peonies, red and purple and
pink and white, and among their stunning

beauty a heavenly fragrance assailed one.
Several tens of peacocks were kept there,
flying and calling in their midst, and if one
threw them a titbit they would all fly down
from the peonies and fight over it, a truly
splendid sight.[33]

Zhang goes on to describe the sights of various
bureaucratic offices (where he presumably
served), but note that for this well-travelled
senior official the kingly palace is the main
sight of Xi'an as far as he is concerned. Only
later in the passage does he get on to the Tang
dynasty relic of the Great Goose Pagoda, now
one of the city's major sights. The fact that the
Great Goose Pagoda survives, while the palace
of the Kings of Qin does not (or survives only
as a ghostly presence underlying the present
layout of the centre of the city), has in the
present reversed the Ming sense of their
relative importance.

Prominent in Zhang Han's account of the
kingly garden are water features such as ponds
and canals. These were equally important in
the gardens of other imperial clan members.
The 'Ancestral Instructions' of Zhu Yuanzhang
strictly forbade the construction of 'detached
palaces' and pleasure grounds away from the
royal *fu* itself, which explains why gardens
were built inside the royal mansion, as an
integral part of it. In 'Offerings from the
Appanages', Zhu Yiyin (1537–1603), King
of Yi in Jiangxi province, is remembered as

'a great builder of terraces and parks, to which he summoned many guests . . .'.[34] In Xi'an, the gardens of the King of Yongshou were dominated by an expanse of water, the *Han bi chi* ('Holding Jasper Pool') planted with lotuses and full of fish and birds, crossed by the 'Surging Gold Bridge' and flanked by an 'Eastern Studio', where guests were entertained. The gardens of the kings of Lintong and of Baoan were famous for their artificial hills and their ponds. These ponds were fed by the two canals, named the Longshou and the Tongji, which fed the city in Ming times and which made these ponds possible. The gazetteers show that the former flowed through the palace grounds of four commandery kings, while the latter passed through those of a further five.[35] This almost certainly gave the royal households collectively a powerful say in the control of water resources in the region of the city, an asset which, as we shall see below, kings were certainly involved in controlling in some other contexts. At the very least it gave them a stake in the allocation of those assets, tying the pleasure parks of the urban landscape which they dominated into the wider landscape.

Galeote Pereira may have been held outside the royal walls, but others were not so excluded. As Zhang Han's account suggests, these gardens were undoubtedly important sites of interaction between the aristocratic and bureaucratic elites in cities like Guilin, Xi'an, Taiyuan and Yanzhou. A fortuitously surviving piece of calligraphy by Yang Rensi (*jinshi* 1628) is a poem praising the 'Mallow Garden' of the King of Jishan, one of the cadet lines of the appanage of Shen, in central Shanxi province.[36] This is undoubtedly a survivor from a much larger body of such celebratory writings. The modern secondary literature, such as it is, can give the impression that the imperial aristocracy lived lives of total seclusion, but in fact there is ample evidence for their palaces as places where kings and degree-holders came together on regular occasions and enjoyed a set of shared cultural practices. For one thing, quite a number of members of the Ming elite had held office in these kingly courts, and even if these were not thought to be plum jobs or the stepping stones to the most illustrious careers they were still quite highly ranked. The two 'administrators' (*zhang shi*) of a princely state were ranked 5a in the Ming administrative ladder (of nine ranks, each split into two), making them very respectable postings. Writing in the early seventeenth century, Shen Defu gives examples of protests against and resistance to being appointed to what were seen by the ambitious as dead-end jobs.[37] However, they may have been perfectly desirable undemanding postings for others, carrying salary and prestige, and he does also give examples of some who rose from posts in a kingly household to important 'proper' jobs. At the beginning of the dynasty in particular, the relationship between king

and Administrator could be close and mutually respectful. The circle of those around Zhu Youdun, King Xian of Zhou, in early fifteenth-century Kaifeng, included a number of men who were prominent in their own day, if (like their royal master) less well remembered now.[38] We have the biographies of a number of other inhabitants of the Zhou palace in these years, and the extant poetry they have left recording excursions and drinking parties in a dense network of poem and response gives the impression that this was a courtly milieu of constant and sophisticated interaction.[39]

An expectation that such relations with learned men were one of the things a king could engage in is contained in the anecdote in 'Offerings from the Appanages' about Zhu Zhijiong, King of Ansai. In addition to being a voracious collector of painting and calligraphy, he 'often regretted that he lived on the borders, and did not manage to roam with the scholars of Qi, Lu, Wu and Chu' (that is, the cultural heartlands of Shandong and Jiangnan).[40] But many scholars *did* see the inside of a kingly palace. In addition to King Zhuang of Yi's 'many guests' mentioned above, we read other accounts in Zhu Mouwei's collection of aristocratic biographies of men who enjoyed acting in the role of genial host. Two of these in particular give a sense that particularly by the later sixteenth century such intercourse was becoming more common. So we read of a king of Qinshui from the Shen lineage in

Shanxi who was enfeoffed in 1567 and who 'was learned and polished, assiduous at versification, he delighted in social exchanges with scholars (*xi shi wang lai*) and had many relations with commoners'.[41] Or we read of Zhu Zaiqin (*d.* 1597), King of Fanshan from a cadet branch of the Kings of Jing in Hubei, who was 'extremely fond of reading books, and extremely learned in classics and histories. His manner was unrestrained and without formality, able to be civil to lesser scholars (*xia shi*). The appanage kings of old would not give or receive name cards, and would not deploy the rituals of guest and host with the gentry (*jinshen*). This king alone changed this.'[42] This extension of kingly hospitality to a lower (if still elite) level of society underlines the extent to which they were a familiar, indeed an inescapable, part of the social landscape in large sections of the empire.

One stratum of society with whom kings and aristocrats certainly did interact was that of religious professionals, and a large part of their presence on the landscape can be mapped through their role as patrons of temples and other religious institutions. After their palaces, it was through the patronage of religious institutions that the aristocracy were most immediately noticeable in and around major cities, and the frequent movement, accompanied by impressive and noisy entourages, between these two settings for courtly and royal activity must have been highly visible.

The first place where art historians of Europe or the Islamic world, in the centuries covered by the Ming period, would look for examples of aristocratic patronage would be religious building. Yet so dominant is the paradigm of 'literati culture' in our view of the period, and still so stubbornly lingering the view that religious art is 'in decline' by the Ming, that little attention has been paid to the temple landscape of a city like Taiyuan in this period. Yet when one does so, it immediately becomes patently clear that the regional kings of the Ming were crucial patrons of building in all the religious traditions of the era. In 'the religious act *par excellence* of the reigning king', they offered sacrifice to the great cosmic powers of heaven and earth, at Altars of Grain, and Altars of Wind, Cloud, Thunder, Rain, Mountains and Rivers.[43] But they were also major patrons of Buddhism and Daoism in their domains. In the case of the Kings of Jin, at Taiyuan, this patronage was expressed through a religious complex which survives in only fragmentary form, but which is still impressive enough to give some sense of its scale and magnificence before it was badly damaged by fire in 1864, further vandalized in the upheavals of the Cultural Revolution, and reduced to the still imposing fragment which is one of the major monuments of Taiyuan today. This is the Chongshansi ('Temple of the Veneration of Goodness', illus. 3), a Buddhist site built in the 1390s by Zhu Gang, First King

of Jin, in honour of his deceased mother, wife of the Ming founder, Empress Ma.[44] As noted above, later gazetteers give this temple precedence over all the other Buddhist institutions of the province of Shanxi, undoubtedly on account not just of its scale (and certainly not of its age) but of its proximity to the kingly line. By venerable tradition there had been a Buddhist site here since the Sui dynasty (581–618), and the name of Baimasi, 'White Horse Temple', was initially retained, but the complex begun in 1381 and completed in 1391 by Zhu Gang was essentially a completely new one, covering some 14,000 square metres (illus. 10). There were major repairs in 1480, and the name Chongshansi was applied from the Jiajing reign (1522–66). Following the fire of 1843 the temple was reduced to an area of 3,192 square metres, which is essentially what survives today, in the form of the impressive main hall (illus. 11).[45] This still contains monumental esoteric Buddha images of early Ming date, together with the glazed tilework platforms on which they stand and several other examples of the lavish furnishings for which the Kings of Jin, as patrons of this temple, paid.[46] Surviving stele texts attest to its ongoing importance to the family. Two such texts, which date from 1563, record an extensive campaign of repairs; the first is by Kong Tianyin (*jinshi* 1532), a Shanxi local who rose to high bureaucratic office outside the province but who is here hymning the

10 Ming dynasty map of the Chongshansi ('Temple of the Veneration of Goodness'),
Taiyuan, Shanxi province.

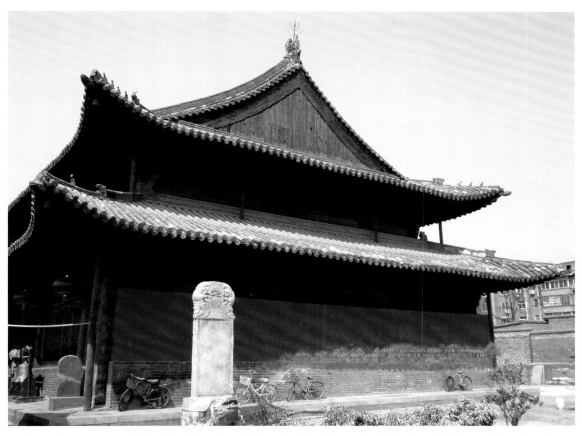

11 Late 14th-century main hall of the Chongshansi ('Temple of the Veneration of Goodness'), Taiyuan, Shanxi province.

geomantic felicity of his native Taiyuan, 'with a mighty appanage set down in its midst, lofty offices and great counties neighbouring it'.[47] A second stele speaks in the voice of the King of Jin himself, recounting how the temple was 'established by my First Ancestor King Gong' to 'repay the grace' of his sainted mother and also to pray for her longevity. It is made clear that the funds were raised by subscription from a lengthy list of (named) administrators of the appanage, and that this has allowed its renovation to a splendid state, with new images, paintings, bells and drums (illus. 12).

The king concludes sonorously, 'This is that which my ancestors have built, have transmitted, that which I must reverence, must cherish, and where my unfailing remembrance is written down to be transmitted in stone.'[48]

Equally important, and possibly even more visibly prominent in Ming Taiyuan, are the pagodas of the Yongzuosi ('Temple of Perpetual Blessing'), one of which has an important association with the kingly house of Jin. Taiyuan lies in the valley of the Fen River, which flows north–south and is flanked by hills and mountains on either side, visible even from

12 Interior of Chongshansi ('Temple of the Veneration of Goodness'), Taiyuan, showing sculpture of 'Thousand-Armed Guanyin'.

today's polluted city. In the clearer air of the Ming, one of the most visible landmarks just outside the city walls would have been the two great brick pagodas (illus. 13), now well within the city limits, which give the Yongzuosi its colloquial name, the Shuangtasi ('Double Pagoda Temple'). One of these pagodas pre-dates the temple itself, and was built in 1599 as the Wenfengta ('Pagoda of Literary Eminence') for reasons associated with the aspirations of local elites who were not of kingly stock. According to geomantic calculation, the topography of

Taiyuan was 'high' towards the northwest and 'low' towards the southeast; the result of this was that the region's *wen*, or 'literary culture', was flowing in that latter direction, a fact that explained the relative lack of success of local men in the imperial examination system and the concomitant domination of those exams by men from the southeastern Jiangnan region. The pagoda, situated at the southeast corner of Taiyuan's walls, had the geomantic effect of 'blocking' this outflow. It stood alone on its eminence for nine years, until in 1608 Zhu

13 Twin pagodas, dated 1599 and 1608, of the Yongzuosi ('Temple of Perpetual Blessing', also known as Shuangtasi, 'Twin Pagoda Temple'), Taiyuan, Shanxi province.

Minchun, King Mu of Jin (*d.* 1610), founded the Yongzuosi, which incorporated into it the existing pagoda, and added its twin, the Xuanwenta ('Pagoda of the Proclamation of Literary Culture'). The phrase *Xuanwen* forms part of the elaborate title of Dowager Empress Cisheng (surname Li, *d.* 1614), the pious mother of the reigning Wanli emperor, and is used here as recognition of her contribution to the costs of the construction of this monument. [49] The 54-metre-high pagodas dominate the skyline to this day. It is difficult at this distance to interpret the full import of this act, but at the very least this incorporation of what was originally a scholar-elite project, made highly visible by building,

reinforces the claim of the Kings of Jin to a pre-eminence in the local landscape.

The Chongshansi was effectively a 'royal' temple, and the case of the Yongzuosi shows the Jin household appropriating (with or without resistance) a space created by other elites. Patronage was probably often effectively a claim to hegemony, at least on a rhetorical level. This can perhaps be seen in the case of the very venerable Buddhist site of the Tianlongshan cave temples, dating back to the Eastern Wei dynasty (534–550), and situated in the hills to the southwest of Taiyuan. An inscription of the late sixteenth or early seventeenth century, composed by Zhu Yinlong, King of Jing'an, gives an account of Jin kingly interaction with this numinous site, described as 'the breast of the Jin appanage of Jinyang' (an archaic name for Taiyuan). It tells how, in the late fourteenth century, 'My First Ancestor King Gong of Jin was given as his portion the state of Jin, and in inspecting the borders of his appanage he saw the rare majesty of these mountains, making embellishments and repairs.' Further repairs had been made over 100 years previously, and now the vagaries of time have required a new campaign of refurbishment. The stele names the monks who have sought contributions, and those who have piously given, including the Dowager Consort of Jin and the reigning king.[50] Similarly, the writing of name boards for temples (as happened on a number of occasions) not only made the king as exemplar of culture visible through his calligraphy, it associated him as symbolic patron and protector with complexes of buildings which were very much part of people's everyday lives.[51] Even in cases where the kingly family of Jin may not have been very directly involved, interaction with the Buddhist establishment of Shanxi and its constant fund-raising activities is visible in the inscription record. A text of 1585, recording a pious donation of land to a temple called the Baoningsi and surviving today in a Taiyuan city shrine, is composed by a member (the name is damaged) 'of the imperial clan of the Jin appanage'.[52] His role as author sheds a little of the royal lustre on what may have been an otherwise rather modest project.

One case where the Kings of Jin very clearly had to negotiate with other powerful local forces is that of the Jinci, 'Shrine of Jin', one of the most important cult sites in the province, situated just to the southwest of the city. Here, a site which was both ritually extremely powerful and crucial in its control of the water resources of a very arid region, was contested in almost every aspect by local elites of varying kinds as well as by the peasants who depended for their livelihood on the outflow of its sacred spring.[53] It witnessed a complex set of struggles over the interpretation of exactly who was venerated at the site, particularly over the identity of the deity known as the 'Holy Mother' (*Sheng mu*) who occupies its main

hall, as well as struggles over the disposition of water resources, involving complex rotas for the flow of water into different channels. In all of these struggles the Kings of Jin, and other branches of the family such as the Kings of Ninghua, were intimately involved. Their claims can be traced through lengthy stele inscriptions.[54] They may also be asserted through modifications made to the buildings on the site and to their decoration. Although much faded now, one of the most visually striking features of the central Shengmudian, 'Hall of the Holy Mother', in the second half of the Ming must have been the paintings which adorned the eaves of this already ancient building, and faced those who approached the shrine (illus. 14). The named patron of these paintings, executed in 1515, was a certain 'Canal-Head Zhang', who appears to have been in some sense a client of the Jin household

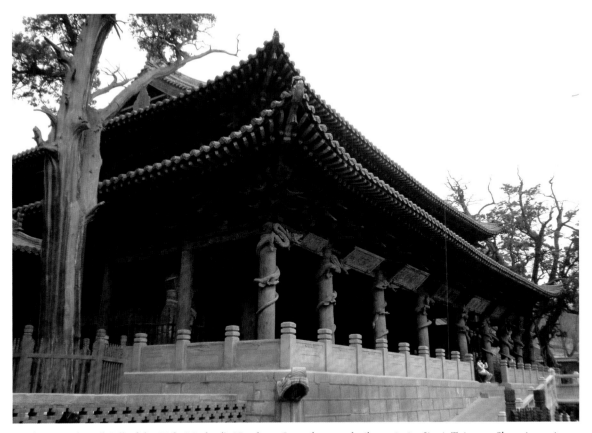

14 Shengmudian ('Hall of the Holy Mother'), Northern Song dynasty, built 1038–87, Jinci, Taiyuan, Shanxi province.

and who was responsible for 'presenting' valuable water rights to it at around the same time.[55] It is therefore at the very least a possibility that the Jin household approved of the imagery and the manner of these once-vivid paintings, and that they incorporate elements of its reading of the shrine's tangled history. Certainly in 1561 both the Kings of Jin and of Ninghua contributed substantial sums to the repair of the Hall of the Holy Mother and to the bridge in front of it.[56] In the 'battle of building patronage' between local peasant forces (who favoured the cult of the 'Holy Mother' as water goddess) and local gentry degree-holding elites (who favoured the cult of Shu Yu, supposed first holder in archaic times of the appanage of Jin), the Kings of Jin were uniquely placed. For they were the *only* power group beholden to *both* the local and the imperial for their legitimacy; they were heirs to both the local goddess and the incarnation of legitimately descended rulership. It was the kingly families who, through pre-existent prestige, were able to do the work on the complex's largest and most visible structure, making it part of their reading of the whole.

The Jin household in Taiyuan was far from unique in its highly visible interactions with religious establishments of varying types, and many temples bore the marks of kingly presence in the landscape. At the Shaolin Temple in Henan province, famous to this day for the martial arts skills of its monks, a number of inscriptions on incised Buddhist images indicate contact between the monastery and the household of the Kings of Hui, often with eunuchs of that household (illus. 15).[57] This line of kings descended from the ninth son of the Zhengtong emperor, and was enfeoffed at Junzhou in 1466; it came to an end with the disgrace and suicide of his great-grandson in 1556.[58] At Changzhi in Shanxi province, the great Shangdang temple fair (which only expired in 1978) was instituted in the mid-fifteenth century by a King of Shen, who had his seat there and who dedicated a famous image of the Jade Emperor. This was very efficacious in responding to prayers for rain (again the role of water in a dry province) and was brought out every year from the 24th day of the 6th month through to the end of the month. The drama which was performed in the god's honour, and the major market, attracted merchants from outside the province.[59] The kingly presence must have been very visible there in the Ming period, if largely forgotten thereafter. In the north of Shanxi province the great Buddhist pilgrimage site of Wutaishan, where the bodhisattva Manjusri had manifested, was the particular object of patronage by the Kings of Dai, whose seat was at Datong. Here, at a site of particular holiness, many patrons competed, up to and including the imperial family in Beijing itself.[60] The work of the monk architect Fudeng (1540–1613) formed a link between Wutaishan and Taiyuan, and illustrates the nexus of royal

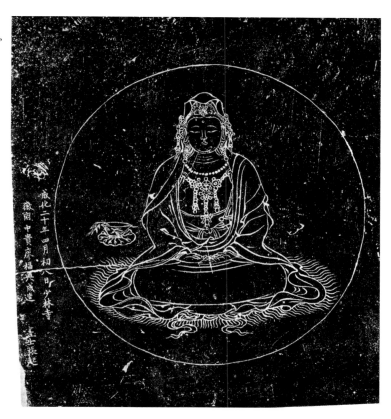

15 Incised stone image of the Buddhist deity Guanyin, dated 1484, Shaolinsi, Henan province.

patronage of Buddhist building. His talents had been identified when he was still a youth by Zhu Junzha, King of Shanyin (*d.* 1603), who reportedly found him sleeping in the porch of a temple at Puzhou, in Shanxi. His most famous and spectacular work is probably the gilded 'Bronze Pavilion' he constructed in the Xiantongsi ('Temple of Manifest Enlightenment') at Wutaishan, but his distinctive style of brick architecture, imitating the more common wooden construction, is seen not only in the 'Beamless Hall' of the

same temple but in the main hall of the Yongzuosi in Taiyuan, where he lived for a period (illus. 16, 17, 18). A favourite of the imperial family, he also worked at some point for all three of the kings of Shanxi province, since it was a visit to Zhu Xiaoyong, King of Shen (enf. 1580), which encouraged him to donate a gilded Buddha image to Mt Emei, in far Sichuan, and to construct for this same king a temple on the site where another of the great bodhisattvas, Samantabhadra, had manifested to devotees.[61]

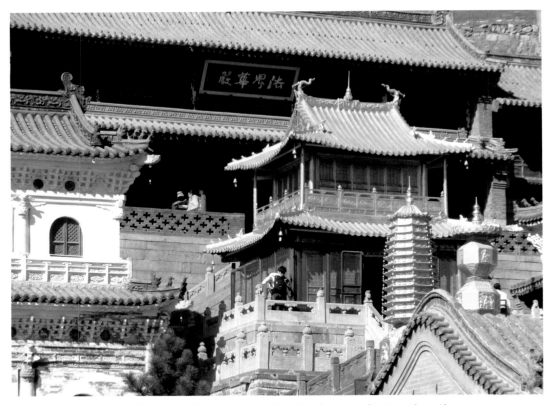

16 Bronze Pavilion at the Xiantongsi ('Temple of Manifest Enlightenment'), Wutaishan, Shanxi province, designed by the monk Fudeng (1540–1613).

17 Beamless Hall, Xiantongsi ('Temple of Manifest Enlightenment'), Wutaishan, Shanxi province, designed by the monk Fudeng.

In 1486, Zhu Chenglian (*d.* 1489), King Hui of Dai, rebuilt the venerable Pujisi ('Temple of Universal Salvation') at Wutaishan for Master Guyue, a monk of great saintliness.[62] A stele of 1557 commemorates the pious donations of 'Madame Zhang of the Dai Palace', telling how she entered the palace as a young woman and was much loved by the king, but despite the splendour in which she was placed she 'often thought of renouncing the world'. The text quotes her directly as saying 'If one does not do good works, where will good fortune come from?' She has ordered the monk Dechun from the 'new chapel in the palace' to feed 108,000 monks at the Jingesi at Wutaishan, and has arranged the casting of

Buddha images, bells and drums. As well as offering a Water and Land Assembly ritual to pray for the souls of hungry ghosts, she personally recited the 'Sutra of the Buddha of Medicine twice'. Her largesse was not restricted to Buddhist causes, since 'She had the two corridors of the temples of the Five Peaks and City God in the prefecture [or 'palace', *fu*] painted, dazzling with gold and blue.'[63] This is an enlightening account of female agency in religious patronage, and was unlikely to have been a unique case.

Arguably, it was also female agency which brought about something like the Wanshou Baota ('Pagoda of Ten Thousand Years of Long Life') on the banks of the Yangtze outside

18 Main hall, Yongzuosi, Taiyuan, Shanxi province, designed by the monk Fudeng.

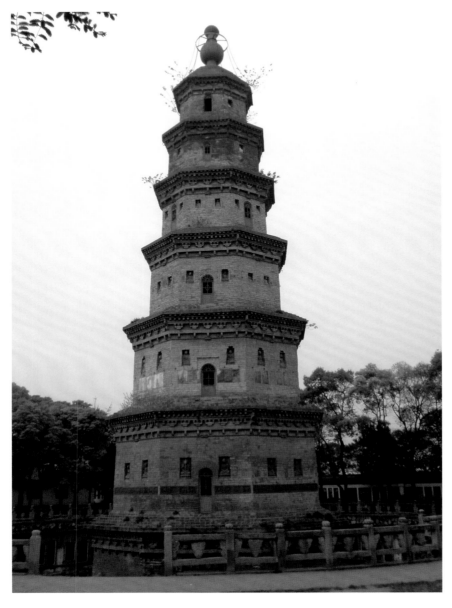

19 Wanshou Baota ('Pagoda of Ten Thousand Years of Long Life'), built 1548, Jingzhou, Hubei province.

Jingzhou, in modern Hubei province (illus. 19). This was constructed in 1548 by Zhu Xianjie, King of Liao, on the orders of his mother, Grand Consort Mao, to pray for the long life of the then-reigning Jiajing emperor (and possibly thereby to deflect his notorious antipathy to Buddhism).[64] Elsewhere in Hubei, and right at the very end of the dynasty in 1642, the Yuquan monastery in Dangyang received financial support from another kingly purse.[65] We can be much less certain of the context of creation of a unique Buddhist sculpture to bear evidence of kingly (or at least kingly household) involvement. This is a gilt bronze image some 61.5 cm high, which carries the inscription 'A figure of Amitabha Buddha made in the year *bingyin*

for/by the Rong household' (illus. 20).[66] The appanage of Rong was established at Changde in Huguang in 1508 for the thirteenth son of the Chenghua emperor; the lineage lasted until the end of the dynasty.[67] The only two *bingyin* years which fall within this span are 1566 and 1626, and the earlier of these seems the more plausible. Stylistically the piece could be even earlier, and it is interesting to speculate if we are here looking at a rather *retardataire* provincial style. Was this piece cast and gilded deep in the provinces where the Kings of Rong lived, or did they commission it from some larger centre? Both are possible, since as we shall see there is evidence for luxury workshops within kingly households, as well as plenty of evidence for their ability to obtain high-end goods from farther away. For now, it is only possible to add this to the considerable body of evidence for kingly courts as centres of Buddhist patronage.

There is equally compelling evidence for kingly interaction with one of the other great strands of the Chinese religious tradition, which we now call Daoism.[68] This is clear from the very first generation of kings, who included some noted adepts in these esoteric religious practices. Probably the most renowned of these is Zhu Quan, King of Ning (1378–1448).[69] An eminent author on numerous subjects including drama and music, he also wrote on medical and alchemical topics. But his religious commitment was not simply expressed in text, or privately in the costume of a Daoist adept in

20 Gilt bronze Buddha, dated 1566, *h*. 61.5 cm.

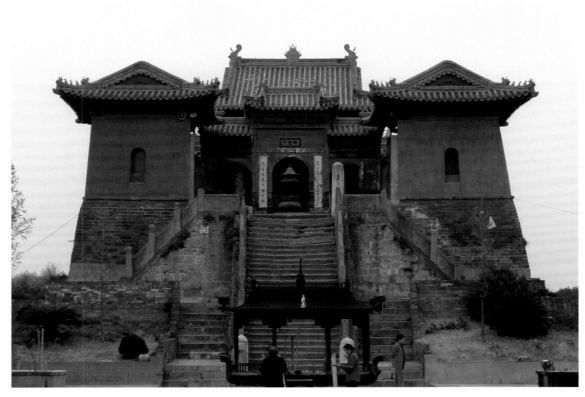

21 Taihuiguan ('Monastery of Supreme Radiance'), founded 1393, Jingzhou, Hubei province.

which he was buried; it was visible to a much wider audience. This visibility took the shape of numerous buildings around his large tomb mound in Jiangxi province, an area noted for Daoist activity. Though none survive, their names, such as 'Palace of Eternal Life' (*Chang sheng dian*) and 'Palace of the Southern Pole Star' (*Nan ji dian*), have a powerful Daoist flavour. This is reinforced by two eight-sided pillars with Daoist talismans carved on them, each 6.9 m high and with a lion on top, their Daoist inscriptions dated 1442 invoking blessing on the people, the emperor and the Ning branch of the imperial house.[70] The possibility that there may have been a full-scale Daoist temple on the site at the time is increased by the survival of just such a temple, in flourishing form, by the side of the grave of his brother Zhu Bai, King Xian of Xiang (1371–1399), at Jingzhou in modern Hubei province. The Taihuiguan ('Monastery of Supreme Radiance', illus. 21) was constructed by the king in 1393 on the site of an earlier foundation, only metres from his now excavated grave.[71] Its reactivated religious life today is still probably only a fraction of the activity it contained in its prime, but it still stands as a vivid reminder of the connections of kings with practitioners

of the Daoist tradition. Zhu Bai was also an active patron of the great Daoist pilgrimage site of Wudangshan, also in Huguang province, and is known to have exchanged poems with prominent Daoist monks based there.[72]

Such connections could also have powerful regional inflections. It is noteworthy for example that the Kings of Jin do *not* seem to have been major patrons of Daoist establishments, or at least not on the same scale as their contacts with Buddhism. None of the lineage's members had personal *hao*, or style-names, of the formula X X *daoren* ('Daoist of such-and-such'), which were very common in some branches of the imperial clan and which often indicate a Daoist affiliation.[73] But some segments of the lineage were more visibly committed, up to the degree of Zhu Tan, King Huang of Lu and tenth son of the Ming founder, who is believed to have poisoned himself in 1389 with a 'goldstone medicine', probably one of the mercury-based elixirs which were such an alluring but deadly part of some forms of Daoist practice.[74] The passionate adherence to Daoism on the part of the Jiajing emperor (*r.* 1522–66) led several of his relatives to follow him, a fact which is usually treated with disdain as evidence of sycophancy by scholar-elite commentators but which we might not wish to be so quick to dismiss. Shen Defu tells us in his collection of anecdotes 'Random Gatherings of the Wanli Era' (*Wanli ye huo bian*) of the award of a hereditary title

of *zhenren*, 'Perfected Being', to the Henan-based Kings of Hui, and he has a lurid series of anecdotes about the similarly titled Zhu Xianjie, King of Liao, builder of the pagoda at Jingzhou (illus. 19) but also a 'lustful and bad' character, who pretended to be a Daoist devotee in order to obtain from the emperor a golden seal, ritual robe and cap, of which we are told: 'Whenever Jie went out, he always wore the robe and cap he had been granted.' (This at least tells us that when kings went out they expected to be seen, and that they were interested in visually advertising their court connections.) This bad king used to carry out *jiao* ('cosmic renewal') ceremonies for people, claiming he had the powers to invoke supernatural blessing. He is said to have used charms and talismans, and for one of them he needed a fresh human head; meeting a drunk in the street, he had him beheaded, which shocked contemporaries and was just one of the numerous lawbreaking exploits which led to his impeachment in 1568 for 'twelve great crimes'.[75]

It was the bad behaviour of kings rather than sincere religious belief which fascinated Ming dynasty memoirists from the bureaucratic elite. But that piety definitely existed, and we do not need to absorb all the prejudices of one part of our sources. There is, as unravelled by Richard G. Wang, a continuous history of less spectacular but highly visible patronage by the Kings of Su in Lanzhou in the far northwest of

the empire (surely one of the Ming cities farthest removed from the glamour of the great Jiangnan metropoles such as Suzhou or Nanjing) of the Xuanmiaoguan there, the 'Temple of Supreme Mystery'. It was rebuilt with kingly funds in 1418, 1430 and 1536 by three successive holders of the title, and in 1541 by Zhu Zhenhong, King Duanhuai of Chunhua, who commissioned calligraphy for the buildings from a certain Xiao Sheng. This man has no sort of fame at all in national terms as a calligrapher, but in remote and impoverished Gansu he may have been a figure of some note. The link between the kingly house and this temple extends right to the end of the dynasty, when the last King of Su, Zhu Zhihong, himself ordained as a Daoist monk, personally wrote the calligraphy for the name board of the temple.[76]

In addition to their interaction with the major religious traditions of China, we have evidence for what at the very least was awareness on the part of kings of some of its minor traditions. For example, the patronage of the Kings of Zhou at Kaifeng was extended in certain ways (if complex and slightly indeterminate ways) to the city's Jewish community.[77] European accounts of the late Ming speak enthusiastically of making converts among the princely families of Shandong and of Jiangxi provinces; in the first case there is a suggestion also of an interest in Islam on the part of one spiritually curious aristocrat.[78] Leaving Jesuit

optimism aside, there may well have been an interest in the exotic and the novel in certain kingly households, an interest reflected in the King of Jian'an's response to Ricci.

If the religious aspects of kingly life in the Ming are only beginning to receive attention from historians, the same is not true of another way in which they were a very visible presence in the landscape: their ownership of large estates. Quite how this was visually manifested in detail is unclear (did retainers wear a livery; were there distinctive forms of boundary markers?), but there can be no doubt that peasants in many parts of the empire would have been very conscious that in their daily lives they were living on or next to kingly land, the major source of the imperial clan's great wealth. The first kings created in 1377 were each granted estates of 1,000 *qing* (a *qing* being 100 *mu*, or approximately 14 acres/5.5 hectares). Thus 3,000 *qing* of Shanxi province was devoted to the upkeep of the three kings established there. Yet by the Wanli reign the Kings of Jin alone had 72,000 *qing*. 'Estate land' (*zhuang tian*) was part of the larger Ming fiscal category of 'official land' (*guan tian*), yet a figure of 72,000 *qing* surpassed that of the total official land in Shanxi province.[79]

No aspect of the appanage kings of the Ming has been so extensively written about as their estates, and entirely from a hostile point of view. For Marxist historians here is the point at which the exploitative and oppressive

feudal ruling class is at its most vile, and the wickedness of the Ming aristocratic estate has been a major theme in Chinese historiography since 1949, if not before.[80] What is slightly curious in much of this historiography is that its major sources are the statements of bureaucratic elites, who complained continuously in memorials to the imperial court and in other writings that the tax-exempt status of kingly and aristocratic land was undermining the fiscal basis of administration (for which they were responsible). The vast grants of land to the ever-expanding imperial family are seen by these commentators and their modern interpreters as unsustainable, and threatening the very existence of the dynasty; after its fall in 1644 this became an unassailable truism. The rights and wrongs of this will not be argued here, but the way in which these officials, who in other contexts are very much 'the baddies' of Marxist historiography, become 'the goodies' when it comes to accepting at face value their view of the situation, shows very clearly the statist bias of most modern Chinese history writing and its assumptions that a strong central power is the natural order of things. Ming local society was complex, as the situation at the Shrine of Jin discussed above demonstrates, and things may have looked different on the ground. As the most eminent historian of Ming finances has pointed out, peasants on kingly estates may have paid less in rent than they would have done in taxes

to official collectors, making them attractive lords.[81] And as another eminent historian has written, of a different society where the rich were good at evading the financial claims of the state:

> A fiscal system whose major potential contributors avoid paying tax is often seen by historians as one which is doomed to failure, but this is naïve; patently unjust fiscal systems can continue for centuries, and often have done. Powerful tax evaders, whether aristocrats or ecclesiastical leaders, can also increase their local power by offering protection to their neighbours, who thus become their clients.[82]

This may partially describe the Ming situation, too. Certainly the commendation of land, involving gifting rather than sale, may have created there, as in all equivalent contexts, a relationship of reciprocity in which the residual wishes of the giver might still have some degree of importance, however slight.[83] A Wanli period gazetteer specifically relates the decline in customs in Zhongxiang to the commendation of estates to aristocracy, leading one to wonder whether and to what extent becoming a tenant of the aristocracy might in fact involve a change in lifestyle. Building up a clientage by 'summoning together the evil and the petty', 'mixing promiscuously with the crowd of petty men' and 'calling together desperadoes' was

one of the things kings are accused of doing.[84] But those stigmatized by officialdom as petty men and desperadoes are unlikely to have seen themselves as such, and standing up staunchly for the rights of clients was what made 'good lordship' in a number of early modern European settings contemporary with the Ming. Harassed as a Grand Coordinator might well have been by the intractability of tax-exempt kings or the defiance of their tenants, it is not sound history to attempt mentally to sit at his desk.

Another complaint lodged at the doors of kings was the excessive service obligations they laid on local people, for transport, for aid in the celebration of life events like weddings and funerals, and for construction projects. After their palaces, which were essentially urban, the most visible markers of a kingly presence in the Ming landscape were their tombs. Again, these would have been inescapable and unambiguous visual indexes of kingly prominence at the local level, and would have been seen by very large numbers of people. The contents of these tombs will be discussed in chapter Four, and here attention will be paid to their external appearance, which is the only aspect most people will have seen. Tombs consisted basically of a 'spirit road' with human and animal sculptures, and its accompanying inscribed stele, leading up to a walled enclosure containing both structures for the performance of necessary rituals and a circular mound

covering a subterranean tomb chamber, richly furnished with grave goods.[85] Their siting was governed by geomantic considerations, their placing within the landscape (usually with hills behind and water in front) designed to confer the benefits of ineluctable cosmic forces on their occupants and on those occupants' descendants. They were also governed by regulations covering scale and decoration, although as we shall see when we enter those tombs which have been archaeologically excavated there still remained scope for large degrees of variation, whether governed by regional or personal choices it is currently hard to say.[86]

Modern Hubei province provides some of the most spectacular surviving examples of Ming princely tombs. The best idea of the setting of a Ming kingly tomb complex can be gained from the valley outside Wuhan which houses the tombs of the Kings of Chu, which lasted from their establishment at the very beginning of the Ming down to the mid-seventeenth-century fall of the dynasty (illus. 22). Here tombs are arranged within the landscape, but they also exist singly. The grandest of all is the UNESCO World Heritage Site of Xianling, where between 1524 and 1559 the Jiajing emperor had constructed outside the city of Zhongxiang a tomb complex on an imperial scale for his deceased father, posthumously raised from the rank of a king to that of an emperor (illus. 23).[87] This tomb is *sui generis* in scale and lavishness. More

22 Site of the tombs of the Kings of Chu, outside Wuhan, Hubei province.

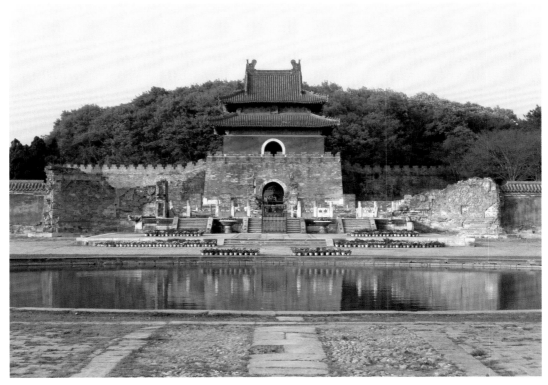

23 Mausoleum of the King of Xing, father of the Jiajing emperor (*r.* 1522–66), at Xianling, outside Zhongxiang, Hubei province.

24 Tomb mound of King Jing of Ying (*d.* 1414), outside Zhongxiang, Hubei province.

in keeping with regulations, but still a dominating presence in the landscape of the same area, is the recently excavated tomb of King Jing of Ying (illus. 24). Twenty-fourth son of Taizu, this king enjoyed his appanage only from 1408 until his premature death in 1414, when his line was extinguished.[88] Local lore has it that the offering hall of this tomb stood until the time of the Sino-Japanese War, when it was demolished by the occupiers for its lumber. But the mound is still a highly impressive presence, and the ground studded with fragments of green-glazed tilework gives a sense of the vanished splendour of the site. Even more can be seen at the site of the tomb of King Zhuang of Liang, ninth son of the Hongxi emperor (*r.* 1425), who held his appanage from 1429–41 and who was also the only holder of his title. The splendid finds from this tomb will be discussed later, but even if it had been robbed

(as so many have been), the great mound, the traces of boundary wall and the numerous fragments of tiled roof which litter the ground would still be enough to indicate the scale of the burial which took place here (illus. 25, 27).[89] The river which still flows in front of the site not only performs functions of geomantic protection but will have made practical the transport of both building materials and tomb contents to a site relatively remote from the city (illus. 26). Peasants who had never seen that city will still have seen the burial of the king.

Even the tombs of quite minor aristocrats will have been prominent within the landscape, and there were a lot of them. They were identified by stele (inscriptions which remained in the landscape) and by buried tomb inscriptions (which did not) bearing their name and titles, which survive in very large numbers in local museums in all the provinces of China where

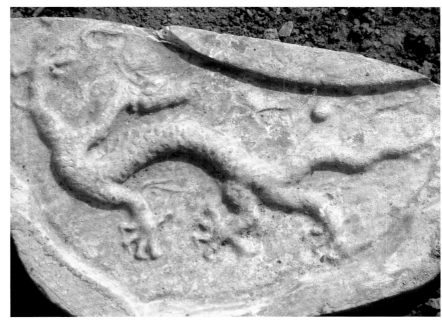

25 (*above*) Boundary wall of the tomb of King Zhuang of Liang (*d.* 1441), outside Zhongxiang, Hubei province.

26 (*above right*) River in front of the site of the tomb of King Zhuang of Liang (*d.* 1441).

27 (*right*) Tile end from the site of the tomb of King Zhuang of Liang.

they were established. The inscriptions them-selves may often be fairly banal, but a stele at the least advertised the titles of the deceased to all who could read them, and their importance even to those who could not. Tomb inscrip-tions, destined not for earthly eyes but interred with the deceased and hence readable only at the point of burial, were often composed by quite senior members of the degree-holding elite, reinforcing the growing sense that these two bodies had much more to do with one another in a province like Shanxi than we would think from standard accounts of Ming society. For example, the inscription for the 1523 northern Shanxi tomb of the Lady of Guichi, granddaughter of King Rongxu of

61

Guanging, a branch of the Dai appanage, is composed by the palace Administrator, but is in the calligraphy of Liu An. A native of Datong (where the Dai lineage was based), he is identified in the inscription both as a holder of the *jinshi* degree and as Provincial Administration Commissioner of Shaanxi.[90] It tells us of the deceased lady: 'Of all of the hundred womanly arts and affairs of the women's quarters there was none in which she was not practised and fully conversant . . . She had the style of a virtuous matron of antiquity.' In doing so, he not only makes the lady's virtues much more visible at the time of her funeral than she herself would have been in her lifetime, but he also advertises his own connections to the appanage of Dai, a dominant force in the region of his birth. For graves made connections manifest, and this was particularly so in the case of royal consorts, whose families could be assumed to have a strong interest in demonstrating to all their association with the kingly aura. So the tomb inscription of the consort of the ninth son of King Kang of Shen, dated 1519, tells us that the late Madame Li came from 'a family great in Lu [central Shanxi] for generations'.[91]

We have no real access to the views of the peasant masses who lived with royal tombs among their fields as part of their everyday lives. Were they ever 'places of memory' for ordinary people, in the same way that kingly palaces served as sites of imaginative reverie

for the better educated? We cannot know for sure, although the persistence of place names derived from Ming kingly tombs may suggest that at the least they were landmarks. Southeast of the walls of Taiyuan, or outside Xi'an (where Kangwangjing Cun, 'King Kang's Well Village' still stands), there remain as markers on the landscape faint verbal echoes of the once-material presence of the great tombs of the aristocracy. The names of tombs join the names of vanished palaces (like Anqiufu Cun, 'Anqiu Mansion Village', outside Yanzhou[92]) in evoking a vanished kingly landscape, moulded by their presence and their progresses, linked by the parades of sedan chairs with blaring trumpets and shouting outriders, the grandiose wedding and funeral processions which must have been a frequent occurrence in many Ming cities, and which made kingly magnificence a visible part of many lives from the most prosperous to the most humble.

THREE

THE WRITING OF THE
KING OF JIN

The palaces and gravesites discussed in the last chapter were all identified to earthly and to heavenly viewers in the Ming by text, by the presence of inscriptions bearing the names, titles and sometimes the life stories of members of the kingly houses. We are able to trace the pious donations of kingly consorts today because they are recorded in texts carved in stone and surviving to this day. This chapter will stay with the kingly production of visible text, but of a rather different (though certainly related) kind. For kingly courts were central to the production in the Ming of what is widely accepted as the most prestigious aspect of material and visual culture, indeed to those practices at which culture itself was made into something both material and visual: the practices of textual creation, reproduction and dissemination we now call 'calligraphy'. While all surveys of Chinese art in English pay lip service to the centrality of this art form, none of them actually takes the further step of making calligraphy central to their own account, and it remains in practice as marginal

as the kings have become in our story of Ming history and society. In drawing attention to this double exclusion, this chapter will attempt to show how it was certain of the kings of Ming China who created crucial monuments of the calligraphic tradition, and how the twin discourses of kingliness and calligraphic authority were closely intertwined. There are no startling new facts in this account, or at least no facts which will be surprising to specialists in the history of Chinese calligraphy (a category in which the present author has no claim to occupy a place); rather, a set of known facts and events will be considered in a somewhat different light, one which seeks to illuminate a pattern of activity which is more substantial and more coherent than assumptions about kingly uselessness have been willing to see. The chapter will then begin to suggest an answer to the pertinent question: what *were* Ming kings 'for', in contemporary terms?

By the late Ming period, an answer to this question was clear to Zhu Mouwei (*d.* 1624),

himself a member of the imperial clan and the author of a collection of biographies of other members of the family entitled *Fan xian ji*, 'Offerings from the Appanages'. Zhu Mouwei was a descendant in the seventh generation of Zhu Quan (1378–1448), son of the Ming founder and first King of Ning, and himself held the title of 'Defender-commandant of the State' (*Zhen guo zhong wei*). Although the main Ning line had been extinguished following the early sixteenth-century attempt to seize the imperial throne by its holder, Zhu Chenhao, its collateral branches were established throughout the province of Jiangxi. Zhu Mouwei descended from the first Commandery King of Shicheng, Zhu Diantu (*d.* 1486), and was himself the administrator of the Shicheng kingly estate.[1] He was a prolific author of works on poetry and philology, and of more than one collection of biographies, one dealing with figures from the city of Nanchang, capital of Jiangxi province, as well as *Fan xian ji* itself, one of our richest sources for the view of its role from within the imperial clan. The work carries a preface by its author dated 1595 and another by a certain Wei Guanggao dated 1600, meaning it cannot have been published before that date. It was republished once in an abbreviated form in the kind of collection of texts called a *congshu*.[2] It remains one of the fullest sources for biographies of members of the imperial clan, and much cited by later historians; it is in no sense an unknown work.[3]

Perhaps not surprisingly, this text is a collection of eulogies of men and women renowned for sterling moral qualities, such as filial piety and frugality, and for their devotion to 'culture' and to study. Allowing for its biases in what is undoubtedly a work of family piety, it is still of some value as a corrective to the unremittingly negative stereotype of the drunken, lust-crazed lout found in some more modern accounts. We do not have to see Ming kings as either paragons or thugs, indeed learning to see them otherwise is a large part of what this book is all about.

A goodly number of those listed (and hence by definition praised) in 'Offerings from the Appanages' are noted as practitioners or aficionados of the art of calligraphy. Some are figures who are already known to historians, and some are considerably more obscure now. In Zhou Mouwei's text, the biographies are arranged by seniority of the appanages, but a reordering of the names into a more chronological sequence shows figures active throughout the span of the dynasty down to the author's own time, though none of the first creation of kings, the sons of Ming Taizu the dynastic founder himself, is singled out for his calligraphic skill. The earliest figure is certainly one with a distinguished profile in the field of culture, and that is Zhu Youdun (1379–1439), second king of Zhou, with his seat at the old Northern Song capital of Kaifeng. Described in what is a recurrent phrase as 'a lover of culture'

(*hao wen*), he is also characterized as someone who regularly practised calligraphy and painting (*shu hua*), as well as being the composer of song lyrics still sung in the author's own time.[4] This comparatively bland mention ignores the major calligraphic rubbing project *Dong shu tang ji gu fa tie* ('Antique Model Calligraphy Assembled in the Eastern Study'), which will be returned to below. The fame of Zhu Youdun as instigator of this and other cultural projects (he was a major dramatist and anthologist of earlier drama) is far greater than that of someone like Zhu Zhanshan, King Xian of Xiang, fifth son of the briefly reigning Hongxi emperor, Zhu Gaozhi (1378–1425; *r.* 1425). Described as bright and intelligent, knowledgeable about poetry and calligraphy and even the classic Confucian text *Spring and Autumn Annals*, the king was the brother of the Xuande emperor, Zhu Zhanji (1399–1435; *r.* 1426–35), the Ming ruler with the highest personal reputation as a calligrapher and a painter.[5] It can be assumed that at least part of the two young princes' education was shared.

The more senior appanage of Jin, at Taiyuan in Shanxi province, supplies the name of King Zhuang of Jin (Zhu Zhongxuan), who inherited the title in 1442 and is described as dying in 1502 at the age of 75, after enjoying it for some 61 years. Here Zhu Mouwei does draw attention to a second major kingly project of calligraphic reproduction, which will also be discussed below, in the following terms:

He loved the study of antiquities and delighted in model calligraphy (*fa shu*). Since the 'Jiang Rubbing' had been lost for many years, he ordered his son Qiyuan to select the ancient and modern ink traces by various hands he had long collected, and had them traced and carved for circulation under the title of 'Antique Model Calligraphy Assembled in the Hall for Treasuring Worthies' (*Bao xian tang ji gu fa tie*), presented to the throne in the ninth year of Hongzhi (1496).[6]

As we shall see, the date is wrong, but the circumstances of compilation of this major collection of calligraphic rubbings (*fa tie*), and their relationship to an earlier Song dynasty set of such rubbings of 1041–63 known (from their place of compilation) as the 'Jiang Rubbings' (*Jiang tie*), are accurately enough recounted to make it likely that Zhu had access to a set of the 'Hall for Treasuring Worthies' collection himself. That King Zhuang of Jin was not the only avid kingly collector of calligraphy in the fifteenth century is shown by the case of the Commandery King of Ansai, Zhu Zhujiong (1427–1473), one of the cadet lines of the appanage of Qing in Shaanxi province. Described as a paragon of filial piety, who observed mourning rituals for his father with a scrupulous rigour even in the face of protests from his mother, he was also in this account a good poet and an excellent practitioner of

calligraphy in the 'regular script' (*kai shu*) style, the one most widely used for formal purposes. He also strove to augment his holdings of good examples: 'If someone had modern or ancient calligraphy he would spend his gold to buy it.'[7] Of his contemporary, King Kangmu of Sancheng (inherited 1471, *d.* 1511) in the appanage of Tang, we are told, 'The king was broadly learned in all the Classics, and particularly devoted to painting. Calligraphy and famous paintings were never out of his hands for a day.'[8] King Ding of Shu, in Sichuan province (inherited 1463), 'loved study, was excellent at calligraphy (*shan shu*) and was competent in literary composition'.[9] King Rui of Jing (inherited *c.* 1450) was 'particularly renowned for his seal script and clerical script' (*zhuan li zhu ming*).[10] There were notable calligraphers in the lower ranks of the imperial aristocracy as well. Zhu Junge (*d.* 1545), son of King Ruiyi of Lingqiu, in the northern Shanxi appanage of Dai at Datong, was 'studious and devoted to literature, and amassed a library of tens of thousands of chapters (*juan*). He particularly loved ancient seal and regular script calligraphy, and had over sixty specimens which he had carved in stone under the name "Model Calligraphy for Venerating Principles" (*Chong li tie*).'[11] And nearer the author's own time, in the Wanli era (1573–1620), the Supporter-general of the State, Zhu Duowen, great-grandson of King Rongan of Ruichang, was a man whose nature was elegant and who

loved study, 'paying no heed to renown and glory'. We are told:

> Duowen was excellent at running and drafting script, and acquired the calligraphic manner of Zhong (You, 151–230) and the Wang (Xizhi, 303–361), and Xianzhi (344–386), which he greatly treasured. Whenever a single sheet would emerge, the aficionados (*hao shizhe*) would buy it at a heavy price, comparing it to the Orchid Pavilion 'wedge' rubbing (*Lanting xie tie*).[12]

And finally, evidence of a scholarly interest in the history of calligraphy by an aristocrat comes in the case of Zhu Mouyin (*fl. c.* 1630), himself a cousin of Zhu Mouwei, author of 'Offerings from the Appanages' and presumably also active around the early part of the seventeenth century. Zhu Mouyin was the author of a continuation to a famous late Yuan/early Ming history of calligraphy, itself in the form of a collection of biographical entries on great practitioners of the art. This is the *Shu shi hui yao*, 'Essentials of a History of Calligraphy', by the prolific fourteenth-century author Tao Zongyi.[13] Zhu Mouyin was responsible in about 1630 for 'Continuation of the Essentials of a History of Calligraphy' (*Xu shu shi hui yao*), adding biographies of Ming calligraphers, including some of the kingly individuals who also feature in his cousin's collection, and

who are mentioned above.[14] Zhu Mouyin begins by listing the calligraphic achievements of six of the Ming emperors, from the 'divine' characters of the dynastic founder down to the Wanli emperor, who had died in 1620. Significantly, the latter is also described as collecting together the pieces of calligraphy he had written as gifts for high officials and for kings, showing that the pattern of distribution of imperial writing continued on into the later part of the Ming.[15] Following this, five kings of the blood and four commandery kings are listed.[16] It seems certain that Zhu Mouyin had the biographical compilation of his kinsman Zhu Mouwei to draw on, as his wording in describing Zhu Zhongxuan, King of Jin's order for the compilation of the 'Antique Model Calligraphy Assembled in the Hall for Treasuring Worthies' is identical to that of 'Offerings from the Appanages'. But what is striking is the much larger degree of divergence between the two texts. Of the nine kings listed as significant calligraphers in 'Continuation of the Essentials of a History of Calligraphy', only three are mentioned in this regard in 'Offerings from the Appanages'. Six out of the nine kingly calligraphers in the 'Continued History' are *not* mentioned as calligraphers in their 'Offerings' biographies, where, for example, we are *not* told of how the first King of Jin ordered a 'Thousand Character Essay' in the compiled calligraphy of the ancient masters Zhong Yu and the

Wang family to be engraved and circulated, or that King Jing of Ning was 'excellent at calligraphy', or that the King of Baoan copied Wang Xizhi's 'Seventeen Letter' (*Shi qi tie*) for engraving and circulation. Worth noting is the fact that no less than five out of the nine imperial clan calligraphers here listed are said to have been involved in the reproduction and circulation (*chuan*) of calligraphic models, an indication of kingly involvement in the dissemination of the canon to which we shall return.

Given the great prestige of calligraphy as a mark of cultural capital in the Ming period, the fact that those growing up in kingly households presumably all acquired the educational capital necessary to master at least the basics, and the high level of skill ascribed to a number of named individuals in Zhu Mouwei's 'Offerings from the Appanages', one might reasonably assume that it would be relatively easy to match this textual record to surviving material objects. But this is far from the case. In fact, and quite to the contrary, we encounter here a problem which will become even more acute in the next chapter, when considering interactions between the kingly households and the 'field of painting', namely the very poor 'fit' between the material and textual evidence. For example, we have no surviving examples of calligraphy by any of the figures who are mentioned in the previous chapter as providing calligraphy for the name boards of

temples patronized by the kingly houses of Jin in Shanxi or Su in Gansu. And (with the exception of Zhu Youdun, and work preserved in rubbing form in the *Bao xian tang* collection) there is no extant work by the figures mentioned in Zhu Mouwei's collection as being skilled calligraphers. Put bluntly, almost nothing survives of the calligraphic output of kingly individuals in the Ming, and where it does survive it comes from individuals who are invisible in the textual record, while those who *are* remembered in this record for their calligraphic prowess are represented by no surviving works. Such invisibility would reach an extreme in the case of a category of work which must not be forgotten, that of calligraphy by the women of kingly households. The Qing dynasty account of calligraphy by women, 'Jade Terrace History of Calligraphy' (*Yu tai shu shi*) by Li E (1692–1752), lists among its seven female calligraphers of the imperial family the Commandery Princess of Anzhu, eldest daughter of Zhu Dianpei, King Jing of Ning in Jiangxi province, telling us she was 'diligent at drafting script and capable as a poet'.[17] It is hard to believe she was a unique example.

Illustrative of the type of isolated pieces which do survive is a hanging scroll with very little documentation, ascribed to an unidentified fifteenth-century 'Prince of Heng', sold from the collection of the great Dutch sinologist Robert van Gulik (1910–1967) in 1983.[18] The piece is roughly 1 metre square, and the text is

a poem by the Tang dynasty poet Liu Yuxi (772–842), the sort of calligraphic exercise which existed in large numbers in the Ming period, often designed to be given as gifts or marks of favour by superiors. It is not possible from the information surviving to identify precisely which King of Heng, an appanage in Shandong province, was responsible, but more to the point is the fact that *none* of the Kings of Heng are credited with any degree of calligraphic eminence by Zhu Mouwei, though a few commandery kings from cadet lines do feature.[19] This single work from a King of Heng comes down to us unconnected to any sense that its writer had a name worth recording in a work which goes out of its way to list the talents (and calligraphy was one of *the* talents) of its subjects.

The same thing is true of two works now surviving in the collections of the Capital Museum, Beijing. One is a large hanging scroll on silk (illus. 28), again a poetic inscription, in the hand of Zhu Xintian, King Jian of Jin (d. 1575). Despite his proximity to the author's own time, he too has no entry in 'Offerings from the Appanages'. Yet he was a distinguished anthologist and author, responsible for a major collection of Yuan dynasty prose published in Taiyuan by the Jin kingly house.[20] The other work is an album of calligraphy on paper in cursive script (illus. 29) by Zhu Yilian, whose biography is totally obscure but who must have been a member of the imperial

方池開曉色圓月下秋陰己
乘千里興還撫一絃琴
晉文思堂書

28 Zhu Xintian, King Jian of Jin (*d.* 1575), calligraphic hanging scroll on silk.

clan active in the Wanli period around 1600 (it is the distinctive second character of his name which is the indicator of this). This Capital Museum album is dated 1612, and there is another extant work, a hand scroll of poems also in cursive script and dated 1621, in the Shanghai Museum. The major modern survey of dated works of calligraphy and painting in Chinese collections lists no more than three dated works of calligraphy by members of the imperial clan (excluding emperors themselves) from the entire span of the dynasty.[21]

The surviving material evidence is perhaps too skimpy to allow any firm conclusions about the style of kingly calligraphy, or whether it is reasonable to speak of a 'kingly' style at all. Zhu Mouwei speaks of work in the regular, clerical and seal scripts, although no examples of the latter two forms survive for us to judge from. He makes no mention of work in cursive script forms, such as we see in illus. 40, or the 'running script' (*xing shu*) such as we see in illus. 28, by the King of Jin. The Van Gulik piece by a King of Heng is clearly related in style to this latter work, although it approaches more closely the standard script, and in the form associated with court calligraphy of the early Ming, particularly with the work of calligraphers like Shen Du (1357–1434) and his younger brother Shen Can (1379–1453), responsible for setting the canons of calligraphic work at the imperial court in Nanjing and then in

29 Zhu Yilian (active *c.* 1600), album of cursive calligraphy.

Beijing in the Yongle reign (1403–24).[22] It would not be surprising if at least initially these canons were also normative in the regional courts of the sons and grandsons of the Ming founder, particularly as Shen Du himself had served in the household of the kings of Zhou during their temporary banishment to Yunnan in the 1390s. The sort of mechanism by which an imperial standard of script was disseminated can be seen in an event of 1406 when the Yongle emperor ordered that a poem on the subject of 'Auspicious Grain' authored by the founding emperor his father, 'be cut in stone and [rubbings] mounted as hanging scrolls, for distribution to all the kings'.[23] It is also an interesting question (easier to pose than to answer) as to whether the calligraphic style of the imperial centre was maintained through the centuries in places such as Taiyuan and Chengdu and Kaifeng.[24]

However, it is not through the surviving works of their own hands that we are able to gauge the importance of kingly individuals and their households in the sustenance of the

art of calligraphy. Far more significant is their role in the creation of collections of calligraphic rubbings. It was the kingly milieu, and the collections it housed, that generated the first examples of these to be produced in the Ming period, predating the involvement of the lower Yangtze literati elite by some centuries. The 'Antique Model Calligraphy Assembled in the Eastern Study' (*Dong shu tang ji gu fa tie*) of 1416, the 'Antique Model Calligraphy Assembled in the Hall for Treasuring Worthies' (*Bao xian tang ji gu fa tie*) of 1489 and the 'Su Palace Edition' (*Su fu ben*) of the 'Model Calligraphy of the Chunhua Era' (*Chunhua ge fa tie*) of 1615–21 are three of the most important monuments of the calligraphic tradition in the Ming. They all emanate from kingly households, and all from centres far from the supposed Jiangnan core of Ming culture, in Kaifeng, Taiyuan and Suzhou (Gansu) respectively. All are well known to scholars of calligraphy, though their interest to now has been less in the Ming context which produced them than it has been in what they tell us about the much earlier masterpieces of calligraphy which they purport to contain. As with all such rubbings collections, they have been treated hitherto often as transparent agents of transmission, valued for the greater or lesser degree of accuracy with which they pass on to later generations lost masterpieces of the calligraphic tradition. Only recently have scholars begun to consider them as

objects worthy of our attention in their own right, and to consider their materiality and processes of production, alongside the knotty theoretical issues they raise regarding questions of authenticity and reproduction within Chinese culture.[25]

Given its importance as the first rubbing collection to be produced in the Ming period, it remains curious (and indicative of the fractured nature of the historical record) that there is no mention of the 'Antique Model Calligraphy Assembled in the Eastern Study' in Zhu Mouwei's 'Offerings from the Appanages', where he does, as noted above, include a brief biography of its creator, Zhu Youdun, King of Zhou. At the time of the collection's compilation, Zhu Youdun still held the rank of Crown Prince of Zhou, his father Zhu Su, fifth son of Ming Taizu and titled King Ding of Zhou (1361–1425) being still alive.[26] Before looking in more detail at his work, it is worth considering the pre-Ming precedents available to him, and describing briefly the genesis of the genre of 'model-letters compendia' (*fa tie*) prior to his day.

Since very early times, written texts had been inscribed on stone in China. And for an almost equally long period, the practice of taking rubbings from these had been used to provide copies which preserve and disseminated (and inevitably accelerated the decay of) these inscriptions.[27] This could be either circulated in its own right, or else could be used as the

template for a rewriting of the text on paper or silk, or for its re-incision on a fresh surface, be it stone or wood. As calligraphy established itself, particularly in the centuries after the Eastern Jin dynasty (316–420), as the supremely valued practice of material culture, rubbings took their place alongside freehand and traced copies as a method whereby the works of an emerging canon of works and masters could be preserved and transmitted to future generations. At the same time, imperial courts (and in these centuries there was often more than one) came to be seen as centres of calligraphic collecting and accumulation, and the sites where such canons were formed. Technology and site came together in the imperial court of the Song dynasty, which reunified China in 960, and which sited its capital at Kaifeng, in Henan province. There, in the reign of its second emperor Taizong (r. 976–97) a project was initiated to make a definitive compendium of rubbings. The project was entrusted to one Wang Zhu, purportedly a descendant of men who were by now universally seen as the apex of the system of calligraphic quality, the 'calligraphy sage' Wang Xizhi (303–361) and his son Wang Xianzhi (344–386). Much of the surviving work of 'the two Wangs' was in the form of relatively casual pieces of writing. Their very informality was seen as capturing, more effectively than more formal texts could, the spontaneity and immediacy which was the most admired aspect of

any calligraphic masterpiece. These notes or letters were known as *tie*, and it is as '*model* letters' or alternatively '*model* calligraphy' (*fa tie*), in the sense that they provided models for future calligraphers to emulate, that they have been known to us since at least Song times. Strictly speaking, a model letter could be either an original surviving text, or a rubbing taken from its inscription on wood or stone, but the former category was from an early date so rare that *fa tie* effectively comes to mean 'rubbings', with characters of white on black. This is certainly the sense in which it is applied to the early Song compendium created in the third year of the Chunhua reign period (992), and known by several variant titles, the fullest being *Chunhua mi ge fa tie*, 'Model Calligraphy in the Imperial Archives of the Chunhua Era'.[28] There is a long-running debate over whether the 419 pieces it contained, divided into ten chapters (*juan*) were cut on wood, rather than stone. This would certainly have accelerated the process whereby the inevitable losses over time suffered by the 'original' works of calligraphy in the Song imperial archives were accompanied by losses to the rubbings, so that actual late tenth-century pulls from the blocks quickly became fabulously rare themselves. This in turn led to further projects of replication, and re-cutting (now often on stone), based now not on putative originals but on existing rubbings. A sort of *mise en abyme* of replication, copies of copies

of copies, has over the past millennium created a vast apparatus of connoisseurship, as scholars struggle to understand which of many competing versions of any given text might most faithfully convey the revered writing of a Wang Xizhi, or any one of the other great masters of early calligraphy whose work comes down to us principally in rubbings form.[29]

It is absolutely not the point to enter into any of the debates around the authenticity of surviving rubbings collections, or the relative merits of those collections formed in the Ming kingly environment, which are the focus of this discussion. But in examining such compendia it is important to grasp a couple of facts which were surely very obvious to contemporaries, but which have perhaps become rather obscured. One is the centrality of courts, and court culture, to the establishment of canons of calligraphic quality. It was under the great Tang dynasty emperor Taizong (*r.* 626–49), and in his capital of Chang'an (modern Xi'an) that Wang Xizhi attained his place as the apex of the calligraphic canon. It was the same emperor who canonized Wang's 'Orchid Pavilion Preface' (*Lan ting xu*) as the greatest of works by this greatest of calligraphers, and limited the chances of subsequent disagreement by taking the original work with him into the tomb. It was at Song Taizong's court in Kaifeng that an attempt was made to fix a full canon of quality through the creation of the 'Model Calligraphy of the Chunhua Era'.[30] Calligraphy

did not take its place in some detached realm of the aesthetic, but was intimately bound up with concepts of rule. The key term here was perhaps *fa*, 'model', 'pattern' and 'law'.[31] It was the duty of the lord to give models and patterns for the realm to follow, and the court was the setting where those models and patterns were appropriately to be crafted.

It is hard to believe that no awareness of this existed in the minds of the King of Zhou and his Crown Prince when they created 'Antique Model Calligraphy Assembled in the Eastern Study' of 1416. All the more so in that (as noted above) the palace they occupied in Kaifeng stood on the foundations of the Song imperial complex, the very ground on which the 'Model Calligraphy of the Chunhua Era' had been formed over four centuries before. This continuity of site is paralleled by a certain continuity of format, with the 'Eastern Study' collection also being a work of ten chapters. The similarity extends into the layout of those chapters, with a group of chapters reproducing the writing of rulers of the past, followed by a number of chapters reproducing work by writers of less exalted social station. The ten chapters in 'Model Calligraphy of the Chunhua Era' contain successively: 'Model Calligraphy by Emperors and Kings of Successive Dynasties' (*Li dai di wang fa tie*); 'Model Calligraphy by Famous Ministers of Successive Dynasties' (*Li dai ming chen fa tie*); 'Model Calligraphy by Various Figures of

Antiquity' (*Zhu jia gu fa tie*); 'Writings of Wang Xizhi'; and 'Wang Xianzhi of the Jin Dynasty'.[32]

The layout of the ten chapters of Zhu Youdun's 'Antique Model Calligraphy Assembled in the Eastern Study' (illus. 30) is analogous, if simpler in that it divides all works into two basic categories: 'Writings by Emperors and Kings of Successive Dynasties' (*Li dai di wang shu*) and 'Writings by Famous Ministers of Successive Dynasties' (*Li dai ming chen shu*). What this division conceals is that Wang Xizhi is here absorbed into the category of 'Famous Ministers', and occupies by himself all of chapters Three, Four and Five. The sequence then goes back in time to run chronologically in chapters Six–Ten from the Eastern Han figure Du Du (active *c.* 75–85 CE) to the Yuan dynasty calligrapher Ouyang Xuan (*jinshi* 1315), with Wang Xianzhi incorporated into this sequence, rather than being given dedicated chapters to himself.[33] Wang Xizhi thus remains the central figure of the canon, but his proximity to rulers is only increased by the shift in his position from one *after* the sequence of ministers (as in the *Chunhua ge* rubbings) to one directly adjacent to 'Emperors and Kings of Successive Dynasties', who continue to occupy the principal place. And if anything the effect of the rearrangement is only to increase the 'courtliness' of the collection as a whole, through its insistence that there are only two categories of calligrapher

worth bothering about, namely rulers and those who serve them as 'famous ministers'. Zhu Youdun omits totally the category of 'Various Figures of Antiquity', in which the earlier Song dynasty collection had included writing by such fabulous figures of the remote past as Cangjie, mythical inventor of script itself, Yu the Great, tamer of the flood and founder of the Xia dynasty, Confucius (551–479 BCE) and Li Si (284–208 BCE), minister of the First August Emperor of Qin (*Qin shi huang di*) and standardizer of the chaotic script forms of the Warring States.

Although examples of these primeval forms of writing are not included in the collection itself, they are prominent in the history of calligraphy which forms the bulk of the prince's preface, where Zhu Youdun explains this omission as well as providing an apologia for the existence of the work as a whole.[34] He begins by rehearsing the generally understood genesis of the script, how the first characters, in the form of the 'eight trigram' combinations of broken and unbroken lines, were created by the primeval sage Fuxi on the basis of the diagram born out of the depths of the Yellow River by a fantastical beast at the dawn of time. The sage emperors Divine Farmer and Yellow Emperor subsequently developed forms of writing based on the shapes of millet stalks and clouds, then Cangjie used the forms of stars in the sky and the tracks of beasts in the mud as the patterns for the creation of characters. He

30 Zhu Youdun, opening
page of volume VI of
Dong shu tang ji gu fa tie
('Antique Model
Calligraphy Assembled
in the Eastern Study'),
1416, ink rubbing on
paper in bound format.

goes on to describe Li Si's standardization of
the seal script, and the creation of the various
other forms (such as the clerical and regular
scripts) by other named culture heroes. Then,

When Emperor Yuan of the Jin dynasty
(r. 317–23) went south, model calligraphy
(*fa shu*) flourished greatly, and Wang
Xizhi, General of the Right, combined
the capabilities of a hundred masters,
completing the excellences of the various
forms, so that in seal script, clerical, regular,

running, drafting and 'flying white' forms,
there was none where he did not achieve
refinement and excellence, such that there
was no one to surpass him. His son Xianzhi
was also outstandingly original. Then
through the Song, Qi, Liang, Sui and down
to the Tang dynasty, capable calligraphers
appeared in numbers, and calligraphy
(*shu fa*) formed its own schools, each with
strong points in their similarities and
differences. But the crucial thing was that
they did not lose the style and rule of the

men of the Jin, the very pattern of the
models of script (*zi fa*).

This, he concludes is the very thing which
went wrong in the Song period, when the great
models of the Jin were no longer adhered to,
though such Yuan luminaries as Xianyu Shu
(1257–1303) and Zhao Mengfu (1254–1322)
to an extent retrieved the situation; while they
might not actually achieve the level of Jin and
Tang work, they are still a great improvement
on the calligraphy of the Song.

The point is not whether this history of
calligraphy, of a Jin/Tang Golden Age succeeded
by Song decline and Yuan renaissance, is accurate
or not, or in any way original. Indeed it may
well have been fairly standard for the period,
shared with the intellectuals present around
Zhu Youdun.[35] Probably equally standard is
the preface's understanding of the 'Chunhua
Era Collection' as the first collection of model
calligraphy to be compiled, and its naming of
some ten further collections seen as derived
from it, beginning with the 'Jiang Rubbings'
(*Jiang tie*) named for their compilation at
Jiangzhou in modern Shanxi province, some
time in the mid-eleventh century.[36] After
listing them, Zhu Youdun gets to the nub of
his motive in creating his own collection, the
very first such compilation of the calligraphy
canon to be undertaken by anyone since the
foundation of the Ming nearly half a century
before his time:

In moments of leisure from waiting upon
my parents, whenever I studied the texts of
ancient letters (*tie wen*), I would assemble
the characters of each writer, and investigate
the writings of each period. Whenever I
got hold of an authentic piece I would
make a freehand copy (*lin*) of those which
had been copied freehand before, and
make a tracing copy (*mo*) of those which
had not been copied freehand before,
assembling them into ten chapters, and
having them carved on stone for the con-
venience of my own perusal, never daring
to show them to other people as objects of
study. When the collection was complete,
I named it the 'Antique Model Calligraphy
Assembled in the Eastern Study'.

The tone of self-deprecation, the claim that the
collection was assembled purely for personal
study with no thought of letting the world
see it is here combined with an assertion
of authorship, though authorship through
the medium of the copy, both freehand
and traced.

'Antique Model Calligraphy Assembled in
the Eastern Study' seems to have been very
rare in subsequent periods, and subsequent
writers make elementary mistakes about the
number of chapters which make it up, or the
names of the actual writers which it contains.
However, even if subsequent writers had not
actually seen the collection, they certainly

knew of its fame, and few fail to mention it.[37] For example, in the 1620s Wen Zhenheng (1585–1645) listed 24 rubbings collections in his 'Treatise on Superfluous Things' (*Zhang wu zhi*), as the full (implausibly full) complement of such treasures which an ideal collection ought to contain. Of these twenty-four, only four are texts of the Ming period itself, and the very first of them to be named is, 'That cut in the Zhou palace [which] is called the "Eastern Study Rubbings"'.[38] Later in the seventeenth century the calligrapher Fu Shan (1607– *c.* 1684) listed 'Antique Model Calligraphy Assembled in the Eastern Study' as the first of three important rubbing collections produced in kingly courts in the Ming.[39] Whether these works were available or not, it seems plausible at the very least that their existence was known to intellectuals and scholars who took an interest in calligraphy, and that their priority was understood. This priority of a kingly milieu in the production of calligraphic rubbings collections is one of the 'facts' about Ming culture which has been mislaid over the centuries, though it remains in plain sight. The two royal calligraphy collections of the courts of Zhou and Jin pre-date by a number of decades the earliest private collection of calligraphy rubbing samples. Although we might consider the collecting and connoisseurship of antique calligraphy to be a quintessential cultural pastime of the Ming scholar elite, the 'literati' of Ricci's invention, it has to be

stressed that this form of cultural practice in the Ming has its origins in an aristocratic and courtly setting which we have perhaps tended to disregard rather too casually. Kingly courts did not simply reflect innovation generated elsewhere, but were themselves sites of cultural newness in the Ming, to a far greater degree than we have been willing to recognize.[40]

The 'Eastern Study Rubbings' collection was not the only significant project to emanate from the Zhou palace in the field of calligraphy. We can assume that Zhu Youdun himself was responsible for inscriptions visible on public sites like temples, and there is evidence for the existence of a now lost rubbings collection of works in his own hand (which if true would be a rather startling innovation).[41] He was certainly responsible for an important project which combined image and calligraphy around the figure of Wang Xizhi, and around his most famous work, the 'Preface to the Orchid Pavilion'. This *Lanting xiu xi xu tie*, or 'Rubbings of the Preface to the Spring Purification Gathering at the Orchid Pavilion' (illus. 31), was completed in the seventh month of the fifteenth year of the Yongle reign (1417), the year after the first project, and it brings together five variant versions of the vanished masterpiece, together with an engraved version of a painting of the scene attributed to the Song dynasty painter Li Gonglin (*c.* 1049–1106).[42] The prestige of this image (illus. 32) was almost on a par with that

31 Text of the *Lanting xiu xi xu tie* ('Preface to the Orchid Pavilion'), dated 1417 after original calligraphy by Wang Xizhi (*c.* 307–*c.* 365), ink rubbing on paper in hand scroll format, 22.1 × 489 cm.

of the calligraphy, but it too was lost (or at least the authenticity of surviving versions was debatable) by the Ming period. In 1373 the Ming founder, grandfather of Zhu Youdun, had himself had a version of this picture engraved on stone, this in turn forming the pattern for the 1417 version.[43] The prince is therefore here again explicitly reproducing something which comes from the imperial centre, acting as a relay station for the 'culture' materialized in the imperial collections taken over from the vanquished Yuan. But such concerns are far from explicit in his preface to his variorum edition of the 'Preface to the Orchid Pavilion' (alternatively known as the 'Purification Inscription'), which again, as with the 'Eastern Study Rubbings', stresses

instead the image of a purely personal enjoyment.[44] This sort of 'variorum' edition of a single text is again a form of cultural newness, again an innovation of a kingly court which in its presentation of multiple possibilities (as against the championing of a single 'best' version) is very sophisticated in its acceptance of plurality and variation, archaeology rather than genealogy, as the model of calligraphic study.

Seventy years after Zhu Youdun had carved in stone his five versions of what many contemporaries saw as the single greatest piece by the single greatest calligrapher of the past, another heir to a kingly seat embarked on an even more ambitious project to produce a total history of calligraphy through rubbings,

32 *Illustration of the Spring Purification Gathering at the Orchid Pavilion*, dated 1417 after original composition by Li Gonglin (*c.* 1049–1106), ink rubbing on paper in hand scroll format, 17.9–18.1 × 329.1 cm.

from the dawn of time to his own day. This was the *Bao xian tang ji gu fa tie*, 'Antique Model Calligraphy Assembled in the Hall for Treasuring Worthies', compiled by Zhu Qiyuan, Crown Prince of Jin, on the orders of his father Zhu Zhongxuan (1427–1502), King Zhuang of Jin, in the second year of the Hongzhi reign (1489).[45] Today, the stones for this large rubbings collection largely (and unusually) survive (illus. 33), and since 1980 they have been appropriately located in the Yongzuo Temple in Taiyuan, whose twin pagodas (illus. 13) were identified in the previous chapter as a very visible sign of the Kings of Jin's pre-eminence in the city.

As we have seen, the biography of King Zhuang of Jin found in 'Offerings to the Appanages' mentions this project as one of that king's major achievements, though its prefaces make clear that the task of editing and compilation was in fact undertaken by his son, who died in 1501, never inheriting the title King of Jin.[46] Although today we might think of Taiyuan as a city far from the cultural centres of the Ming period, the presence there of the court of the descendants of Ming Taizu's third son was of major significance to the region. Thus when Zhu Qiyuan set out to obey his father's command to 'assemble antiquity' through model calligraphy, he had particularly rich material to work on. He begins his preface to *Bao xian tang ji gu fa tie* with the following words (illus. 34):

33 Surviving stones of the *Bao xian tang ji gu fa tie* ('Antique Model Calligraphy Assembled in the Hall for Treasuring Worthies', 1489), Yongzuosi, Taiyuan, Shanxi province.

My great-great-grandfather King Gong was fond of calligraphy from his childhood, and when he first went to his state the Grand Ancestor and Founding Emperor presented him with a great number of calligraphic specimens of earlier ages. My great-grandfather King Ding was by the favour of the Founding Emperor instructed in writing by the Secretariat Drafter Zhan Xiyuan, and so was outstanding with the brush among his contemporaries. My grandfather King Xian and my royal father both loved calligraphic study, and so for several generations have collected and amassed both ancient and modern works, such that the holdings are extremely rich. And I, in the intervals of waiting at table and enquiring after their health, have set my heart on the works of the men of ancient times, and have ordered my attendants to fetch the calligraphic traces and writing samples of the men of ancient and modern times, to spread them out to left and right, and have immersed myself till day's end in the amusement of studying them.[47]

34 Zhu Qiyuan, preface to *Bao xian tang ji gu fa tie* ('Antique Model Calligraphy Assembled in the Hall for Treasuring Worthies', 1489).

The Kings of Jin as we have seen were established at Taiyuan in 1378, under Zhu Gang (1358–1398), the third son of Ming Taizu. As a line arguably senior to that of Zhu Di, the fourth son and the usurping Yongle emperor from whom all subsequent early Ming emperors descended, the four generations of Kings of Jin down to the time of Zhu Qiyuan enjoyed great prestige.[48] One mark of that prestige was that, as with the establishment of all the other kingdoms, valuable cultural treasures of the imperial collection were dispersed to the regional courts. This was particularly true of calligraphy, which the first Ming King of Jin practised assiduously, under the instruction

(according to his descendant) of Zhan Xiyuan, the calligrapher responsible for key aspects of the 'look' of the new Ming dynasty, as the writer of the name boards for its recently constructed temples and palaces in Nanjing.[49] Though not recorded as a calligrapher by Zhu Mouwei, he is praised by the most rigorous of twentieth-century connoisseurs for the quality of his hand, on a par with that of his nephew, the Xuande emperor.[50] Zhu Xiyuan tells us also in this passage that on 'going to his state' Zhu Gang received from his father a number of calligraphic treasures from the imperial collection itself. These reputedly included the precious copy of the 'Chunhua Era' rubbings

collection which had once belonged to the Song dynasty prime minister Bi Shian (938–1005), along with copies of other major early Song rubbing collections, the 'Jiang Rubbings' and the 'Daguan Rubbings' (1109).[51] On the basis of some 40 surviving works with 'Jin Palace' seals, it can be demonstrated that the collection contained significant surviving works by many canonical calligraphers such as the 'two Wangs' (illus. 35).[52] These surviving works are likely to be only a portion of once much larger holdings of calligraphy.

In his preface quoted above, Zhu Qiyuan explicitly situates himself in this lineage of *kingly* collecting and connoisseurship, before going on to relate the process whereby he effected the creation of the 'Treasuring Worthies' collection.[53] As with Zhu Youdun's preface to the 'Eastern Study' collection, the language is that expected of the connoisseur, the relaxed air of one not trying too hard, an effortless command of the tradition in which hard work is presented as 'amusement' and 'passion' (*bi*).[54]

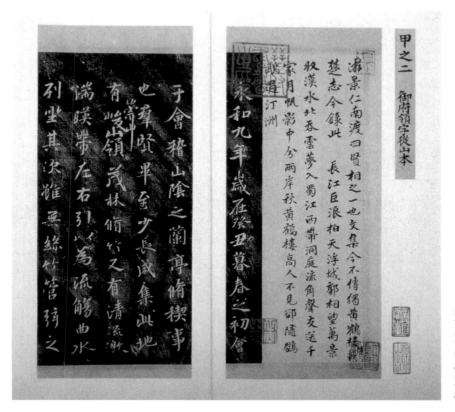

35 'Imperial Court Version of the Lanting Preface', Song dynasty (960–1279), ink rubbing of calligraphy by Wang Xizhi (*c.* 307–*c.* 365), dated 353, 26.2 × 12.5 cm.

We see in the preface the degree to which the project came out of the social interaction, which was almost certainly an interaction carried out in discussion over actual pieces in the collection, between Zhu Qiyuan, a member of a regional kingly court, and two members of the degree-holding elite, Zhang Yi and Zhai Xuan. The former was himself from Taiyuan; he gained the *jinshi* degree in 1460, rose to be Right Vice-Minister of the Board of Works, and died in 1500.[55] The latter figure, Censor-in-chief Zhai Xuan (1433–1501), is also well documented; born in Henan, he served as Grand Coordinator of Shanxi, which is presumably how he came to know the Crown Prince.[56] This is the kind of interaction which is not recorded in the writings of those scholars based in Jiangnan, writings on which much of our understanding of Ming culture is based, partly for the reason that no kings were located there. It is also worth noting that the Crown Prince of Jin's project marshalled the agency, whether in honorific or in practical terms it does not really matter, of a number of the ranking officials of Shanxi Province, Administration Vice-commissioner Wang Jin, the Deputy Commissioner Yang Guangpu, the Assistant Commissioners Hu Han and Yang Wenqing.[57] These were men who happened to be in Shanxi; the latter three were originally from Shandong, Jiangxi and Zhejiang respectively. Their participation in the production of the Crown Prince's *fa tie* collection, which

presumably gave them access to the riches of the Jin palace collection, is an example of a possible way in which an understanding of what 'antiquity' was and could be was disseminated through a wider elite of the empire. Rather than the habitus of connoisseurship, how to look, what to say about things seen, being firmly lodged in the 'literati', here we can actually see in action the social relationships whereby it might potentially be transferred from a courtly to a non-courtly milieu.

An analysis of the contents of its twelve chapters shows the considerable extent to which the 'Hall for Treasuring Worthies' collection draws as models on the 'Chunhua Era' and 'Eastern Study' collections which preceded it, but also shows the extent to which it has a very distinctive agenda, which may give us a precious insight into the thinking of at least one kingly individual. Chapter One contains pieces by archaic figures (illus. 36); chapter Two is devoted to work by rulers, beginning with one piece each from the founder of the Western Jin dynasty, Wudi (*r.* 265–90) and of the Eastern Jin dynasty, Yuandi (*r.* 317–26). There are five pieces by rulers from the period of Northern and Southern Dynasties before numerous samples of the hand of Tang emperors Taizong (*r.* 627–49) and Gaozong (*r.* 650–83). Then come three pieces by the Song founder Taizong (*r.* 976–97) followed by the calligraphy of a small number of non-ruling members of royal houses, beginning with Sima

36 Rubbing of the calligraphy of Confucius, from *Bao xian tang ji gu fa tie* ('Antique Model Calligraphy Assembled in the Hall for Treasuring Worthies', 1489).

Daozi, son of the Jin ruler Jianwendi (*r.* 371–2), and going on to two kings (*wang*) of the Chen dynasty (557–89). There is then a huge, and very significant, leap forward in time to include calligraphic work by the Ming dynasty Kings of Jin, the immediate ancestors of Zhu Qiyuan. Chapters Three to Seven are devoted to the calligraphic work of the 'two Wangs', Wang Xizhi and Wang Xianzhi. Chapter Eight contains work by 42 other figures of the Jin dynasty; chapter Nine contains writings by figures of the Southern Dynasties subsequent to the Jin. Chapter Ten contains writers of the Tang dynasty; chapter Eleven contains six

37 Rubbing of
the calligraphy of
Zhang Bi (1425–1487),
from *Bao xian tang ji
gu fa tie* (1489).

calligraphers of the Song dynasty and ten Yuan calligraphers. Chapter Twelve is devoted to calligraphers of the Ming dynasty, the most recent figure to be included being Zhang Bi (1425–1487), who had died just two years prior to the compilation of *Bao xian tang ji gu fa tie* in 1489 (illus. 37).[58]

An analysis of these contents might point to a number of distinctive features. The twelve chapters betray a desire to go beyond the ten chapters of the Song dynasty 'Chunhua Era' and early Ming 'Eastern Studio' rubbings collections. They suggest a desire for comprehensiveness not previously achieved, as

explicitly expressed in Zhu Qiyuan's preface. Such a desire is of course an ideological and not simply an aesthetic positioning, or rather it is aesthetics of incorporation, envelopment and completeness which is itself inescapably ideological. It is seen in a rare editorial note inserted towards the end of chapter Eleven, in the midst of the run of Yuan dynasty calligraphers, which states:

> When the collection of calligraphic samples was almost completed, only writings of the Yuan dynasty alone were rather few. I happened to be looking in the calligraphy and painting store, and got hold of 'Layered Peaks on Misty River' (*Yan jiang die zhang tu*) by Wang Jinqing (Wang Shen, *c.* 1046–after 1100) and 'Autumn Forests' (*Qiu lin tu*) by Monk Juran, and numerous Yuan officials had inscriptions and poems

on them. I studied their writings, and these were all genuine pieces. I therefore ordered them to be engraved as follows, to complete the writings of that age.[59]

This search for a completeness of sequence, from the inventor of writing Cangjie to the compiler's own time, arguably situates the present project as one which incorporates and so transcends all previous rubbings collections, as listed in the preface; 'So I assembled such collections as the *Chunhua*, the *Jiang tie*, the *Daguan tai qing lou* and the *Bao Jin*, along with the work of not less than several tens of those renowned in the present dynasty.' The first and most famous of these compilations, dated 992, has already been encountered. The second is the *Jiang tie*, compiled in Jiangzhou (hence the name) by the official Pan Shidan in the Qingli and Jiayou reigns of Song Renzong

38 Mi Fu (1051–1107), detail from 'Poem Written on a Boat on the Wu River', *c.* 1100, hand scroll, ink on paper.

(*r.* 1041–63). The third, often simply known as the *Daguan tie*, is a Southern Song work, compiled by Cai Jing under the orders of Song Huizong in 1109. The fourth work referenced is the 'Model Calligraphy from the Treasuring Jin Studio' (*Bao jin zhai fa tie*), another Southern Song collection which alludes to the studio name of Mi Fu (illus. 38), whose work provides a sizeable portion of its contents and who was as responsible as anyone for the accepted view of the Jin period as being the source of ultimate standards in calligraphic practice.[60]

The Northern Song period *Chunhua ge fa tie* and Zhu Yuodun's 'Eastern Study' collection provide the pattern for another feature of 'Antique Model Calligraphy Assembled in the Hall for Treasuring Worthies', namely its stress on the writing of rulers and on a courtly milieu. From the latter of these two comes the (in this context) all-important stress on rulers of 'Jin' as the highpoint of the calligraphic canon. The 992 'Chunhua Era' rubbings collection opens its first chapter, of 'Model Calligraphy by Emperors and Kings of Successive Dynasties', with a piece of writing by the Han emperor, Zhangdi (*r.* 76–88). The 1416 'Eastern Study' collection, by contrast, opens with a piece by the founder of the Jin dynasty, Emperor Wudi. And it is this selfsame piece which opens the second chapter of the 'Hall for Treasuring Worthies' collection of 1489 (illus. 39).[61] In this latter context, the emphasis on 'Jin' takes on a new

meaning, since it is in the palace of the King of Jin (the character is the same) that the collection itself was put together. It should be remembered that 'Jin' is both a regional and a chronological label. In the former context it was the name of a state (*guo*) based in Shanxi province, which was a major player in the power politics of the Bronze Age. The same name, and the by-then archaic title Duke of Jin (*Jin gong*), was revived in 263 CE for Sima Zhao, regent of the Three Kingdoms period of the Wei dynasty; he was raised to the rank of King of Jin (*Jin wang*) in 264. His son Sima Yan inherited this title in turn in 265 and went on to found the Jin dynasty (265–420), with its capital successively at Luoyang and after 317 at Jiankang, the modern Nanjing.[62] The choice by Sima Zhao of the regional title Jin, extinct for over 700 years (the length of time which separates us from the Yuan dynasty), may well reflect a particular regional awareness and acknowledgement of a power base. It certainly alludes at the same time *both* to a notion of region *and* to a distant but glorious antiquity. Its antiquity and its strong association with Shanxi made it the obvious choice for the title of the Ming appanage situated at Taiyuan, and was granted to Zhu Gang by his dynasty-founding father.

There are hence, in the 'Hall for Treasuring Worthies' collection, many pieces of writing by rulers bearing some variant of the 'Jin' title. Those who bore the Mandate of Heaven as imperial rulers come first; thus the emperors of

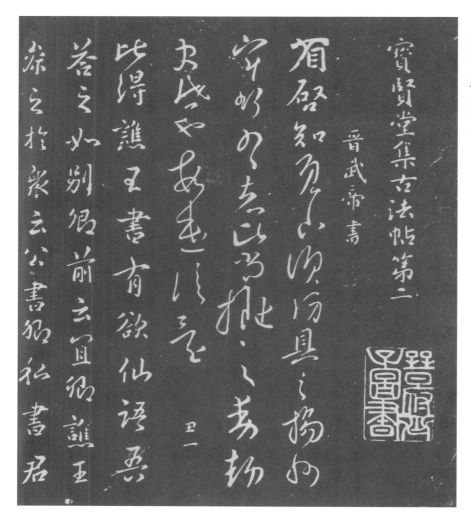

39 Rubbing of the calligraphy of Jin Wudi (*r.* 265–90), from *Bao xian tang ji gu fa tie* ('Antique Model Calligraphy Assembled in the Hall for Treasuring Worthies', 1489).

the Jin dynasty in the fourth century open chapter Two, and its most 'recent' emperor is Song Taizong, who before succeeding his elder brother bore the title of King of Jin (*Jin wang*), the same title Zhu Qiyuan's father held at the time of the collection's compilation and which he was expected one day to bear himself.[63] Song Taizong is immediately followed by another Jin dynasty bearer of the title of *wang*, namely Sima Daozi. He in turn is very quickly followed by the consecutive sequence of Ming dynasty Kings of Jin, who comprise Zhu Qiyuan's immediate lineage and who close the chapter. The effect of this is to insist that the rulers who

40 Calligraphy of current King of Jin, from *Bao xian tang ji gu fa tie* (1489).

matter to the history of calligraphy and to the construction of antiquity effected by this compilation are those who bear the title Jin, whether they be the *Jin* Wudi with whom the sequence of rulers begins, or the King Xian of *Jin* and King of *Jin* (illus. 40) with which it ends.

If the last calligrapher in chapter Two is 'the King of *Jin*', then the very next one, the first of chapter Three, is none other than *Jin Wang Xizhi*, 'Wang Xizhi of the *Jin*' (illus. 41), thus effecting a smooth link between them. Wang Xianzhi and all of the calligraphers in chapter Eight are similarly headed, meaning

that over half of the contents of 'Antique Model Calligraphy Assembled in the Hall for Treasuring Worthies' consists of work by calligraphers who are identified in some way or another, either as its rulers or its subjects, with Jin. If one goes further and considers the seal *Jin fu shi zi tu shu* ('Seal of the Crown Prince of the Palace of Jin') which heads each chapter, a 'peritext' forming part of a larger apparatus of 'paratext' in Gérard Genette's sense, directing our reading of what follows, then all the calligraphy in the entire collection is appropriated in some sense into the aura of 'Jin', collapsing place and period into each other.[64]

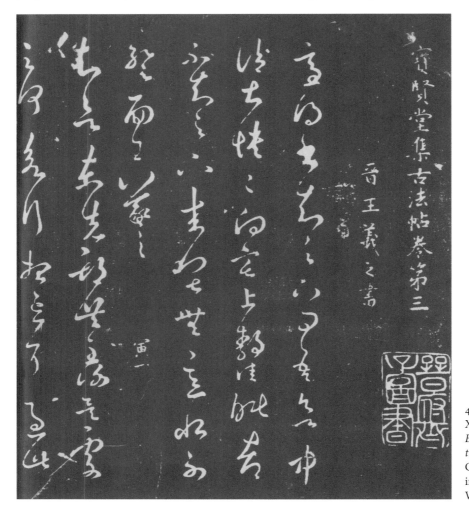

41 Calligraphy of Wang Xizhi (*c.* 307–365), from *Bao xian tang ji gu fa tie* ('Antique Model Calligraphy Assembled in the Hall for Treasuring Worthies', 1489).

In fact, 'Antique Model Calligraphy Assembled in the Hall for Treasuring Worthies' is saturated with what one can only call 'Jin-ness'. This encompasses several things, and it is part of the power of the concept's associations that it is never too explicitly defined. On the one hand it is a place, a region, modern Shanxi. On the other it is a period. If we take the first of these initially under review, it becomes clear that, as with any act of collecting or compilation, strategies are at work here to *make* an order and not just reflect or index it. This becomes clearer if one considers the sources of the collection, in the model calligraphy collections of the Song period. As described above, Zhu Qiyuan cites four sources: 'So I assembled such collections as the *Chunhua*, the *Jiang tie*, the *Daguan tai qing lou* and the *Bao Jin*, along with the work of not less than several tens of those renowned in the present dynasty.' But analysis shows that these are not used equally. Of particular significance is the role of the *Jiang tie* as a model, a fact recognized as early as the seventeenth century by Fu Shan, and analysed in more detail by the modern scholar Wang Hongbin.[65] Significantly, the late Ming 'Offerings from the Appanages' cites *only* the desire to preserve the contents of the *Jiang tie* as the inspiration for the calligraphy-loving King Zhuang to order his crown prince to create the Hall for Treasuring Worthies collection.[66] That significance lies precisely in the fact of the Shanxi

provenance of this Song collection, the earliest in date after the *Chunhua ge fa tie*. Jiangzhou, where it was created (now Xinjiang county, Shanxi province) had been the third capital of the state of Jin in the Spring and Autumn Annals period. More immediately, the region preserved into the Ming period a number of the actual stones on which the precious ancient calligraphic samples were cut. The Ming dynasty Kings of Jin not only owned a set of the Song dynasty rubbings of the *Jiang tie*, part of the founding gift to Zhu Gang from his father, they also were custodians of some (how many is not exactly clear) of the actual Song dynasty stones from which the rubbings, the earliest such collection with a Shanxi provenance, were taken.[67] The 1459 enlarged edition of the fifteenth-century collector's manual *Xin zeng ge gu yao lun*, 'Essential Criteria for the Investigation of Antiquity', mentions their preservation in the Jin palace and suggests that there were some 50.[68] (This is important in its own right, because it suggests a wider public awareness of what princes had.) That this Song dynasty Shanxi rubbings collection was a general inspiration for the Ming period rubbings collection there can be no doubt. For example, it is the *Jiang tie* that is the first to construct a historical sequence by putting the primeval Cangjie and the Qin functionary Li Si first, rather then commencing with imperial hands as *Chunhua ge fa tie* does. It also breaks with the view of the Tang dynasty

as end point, bringing the history of calligraphy up to its own time; and seven pieces in *Bao xian tang ji gu fa tie* are direct tracing copies of works in the *Jiang tie* collection.[69]

But what is more telling, as a practice of direct identification between the two sets, is that some of the *Bao xian tang* collection is directly incised on to stones from the earlier set.[70] Two stones from the eleventh-century *Jiang tie* are directly embedded in the 156 stones which survive in Taiyuan today from the Ming royal project; indeed it seems possible that the later stones were cut to conform in size to the earlier ones, though the material in terms of type of stone is different. One of these two Song stones bears on its earlier side writing by Wang Xizhi, while on its later side it carries part of the prefatory matter, the letter of Zhu Qiyuan to his relative, the Hongzhi emperor (illus. 34). This is surely no thrifty reuse of materials. Rather it is a deliberate strategy to associate Zhu Qiyuan's project with the lustre simultaneously of Wang Xizhi (a subject, let us remember, of *Jin*) *and* of the Song dynasty connoisseurship of this treasured material. The Song stones are physically appropriated into the Ming project, and their charisma is appropriated in a very material way, a way which presences antiquity on at least two levels (one might recall the embedding of the Song imperial palace in that of the Kings of Zhou). But, it should be stressed, in this case the specifically local,

the distinctively Jin, is an important part of that antiquity.

The imperial centre's suspicion of any sign of fissiparous tendencies on the part of regional kings is well known. It was present in the dicta of the Ming founder himself, and was very pronounced in the policies of his grandson and successor, the Jianwen emperor. When that emperor's uncle, Zhu Di, King of Yan, overthrew him after a bitter civil war, part of the propaganda Zhu Di deployed in that war related to the undoing of the wrongs kings had suffered at the hands of bureaucrats in the imperial court. But although Zhu Di was ritually scrupulous in his treatment of his kingly relatives, a suspicion of their potential for rebellion remained at the heart of imperial policy, that suspicion being only confirmed by the two great early sixteenth-century kingly rebellions that occurred not so long after the death of the calligraphy-loving Zhu Qiyuan. It may therefore seem rash to argue for particularly regional or particularist features of the 'Hall for Treasuring Worthies' collection.

But it depends on how that particularism is expressed, as well as what it expresses. The 'state of Jin' over which Zhu Qiyuan's father presided, was a sovereignty with a centre but without mappable boundaries, and at that centre stood the royal storehouses of calligraphy and painting, where the treasured Song dynasty stones of the *Jiang tie* were brought and where the work of producing the 'Antique

Model Calligraphy Assembled in the Hall for Treasuring Worthies' was carried out. It was a centre which affirmed a relationship with a greater centre, in the form of the imperial court. This relationship is very explicit in the preface quoted above, where Zhu Qiyuan addresses his imperial relative to whom the collection is presented, the Hongzhi emperor. And it is also explicit in the emperor's reply:

> The Emperor proffers this letter to his ancestral uncle the King of Jin. Inasmuch as the carvings of the 'Jiang Rubbings' on stone of Our ancestral great-uncle King Ding of Jin have suffered losses and damage over many years, you have now ordered your crown prince to make selections from the old collection, to investigate broadly a mass of writings, that the calligraphic examples of the famous men of ancient and modern times might be copied and engraved, and assembled into a set of rubbings to be presented to Us. We have perused it on one occasion, find it meticulous in its composition and not without care in its execution, and We have had it placed in a convenient hall to be available for Our leisure. For a man's emotions must have that on which they dote, and the fact that Our ancestral uncle is a close relative from the Imperial Clan, secure in nobility and riches, and is yet able to 'rest his emotions' in literature and art, unmoved by lust and greed, with lofty resolve and praiseworthy goodness, leads Us to write specially to praise him. We have observed that in the presentation it is said, 'In the Way of the Sage the six forms of character alone must be transmitted'; now particularly at times of enjoyment in art, he does not forget the path of moral resolve, but considers the instruction of the court as even more important; how great thereby is the glory of the appanages which support Us! Our ancestral uncle is an illumination unto them. Twenty-ninth day of the intercalary third month of the ninth year of Hongzhi (1496).[71]

The transmission of the 'six forms of character' (*liu shu*) was a central responsibility of good stewardship of the Mandate of Heaven, since it was the visible form of *wen*, of that agency in the production of meaningful marks which distinguished humanity from beasts. The production of rubbings collections in the kingly courts, drawing on materials which had been provided to them at the dynastic founding from the imperial centre (a centre from which *wen* radiated to the furthest corners of the Earth), is therefore far from being a dilettantish or a purely aesthetic practice. Instead it demonstrates the collective commitment of the imperial family to the values of *wen*, and as such demonstrates their fitness for continued rule.

Here we must be careful to avoid a sort of reductionist instrumentality, whereby the commitment of the imperial family to 'culture' is merely the mask for their dominance, a sort of 'logic of instrumental reason' which exists to provide legitimation for 'real' power. An instructive comparison can be made with the situation in pre-modern India, the object of a subtle and highly important study by Sheldon Pollock, who argues, 'we must be cautious about reducing the relationship between culture and power in the Sanskrit world to one of simple instrumentality . . . [instead] a vision of grammatical and political correctness – where care of language and care of political community were mutually constitutive – was basic to the cosmopolitan ethos from the very beginning.'[72] This mutual constitution of the Sanskrit concepts of *kāvya* (culture, literature) and *rājya* (rule) is perhaps reminiscent of a mutual constitution of *wen* and *fa*, with the latter being the 'rules' of script and the 'models' of good calligraphy certainly, but a term with a very much wider resonance throughout the Ming understanding of the world. Just as the writings of the past, in the form of *fa tie*, reproduced models of correct writing for the present, so the imperial centre reproduced itself in those regional centres where the preservation and ordering of these models was carried out. And of course these centres depended in a literal biological sense on the reproduction of the imperial family, the pattern and model of all families within the empire. This is another reason why, in a break with previous collections of *fa tie*, it is so important that the 'Hall for Treasuring Worthies' collection include work by one living calligrapher, a living calligrapher who is none other than the King of Jin, Zhu Zhongxuan. Here there is a visible reproduction of the imperial centre in stylistic terms, in the clear modelling of the Kings of Jin's writing on Ming court styles exemplified by the men in chapter Twelve. This is noteworthy if one compares the hand of the living King of Jin with that of Zhang Bi, for example (illus. 40 and illus. 37). The early Ming court style, as exemplified by someone like Zhang Bi, is in turn about the encompassing, the bringing together of different manners, the combination of different scripts in the same piece; it is an aesthetic of the collection, broad and not narrow, in which the work of such as Wang Xizhi of the Jin bears a central place.[73] Such an encompassing and incorporative practice, clustering round a cultural centre, is what in the end *Bao xian tang ji gu fa tie* itself is about.

Later connoisseurship has been less than sympathetic to the quality of the 'Hall for Treasuring Worthies' collection, in terms of its contents. In his 'Five Miscellanies' (*Wu za zu*) collection, Xie Zhaozhe (1567–1642) dismissed both it and the 'Eastern Study' rubbing collection as

not made by an eye attuned to the proper brush methods, nor are they executed by an inspired hand. Withered and unstable, they are only good as dried dates: a light snack before a meal.[74]

In the Ming and early Qing both Wang Shizhen and Fu Shan wrote of it in less than enthusiastic terms, and it is not mentioned by Wen Zhenheng in the 'Treatise on Superfluous Things' listing of desirable rubbings collections.[75] The laconic annotation 'fake' (*wei*) follows a large number of items as they are listed by one of the great experts of Chinese calligraphy today, applied not only to such impossibilities as the purported script of Cangjie and Confucius but to all of the writings of pre-Tang rulers listed in chapter Two.[76] Its fate therefore contrasts considerably with that of the kingly project of calligraphic reproduction to be discussed, the so-called 'Su palace edition' (*Su fu ben*) of the 'Chunhua Era Rubbings Collection', produced in a setting even more remote from the supposed heartland of Ming culture, the palace of the Kings of Su at Lanzhou in Gansu. But it will be remembered that it was a city where the kings of Su were not only major patrons of its Daoist religious establishments, but themselves the calligraphers of the names of those temples, visible to residents and visitors alike. Here in 1615 Zhu Shenyao (d. 1618), King Xian of Su, ordered two calligraphers named Wen Ruyu

and Zhang Yingzhao to produce this new edition on the basis of a Song dynasty original he owned. Like the precious works which lay behind the 'Eastern Study' and 'Hall for Treasuring Worthies' collections, this treasure was the result of a gift from the Ming founder to one of his enfeoffed sons, in this case to Zhu Ying, first King of Su. King Xian died before the work was completed in 1621, and it was finished under his son Zhu Zhihong (d. 1643).[77] It remains one of the most highly regarded versions of this elusive and simulacral masterpiece (illus. 42).[78]

Coming as it does from close to the end of the dynasty, the 'Su palace edition' demonstrated the continuing commitment of kingly courts to the practice of calligraphic reproduction through the Ming. And it is not unique of its period; in 1592 Zhu Yiyin (1537–1603), King Xuan of Yi in Jiangxi province, had reproduced the early Ming rubbings of the 'Orchid Pavilion Preface' originally produced by Zhu Youdun as Crown Prince of Zhou, stating:

> With the passing of time [the rubbings] were rarely transmitted, and as the years grew long the stones decayed, and the authenticity was inevitably lost. In the intervals from the affairs of the state, I have been rather fond of these rubbings, and have loved to bring out the old holdings from previous courts, uniting them

with the 'Eighteen Colophons' tracing copy version of Zhao Chengzhi, and inviting from afar the outstanding craftsmen of Suzhou, I have again had them copied on to stone. This took in all ten years, from the time the work began, and oh what a delight![79]

But one feature distinguishes these two late Ming projects from earlier ones, and that is their dependence on the cultural skills of the Jiangnan literati heartland; the otherwise shadowy Wen Ruyu, calligrapher of the 'Su palace edition', came from Suzhou, as did the 'outstanding craftsmen' summoned to Jiangxi by the King of Yi. The 'Eastern Study' and 'Hall for Treasuring Worthies' collections either drew directly on more local resources, or at the least do not feel it necessary to mention their use of skills from places such as Suzhou. In the century which separates the two fifteenth-century kingly calligraphic projects from the two Wanli era ones, the Jiangnan elites had themselves become active as producers of calligraphic rubbings collections, the earliest of these being the *Zhen shang zhai fa tie*, or 'Rubbings Collection from the Studio of True Connoisseurship', of 1522, produced by the Hua family of Wuxi.[80] It is perhaps not surprising that the degree of exchange between aristocratic and degree-holding scholar elites should lead the former to draw on the technical skills which the patronage of

the latter supported in cities like Suzhou. But we must keep sight of where priority lies here. It was in the kingly courts of the Ming that the two earliest independent rubbings collections were formed, and it was in a kingly court that the most highly regarded Ming version of the supreme monument of the calligraphic canon was produced. And there were other calligraphy-related projects, like the printed work from the palace of the kings of Lu in Shandong, produced in 1636 and entitled 'Compilation of Ancient Calligraphy, An Edition Newly Carved and Annotated by the Lu Princely House' (*Lu fan xin ke shu gu shu fa zuan*).[81] Taken together they make a powerful case for the centrality of kingly patronage in the reproduction of calligraphy in the Ming.

It is perhaps not going too far to suggest that reproduction in its more fundamental and biological sense was the central fact of the imperial clan, its principal purpose. And there are therefore some intriguing analogies between that task of biological reproduction and the work of cultural reproduction carried out by the rubbings collections. For a start, both forms of reproduction required the close and direct involvement of what were seen by elite males as necessarily and irrevocably subaltern categories of people; women (in the case of families) and artisans (in the case of calligraphic rubbings). Both of these categories have been largely absent from this account so

歷代帝王法帖第一

漢章帝書

辰宿而張忽志海碱河渎

辨羽翔就沛火帝烏殳人

呈好物文字乃釈太述述

42 'Calligraphy by Emperors and Kings of Successive Dynasties', '*Chunhua ge fa tie*', from *Model Calligraphy of the Chunhua Era*, Su Palace edition (1615–21), opening page of *juan* 1.

far, an absence which reflects the priorities of Ming sources, but which is in absolutely inverse proportion to their importance to the relative processes. Anxiety about the 'authenticity' of family lineages (was the next King of Chu *really* the son of his father?) certainly surfaces in Ming writing, and will be addressed in a subsequent chapter. But there is very little expressed anxiety in the material surrounding collections like the 'Eastern Study' and 'Hall for Treasuring Worthies' which explicitly addresses the fact that these objects depended for their very existence on the agency of men who, by their very possession of technical skill in stone carving and the making of rubbings, were theoretically disbarred from any kind of higher appreciation of the content and meaning. In order to be 'transmitted', culture had to be put, physically and materially, into the hands of those who by definition could not fully understand it. This paradox is little addressed in the kingly collections themselves, although as long ago as the Northern Song the great connoisseur Mi Fu had been scathing about the value of the whole category of rubbings as a source of lessons, arguing, 'One cannot learn from stone engravings.'[82]

We might go one step further in the analogy between the transmission of authentic bloodlines and the transmission of 'true' specimens of model calligraphy, by seeing the latter as what the late Alfred Gell described as 'fractal' objects, in a context where personhood itself was understood as also to a degree fractal. That is to say, a person was 'always an entity with relationship integrally implied', where 'People exist reproductively by being "carried" as part of another, and "carry" or engender others by making themselves genealogical or reproductive "factors" of those others. A genealogy is thus an enchainment of people.' Similarly, a 'fractal object' is always 'an entity with a relationship integrally implied'.[83] Both the bodies of the King of Jin, or the King of Zhou, and the collections of rubbings which they ordered into being, are fewer entities in themselves than links in an ongoing reproductive chain, which is never definitive or final. For the pathos implicit in the rubbing is that, despite being literally taken from something which is 'carved in stone', it of necessity undoes its own permanence in fulfilling its function of transmission. There are two aspects to this. At one level a rubbing undoes its own claims through its materiality,

> since like a seal in both Chinese and other contexts a rubbing is; a device, that acts as both guarantor of authenticity, and a facilitator of its own circumvention . . . the mechanism which gives the seal authority can also bring about its undoing: for an impression can easily be made from the impression itself, so replicating the original seal, which can then be used fraudulently.[84]

Any rubbing could be used as the source from which blocks could be cut, themselves to act as the source of further rubbings. Another aspect is simply that the act of making a rubbing itself does a certain amount of damage to the stone, gradually wearing away its surface through the act of tamping the sheet of dampened paper against it.[85] Rubbings taken from the stone at different periods are therefore different in appearance, in value and in cultural force. Taken together, these two aspects mean that all rubbings exist in a chain of replication, of replicas of replicas, each a little bit fainter and less distinct than the last, which parallels the chain of biological reproduction through which the sons of emperors were successively titled as King, Commandery King, Defender-general of the State, Bulwark-general of the State and so on, right down to Supporter-commandant of the State. Each of these was a slightly fainter replica of the imperial grandeur which stood at the beginning of the chain. The kingly interest in replicating one of the central facts of human culture, its script, thus faced both ways, drawing attention to their connections to the ultimate origins of civility, at the imperial centre, at the very same time as it drew attention to their necessary distance from it. But the *claim* of unimpeded transmission, even if undercut by the material facts, remained throughout the Ming period a potent one.

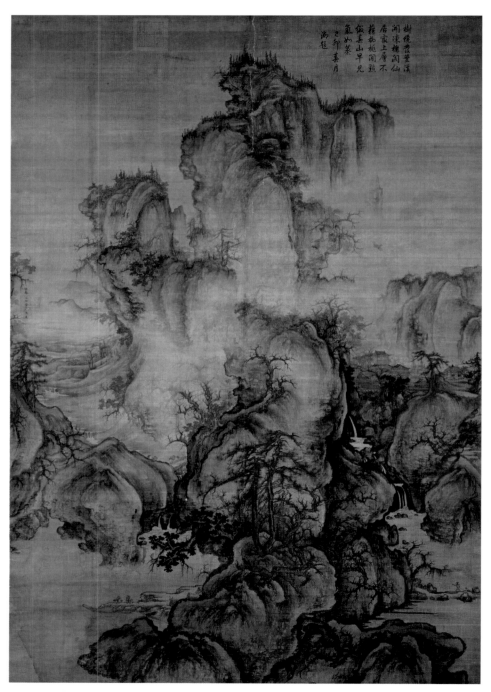

43 Guo Xi (*c.* 1000–*c.* 1090), *Early Spring*, dated 1072, hanging scroll, ink and colour on silk, 158.3 × 108.1 cm.

FOUR

The Painting of the King of Zhou

It might be argued that to separate kingly engagement with 'calligraphy' from 'painting', as is done here, is anachronistic and unnecessary, since arguably these two cultural practices formed a unified discourse in the Ming: *shu hua*, 'calligraphy and painting'. Certainly Song Lian (1310–1381), who may have instructed the first King of Jin in the former at the beginning of the dynasty, was only echoing a long-established truism when he wrote that 'calligraphy and painting are not different Ways, but are as one in their origin.'[1] And as with calligraphy, there is considerable evidence for Ming kingly houses as sites in which painting was collected, discussed, produced and circulated. A clear pattern of the dissemination of images from the imperial centre to the kingly courts was laid down in the Hongwu reign (1368–1398) when, for example, the Ming founder ordered a portrait of himself with which he was particularly pleased to be produced in multiple copies and sent to 'all the kings'. Portraits of the Yongle (*r.* 1403–24) and Xuande (*r.* 1426–35) emperors were similarly produced in multiple

editions.[2] This demonstrates that portraits of the ruler were not, at least in the early Ming, restricted purely to funerary or posthumous contexts, but rather played the role of replicating the imperial presence in multiple sites. Furthermore, at least as regards the early Ming, it seems undeniable that it was in kingly palaces that some of the most significant assemblages of the valued painting of the past was to be found, something which is confirmed both by the evidence of archaeology and by the presence on surviving objects of the collection seals of royal owners.

Paintings appear among the tomb contents of one of the first of the Ming founder's sons to die. Zhu Tan, posthumously King Huang of Lu (in Shandong province), was buried in 1389 at the age of only nineteen having apparently first gone blind as the result of an alchemical 'goldstone medicine'. The contents of his tomb, unusually but not uniquely for a Ming burial, contain not only the expected attendant figures and model vessels but actual objects relating to the so-called four accomplishments of a

gentleman, *qin qi shu hua*, that is to say the *qin* or *guqin* zither, *qi*, the game of chess (usually known in English by its Japanese name of *go*), calligraphy, *shu*, and painting, *hua*.[3] Found in this tomb along with the zither and chess set were some seven Yuan dynasty printed books, histories, classics and poetry, in fine scholarly private editions from the Jiangnan region, as well as paper, brushes and ink. Four personal seals found in the tomb include ones with the legends 'Painting and Calligraphy of the Lu Palace' (*Lu fu tu shu*) and 'Viewed at the Gate of Heaven' (*Tian men yue lan*); these were for impressing on paintings owned or viewed by Zhu Tan. There were also three actual paintings. One is an anonymous Song dynasty fan painting of a mallow flower, inscribed by Emperor Gaozong of the Song dynasty (*r.* 1127–62) and bearing the seal of the greatest Yuan dynasty collector of the Mongol imperial family, Princess Sengge Ragi (*c.* 1283–1331), who herself bore the title of Great Princess of the State of Lu, alluding to the same Bronze Age homeland of Confucius as Zhu Tan's own title, 'King of Lu'. There are inscriptions by the Yuan dynasty connoisseurs Feng Zizhen (1257–1327) and Zhao Yan (active *c.* 1300–25), who are both known to have inscribed works in her collection.[4] The second painting is a hand scroll of a lotus flower by Qian Xuan (*c.* 1235–after 1301), which also bears colophons by the same two men and hence may have the same provenance.

The third is an anonymous Song dynasty landscape painting in the *gongbi*, or 'meticulous brushwork' style.[5] What is most significant in the present context is that all three of these works bear the so-called *siyin* half-seal, a curatorial device of the early Ming imperial collections which reveals that all three pictures were in that collection, prior to their ownership by the short-lived Zhu Tan. Thus we have more incontrovertible evidence that the early Ming kingly collections had their origins in gifts from the imperial holdings in Nanjing, where the Yuan dynasty imperial collection of painting was transferred after the expulsion of the Mongols from China. As the kings were sent out 'to their states' at the beginning of the dynasty, there went with them the materialization of the power of imperial *wen*, in the form of calligraphy and painting, so that this *wen*, this culture, would be relayed and reinforced across the whole surface of the world.

The origins in the early imperial collection (and hence further back in the Yuan and Song imperial collections) of much of the painting owned by early Ming kings is borne out by the best analysed of such holdings to date, those of the Kings of Jin, at Taiyuan in Shanxi. Richard Barnhart, building on the work of Jiang Yihan, has identified 33 authentic works of early calligraphy and painting (9 of the former category, 24 of the latter), which bear various seals of the Jin palace.[6] Fifteen of these items also have the *siyin* half-seal of the early

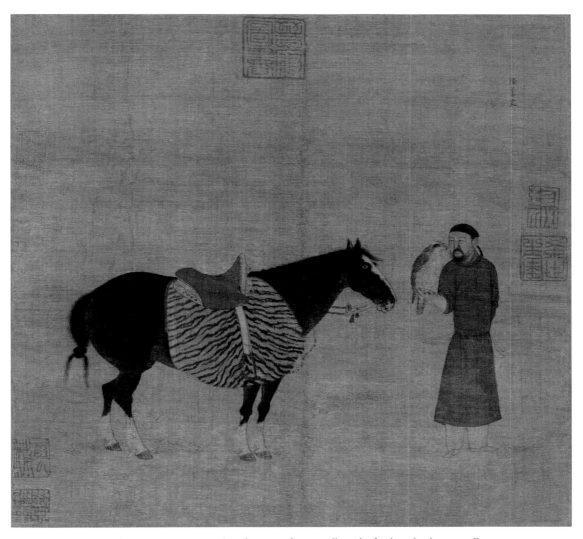

44 Chen Juzhong (attrib., active *c.* 1201–1230), *Falconer and Horse*, album leaf, ink and colour on silk, 24.8 × 26.3 cm.

Ming imperial collection, showing that they share a provenance as gifts from that collection to the King of Jin, most likely on his investiture in 1378. This initial gift contains what are now some of the most prestigious and canonical of surviving pre-Ming works, paintings like the Northern Song monumental landscape *Early Spring* by Guo Xi, dated 1072 (illus. 43), and the *Water Mill* once attributed to Wei Xian and now in the Shanghai Museum.[7] There is every reason to think that the works we can identify now as part of this great collection are only a small part of the original. Indeed, new works continue to be added to the corpus, like the small painting of a falconer and horse attributed to Chen Juzhong, which

bears in the centre of its top edge (a placing particularly associated with imperial and kingly seals) the legend *Jin fu tu shu*, 'Painting and Calligraphy of the Jin Palace' (illus. 44).[8] And we can assume that the Jin collection was equalled by at least some of those of Zhu Yuanzhang's other sons, assemblages of now lost work which we can only imagine, or which survive only in even more scattered fragments.

Kingly households whose creation post-dated the first decades of the Ming were also involved in the collecting of painting. An album leaf in the Freer Gallery of the popular courtly theme of *Knick-knack Peddlar and Playing Boys*, which bears the signature of Li Gonglin (*c.* 1049–1106) but which is more plausibly of early to mid-fourteenth century date, carries the seal *Guangze wangfu zhenwan*, 'Treasured for enjoyment in the Guangze

45 Li Gonglin (attrib., *c.* 1049–1106), *Knick-knack Peddlar and Playing Boys*, early to mid-14th century, album leaf, ink on silk, 21.8 × 29.4 cm.

kingly palace' (illus. 45). This locates it in the possession of one of the collateral branches of the appanage of Liao, which was created in 1392 for the fifteenth son of Taizu, Zhu Zhi (*c.* 1378–1424). It descended to Zhu Zhi's grandson, Zhu Enji (*r.* 1480–95), King Hui of Liao, whose second son Zhu Chongrang was the first holder of the title of Commandery King of Guangze, from 1487 to 1546.[9] The seal cannot therefore have been added to the painting prior to 1487 and may suggest a process of division of the kingly holdings akin to that which saw elements of the imperial collection divided up among emperors' sons. The collection of imperial clan biographies, 'Offerings from the Appanages', talks of the warm relationship between the first King of Guangze and his elder brother, King Gong of Liao, described as a moral paragon who doted on his younger brother and permitted him to enjoy the same quality of food and drink, clothing and insignia as himself, as well as the same level of 'treasured enjoyments' (*zhen wan*).[10] This is the very same term as that found on the seal, alluding to the shared culture of connoisseurship within the various branches of the Liao appanage. The same seal appears in a very intriguing context, on a famous set of hanging scrolls of *Landscapes of the Four Seasons* by the Japanese monk painter Sesshū Tōyō (1420–*c.* 1506), who visited China in the years 1467–9.[11] Sesshū's travels did not bring him to inland Hubei, and he certainly did not

visit the court of the King of Guangze, since the title as we have seen was not created until 1497, so we are left with the question of exactly how these works came into (and left) the kingly collection.

Other seals are recorded indicating kingly ownership.[12] One of two known seals of Zhu Changfang, King of Lu (*d.* 1614), appears on a large and decorative hanging scroll of a bird-and-flower subject, which carries a signature of the Liao dynasty (907–1125) painter Xiao Rong (illus. 46). The painting is certainly much later, not in fact earlier than the fifteenth century, though whether this indicates poor connoisseurship on the part of the king, or an optimistic signature added subsequent to his ownership, is impossible to tell.[13] At least eleven other items in the National Palace Museum of Taipei alone, the majority of them albums which assemble small works by different artists but also including one piece of calligraphy ascribed to Wang Xizhi, carry the inscription *Lu wang zhi bao*, 'Treasure of the King of Lu'.[14] This evidence for the involvement of a late Ming king with the ownership of paintings raises the question of their relationship with the highly developed art market of the period. It seems perfectly likely that pictures came into kingly collections via this market, but did they also leave via it too? For example, an early (probably thirteenth-century) copy after Guo Zhongshu, of the composition entitled *Towing Boats under Clearing Skies after Snow* (illus. 47), not only

46 Signature of Xiao Rong (active Liao dynasty, 907–1125), *Bird and Flowers*, here dated 15th century, hanging scroll, ink and colour on silk, 145 × 83 cm.

47 Song copy after Guo Zhongshu, *Towing Boats under Clearing Skies after Snow*, probably 13th century, hand scroll, ink on paper, 49 × 143 cm, artist unknown.

carries seals of a King of Jin (probably the third king, Zhu Zhongxuan, commissioner of the 'Hall for Treasuring Worthies' rubbing collection discussed in the previous chapter) but also of the great banker and art collector Xiang Yuanbian (1525–1590), who owned one of the grandest assemblages of painting and calligraphy of the entire Ming period.[15] The possibility that a picture could have travelled over the course of the sixteenth century from a kingly collection in Shanxi to a merchant collection in Jiaxing in the lower Yangtze, through what channels and by the hands of what intermediaries we cannot know, shortens the conceptual distance between these two social settings and suggests that there may have been more interaction than we might suppose between them. Certainly the later stereotype of the 'bad Ming king' sometimes includes a rapacious lust for the acquisition of artworks along with the more commonly seen image of them

as despoilers of local women. A nineteenth-century gazetteer of part of Huguang province skewers the last King of Min, who died in 1643 at the hands of peasant rebels, as being equally avid for both, with the statement:

> He was particularly fond of antiques, and if someone had a fine piece of calligraphy or painting, he would send an adjutant (*xiaowei*) to acquire it. If there was the slightest resistance, the family was immediately ruined. Many scholar gentry (*shidafu*) families moved to avoid him . . . but the clan members became ever more arrogant, so that the people suffered unbearable hardship.[16]

Whether sober fact or local legend, the association of kings and the collecting of painting was at least in later centuries a believable one, and for good reason.

There are in fact a number of contexts, other than that of simple ownership, where the kingly world intersects with what was also increasingly seen as a separate *hua tan*, 'field of painting'. The 'Offerings from the Appanages' of around 1600, one of two voices we have on the topic from within the imperial lineage itself, lists five kings as having some talent in the art. The first of these is the polymathic Zhu Youdun (1379–1439), King Xian of Zhou, compiler of the 'Eastern Study Collection' of calligraphic rubbings and continuously renowned since the early Ming for his role as a playwright. Of him it is merely said that he 'practised calligraphy and painting', presumably in his palace on the site of the Northern Song capital at Kaifeng.[17] To the south of him at Nanyang, also in Henan province, lay the palace of the Kings of Tang, and we are told that Zhu Miti (d. 1523), King Cheng, was 'broad in study and diligent at poetry and painting'.[18] Equally sketchy are the mentions in 'Offerings of the Appanages' of the talents of the three commandery kings singled out for their interests in painting. From the same lineage of Tang came an uncle of King Cheng, Zhu Zhigui (d. 1511), King Kangmu of Sancheng, described as 'broadly learned in all the Classics, and particularly devoted to painting. Calligraphy and famous paintings were never out of his hands for a day.'[19] In Jiangxi province one of the cadet branches of the appanage of Ning, forfeited for rebellion, produced Zhu Gongluo, King Ruijian of Lean, who received his title in 1545 and who is simply described as 'skilled in the matter of painting' (*jing hui shi*).[20] The only kingly painter to be referred to in this text in any but the most cursory of terms is Zhu Houkun, the second son of King He of Jing, who received the title of King of Fushun in 1514. Orphaned at an early age, he grew up to be a lover of all the arts, particularly a lover of poetry and of painting. Zhu Mouwei then gives us a curious anecdote:

> One day he spread out white silk and pictured Sichuan sunflowers turning to the sun; bees clustered on the flowers, and when brushed away they kept coming, such was the wondrous lifelikeness.[21]

This tribute to mimetic ingenuity, to a degree sufficient to fool birds and beasts (or in this case, insects), is of a type familiar in the Western literary tradition from Pliny onwards, and is not unknown in early Chinese texts either. But the emphasis on the ability to achieve verisimilitude to this sort of degree seems to run absolutely counter to everything we think we know about what was valued in painting in the Ming period, when standard accounts have it that 'form likeness', one of the venerable six laws of Xie He (active *c*. 500–535), was considerably less regarded than 'spirit resonance'. The ability

to transcribe the appearance of phenomena so well that the image looked 'just like' the real thing was in the Ming (or so most standard accounts would have it) seen as the territory of the artisan, the craftsman whose technical skill forever occluded the deeper penetration into phenomena of the educated amateur. It would be going ludicrously too far to build a notion of some aristocratic counter-aesthetic of mimetic accuracy on this one anecdote, but it does just serve to remind us that the received wisdom about the history of painting in the Ming is itself a carefully crafted artefact, the result of centuries of honing and burnishing, its self-evident correctness possibly masking a much more plural reality of the world of pictures at the time.

The second Ming text which lists imperial clan painters is by Zhu Mouyin, the author of the account of calligraphers already discussed above. His five-*juan* edition, 'Essentials of a History of Painting' (*Hua shi hui yao*) with preface dated 1631, is similarly a continuation of a work by the Yuan/early Ming author Tao Zongyi. His fourth chapter contains brief biographical accounts of painters, or of figures involved with painting, from the Ming dynasty, beginning with four emperors (from Taizu to Xiaozong) and going on to mention six kings of the blood and eight commandery kings. A nearly complete translation of these lapidary characterizations follows:

King Ding of Zhou, given name Su, fifth son of Gaozu, with his state at Kaifeng. The king, knowing that his state was vast in territory, and that the various grasses grew luxuriantly, collected those able to support the hungry, obtaining more than four hundred kinds. He made the 'Basic Plants for the Relief of Famine' (*Jiu huang ben cao*) in four *juan*, devoting himself to drawing the pictures and annotating them . . .

King Xian of Zhou, given name Youdun, was conscientious and fond of study, diligent also at calligraphy and painting, his peonies in vases and dishes had a most divine aspect.

The King of Xiang was excellent at painting children.

The King of Liao was excellent at figure painting.

King Cheng of Tang, given name Miti, his state was at Nanyang. He was broadly learned and diligent at poetry, also excellent at painting.

King Gongjing of Zhenping, Youguang, the eighth son of King Ding of Zhou, was fond of study and diligent at poetic recitation, also conversant with painting; he did a 'Chrysanthemum Album' (*Zhu pu tu*).

King Kangmu of Sancheng, Zhigui, was the son of King Xian of Tang. He was broadly familiar with all the classics, and particularly excellent at painting; he did such pictures as *Aged Heroes, The Queen Mother [of the*

West], *The Nine Elders* and *The Hundred Flowers*, all marvels of their age.

The King of Fushun, Houkun, was the second son of King He of Jing. He was diligent at poetry, and particularly excelled at painting. He once painted several scrolls of Sichuan sunflowers and exposed them to the sun, and bees and butterflies congregated on the flowers, when brushed off they kept coming.

The King of Hengyang was excellent at painting eagles.

The King of Yongning was excellent at painting peonies.

King Jing of Ning, Dianpei, his *hao* was 'Lazy Immortal of the Bamboo Grove', and he was the grandson of King Xian of Ning. He sketched landscapes and plants which were natural, divine and marvellous.

The King of Jian'an, his *hao* was Zhongxian, he was excellent at birds and beasts.

The King of Zhongling was excellent at painting human figures.[22]

It is hard to see what the reader is meant to take from these extremely gnomic entries, or what information can be gleaned if the oeuvre of the king in question is not already familiar. The key information given about an individual in most Ming and Qing biographical sources is geographical, where a person was from, and seventeenth-century readers and writers on painting were accustomed to thinking of artists as being 'from Suzhou' or 'a man of Hangzhou' in a way which mattered. Kings lack this precise 'fix', or at least are characterized only by the archaic names of their appanages, which may well, especially in the case of the commandery kings, have been obscure to readers. There is also no clear information on when in the dynasty these individuals had lived; rather the imperial clan is a sufficient coordinate both in space and in time. The entries are arranged first of all hierarchically, with five 'kings of the blood' preceding a further nine, eight of whom are lower-ranking 'commandery kings', identified by their double-character state names and titles. One of the nine is Zhu Dianpei (1418–1491), King Jing of Ning, from the appanage which was abolished on the rebellion of its holder, a fact which may explain its relegation to the end of the list. The first four are furthermore listed in the order of precedence of the states, which depends on proximity to the Ming founder.[23] The kings of Tang descended from the 23rd son. The same principle (which orders entries in 'Offerings from the Appanages') probably governs the order of the listing of the commandery kings. But the majority of the names in 'Essentials for a History of Painting' (nine out of fourteen) have no entries in 'Offerings from the Appanages', or at least are not there identified as possessing any skill in painting. The former text in every case can give us a bit more than a generic 'skilled at painting', telling us typically

about the subject-matters with which individuals were most closely identified: children for King Xian of Xiang, figure painting for King Jian of Liao, eagles for the King of Hengyang, 'most lovely peonies' for the King of Yongning. Note that only one royal painter, King Jing of Ning, is described as producing work in the genre of landscape, most prestigious of all in the canon of literati opinion. Whether that canon was as universally adhered to as we might now imagine is only one of the questions which this faint and blurry image of the royal practice of painting might lead us to reconsider.

If we attempt to approach that world of pictures through the medium of texts which have painting as their primary focus, and see what they have to say about members of the imperial clan (rather than, as with 'Offerings', having the clan itself as its focus), a similarly intriguing and slightly baffling set of evidentiary fragments presents itself. It should perhaps be stressed that there is in Ming culture no sense that painting is itself a déclassé or intrinsically artisanal activity – quite the reverse. Many members of the Song imperial house of Zhao had demonstrated significant skill as painters.[24] The notion that it was appropriate for the scions of the ruling house to practice the elite art of painting also existed beyond the Ming imperial courts of Nanjing and Beijing in the greater Ming world. For example, in Korea, where Ming cultural practices held great prestige, a number of members of the royal

family had reputations as painters in the course of the sixteenth century. These included Yi Am (1507–1566) and Yi Jeong (1541–1622), both of whom were direct descendants of the great King Sejong (r. 1418–50), as well as Yi Gyeong-yun (1545–1611), a great-grandnephew of one of the sons of King Seongjong (r. 1469–94), as well as the former's own illegitimate son Yi Jing (1581–after 1645).[25] So no strictures existed against picking up a brush: quite the reverse.

One of the most quoted sources on Ming (and earlier) painting is the 'Precious Mirror of Painting' (*Tu hui bao jian*), compiled on the very eve of the founding of the dynasty in 1365 by Xia Wenyan. In 1519 it was augmented by Han Ang, who added a further sixth chapter with biographies of 114 Ming artists, including such well-known names of the literati canon as Wen Zhengming (1470–1559), whose earliest biographical notice is to be found here.[26] This text contains no mention of Zhu Youdun or indeed of any kingly painter, although it does list as painters three fifteenth-century Ming emperors, giving them precedence at the head of the chapter in a way which breaks the otherwise chronological sequence of names but which is perfectly in keeping with the respect and precedence due to such exalted figures. The first Ming emperor to be so distinguished is Zhu Zhanji, posthumously Xuanzong, whose reign title of Xuande spans the years from 1426–35. The precedence given to this name would not surprise anyone familiar even

48 Zhu Zhanji (Ming Xuanzong, *r.* 1426–35), *Gibbons*, dated 1427, hanging scroll,
ink and colours on silk, 162.3 × 127.7 cm.

with the outlines of Ming painting history; he is probably seen as the most talented of all Ming or Qing emperors with the brush, and a considerable body of his work survives in collections today (illus. 48). The other two emperors who are noticed here are Xianzong (the Chenghua emperor, *r.* 1465–87) and Xiaozong (the Hongzhi emperor, *r.* 1488–1505). The joint entry for these two rulers reads in full as follows:

> The products of the imperial brushes of Xianmiao and Xiaomiao are all images of divinities, recognisable by dates and seals. In the imperial clan (*zong shi zhong*) were those skilled at painting images of divinities, as well as genres such as golden vases and golden dishes, peonies, orchids, chrysanthemums, prunus and bamboos: many old families treasure them in their collections.[27]

The wording suggests at least the possibility that the phrase 'within the imperial clan' refers not only to the emperors named but also to other members of the lineage, in fact it would be curious if it did not. The subjects referred to are congratulatory ones, the matter of gift paintings for presentation or religious icons, and as such the type of Ming images least likely to be preserved and most likely to be misattributed if preserved at all. This therefore raises the possibility that a body of work once existed produced by 'members of the imperial clan', some of which may survive today under different names. It is rash to try and identify actual pieces, but the *type* of image which Han Ang means might possibly be represented by something like an image of the ferocious protective deity Marshal Wen (illus. 49).[28] It would be piquant (if ultimately unknowable) if some of the plethora of surviving religious images from the Ming, a class of objects relatively low in status as both functional images and as the products of artisans, turned out in fact to be from the hands of men through whose veins the imperial blood coursed. It would also be a reminder that our received story about the world of painting in the Ming has lacunae whose very existence is obscure to us.

This is borne out more strongly if we consider one of our principal sources for the study of Ming painting, a text to which scholars have turned again and again but which we have generally chosen to read in accordance with a set of presumptions which involve on occasions an almost wilful disregard of the text's own priorities. The 'Records of Ming Painting' (or, arguably, 'Records of Ming Painters', *Ming hua lu*) by Xu Qin is datable to after 1677, which is to say that it dates from a generation after the fall of the dynasty in 1644. A relatively extensive text in eight chapters, it consists of over 550 biographical entries, largely divided into categories by typical

subject-matter such as 'Landscape', 'Bird and Flower' or 'Monochrome Plum'. The first three categories, however, refer to the status of the artists there listed, and the first is 'Imperial Painters', consisting of four entries for the three emperors already recorded in 1519 by Han Ang, plus Zhu Houzhao, posthumously Wuzong, who reigned as the Zhengde emperor from 1506 to 1521.[29] The second category is that of *Fan di,* 'Appanage Households', which contains fourteen names, identical with those of Zhu Mouyin's 'Essentials of the History of Painting' as laid out above.[30] Again the textual precedence of kings tells us something about their ongoing importance to contemporary audiences, which we would be unwise to consider as purely formalistic.

None of this kingly painting, as described in 'Records of Ming Painters', survives. What is more it does not seem to have survived for very long after the Ming dynasty, or at least was not noticed by connoisseurs in the succeeding Qing period. This can be confirmed by a trawl through the 'Bibliography of Paintings Recorded in Successive Dynasties' (*Li dai zhu lu hua mu*) of Fu Kaisen, also known as John C. Ferguson (1866–1945).[31] First published in Beiping, as Beijing then was known, in 1934, it lists all the paintings mentioned in 108 separate historical catalogues and texts on painting, enabling one today to make statements about what past connoisseurs and collectors believed they had seen, or at least thought it worth

recording (regardless of course of the authenticity of these works).[32] What is immediately startling if one turns to Ferguson's index and looks for works recorded as being by painters with the imperial surname of Zhu, is just how pitifully few there are. In fact there are only six entries. One records two anonymous portrait images (certainly funerary or commemorative portraits) of King Xian of Xing, which were recorded in 1749 in a catalogue ordered by the Qianlong emperor of all surviving portraits of previous rulers stored in the Nanxun Hall of the Forbidden City.[33]

Of the other five entries, three are by men who have entries in the 'Records of Ming Painting' listing. The first of these (in terms of the date of its production) is a work by Zhu Youdun, King Xian of Zhou, whose *Peach Blossoms and Flowing Water* (*Tao hua liu shui,* the format not noted) is mentioned in an early nineteenth-century manuscript catalogue by an as-yet-unidentified author.[34] A hanging scroll entitled *Broken Branch of Peach Blossom* (*Zhe zhi tao hua tu*) by Zhu Zhigui, King Kangmu of Sancheng, is recorded in a late seventeenth-century catalogue by the major official and prominent collector Bian Yongyu (1645–1712).[35] Then a hand scroll of flowers by Zhu Gongluo, King Ruijian of Lean, is noted as recorded in Zhou Shilin's *Record of the Waters of Heaven [Melting] the Iceberg* (*Tian shui bing shan lu*), a work printed in the early Qing on the basis of a Ming manuscript.[36]

49 Jiang Zicheng (attrib.),
Marshal Wen, late
14th–early 15th century,
hanging scroll,
ink and colours on silk,
124 × 66.1 cm.

It is important for a number of reasons. The 'Iceberg' in question is the vast and ill-gotten wealth of Grand Secretary Yan Song (1480–1565), confiscated by imperial edict (the 'Waters of Heaven') on his posthumous disgrace. A unique document from the period, it lists painting and calligraphy as merely one category of luxury material culture, among pages of lacquered beds, textiles and precious metal tableware.[37] The fact that the immensely powerful Yan Song owned a work by the King of Lean, among a mass of other works, many of which had been acquired as gifts given by those seeking patronage from or simple ingratiation with the great man, suggests something interesting about the relationship between at least one member of the imperial aristocracy and the highest reaches of the bureaucracy. And it is the *only* contemporary (that is, contemporary to the Ming period) record of someone in the Ming owning a painting by a member of the imperial clan. This is made all the more significant by the fact of where the picture is *not* recorded. In addition to the bald listing of paintings in 'The Waters of Heaven', there was another catalogue made of Yan Song's holdings of paintings and calligraphy, carried out in 1569 by Wen Jia (1501–1583), son of the great literatus painter Wen Zhengming (1470–1559).[38] Here a more selective listing of the Yan Song paintings is made, perhaps more in keeping with the canons of artistic quality which Wen Jia represented, and

the King of Lean's scroll of flowers is not included. Does this tell us that he was not a very good painter? That Wen Jia excluded evidence of kingly flattery of a fallen magnate? That he left out most of the contemporary pictures presented to Yan Song? At the very least it shows us in action the sort of filtering mechanism by which the products of kingly brushes, known about from textual sources, have failed to pass down to us in material form.

The final two pictures recorded in Ferguson's search of later catalogues are by figures much lower down the imperial hierarchy than a King of Lean. A picture entitled *Sitting Alone by a Secluded Torrent* by Zhu Duozheng (1541–1589) is recorded in a Republican period catalogue.[39] This man, with the rank Supporter-general of the State, was a great-grandson of King Xishun of Yiyang and had a substantial reputation in his lifetime as a calligrapher and painter; there are even surviving works by him (though not this one), as we shall see below. He was also probably the grandfather of the famous seventeenth-century painter known as Bada Shanren (1626–1705).[40] Note that he is not mentioned in either 'Offerings from the Appanages' *or* 'Records of Ming Painters'. Nor is Zhu Gongzhen, whose *Rainbow Moon Tower* appears in a nineteenth-century catalogue.[41] Identifiable as a member of the imperial clan on the basis of the first character of his personal name (shared with

better-recorded figures), no coherent account of this figure can be found to date in standard reference books. We are therefore left with the fact that, in the whole vast written record of Ming and Qing period painting catalogues, between them listing many thousands of works, only five pieces can be associated with members of the imperial clan, and that for most of those listed as painters in Ming or immediately post-Ming texts not a single work was even noted, let alone preserved. We are dealing here with a largely vanished history, and with a material record which may seriously skew our picture of who painted and what they painted in the China of the Ming.

This historical oblivion gets only more intense if one considers the scraps of evidence that exist for the production of painting by a doubly marginalized group, the women of kingly households. Here we are dealing with fragments of information, but what again may be significant is the fact that the compiler of the most comprehensive body of material recording the work of women painters through history thought it necessary or worthwhile to have some representation, however exiguous, of women from the palaces of Ming appanages. The early nineteenth-century collection of biographies of women painters entitled 'The Jade Terrace History of Painting' (*Yu tai hua shi*) by Tang Shuyu includes three such notices in its first chapter, which again groups women of the imperial family through history together.[42] From the early eighteenth-century standard dynastic history it takes an anecdote about Madame Guo, consort of the first and last King of Ying, Zhu Dong (he of the spectacular tomb seen in illus. 24). She was the daughter of Guo Ying (1335–1403), one of the paladins and companions of the Ming founder.[43] On the death of her lord, and having borne no sons, she virtuously hanged herself, but only after painting a self-portrait to leave for her attendants. There is no independent corroboration of this sad tale, which echoes accounts of female self-portraiture found in pieces of fiction and drama. Slightly more grounded is the other account in the 'Jade Terrace History', of Madame Han, consort of none other than the multitalented Zhu Youdun, King Xian of Zhou. The citation here is from the king's collected works, where he tells of how this lady rewarded the doctor who had cured her of a dangerous fever with a gift of a painting of plum blossoms, a painting to which the king himself had added a poetic colophon at the doctor's request. And finally, in the briefest of notes, the text quotes an account of the nineteen-year-old Guo Liangpu, an attendant in the palace of the pathetic King of Yongming, Zhu Youlang, a grandson of the Wanli emperor and one of the players in the tragic events of the 'Southern Ming' attempt to sustain resistance to the Manchus after 1644. Amid this picture of collapse and flight, Miss Guo 'elegantly

50 Zhu Zhigui (*d.* 1511), 'Flowers of the Season and Butterflies', from *Album of Collected Famous Ancient Paintings*, album leaf, ink and colours on silk, 28.8 × 25.6 cm.

excelled at the three perfections' (poetry, calligraphy and painting), as well as being a capable boxer, fencer and horsewoman. Needless to say, the work of these royal women is even more irrevocably lost than that of the royal males they partnered, and barring some startling archaeological find we are never likely to see the painting of Ming kingly women.

The situation is however little better for their male counterparts. The most comprehensive (if still selective) survey of the paintings surviving in China's museums, *Zhongguo*

gudai shuhua tumu, 'Illustrated Catalogue of Selected Works of Ancient Chinese Painting and Calligraphy', lists no work at all by any holder of a Ming kingly title as being present in their collections. The National Palace Museum in Taipei holds as part of an album entitled 'Collected Famous Paintings of Antiquity' (*Ji gu ming hui*) a single album leaf of flowers and butterflies by Zhu Zhigui, King of Sancheng (*d.* 1511), one of the commandery kings most insistently recorded as having artistic talents in the written sources (illus. 50). But a careful listing by Liu Jiuan of all the *dated*

51 Zhu Youdun (1379–1439), *Zhuge Liang*, dated 1416, hanging scroll, ink and colour on paper.

paintings surviving today from the Ming period (and one which takes sporadic account of collections held outside China) manages to gather together only the paltry total of three extant works bearing secure dates by members of the imperial clan, showing us again the extreme mismatch between the biographical accounts and the material facts which is characteristic of this topic. Two of these works are by lower-ranking members of the clan and date from the late Ming. One is a landscape fan in the Wuxi City Museum by Zhu Duozheng. Note that this piece, dedicated to an unidentified 'Wenqiao', is *not* the same work as that mentioned above by him, a scroll recorded in a Republican period catalogue, giving us the paradox of recorded works which are not extant and extant works which are not recorded.[44]

But in addition to these, we do almost miraculously find in Liu Jiuan's listings one piece of dated work surviving from the brush of an important member of a Ming kingly line. This is the portrait of *Zhuge Liang*, dated to the ninth month of the fourteenth year of the Yongle reign, equivalent to 1416, painted by Zhu Youdun, King Xian of Zhou, and now in the collection of the Capital Museum, Beijing (illus. 51).[45] Again, this is a work which has passed through six centuries without leaving a trace of itself in the copious literature on Chinese painting, and it is somewhat puzzlingly left out of *Zhongguo gudai shuhua tumu*. In

the absence of any meaningful comparators it is hard to say that it is definitely not a genuine work. The subject-matter is far from implausible, when taken in context. It depicts Zhuge Liang (181–234), arch-strategist and counsellor of the righteous ruler of Shu, one of the Three Kingdoms striving for hegemony in the chaos after the fall of the Han dynasty. He was, significantly, a native of Henan province, site of the Zhou appanage. By the Ming period he had acquired a towering reputation both as a man of integrity and as a quasi-magus of near-supernatural insight and cunning, using his stupendous talents loyally in the service of his lord. By the early fifteenth century his fame was enshrined in works for the stage and in the new format of the prose novel: he is one of the central characters of the 'Romance of the Three Kingdoms' (*San guo zhi yan yi*), traditionally attributed to Luo Guanzhong (*c.* 1315–*c.* 1400), and remains a prominent historical figure in Chinese popular culture today.

The hanging scroll, incorporating a lengthy inscription in a spiky cursive script, depicts the sage seated at a table with a book in his hand, though no characters are visible. He wears a distinctive form of headgear associated with him and by which he can be immediately recognized. Beside him on the marble-topped table a vase of crackle-glazed porcelain contains a branch of coral and an ornament known as a *ruyi*, the name meaning

'according to your wishes'. There is a small burner and box for incense. It is an image of the scholar in contemplation, but with this particular scholar associations of learning placed at the service of the ruler are uppermost, and it is hard not to see this as in some sense a self-portrait, simultaneously asserting Zhu Youdun's great talents and affirming that those talents are fully at the service of his uncle, the Yongle emperor, who had come to power after a protracted civil war. The Zhou line of the Ming imperial house had been prominent beneficiaries of Zhu Di's victory in that war; imprisoned and banished to Yunnan by the Jianwen emperor, Zhu Youdun and his father Zhu Su, first king of Zhou, had been restored to favour and honour on the fall of Nanjing to the forces of the King of Yan in 1402. However, imperial suspicion of them persisted and at the time the picture was painted in 1416 relations between the emperor and Zhu Su, his last surviving full brother, were potentially tense, making identification with a paragon of loyalty from the past all the more pertinent.[46] The picture is unique; as already said it is the sole surviving work from a Ming king and so it would be very rash to make it part of any pattern or larger narrative, while at the same time it serves to remind us of the very partial nature of the material on which we have grounded the narratives of Ming art which have served us up to now. It *is* a figure painting, and we have the testimony of the Ming

continuation of 'The Precious Mirror of Painting', from only (only!) a century later, that 'In the imperial clan were those skilled at painting images of divinities'. It is certainly a very different kind of figure painting from that associated with the professional court painters of the imperial workshops, whether the anonymous works of imperial portraiture or the meticulously detailed renderings of deities and warriors from someone like Shang Xi (active in the succeeding Xuande reign, 1426–35).[47] In some ways the work looks forward (and here I am bracketing out the question of its authenticity) to the professional and court painters of later in the fifteenth century, to the work of artists such as Wu Wei and Zhang Lu.[48] But in the end we must admit our limited ability to structure any sort of narrative around such fragmentary evidence.

The textual, as opposed to material, evidence for Zhu Youdun as a painter, and for the role of painting in his household, is nevertheless relatively more abundant than that for any other Ming king.[49] His modern biographer claims, somewhat conventionally, that painting was done purely as an act of personal expression and for pleasure, although the terms most usually associated with the king's output as a painter are *gong*, 'skilful', and *jing*, 'refined', both of them associated (at least in later critical discourse) with the meticulous and careful depiction of the observed world rather than with the self-expression of the literatus. This

may serve to remind us of the possible degree to which such a dichotomy is an artefact of later critical writing at the beginning of the twentieth century. The king's own collected poems, under the title *Chengzhai yue fu*, 'Lyrics of Chengzhai' (a style-name), touch on painting at only a few points. In one recorded preface he talks about doing a 'Farewell Picture' (*Songbie tu*) for 'the Moral Mentor Master Yu' on his retirement from office, and the preface goes on to state: 'my sons and younger brothers the commandery kings, and all the famous gentlemen of the appanage, the officers of the palace, all wrote poems to present to him on setting out.' This was the kind of socially engaged and occasional painting which was central to the practice of any elite Ming painter. Another surviving preface to the poem inscribed on a (lost) painting is dated 1432 and records the flowering of the peonies outside the hall of his principal consort; he ordered his favourite, the musician and dancer Hong'er, to pick a branch for him to enjoy at dinner and to use as the inspiration for a painting and poem associating the flower's beauty and moral worth with that of his wife.[50] Evidence that he painted the subject-matter of both peonies (*shaoyao*) and tree peonies (*mudan*) exists in the form of recorded poems inscribed on such paintings by Li Changqi (1376–1452).[51] Five extant verses of this highly regarded poet touch on the painting activities of the King of Zhou: two relate to paintings of peonies, one to a scroll of orchids,

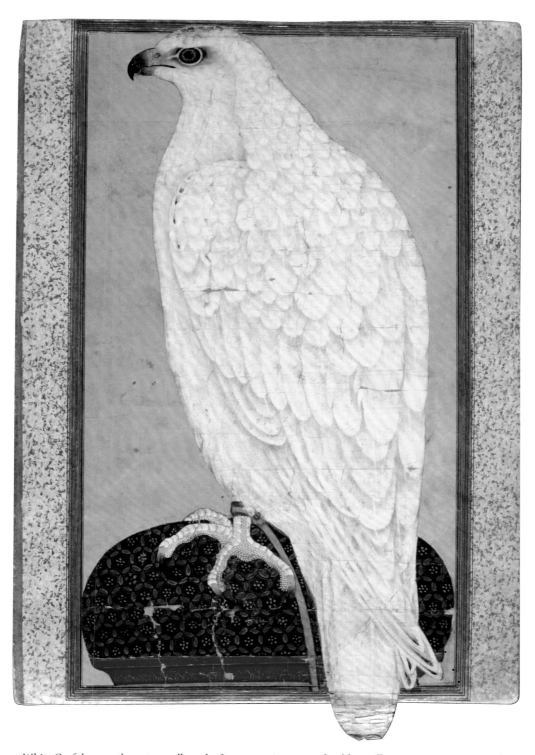

52 *White Gyrfalcon*, 15th century, album leaf, opaque pigment and gold on silk, 44.8 × 26 cm, artist unknown.

one to a scene of palace beauties playing football and one to an image of the hunting eagle Baihaiqing (literally, 'Black on the White Sea') (see illus. 52 for a similar example). Along with the surviving Zhuge Liang painting, they suggest a range of subjects as well as the practice of the presentation of paintings to favoured associates. The supposedly most highly esteemed theme of landscape is missing from the list, although one of his poems does describe a boating excursion into the countryside, and its (perhaps rather conventional) invocation of birds at evening nesting on sandbars, fishing boats mooring and the glassy surface of the lake with distant mountains ends with the line, 'All this ought to be set down in a painting!', even if we have no firmer evidence that he himself ever did so.[52]

There is also a small quantity of evidence for the king's own engagement with the painting of others. At least two in his dramas contain passages which display knowledge of the history and styles of painting, and drop the names of a number of painters. Although one author sees this as a sign of a deep knowledge of the history of Chinese painting, it is equally possible to argue that an ability to invoke such very well-known artists as Ma Yuan (active *c.* 1190–*c.* 1225), Guan Tong (active 907–923), Li Zhaodao (active *c.* 670–730), Mi Fu (1051–1107), Zhang Sengyu (active 500–550) and Wu Daozi (active *c.* 710–760) as the great names of the past is not much more than

basic information which any educated person of the period might know.[53] What is perhaps significant in such a list is that it combines figures from what would later come to be seen as very different lineages of artistic achievement, Southern Song academicians and figures later seen as heroes of 'literati painting'. There is certainly no hint in any of the fragmentary sources of an identification of the king's own style in terms of the masters he followed, something which is different from the normal way of classifying and labelling painters in many Ming texts. This may in fact reflect the fluidity and instability of the history of painting as it existed before the codifications which came to be normative later in the dynasty and which 'tidied up' history into a number of bounded and possibly mutually exclusive traditions. It is quite possible that in the 1420s things did not seem quite so neat.

Whatever part painting played in the life of King Xian of Zhou, it is safe to say that the single surviving work represents only a tiny part of his output, and that even then it is considerably more than the surviving work of many other kings or imperial clan members with reputations as painters. Why should this almost total extinction of their work have taken place? If they were so active, why does so little survive? One explanation which has some real merit lies in the devastation of so many kingly palaces at the fall of the Ming. Peasant rebels besieged Kaifeng, seat of the Kings of

Zhou, who broke the dykes of the Yellow River and subjected the city to a horrendous and devastating flood in 1642. The early eighteenth-century 'Ming History' laments that 'the famous vessels and precious collections of the palace were all submerged in the great deluge.'[54] There can be no doubt that enormous losses were suffered. However, as we have seen, there is equally good evidence that paintings were used by the king as objects of gift-exchange in the creating of affective ties; Li Changqi writes in one poem about looking at a picture of peonies given to him by the now-deceased king and remembering the time they spent together. We have also seen that he painted at least one farewell painting, which went with its recipient. And the Zhuge Liang image is unlikely to have been in the Kaifeng palace when it was submerged to the roof-beams. Taken together, these snippets of evidence leave us with the puzzle as to why so little attributed work is still extant, a puzzle that is more likely to be resolved by considering the subsequent esteem in which kingly work was held (or *not* held) than in the simple facts of destruction.

As noted above, *any* works by artists descended from the kingly houses are extremely rare. But one surviving work involving less exalted figures than the King of Zhou, and from nearer the end than the beginning of the dynasty, at least shows us in visual form the integration of the kingly class with other forms

of elite, around the art of painting. This is a long hand scroll of orchids, in the imperial collections by the eighteenth century and now in the National Palace Museum, Taipei. Modern cataloguing practices describe this picture as being 'by' Zhou Tianqiu (1514–1595) but in truth he is more like the impresario, or conductor of a group of performers, providing the setting in which they can work their variations on a theme, which in this case is that of orchids.[55] The scroll, which is on paper, is dated 1580. It shows eleven clumps of flowers painted by Zhou himself, set on a surface thickly clustered with over 70 poetic and other inscriptions.[56] Three of these inscriptions are by members of the imperial clan, though in this case they are identifiable only by their distinctive personal names, there is no visible claiming of an exalted status (illus. 53). The most renowned of them (judging by the fact that he has left enough biographical trace for his precise dates to be identifiable) is Zhu Duogui (1530–1607), Supporter-general of the State. He was a descendant in the sixth generation of Zhu Quan, son of the Ming founder and first King of Ning.[57] He is joined on the paper surface by the much more shadowy figures of Zhu Duoli and Zhu Duocheng, about whom we know almost nothing, though given the placing of their inscriptions they are likely to have been junior to him as members of the same generation.[58] What may be significant here is the ease with which minor members of

53 Zhu Duogui (1530–1607), inscription on a section of hand scroll by Zhou Tianqiu (1514–1595), *Orchids*, dated 1580, ink on paper, 33.1 × 431.9 cm.

the imperial clan are able to blend into a gathering of the elite of Nanjing, the empire's southern capital, as part of a social set which includes rising stars of the degree-holding elite like Li Weizhen (1547–1626), elite amateur painters like Sun Kehong (1532–1610) and connoisseurs like Zhan Jingfeng (*juren* 1567), and one of the most celebrated of all the city's many courtesans, the famous Ma Shouzhen (1548–1604).[59] The painting's many inscriptions are like a social map of a great Ming city, and the precise nuances of relationships and hierarchies it reveals are too subtle to be graspable at this distance. But its value to the present argument is that it shows, if in a different way from the

work of the King of Zhou, the members of the imperial clan not as a wholly separate narrative which is disengaged from other forms of elite sociability in the Ming, but rather as intimately bound up with that sociability. Painting was just one of the fields on which that binding and interlinking could take place.

However, painting is perhaps a much wider field than that implied by highlighting something like Zhou Tianqiu's scroll of orchids, and the role of the imperial aristocracy as patrons of painting also has to be taken into consideration. The great palaces that kings inhabited must have required considerable amounts of large-scale decorative painting,

some of which may even survive if now disguised under implausibly optimistic attributions, usually to famous early artists. Richard Barnhart has drawn attention to three paintings bearing the ownership seals of the Kings of Jin, and later catalogued as anonymous Song works, which on stylistic grounds he identifies as 'late fourteenth-century works, contemporary with Chu Kang, and . . . perhaps painted for his palace as decorative pictures by artists employed by him or by his court'.[60] With titles like *Pure Leisure in the Shade of a Wutong Tree*, *Editing Texts* and *Peace and Harmony* (a rebus on the subject of *Quails and Millet*, which have the same pronunciation), these are appropriate works for palatial decoration (illus. 54).[61] Similarly, the large hanging scroll with King of Lu seals (illus. 46) may just be a very late example of a style of Ming court decorative painting with auspicious subject-matters, practised in the metropolis in the fifteenth century but just conceivably surviving for a lot longer in provincial courts. They raise the question of whether kings in these provincial centres relied on artists from the imperial centre, or whether, as seems more likely, a major city like Taiyuan was itself able to supply the court that was situated there with the level of skill appropriate to projects which the kings and their families might choose to patronize.

Such painting might not be purely 'decorative'. A surviving large hand scroll portrays

54 *Quails and Millet*, here dated late 14th–early 15th century, hanging scroll, ink and colour on silk, 105.4 × 51.6 cm, artist unknown.

a marvellous beast of good omen, presented in 1404 to the Yongle emperor by his brother, King Su of Zhou, and commemorated in a festive drama by Zhu Youdun, eldest son of the same king and artist of the Zhuge Liang picture discussed above. It is shown in the form of a white tiger-like animal, a mild and benevolent creature despite its ferocious grimace.[62] It would be normal to assign this picture to a 'court painter' but it may just be worth considering *which* court, and whether at the very least the King of Zhou might not have had a hand in the commissioning of the work which commemorates his splendid gift. Similarly, an often-published pair of huge and detailed pictures of imperial processions are certainly survivors of what was once a much larger body of work showing ceremonial occasions and journeyings.[63] Might not kings too have had their grandeur pictured in this way, by artists under their direct patronage?

This issue of kingly patronage is also germane to projects of religious painting and the decoration of temples. Once again it is Taiyuan, and the activities of the Kings of Jin, which provide some of our most suggestive evidence. The first King of Jin, Zhu Gang, was as we have seen above a considerable patron of temples in the immediate vicinity of the city. The Duofusi, 'Temple of Multiple Blessings', is one of these, built (or rebuilt, the site having been a temple in the Tang dynasty) by his initiative in the late fourteenth century. By the

middle of the succeeding century it stood in need of substantial repair, and an inscription on a roof beam dated to the seventh year of the Jingtai reign (1456) ascribes the patronage of this reconstruction to an unnamed 'lady of the Jin palace', giving us valuable further evidence of female agency in the support of religious institutions.[64] A further inscription dated to 1458 (and only uncovered in 1988 in the course of a restoration campaign) gives an indecipherable name of the head priest, who was responsible for commissioning the over 90 square metres of wall painting showing 84 scenes from the life of the historical Buddha Sakyamuni which cover the walls of the main hall (illus. 55).[65] It seems perfectly possible that, in a temple so intimately associated with the kingly family, the lady responsible for the building also enjoyed some degree of agency with regard to the decoration of the walls, agency which might have related to the choice of artists, of subjects, or both.

This hypothesis is strengthened if we consider the case of the major urban temple, the Chongshansi, which as we have seen in chapter Two was very much the 'family temple' of the Jin kingly line. Devastated by fire in the nineteenth century, its surviving portion does not now house any wall paintings of Ming date. However, among its treasures are a much rarer survival, an album of miniature paintings, leaves measuring 37 by 58 cm, which are believed to be cartoons for (or after)

55 Scenes from the life of the Buddha, *c.* 1458, wall painting from Duofusi ('Temple of Multiple Blessings'), Taiyuan, Shanxi province.

the long-lost wall paintings executed in its main hall in a major campaign of restoration undertaken in 1483 (illus. 56). There are two sequences of pictures: 84 sheets in the first sequence of scenes from the life of Sakyamuni, from his miraculous birth to his achievement of nirvana, and 53 scenes in the sequence of the '53 Stages of Sudhana', Sudhana being a disciple of the bodhisattva Guanyin, principle deity of the temple.[66] Prefaces by Zhu Zhongxuan, King of Jin, attest to the close interest of the kingly family. As Marsha Weidner has pointed out, 'in this pictorial narrative, Shakyamuni's childhood and

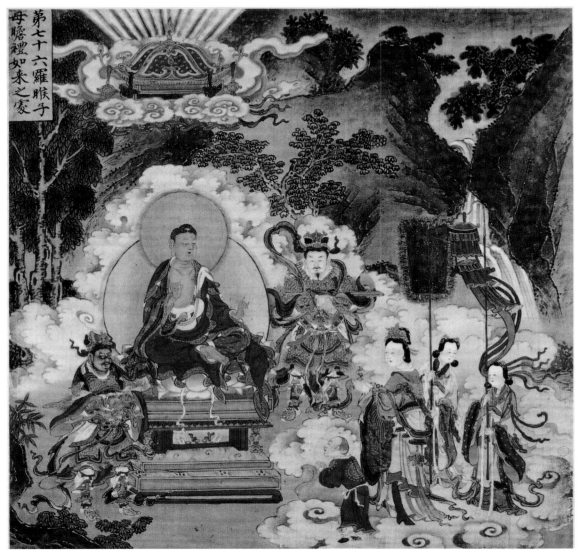

56 Two scenes from the life of Sudhana, *c.* 1483, album leaf, ink on paper, 37 × 58 cm, cartoons of the wall paintings of the Chongshansi ('Temple of the Veneration of Goodness'), Taiyuan, Shanxi province.

boyhood home were those of a Ming prince', and in fact what we see are scenes of courtly life wrapped in the supernatural aura of numinous clouds. As the young prince rides out on horseback with his armed attendants we seem to catch a glimpse of the progress of real princes through the streets of Taiyuan (illus. 57). The purpose of this album, which is both highly finished and unique among surviving Ming paintings, is unclear; some scholars suggest it was made in order to enable subsequent upkeep of and restoration work on

57 Scenes from the life of the Buddha, *c.* 1483, album leaf, ink on paper, 37 × 58 cm, cartoons of the wall paintings of the Chongshansi ('Temple of the Veneration of Goodness'), Taiyuan, Shanxi province.

the murals.[67] However, it seems just as likely that this is some sort of equivalent of the 'presentation sketch' designed to give the kingly patron a sight of the mural programme and a chance to approve it prior to the work being carried out. It does not seem coincidental that the subject-matter of both this and the surviving Duofusi murals should concentrate on reminding us that the historical Buddha was himself of kingly status, or should elide time and space to make the world-saviour himself look like a contemporary scion of the kingly household, who were the temple's chief worshippers and patrons.

At another, but much more complicated, site of religious power just outside Taiyuan, the Kings of Jin may have exercised a much more attenuated form of agency, which still

had an impact on the production of paintings. Although they are now greatly faded and hard to make out (due to their external positioning), the wall paintings under the eaves of the 'Hall of the Holy Mother' at Jinci, the 'Shrine of Jin', must once have been a dominating visual element to those approaching the venerable and ancient building (illus. 14, 58). This campaign of decoration of a structure already well over 400 years old was carried out in 1515, the chief patron being the local notable and controller of the all-important water rights Zhang Hongxiu, 'Canal-Boss Zhang'. This was the same person who at around the same time 'offered' a share of the water rights to the lands of the Kings of Jin.[68] As we have seen (chapter Two), the Kings of Jin and their collateral branches had a strong tradition of patronage

58 Murals, dated 1515, from the eaves of the Shengmudian ('Hall of the Holy Mother'), Jinci, Taiyuan, Shanxi province.

of the site. They also had experience of the commissioning of artists to produce other programmes of mural decoration. Does the procession of lavishly accoutred goddesses and attendants in the Jinci murals (illus. 59) allude at some level to the sort of progress made by women of the household to this site, just as the life of Shakyamuni murals reflect kingly visibility in the environs of Taiyuan? On a wider scale, we might consider how much kingly patronage of this sort of temple decoration, not just in Shanxi but right across the empire, is lost, and how correspondingly the role of that patronage has, like so much of what they created or owned, slipped from our view.

One possible way of guarding against the loss of important images is their reproduction, and just as with calligraphy it seems that kingly households were involved in this activity. Yet

59 Detail of procession of goddesses, from murals dated 1515 from the eaves of the Shengmudian ('Hall of the Holy Mother'), Jinci, Taiyuan, Shanxi province.

again there is an intriguing analogy between biological reproduction and cultural reproduction, with kingly lineages attending to both. The carving of images in stone was a technology used in the Ming for the preservation and dissemination of pictures as well as of specimens of calligraphy, and indeed such carving can be seen as being principally employed for pictures which were seen as of great importance. We have already encountered one project which combined image and calligraphy, namely Zhu Youdun, King of Zhou's 1417 version of the 'Preface to the Orchid Pavilion' with a reproduction of the painting of this iconic scene putatively by Li Gonglin (illus. 32). This was recut in 1592 by the King of Yi.[69] Two stele now in Xi'an bear auspicious images and poems attributed to Zhu Chenglin, King of Yongshou. One, dated 1488, is a *Nine Nines Chart for Dispersing the Cold*, a form of talismanic image associated with the new year and the cycle of seasons (illus. 60).[70] The other, dated 1494, is a *Picture and Poem on an Auspicious Lotus* and shows the sort of natural marvel, in this case two lotus flowers growing from a single stalk, which was seized on in the Ming period as a visual sign of Heaven's favour towards the rule of the dynasty. That a member of the imperial clan in the provinces should draw the imperial court's attention to such a good omen in pictorial form was only to be expected, and that such a picture should be

60 Zhu Chenglin (active late 15th century), *Nine Nines Chart for Dispersing the Cold*, dated 1488, rubbing.

preserved in stone for the edification of future generations was equally natural.

Perhaps the most significant, or at least most widely disseminated, of kingly projects to put pictures into a wider circulation was the series *Pictures of the Traces of the Sage*, scenes from the life of Confucius, which occupied the attention of two separate lineages of the imperial clan in the course of the sixteenth century.[71] Although there had been at least two versions of scenes from his life produced by members of the scholar-official elite over the course of the fifteenth century, the earliest surviving recension of these scenes dates from 1506 and is associated with Zhu Jianjun (1456–1527), King of Ji, whose court was at Changsha in Huguang province (modern Hunan). As with a number of other projects, we can see here a form of interaction between official and aristocratic elites which has escaped our standard accounts of the period. The version of Confucius's illustrated biography reproduced by the King of Ji reused images from a (now lost) set published by a group of Hunan officials in 1497. The site of its publication under kingly auspices was the Yuelu Academy, used by the king as the name of his imprint for a number of other Confucian classic texts.[72] This renowned Changsha academy was the site where the great philosopher Zhu Xi (1130–1200) had taught in the Song dynasty. It is significant that this hallowed site, an enormous source of local pride and local elite

identity, should at this point in the Ming have been dominated symbolically by the kingly house, and it suggests one way in which the kingly house could function as a focus of local identity, by reproducing the *past* cultural glories of the region in a way which was acceptable to an imperial centre suspicious of signs of particularism of a more dangerous kind.

The second oldest set of images of the life of Confucius to survive from the Ming period is also a kingly production, published in 1548 at Luzhou (modern Changzhi) in central Shanxi province under Zhu Yinyi, King Xian of Shen, described in his biography in 'Offerings from the Appanages' as 'suave and polished, fond of literature and of scholars'.[73] Julia Murray has demonstrated how this version (illus. 61), which she describes as more finely drawn than the Changsha set, does not depend directly on it but on a lost version that draws directly on the equally lost 1497 version.[74] The two kingly sets thus do ultimately share a common point of origin, though produced independently of each other. Murray's careful scholarship has untangled the complexity of the several versions of an illustrated life of Confucius which circulated in the mid-Ming period, and she rightly draws attention to the fact that projects of this type clearly had their origins in the scholarly elite. However, it might be posited tentatively that she underestimates the significance of the fact that the two earliest *surviving* versions of

these scenes *both* have their place of origins in kingly households, and her statement that 'The theme was taken up in succession by Ming princes . . . to enhance their cultural prestige' could be read as claiming that they lacked cultural prestige to begin with. In fact, and if we lay aside the implicit prejudice against kings which pervades our later sources and forms many assumptions about the period, the reverse might be said to be true, with the cultural prestige of kingly households being the necessary mechanism whereby projects of shared concern (like the *local* commemoration of the sage Confucius) achieved visibility and permanence. This could be through the replication of pictures as well as through

the republication of texts, to be discussed in a subsequent chapter.

As a coda to a major project of pictorial replication like the 'Pictures of the Traces of the Sage', another act of aristocratic replication of images can be mentioned. A case in which aristocrats can be shown to have acted as 'early adopters' of significant cultural developments is in relation to the publication of manuals of painting techniques, which would proliferate from the seventeenth century onwards but which were new in the late Ming. One of the very first of these to survive (though it survives in a single complete copy) is the *Hua fa da cheng*, 'Great Synthesis of the Models of Painting', which has a preface

61 Scene from the life of Confucius, from *Shengji tu* ('Pictures of the Traces of the Sage'), edition of Zhu Yinyi, dated 1548.

dated to 1615 and which is attributed to Zhu Shouyong, Commandery King of Taixing, and to his relative Zhu Yiya.[75] Zhu Shouyong belonged to one of the cadet branches of the Kings of Lu, in Shandong province, the very first of whom was the same Zhu Tan with whom this chapter opened and who was buried with his collection of paintings nearly two and half centuries before the publication of the 'Great Synthesis'. The text itself is in eight chapters, which variously anthologize a number of pre-Ming theoretical texts on painting, collect together artists' biographies (incidentally providing accounts of a number of imperial clan painters who are not mentioned in any of the other sources cited above) and cover such separate themes as the painting of birds, figure subjects, landscapes and the composition of poetic colophons for painting. They include woodblock illustrations of examples, some of those of birds supposedly being the compositions of the King of Taixing himself and bearing his signatures and seals. A final chapter returns to the theme of landscape and is illustrated with woodblock versions of paintings (illus. 62) by two imperial clan painters, Zhu Guan'ou (*fl.* 1522–1566) and Zhu Yipai (*d.* 1642), son of the work's compiler Zhu Shouyong.[76] The two prefaces to the work are provided by men who were not members of the imperial clan, the first of them being a ranking member of the bureaucratic elite, the prefect Zhang Quan, holding office in Junzhou

in Shandong, where the Lu kingdom had its centre. The second is by the otherwise unknown Wang Shengjiao. Both are liberally scattered with the honorific raising of characters which visually mark the status of the imperial clan in all its branches; the third line of the first preface raises the character 'Lu' (in the phrase 'appanage of Lu') in a way that makes it stand out boldly against a horizontal line of blank white space. The ritual primacy of the imperial clan, and their role in setting patterns and models, suffuses the texts of these prefaces, in statements like 'The flourishing of imperial appanages reaches its apogee in the world under the present Ming dynasty' but also through the repetition of the word *fa*. This *fa* (pattern, model) appears in *fa tie*, the 'model calligraphy' which is canonized in the collections of the King of Zhou and the King of Jin, discussed in the previous chapter. It appears in the title of the work itself: *Hua fa da cheng*, 'Great Synthesis of the Models of Painting'. And it appears in the claims (from Wang Shengjiao's second preface) that

His Present Majesty governs the world through humaneness and filial piety, and the several appanages receive this model (*feng fa*) with diligence, themselves wishing through literature and art to provide a model for the world . . . (*yi wen yi fa tian xia*).

62 Zhu Guan'ou (*fl.* 1522–1566), 'Landscape', woodblock print from Zhu Shouyong and Zhu Yiya, *Hua fa da cheng*.

Here is an explicit statement of the appanages' role as relay stations for the governing grandeur of the imperial centre, and their role in deploying 'culture' (as an alternative translation of *wen*) to set models for the world. In using the established but newly vibrant technology of woodblock book illustration to provide one of the first sets of 'patterns and models' for the production of pictures, a kingly figure like Zhu Shouyong is drawing on the precedents which had long existed in the field of calligraphy. The appropriateness of a king seeking to do so is fully consolidated by the way they were themselves patterned after the imperial centre, as replicas of the imperial bloodline, receiving and passing on its power in text and in image.

63 Golden bowl, from the tomb of King Zhuang of Liang (*d.* 1441), *dia.* 15.6 cm.

64 Hairpin, from the tomb of King Zhuang of Liang (*d.* 1441), gold inlaid with gems, *l.* 44.3 cm.

FIVE

THE JEWELS OF THE
KING OF LIANG

Every morning, when the magnificent new Hubei Provincial Museum opens in the city of Wuhan, the visitors who make their way among its archaeological treasures crowd in particular numbers to a gallery on the top floor. This dimly lit space, itself reminiscent of the darkened interior of the tomb, houses the spectacular finds from the grave which bears the name of one of the most short-lived of Ming dynasty appanages, that of King Zhuang of Liang. First and last holder of the title King of Liang, Zhu Zhanji (1411–1441) was the ninth son of Zhu Gaozhi (1378–1425), whose premature death makes him the shortest-reigning of all Ming emperors; his fleeting reign period of Hongxi lasted from 20 January 1425 to 7 February 1426.[1] The King of Liang enjoys no renown as a significant figure in Chinese history, and few would have been aware of his name before the excavation by archaeologists of his tomb, situated in a rural area 25 km southeast of the city of Zhongxiang, in the rich agricultural land of central Hubei province (illus. 25).[2] In recent years this now

famous tomb, described on its excavation as the most important find of Ming dynasty date since the excavation in 1956–8 of Ding Ling, mausoleum of the Wanli emperor (r. 1573–1620), has become a reference point for the study of many types of Ming material culture.[3] What brings the crowds is the astounding array of tomb contents: in addition to objects in ceramic, jade and non-precious metals such as bronze and iron, the tomb contained unprecedented quantities of gold and silver in the form both of metal vessels and of jewellery (illus. 63, 64), much of the latter also mounted with gems of stunning size and quality. Most of these were objects used in life – they were not made especially for interment and hence they give us a glimpse of the lavishness of life in the vanished palaces of the Ming appanages. They have made the hapless King Zhuang of Liang an immediately recognizable name not just to specialists but to many more people in China, who have read of or seen these truly impressive finds. Yet the attention paid to the tomb of 'King Zhuang of Liang' (in Chinese

Liang Zhuang wang mu, the title of the monograph on the site) conceals an important fact. Many of the finds, and many of the most spectacular finds, clearly relate to the kingly consort who is also buried there, the Lady Wei, who outlived her husband to die ten years after him in 1451. If Ming kings have been, as argued above, almost invisible to the historical gaze over the last century, then even more occluded from that gaze are the women who were their marriage partners and whose central role in reproduction of the biological sort, bearers of imperial lineage children, parallels the concern with kings as bearers of cultural reproduction through the sorts of practices already discussed in previous chapters. However, the act of burial gives these women a degree of fleeting visibility and the survival of the material culture of death allows us to at least begin the task of seeing some of the ways in which they mattered at the time, and perhaps even some of the ways in which they exercised agency in a formally and actually patriarchal society.

There can be no doubt that royal tombs mattered in the Ming. Their prominence in the landscape, at least in provinces like Huguang, has already been mentioned. They were certainly the objects of considerable central regulation, as prescriptive written sources show.[4] However, and in contrast to the situation with regard to the vanished palaces, tombs actually survive in some numbers and it therefore becomes possible to set the ideal picture of the regulations alongside practice on and in the ground. A recent volume lists as extant some 56 tombs of kings of the blood (*qin wang*), plus ten tombs of kingly consorts and thirteen tombs of commandery kings.[5] The majority of these are simply tomb sites, their contents having been robbed in past centuries. A shorter list of 23 tombs, for which sufficient archaeological evidence persists to form an idea of their form and contents, would include tombs from the entire span of the Ming dynasty, beginning with the interment in 1389 of Zhu Tan, King of Lu and son of the dynastic founder, to the 1634 burial of Zhu Youmu, King Ding of Yi. It includes examples from a very broad swathe of the Ming territory where kingly appanages were to be found, from the modern provinces of Hubei and Shanxi (the two case studies to which this account returns) but also from Shandong, Henan, Liaoning, Jiangxi, Shaanxi and Sichuan.[6] What an analysis of this body of material immediately displays is that, far from being controlled by a single normative pattern, there is no standard practice in the construction of the kingly tomb; rather, a considerable degree of variety, and variety to which there is no discernible pattern, either on chronological or geographical grounds. While it is probably safe to say that all tombs involved a mound, visible in the landscape and surrounded by a protective enclosure approached via a statuary-lined path, and that they all

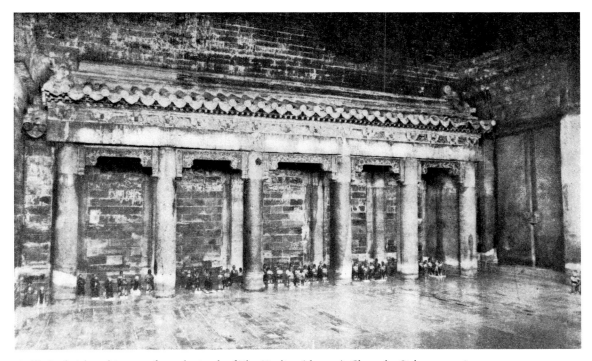

65 Fictive brick architecture from the tomb of Zhu Yuelian (*d.* 1410), Chengdu, Sichuan province.

involved above-ground structures decorated with elaborate tile-work roofs, most of which survive only as sherds (illus. 27), when it comes to what happens underground, in the tomb chambers themselves, there is a wide degree of variation. Any discernible pattern of chronological change is very hard to make out. In Sichuan province (and occasionally elsewhere) we see a fondness for elaborate fictive architecture, imitations of wooden bracketing in glazed, painted and lacquered stone, which is not present elsewhere (illus. 65).[7] Some tombs have a degree of internal decorative painting; others do not. Perhaps all that can in the end be said is that while our sample is too small to establish a pattern, it is large enough to establish that there is no pattern, and that

variety is more important here than the supposed conformity to regulations on which the published excavation reports so curiously and insistently harp. What might be stressed instead is that variety implies agency and choice; the kingly tomb was not built and outfitted to a set pattern, but rather reflects human decisions made in specific social and historical contexts. Quite who made those decisions, and how that agency was exercised, is a more difficult question.

The evidence that decisions *were* made, rather than simply reaching for a rulebook, is equally evident when it comes to an analysis of the contents of tombs. In 'Offerings from the Appanages', when the text seeks to make a particular point that King Ruisu of Dangyin

was not only 'a lover of culture and elegance' but a paragon of frugality, 'without the slightest habit of extravagance', it tells us that at his death he was buried plainly, 'without extra jade and silk'.[8] There may be a degree of protesting too much, the rare notice of such frugality being a sign that others did not make the same choices. But here again the picture is one of variety rather than standardization. Many tombs have as noted above been robbed at some time in the past, so in order to be more rigorous with regard to tomb contents it is safer to restrict the analysis to those ten tombs which have never suffered such depredations. This still gives us a wide chronological range, although the geographical range is more restricted, with one example from Shandong, three from Hubei and six from Jiangxi. Taking those ten tombs, we immediately see variations, since in only six of them were the female consorts buried in the tomb chamber along with their husbands (in the other four cases the women presumably had completely separate tombs elsewhere); this is a possibly important indicator to which we shall return. Tomb contents can vary considerably. One indicator of this can be seen in the presence or absence of tomb figures, those small sculptures of human and animal attendants which are the descendants of the Terracotta Warriors of China's First Emperor and which later took the form of the large glazed camels, horses and humans which are the pride of museum

and private collections today. The practice of placing such figures in tombs, images of the attendants who would serve in the afterlife, continued into the Ming period, and some kingly tombs contain significant retinues of them, though they never individually reach the scale of their earlier counterparts (illus. 66).[9] They may be of painted or glazed clay, or sometimes are undecorated. But significantly, not *all* kingly tombs contain attendant figures. In fact, of our control sample of ten unrobbed tombs, a full eight do not. And in the two which do, variation persists. The tomb of Zhu Tan, of 1389, contains over 400 figures of men and horses made of painted pine, making up a complete picture of the kingly honour guard and civil officials of his court. In the 1539 tomb of Zhu Youbin, King Duan of Yi (in Jiangxi province), the figures are of painted grey earthenware and number just 110, with 30 male and female musicians making up the largest single group within that figure.[10] A number of robbed tombs still retain their tomb figures, since until very recently they had no value in this world, only in the next, and if we take them into consideration this variation between wood and ceramic can also be seen, but again with no discernible chronological or geographical pattern; rather, contingency and local choice seems to have been at work. Similarly various are the placing and arrangement of figures within the tomb. For example, in the tomb of 1539 just mentioned, the figures

66 Ceramic tomb figures from the tomb of King Xi of Shu
(*d.* 1434), Chengdu, Sichuan province.

are arrayed in six rows in front of the coffin platform. In a tomb from 1495, the figures stand either side of their dead master.[11] That may seem like a pedantic distinction, as may be the difference between ceramic and wood as a material, but in a context and culture where positioning and materiality were both of great importance it would be unsafe to assume that such things are purely random.

The more precious contents of tombs, those more likely to attract the attention of tomb raiders both in the past and present, can vary considerably too. Of the ten untouched

tombs, only two contain precious metal vessels. One of these is the tomb of King Zhuang of Liang, dated 1441, which is in fact the earliest example to contain gold and silver plate; two earlier tombs have no such items.[12] Both of the tombs containing gold and silver vessels also contain the female consorts of kings, either singly or together with their husbands. Only seven of the ten contain any precious metal jewellery, and again they are tombs where female interments are prominent. It is hard not to escape the conclusion that personal choice, rather than regulation, governed to a large extent what went into a tomb. We have already seen how Zhu Tan, King of Lu, was buried in 1389 with paintings from his collection, but his is the *only* Ming kingly tomb from the entire dynasty to contain such items. This same king was, uniquely, buried with the other accoutrements of the four traditional pastimes of a gentleman, in addition to calligraphy and painting: the *guqin* zither, and a chess set. Two other tombs from the first half of the fifteenth century, and both from Sichuan, also contain writing implements, but in the form of items made especially for burial (often in pewter or wood or ceramic) rather than the actual functional brushes and inkstone possessed by Zhu Tan.[13] Zhu Tan's brother, Zhu Quan, famed in later years as a Daoist adept, took with him into the tomb a *guqin* zither but does not appear to have had any of the other four pastimes at his side in death.[14] A very few tombs

67 Lacquered iron helmet, from the tomb of King Zhuang of Liang (*d.* 1441), *h.* 18 cm.

contain weapons, a reminder of the original role of the appanages as 'a fence and a screen' protecting the imperial house. Zhu Yuelian, heir of the king of Shu in Sichuan, was buried in 1410 with an iron helmet and sword (a very 'Japanese' looking sword, though the illustrations of the excavation are poor), and perhaps more extraordinarily with an iron bow strung in bronze, a western Asian accessory of the mighty warrior which hints at an early Ming admiration for the peoples of the steppe.[15] The other tomb to contain weapons is that of King Zhuang of Liang, who had with him a lacquered iron helmet (illus. 67) painted with the single large character *yong*, meaning 'valiant', and a straight-bladed sword.[16] Why

weaponry mattered to these two individuals and not to others, just as why painting mattered enough to Zhu Tan, is not immediately evident, but what is clear is that it did matter and that the contents of the kingly tomb represent not a standard kit but rather choices, whoever those choices were ultimately made by.

This element of choice becomes even clearer if we consider what might loosely be described as the 'religious' elements in the contents of tombs. If the material culture of the tomb is an index of belief or at the least of understandings about what might be appropriate, than we have to accept that on the material evidence such beliefs and understandings were highly various. Again there is no standard

pattern, no 'off-the-shelf' package of elements. The tomb of King Zhuang of Liang, who died in 1441, contains images and objects with a distinct connection to the Tibetan schools of Buddhism which were so valued at the imperial court itself, most notably the golden figure (possibly a hat ornament) of the protective deity Mahakala (illus. 68), but also numerous plaques with Tibetan or Sanskrit texts, golden *vajra* thunderbolts, and rosaries with beads in the form of skulls.[17] The tomb of Zhu Quan, buried only eight years later, includes robes and headgear markedly similar, according to the excavators, to those worn by Daoist priests today, and has no explicit 'Buddhist' items.[18] Dating from 1495, the Shaanxi tomb of Zhu Gongzeng, King Duanyi of Qianyang, contains a land contract (*mai di juan*) in which the land for the tomb is ritually purchased from the local deities and in which there is mention of the emissaries of the Five Emperors.[19] These contracts are common in a whole range of Chinese tombs of the later imperial centuries, but they appear sporadically in kingly tombs. In fact the only other tomb in which such a land contract appears is that of Madame Liu, consort of King Duan of Jing in Hubei,

who was buried in 1559. However, in this case the tomb also includes explicitly Buddhist items, in the form of large golden coins made specifically for burial, inscribed with the name of Amitabha Buddha.[20] There are trigrams painted on the walls of the tomb of King Duan of Yi, buried in Jiangxi in 1539, and inscribed on burial coins in the tomb of his descendant, King Xuan, buried in 1603.[21] In the same 1603 tomb the king's consort, named Li Yinggu, had

68 Hat ornament in the form of the Buddhist deity Daheitian (Mahakala), from the tomb of King Zhuang of Liang (*d.* 1441), gold, *h.* 9.4 cm.

on her person a Daoist certificate of indulgence, purchasing her escape from the pains of punishment in the afterlife. The certificate itself is woodblock printed, with the name of the deceased filled in ink along with her date of birth, registration and the date of completion of the certificate, as well as an image of the Daoist deity *Taishang laojun*, 'The Supreme Lord Laozi'. Less than 30 years later, in the same province and from within the same kingly line, Madame Wang, consort of King Ding of Yi, was buried with coins inscribed with wishes for her ascent to the (Buddhist) 'Western Heaven'.[22] How are we to read this variety, or other examples of it like the unique instance of the placing of a gold and a silver bead in the mouth of the deceased, as seen in the 1502 tomb of a consort of a King of Ning?[23] Did the Lady Li Yinggu feel that her sins rested so particularly heavily on her that she needed the comfort of a purchased indulgence? Do the Tibetan images in the tomb of King Zhuang of Liang suggest that he was 'a Buddhist', while his older contemporary Zhu Quan was 'a Daoist'? Did those three kings whose unrobbed tombs contained no such explicitly 'Buddhist' or 'Daoist' items eschew them out of 'Confucian' rectitude? Does the specific materiality (imperviousness to decay and degradation) of the very gold itself which is present in kingly tombs have a religious connotation, related possibly to alchemical beliefs or hopes for immortality? Modern understandings of the religious ecology

of Ming China very much seek to transcend older, missionary-derived pictures of China as possessing 'three religions', bounded sets of beliefs and practices which were mutually exclusive, in favour of an understanding of ways of dealing with life crises (death being the most incisive of these) which drew in different contexts from different sources. What is interesting about the religious context of the kingly tomb in the Ming is that it demonstrates, at this most solemn point in the life cycle, that choices *were* made and that different individuals drew on different types of salvific possibility.

If we now look then in more detail at the total ensemble of contents of the tomb of King Zhuang of Liang, it is not because it is a 'typical' kingly tomb but because no such thing exists. But its contents can raise a number of important issues which might take us behind the facade of regulations and which might show us a more complex picture, one in which, most significantly, the women of the kingly household, whose presence has been muted in this account up to now, might make a more prominent appearance.[24] The tomb lies some 25 km southeast of the city of Zhongxiang, in Hubei province; a river running across the front of the slope into which the tomb is set provides both geomantic auspiciousness and the means by which the large array of objects could have been transported from the city (illus. 26). Of the complex of walls and structures which once existed above ground, there now remain only

fragments of brick and tile-work, the latter glazed and decorated with dragons (illus. 27). A vaulted brick antechamber and flat-ceilinged tomb chamber lay at the end of a short, sloping entrance passage. In 2001, when archaeologists entered the tomb chamber, it contained 1.5 metres of standing water, and the position of objects had clearly shifted dramatically since their deposition, making it hard to say anything about their original layout. The flooding of the tomb had also led to the almost total loss of organic materials, not only the bodies of those interred but the lacquered wood coffins which had contained their bodies, the textiles and clothing in which they had been wrapped. In compensation (and ensuring its subsequent attraction to a wide audience), the tomb contained an unprecedented quantity of precious metals. The published tomb report lists 120 golden vessels and implements, 360 silver items, 3,200 pieces of jade and other precious stones, 330 gold hair and hat ornaments, and some 200 gold and jade belt plaques (illus. 69, 70, 71). These vastly out-number the 8 pieces of porcelain, or 50 pewter imitations of vessels and utensils. It needs to be stressed again that not all Ming kingly tombs are like this. The tomb of Zhu Zhen, sixth son of the Ming founder as King Zhao of Chu, sits in a valley now almost on the outskirts of the encroaching megacity of Wuhan. Excavated in 1990–91, it too was

unrobbed.[25] Despite being of equal status and having their appanages situated in the same province, the first King of Chu (founder of a long line which endured to the end of the Ming dynasty) and the first and last King of Liang were buried in very different manners. The former tomb contains no precious metal vessels but is instead dominated by miniature pewter, iron and ceramic models.[26] Why should this be?

One answer may lie in the differing marital histories of the two deceased kings. His consort, who was presumably given a separate tomb

69 Golden ewer, from the tomb of King Zhuang of Liang (*d.* 1441), *h.* 24.2 cm.

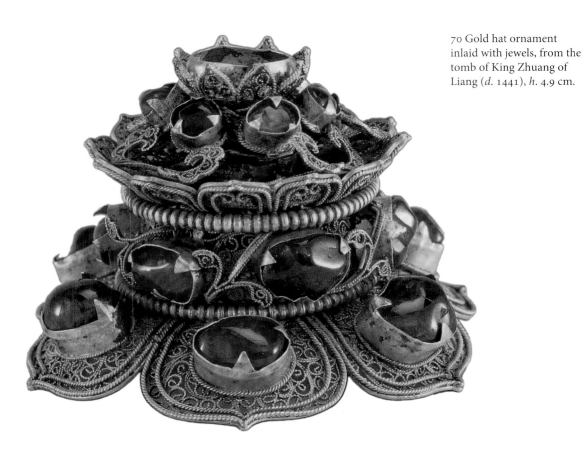

70 Gold hat ornament inlaid with jewels, from the tomb of King Zhuang of Liang (*d.* 1441), *h.* 4.9 cm.

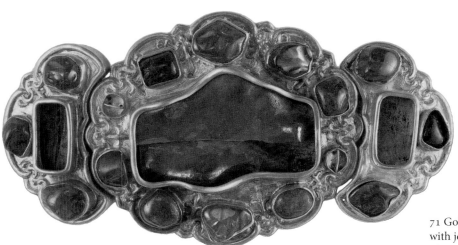

71 Gold belt buckle inlaid with jewels, from the tomb of King Zhuang of Liang, *l.* 10.2 cm.

72 Carved stone cover of the 'tomb inscription' (*mu zhi*), from the tomb of King Zhuang of Liang, *h.* 73 cm.

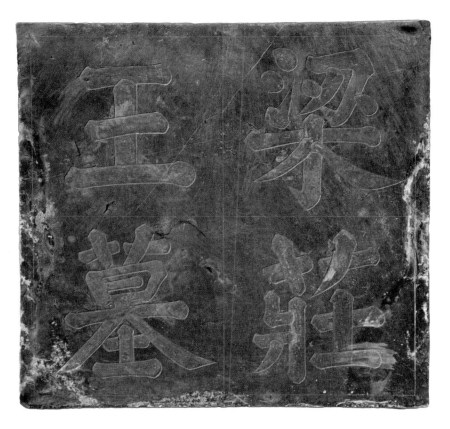

complex of her own, predeceased the King of Chu; there is certainly no trace of her in his tomb. The marital affairs of King Zhuang of Liang were rather more complex, but can be reconstructed from the formal epitaph incised on a covered stone slab and placed in the tomb, where its purpose was to announce the king to the powers of the next world, rather than record his virtues in the present (illus. 72).[27] This 'tomb inscription' or record (*mu zhi*) describes the late Zhu Zhanji as the ninth son of the late emperor Renzong, and names his mother as Madame Guo, Precious Consort Gongsu. It tells us that he was born on the seventeenth day of the sixth month of the

ninth year of the Yongle reign (equivalent to 7 July 1411); he was enfeoffed as King of Liang on his father's accession in the 22nd year of Yongle; he went to his state at Anlu *zhou* (the modern Zhongxiang city) in Huguang in 1429, the fourth month of the eighth year of the reign of his brother, the Xuande emperor. He died there of illness on the twelfth day of the first month of the sixth year of the reign of his nephew, the Zhengtong emperor (3 February 1441). The laconic and formulaic nature of the account of imperial grief, of the three-day cessation of court audience, and of orders for honours and sacrifices, does not mean that he was not actually mourned. The inscription

then goes on to name his consorts. His first principal consort (*fei*) was a lady surnamed Ji (her personal name is not recorded). She was the daughter of a man named Ji Zhan, who was a local military officer, a commander (*zhi hui*) in the Anqing Guard, a unit based in what is now Anhui province. The date of her death is not recorded here (though the 'Veritable Records' tell us she died in 1428).[28] His second consort was a lady surnamed Wei, also the daughter of a military man, the Nancheng Cavalry Commander Wei Heng. By her he had two daughters. He was interred on the 26th day of the eighth month of the year in which he died (the lengthy gap being explicable by both the choice of an auspicious day and by the necessary time taken to assemble the lavish funerary goods). The inscription concludes with a eulogy of the deceased king's virtues, telling us of his intelligence and bravery, his 'fondness for study and delight in goodness' as well as his exemplary embodiment of the virtues of filial piety and friendship.

The fact that both of the king's successive consorts were the daughters of military officers is not surprising. From the very beginning, the Ming dynasty had been wary of building up the power of consort families (there were enough disastrous precedents in Chinese history to act as a warning), in favour of choosing girls of respectable but relatively humble lineage, selected for their looks and their character.[29] At the very beginning of the dynasty it was the

families of the founding emperor's generals who provided wives for his sons.[30] But these paladins were viewed with great suspicion, and the practice was discontinued. It was not unknown for the sons of the founder to be married to 'foreign' princesses, in a continuation of the Yuan pattern. The late Ming anecdotalist Shen Defu has an entry on 'Kings of the Blood Marrying Foreign Women', which tells how Taizu's second son the King of Qin had a (named) Mongol wife, who committed suicide when he died. He tells too of the numerous Korean maidens presented in the Yongle reign and taken as concubines, but concludes, 'At this time they still followed the old Yuan customs, and had not forbidden dependent states to present women. From then on this was gradually not heard of.'[31] Later Ming kings were all married to Han Chinese women, and mainly those from the region where they held their appanage. We have already noted one tomb inscription, of a consort from the Shanxi appanage of Shen, which boasts that she came from 'a family great in Lu [central Shanxi] for generations'.[32]

A daughter's marriage might elevate a family to wealth and prominence, but this was not permanent and there was no ongoing pattern of marriages with the same set of families. This was deliberately designed to prevent the creation of aristocratic lineages which might threaten the primacy of the imperial clan; a practice shared with that

other great Eurasian empire, the Ottoman.[33] The Ji family and the Wei family were to enjoy prominence as the relatives by marriage of the king, and one or other of the two commanders might have been the grandfather of a king had the genetic material been stacked more in their favour. But it was not to be. Consort Wei's own tomb epitaph gives us a little bit more detail. She was selected as consort to the emperor's brother in the eighth year of Xuande (1433), presumably after the death of his first consort. On the death of her lord 'she wished to follow the king in death', but the imperial benevolence forbade this request by ordering her to stay alive to care for her two young daughters and 'continue to manage the affairs of the kingly palace'. She died in the second year of the Jingtai reign (1451) at the age of 38, after a widowhood of ten years, and was buried the same year.[34]

What this bald account makes plain is that Consort Wei was still alive when King Zhuang of Liang died, and that she lived for a further ten years after that before her own interment. What we have, therefore, in the material assemblage of the tomb called 'The King Zhuang of Liang' tomb, is really the 'Consort Wei' tomb, since we have no absolutely secure way (given the disturbance of the contents) of knowing how much of the material presently there was interred with the king in 1441, and how much with Consort Wei ten years later. What can certainly be inferred is the precariousness of her and her family's position in the years of her widowhood, given that there was no son and heir to inherit. As long as she lived the Wei perhaps had some hold on the estates and emoluments which went with the now extinct appanage, but that hold was immeasurably loosened on her death. Does this partly explain the lavishness of the burial? In writing of a much earlier context in which splendid arrays of burial goods were important, one historian of early medieval Europe has this to say about the relationship between burial and status:

> A significant strand of interpretation links the practise of furnished burial itself to the competition for status inside communities. This theory . . . argues that the moment of furnished burial was a similar public display of the disposal (into the ground) of valuable possessions. The corollary would be that the communities practising it had unstable hierarchies, negotiable though (among other things) local displays of wealth, based therefore on temporary distinctions of rank rather than permanent social status.[35]

Temporary distinction of rank in a possibly unstable hierarchy, and not permanent social status, was exactly what the Wei family enjoyed through the marriage of one of their women into the imperial clan. It might therefore be a feasible, if still speculative, interpretation, that the particularly lavish display of gold and silver, carried through the Hubei countryside

on the journey from the kingly palace in the city, was designed to assert that the Wei family still counted for something. Reopening the kingly tomb allowed them to insert their daughter and her great weight of golden jewellery, her gilded bronze certificate of imperial appointment as a kingly consort, her tomb inscription with its record of her willingness to die and her acceptance of the imperial order to 'continue to manage the affairs of the kingly palace'. It might have been a last attempt to impress on local society that their social connections were still with the very highest. At the very least, it reminds *us* that women mattered. If we turn our attention away from the model of a Ming China dominated by non-hereditary elites whose ascribed status depended on exam success, towards those elites for whom hereditary succession was crucial, it is much harder to forget about the role of women.

Our textual sources do their best to make the women married into the Ming imperial clan invisible to us as historical actors. One clear example of this can be seen in the two versions of 'Offerings of the Appanages', the first of which, in four chapters, was prepared by the imperial clan member Zhu Mouwei in 1595. The most easily accessible version to scholars is the one-chapter abridgement contained in the *congshu*, or collection of texts, entitled *Xu shuo fu* and published in Hangzhou in the last decades of the dynasty.[36] This systematically removes the biographies

of all the lower ranking male imperial clan members, those holding the variously titled ranks of 'General' (*jiangjun*), and all of the (admittedly rather few) women. Imperial women mattered almost not at all to the Jiangnan scholar editors of the text. However, their priorities are a very poor guide to the actual historical situation, especially to that pertaining in the very different social and cultural milieu of the early Ming, outside the Jiangnan region. If, as has recently been argued, it makes sense to see the early Ming dynasty as being effectively a successor state to the Chingisid Mongol empire, then that empire's attitude towards women and the relatively high status afforded to royal women in the Eurasian steppe culture from which it sprang may be significant. Recent research has increasingly shown us how in other examples of those successor states, such the Timurids, the Mughals and even the Ottomans, royal women were far more powerful and active than the orientalist notion of 'purdah' would suggest.[37] It is a moot point to what extent the practice of imperial clan consorts following their husbands in death is an example of a continuation of Mongol practice; certainly it was not the general custom of earlier imperial dynasties such as the Tang and the Song. When Zhu Youdun, the highly cultured King Xian of Zhou, died in 1439, the standard eighteenth-century dynastic history of the Ming tells us, eight of his consorts hanged themselves in

order to be buried along with him, and one modern author has suggested that a play by the king specifically promotes the correctness of widow-suicide.[38] Zhu Youdun's own writings are one of the few sources to give us any sort of detailed picture of an imperial clan woman, in particular of his most beloved companion Palace Lady Xia Yunying.[39] She apparently entered the palace at age thirteen (when the king was already 29), and she was his consort in fact after the death of his official wife. Zhu Youdun describes himself as distraught when she died, and wrote her epitaph himself. This 'Tomb Inscription for the Lady Xia Yunying' tells how she was a native of Shandong province, a prodigy who could recite the 'Classic of Filial Piety' at the age of five, and certain named Buddhist sutras at the age of seven. She was adept at the arts of music, chess and needlework, as well as being possessed of 'an incomparable beauty'. The king talks openly of how,

> When my original consort Madame Lü passed away, she took complete control of household management, and when there were major affairs in the state, they would be agreed with her. In her understanding and her morality, she had the manner of an enlightened lady. I often commanded her to recite poetry, and Yunying would offer up her drafts.

She apparently fell ill suddenly at the age of 23, retired to her room and sought ordination as a nun, receiving the Bodhisattva precepts and taking the religious name Wulian. After a further two years of an exemplary pious life she died at the age of 24, in Yongle 16 (1418). Finally, we are told how she named her dwelling Duanqing ge, 'Belvedere of the Acme of Purity', and left behind a text of *Poems from the Tower of the Acme of Purity*, with 60 titles in it. This poetry collection does not survive, although three of her poems, entitled 'Autumn Begins', 'Clearing after Rain' and 'Autumn Night', are anthologized elsewhere – they are a rare female voice from within the walls of a Ming kingly palace.[40]

Faint as the historical trace of these kingly women is, the material cultural evidence perhaps gives us another way of seeing the agency of imperial clan women, and seeing how and why they mattered. To return to the case of Consort Wei, widow of King Zhuang of Liang, we have seen above how it is possible to argue that she, or at least she as part of the Wei family, played a central role in determining the contents of the kingly tomb. This might explain the emphasis on pairs of objects in the tomb chamber; there are two sets of gold chopsticks (illus. 73) as well as two golden spoons, the material expression of an ideal of companionate marriage. Perhaps indicative of her agency in a more complex way are the two large gold ingots.[41] One ingot, 1,874 grams in weight,

73 Two pairs of golden chopsticks, from the tomb of King Zhuang of Liang (*d.* 1441), dated 1424 and 1425, *l.* 24.7 cm.

bears an inscription dated to the fourteenth year of Yongle (1416) and adds the information that it was cast by the 'Jewellery Service, following the Imperial Chariot'. The 'Jewellery Service' (*Yin zuo ju*) was one of the Eight Services of eunuch craftsmen manufacturing objects of plate for the imperial table, while the term 'following the Imperial Chariot' indicates that at that point the emperor was outside the capital, in this case having left Nanjing for one of his trips back to his power base in what was already designated as the new northern imperial capital of Beijing.[42] The second of these, weighing in at an impressive 1,937 grams of over 80 per cent pure gold, carries the inscribed date 'seventeenth year of Yongle' (equivalent to 1419) and the information that it was 'Purchased from the Western Ocean' (illus. 74). This almost certainly relates it to the celebrated voyages of the eunuch Admiral Zheng He (1371–1433) into the Indian Ocean and as far as the coasts of Arabia and Africa; it is the sole excavated object of any type to carry this illustrious connection. The explanation for two such items, clearly with imperial court provenances, in the tomb, may well be related to the King of Liang's two successive marriages, with one being presented as part of a splendid array of imperial gifts on each occasion. Their entombment is a spectacular withdrawal of wealth in its most desirable and liquid Ming form, that of solid ingots of gold, and a powerful statement both of the fact of marriage to the

74 Golden ingot, from
the tomb of King Zhuang
of Liang (*d.* 1441), dated
1419, *l.* 13 cm.

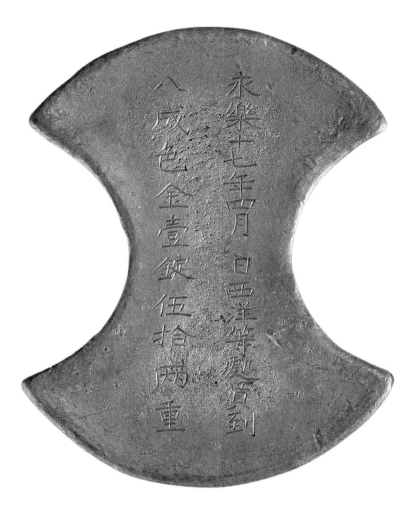

永樂十七年四月 日西洋等處買到
八成色金壹鋌伍拾兩重

king and of the validation and authorization of
that marriage by the imperial centre. No kingly
marriage could be contracted without the
approval of the reigning sovereign, duly regis-
tered by the Court of the Imperial Clan.[43] The
distribution outwards from the imperial centre
of the tribute goods of the whole world, pre-
cisely at the point of marriage, makes the point
that the women entering into the imperial clan
are enmeshed in a reciprocal flow of allegiance
and benefaction from the centre out to the

widest edges of the world. They are central,
not peripheral, to an imperial making of the
world which was defined by the presence of
its imperial centre.

In fact a large number of the precious metal
objects found in the tomb carry inscriptions
locating their place of manufacture to the *Yin
zuo ju*, the 'Jewellery Service' of the imperial
court. These include the larger of the two golden
ewers (illus. 75), which is dated to the first year
of the Hongxi reign (1425), a golden ladle

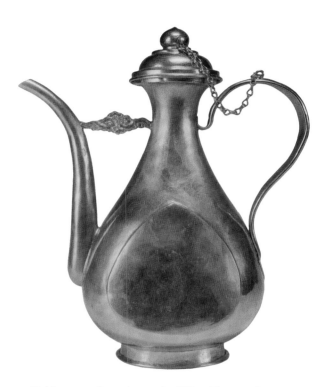

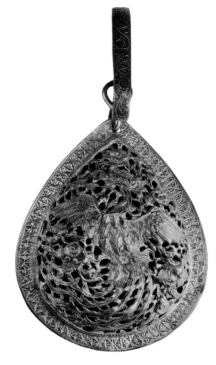

75 Golden ewer, from the tomb of King Zhuang of Liang (*d.* 1441), dated 1425, *h.* 24.2 cm.

76 Golden pomander, from the tomb of King Zhuang of Liang, dated 1432, *h.* 14.2 cm.

dated to the same year and the two pairs of golden chopsticks, one dated 1424 and one dated 1425.[44] A gold openwork pomander, designed to contain some perfumed substance and to be worn at the waist, is dated 1432, while the *Yin zuo ju* is again 'following the Imperial Chariot' and is decorated with the mythical bird *feng*, often translated into English as 'phoenix' (illus. 76).[45] Given the associations of this iconography with the empress (analogous to the dragon as an image of the emperor) it is tempting to see this object

as one coming from the imperial centre to Consort Wei, possibly through the agency of a woman at the imperial court; perhaps the same is true of the pair of magnificent filigree hairpins also in phoenix form (illus. 77). This kind of gift-giving relationship between women is the sort of thing on which the textual record is necessarily silent, but there are scraps of evidence from other Ming tombs which may allow us to posit its existence. Certainly in death, women of kingly courts received obsequies ordered by named powerful women at court.

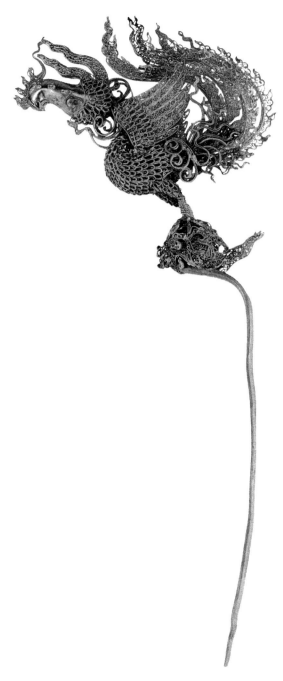

77 Golden hairpin, from the tomb of King Zhuang of Liang, *l.* 23.3 cm.

In the case of Madame Feng, secondary consort of King Kang of Ning, who died in Jiangxi province in 1516, the funerary inscription in her tomb tells us that offerings were ordered on her behalf by three named women at court, the Zhengde emperor's powerful grandmother and mother, as well as an imperial princess.[46] Although the donors are not named, the presence in tombs of jewellery from the imperial workshops, some of it of considerable age by the time it was buried, suggests the possibility of gifts passing from women at court to women in the provinces. Madame Peng, consort of Zhu Youbin, King Duan of Yi in Jiangxi province, died in 1537, and had among her grave goods a pair of extremely elaborate hair ornaments in the form of phoenixes, partly woven out of gold wire and resembling those in illus. 77 from the Lady Wei tomb. They carry a *Yin zuo ju* inscription dated 1424, making them over 100 years old at the time of burial.[47] Other hairpins and the fitments for jade pendants, also from the imperial work-shops, are dated 1493. The excavation report compares the 1424 pair to identical hairpins excavated in 1958 from the tomb of Madame Wan, consort of Zhu Houhua, Zhu Youbin's son.[48] A third pair of these same 1424 hairpins comes from the tomb of Madame Sun, consort of Zhu Yiyin, King Xuan of Yi (1537–1603). She had died in 1582. Additionally, Madame Sun had palace-manufactured jewellery dated 1522, identical to pieces from the tomb of her

predecessor Madame Peng.[49] That three kingly consorts of successive generations should possess identical antique hairpins from 1424 (and have worn them, the Madame Peng pair show signs of repair), and that two women who died 50 years apart should have identical jewellery from 1522, suggests a number of scenarios: perhaps items were supplied from the imperial palace stores at each kingly marriage, or perhaps a group of such items had existed in the stores of the kingly Yi palace since the early Ming, and passed from mother-in-law to daughter-in-law. Either way, there is a suggestion of the links between kingly women at the centre and in the provincial courts, of female ties across space and time. The 'givers' of Ming kingly brides were at least as much the central imperial court (and its powerful women) as were their own natal families, and the gold hairpins from imperial treasuries materialize this connection in a very plain way.[50] Furthermore, hairpins and hair ornaments were objects of powerful meaning in the Ming, understood as being at the core of a woman's identity. The jingle, 'For a scholar, his inkstone is like her hairpins for a beautiful woman', indicates a gendered understanding of those key items of material culture, an understanding which was pervasive. Did 'antique' hairpins have a particular meaning within this understanding? We will never be able to recover the individual meanings these items had for their female owners, the precise calculations which led to choices about trans-

78 Silver bottle, from the tomb of King Zhuang of Liang (*d.* 1441), *h.* 13.7 cm.

mission through the generations as opposed to interment and removal from circulation, but that does not absolve us from at least noticing that there *is* evidence in the archaeological record of choices being made.

Jewellery, or more broadly work in precious metals, is one of the areas where we can see evidence of the kingly courts as themselves being centres of luxury manufactures. A plain silver bottle in the King Zhuang of Liang tomb carries the inscription 'Made in the Administration Office of the Liang Palace, 8 *liang* 1 *qian* in weight' (illus. 78).[51] The same office is

79 Porcelain stem-cup painted in underglaze blue with silver stand and golden lid, from the tomb of King Zhuang of Liang, *h.* 19.3 cm.

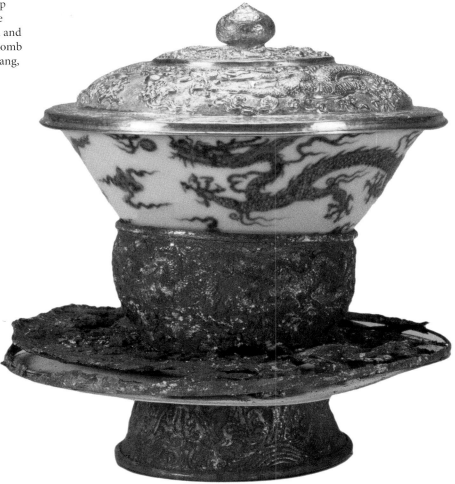

identified as responsible for the manufacture of a golden lid, worked with a design of striding five-clawed dragons, which covers a porcelain stem-cup (illus. 79).[52] Such dragons are generally thought of as an imperial prerogative, but the cover was presumably manufactured locally to match the design of the dragons on the porcelain, which may well have been an imperial gift, removing the imputation of lese-majesty. One of the very grandest products of such a

kingly court workshop, demonstrating clearly that such courts could be centres of patronage for luxury crafts at the highest level, is the 'phoenix crown' of Madame Sun, consort of the King of Yi in Jiangxi. This astonishingly virtuosic piece of filigree goldwork, decorated with over 3,000 tiny seed pearls, bears comparison with items excavated from the imperial mausoleum of Dingling outside Beijing. Its inscription reads in full:

The year *geng chen* of Wanli of the Great Ming (1580), on an auspicious day of the 5th month, made in the Seals Office (*Dian bao suo*) of the Kingdom of Yi, a pearl crown mounted with gold phoenixes, each calculated at a weight of 2 *liang*, 2 *qian* and 8 *fen* exactly.[53]

One of the mirrors in this tomb also carries an inscription stating it was a product of the same workshop. Yet the interplay of local and central is underlined by the presence in this tomb also of items which are clearly gifts from the imperial court. In this case they are bolts of white cotton, identified by inscription as 'Western Ocean cloth' (*Xi yang bu*). As with the gold ingots nearly 200 years earlier, or the massive gems which stud the belts and hair ornaments of Lady Wei and her lord, the imperial centre absorbs the tribute of the whole world and re-circulates it to the courts of those who serve as 'a fence and a screen' around it. Traces of those gifts are traces of social relationships which stood in need of constant affirmation – kings might be remote in miles from the imperial presence but they were conceptually ever close to its beneficent concern.

The low visibility (to put it mildly) of aristocratic women as historical actors in modern accounts of the Ming period is paralleled by the lack of attention studies of Ming art and material culture have paid to things like golden hairpins. The literature on ceramics (which rarely appear in Ming kingly tombs) is vast; the literature on precious metals, and especially on jewellery, is thin by comparison.[54] But it could be argued that our modern priorities in this regard exactly reverse those of the period itself. And if gold mattered, women mattered even more. Here more than anywhere absence of evidence should not be taken for evidence of absence. But in fact there *is* evidence, above and beyond that provided by the tombs, of concerns around one of the key roles of Ming aristocratic women, that of reproduction, and its concomitant assurance of dynastic legitimacy. In China, as in so many other specific contexts, while courts might be designed to project the authority of male rulers, 'they maintained themselves through the reproductive and productive activities of women.'[55] These issues existed from the very beginning of the dynasty and became particularly acute after Zhu Di, King of Yan and fourth son of the Ming founder, usurped the imperial throne from his nephew the Jianwen emperor in 1402. It was an important part of his claim to the throne that he was a biological son of his father's principal legitimate consort, Empress Ma, although even in his own time the alternative view that his mother was a Mongol or Korean concubine was in circulation.[56] The same uncertainty attends the parentage of Zhu Su, first King of Zhou, whose court at Kaifeng we have encountered as the setting

for the production of the first of the Ming dynasty calligraphic rubbings collections, the *Dong shu tang ji gu fa tie*. In fact, there has long been debate among historians about the identity of Zhu Su's mother and his consequent ranking among Taizu's sons. Although the later dynastic histories always call Zhu Su the fifth son, a recently excavated tomb inscription of a Zhou appanage commandery king, King Anjian of Pujiang, calls him the seventh son, underscoring the fluid and negotiated nature of these (very important) rankings.[57] Certain appanages, those of the Kings of Jin at Taiyuan for example, certainly derived continued prestige and ritual precedence through the dynasty from the proximity of their descent from the dynastic progenitor. This can be felt in the precisely judged ceremonial language of the prefaces to the calligraphic collection *Bao xian tang ji gu fa tie*, quoted in chapter Three, in which an emperor who is descended from the fourth son of the founder communicates with a prince whose line descends from the third son, and in which the conflicting claims of lordship and family have to be nicely weighed.

Claims and counterclaims about the authenticity of descent were heard throughout the politics of the Ming dynasty. One of the propaganda claims of Zhu Chenhao, King of Ning, when he rose in rebellion against the Zhengde emperor in 1519, was that the emperor was not really of the blood imperial.[58] The issues of biological versus ritual parentage occupied the Ming court and bureaucratic elite for years after 1521 when that same Zhengde emperor died without issue and his successor was sought from the appanage of Xing, whose holder ascended as the Jiajing emperor in 1522. The 'Great Ritual Controversy' (*Da li yi*) went right to the heart of how political legitimacy, reproductive biology, human emotion and authenticity of descent were to interact, the stakes being no less than the right ordering of the imperium and the cosmos.[59] This is a well-studied case, but it is only one of a number of succession disputes which convulsed the Ming imperial clan, and provided scandalous and fascinating material for onlookers from well outside its ranks. The reproductive politics of the imperial house were a matter of great interest to the bureaucratic elite, as can be traced through a text like Shen Defu's 'Random Gatherings of the Wanli Era' (*Wanli ye huo bian*), which devotes considerable space to the topic. For example, an entry in this text entitled 'Kingly Elder Brothers and Kingly Uncles' tells an enormously complicated tale of the succession to the appanage of Jin, with the degradings and reinstatements of its first few holders.[60] Another goes into great detail about the debates over posthumous titles to be awarded to a King of Huai, and make explicit analogy between this and the Great Ritual Controversy.[61] This aristocratic and courtly early Ming culture was clearly a subject of some fascination to a later scholarly elite which might have had little direct contact

with the aristocracy (Shen Defu hailed himself from Zhejiang, where there were no actual appanages). So too was what one can only call gossip, seen in its most lurid form in an entry entitled 'The Death by Hanging of the King of Zhao'. After restating the proverbial dangers of sleeping alone (since it lays the sleeper open to ghostly attack), Shen recounts what happened to Zhu Houyu, King Kang of Zhao (incidentally revealing that king's theoretically taboo personal names were known outside the imperial family). A studious man, in his later years he cut himself off from his consorts and concubines and lived alone in a tower, with only one boy to attend him in the night. The story goes on to describe how this servant

> happened to get up in the night and brushed against the king's foot, then saw the king hanging from his bedpost. He called in alarm for his concubine Madame Zhang and his fourth son, Zaiwan, King of Chenggao, who came to see but breath had already fled. We do not in the end know at what he time he passed away.[62]

This incident took place in 1560, some half a century before the completion of the first part of 'Random Gatherings' in 1606. Shen goes on to remark that the unhappy king had no visible sins, and should not have attracted the jealousy of ghosts. However, several days before his death he had been seen by his attendants mumbling to himself, 'as if in hatred for something'. A possible rational explanation for Shen lies in the rumours of a possible adulterous relationship between Madame Zhang and Zaiwan (technically but not necessarily biologically incestuous), which had driven the king to take his life out of chagrin. Shen Defu was writing in Beijing, and here we see a flow of kingly gossip and scandal between the provinces and that imperial centre to parallel the gifts and objects which flowed more decorously along those channels and which appear now in the kingly tombs.

But perhaps the most prolonged and most vicious of the scandals which Shen relates with such lip-smacking relish was that relating to the succession of the rich appanage of Chu, with its seat at Wuchang in Huguang province, modern Wuhan. Under the heading 'Reasons Why Yingyao Was a Traitorous Assassin', he tells how Zhu Xianrong, King Min of Chu, was assassinated in Jiajing 24 (1545) by his son and crown prince, Zhu Yingyao, who feared he was to be set aside and planned to murder his father at a banquet. However, the plot leaked out and rather than succeeding his father he was taken to the capital in chains. The father, Shen tells us, really did prefer another son, and often told Yingyao this, on account of which he hated him. Shen remarks how this kind of favouritism has been an abiding problem of the imperial family, up to and including emperors.[63] Here we see the imperial clan as

a sort of theatre of dysfunctional possibilities, a First Family acting out for the Ming audience all the possible psychodramas. The Chu appanage continued to provide plenty of such material, as Shen recounts in his next entry, 'The Chu Household's Successive Encounters with Misfortune'. Following the assassination, and the degrading of the murderous son, a younger brother Zhu Huakui (1572–1643) succeeded. Rumours as to the virility of this new king were rife, and when he died and was succeeded by a baby, rumours at once began to circulate that the child had been introduced from outside the lineage, through the connivance of a consort, and was in fact the child of her own brother.[64] The ongoing struggle over the legitimacy or otherwise of the King of Chu lasted for decades, acted in some degree as a proxy for existing bureaucratic factions and led to the ruination of several promising official careers.[65] It was a cause célèbre, much remarked on by Ming writers, one of whom, the great traveller Xu Xiake (1587–1641), noted in his account of his journey through the region that 'The affair of the clan of Chu was considered as an injustice by the entire empire.'[66] The writer Zhang Dai (1597–*c*. 1680), whose nostalgic writings on the late Ming have been deployed to such effect by Jonathan Spence, had more than one relative whose official position embroiled them to a degree in the affair.[67]

At the heart of this (and other) disputes there clearly lay the vexed issue of the reliability of women, who might be marginalized within the written historical record but whose prominence in the kingly tomb, or as the occupants of tombs of their own, reminds us of their very visible importance and centrality to contemporaries. Here was one of the central paradoxes of Ming culture, and one which it could be argued links two pieces of Ming material culture which have had very different fates as objects of historical attention. One is a much-studied elite 'art form', namely calligraphy (illus. 41), which is firmly gendered as male, while the other (despite the preciousness of its material) manifestly stands at the other end of a hierarchy of esteem. It would be hard in fact to think of a type of Ming object less written about than the gold hairpin of the aristocratic women (illus. 77). Yet there is a certain homology between them in that both are involved in the central fact of reproduction. The reproduction and transmission of calligraphy through the form of rubbings, as seen in chapter Three, required that the most precious aspects of culture be put into the hands of the subaltern, the craftsmen who actually cut the stones for the kingly rubbings collections. Similarly, the reproduction and transmission of the patriline from father to son had of necessity to pass through the subaltern bodies of women, taken in marriages which were validated through gifts such as the jewellery they received from the imperial centre. Kings and calligraphy are reproduced in the same

way, a little less legibly each time. Just as reproduced calligraphy got fainter and fainter as stones were cut from rubbings which formed the basis for new stones, so the blood imperial became increasingly faint as it passed through the eight ranks from King to Supporter-commandant of the State. In both cases, the power of an original is in one way weakened by reproduction but in another way enhanced, since the existence of the original is reasserted in every act of reproduction. Any account of Ming culture which puts calligraphy at its heart and ignores the hairpins is missing something which was perhaps so obvious (if disquieting) to contemporaries that they did not make it explicit for us. Robert Nelson's formula, that certain things have 'demanded history' at the same time as they resist history, might give us a way of beginning to think about the visually dazzling but historically resistant gems we are only now beginning to write into our image of the past of Ming China.[68]

THE BRONZES OF THE KING OF LU

Marriage ties, of which tombs give such striking evidence, were one of the key ways in which the kingly lineages of the Ming interacted with local society, and (especially early in the dynasty) with military and bureaucratic elites. In 1459, when the high official Ni Qian (1415–1479) was accused of taking bribes from a recently deposed King of Liao, it was a significant fact in the charges against him that his second wife was from the same family as the ex-king's mother, both of these women being descendants of the early Ming general Guo Ying (1335–1403). A modern biographer remarks, 'Perhaps some innocent transactions among relatives were misrepresented as evidence of a political intrigue', but the episode should serve to remind us that women bound lineages together and that though there was no direct intermarriage between high officials and the imperial clan, they might on occasion have in-laws in common.[1] However, the kingly and bureaucratic elites of the Ming shared other ties too, around a range of cultural practices, from the shared engagement with calligraphy and painting discussed above to poetry, music and the fascination with the material culture of the deep past. None of these were sited in the Ming in an autonomous realm of 'aesthetics'; all had stronger resonances and associations with the ordering of the world. When kings involved themselves in the printing of books, the design of musical instruments, or the manufacture of archaic bronze vessels (illus. 80, 81, 82), they were both asserting their shared values with a broader elite and at the same time asserting their role as cultural models or even leaders, a role which many seemed happy to concede, and even to celebrate.

In a whole range of ways kings were significant figures in the lives of many members of the non-hereditary bureaucratic elites of the Ming, their significance being to an extent occluded by the fact that there were no appanages in Jiangnan, the region from which we have drawn so much of our evidence as to what Ming culture was like. But in fact a number of much more famous figures from the

80 Xiao Tong (501–531), ed., *Wen xuan* ('Literary Anthology'), printed book, dated 1487, Tang appanage edition reprinting the Yuan dynasty edition by Zhang Bowen.

81 Zhu Changfang (1608–1646), King of Lu, *guqin* zither, dated 1634, wood, lacquer and silk strings, *l.* 118.5 cm.

82 Bronze tripod vessel, dated 1635, *h.* 21.4 cm.

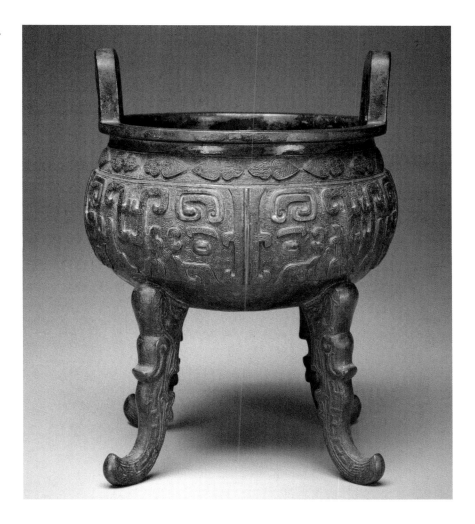

period had a degree of connection to the milieu of a kingly court, or had their ideas partly formed there, as even a cursory search of the most obvious secondary literature reveals. Jobs in kingly courts might have been less sought after than those in the regular bureaucracy, but they were jobs nonetheless, and they brought with them aspects of patronage and protection which must have mattered to their holders. For example, the father of Yang Xuan (1425–1478), who himself went on to have a successful official career, was the first family member to get a degree, and served as a secretary in the household of the Kings of Shu in Chengdu. The young Yang Xuan will have grown up in the palace environs. The family was not originally from Sichuan, so we know that people travelled to these jobs. Grand Secretary Jiao Fang (1436–1517) was the grandson of another man to break into the ranks of degree-holders, who

went on to serve as an instructor in the palace of Zhu Chongyu, King of Han. Another major Ming writer who had the same sort of background was Li Panlong (1514–1570), son of Li Bao (*d. c.* 1522), who served Zhu Jianlin, first King of De (enfeoffed 1467, *d.* 1517) in Shandong. The 'poet, essayist, artist and official' Wang Siren (1575–1646) was the son of the court physician to Zhu Yiyin, King of Yi, at Nancheng in Jiangxi. And Lu Bing (1510–1560), powerful commander of the 'Embroidered Uniform Guard' (*Jinyiwei*) under the Jiajing emperor, was the grandson of Lu Chi, a man who had served Zhu Youyuan, King of Xing, Jiajing's father. Lu Song, father of Lu Bing, followed Jiajing to Beijing. Here we see three generations of the same family engaged in close personal service to the ruler, as members of a court society which functioned in the provinces as in the imperial centre.[2]

Perhaps the most important figure to come from a family with a record of service in a kingly court was Zhang Juzheng (1525–1582), the Grand Secretary who dominated the government of the empire to an unprecedented degree in the late 1560s and 1570s. He came from Huguang, arguably the most 'kingly' of all provinces, and his grandfather had been a guard in the palace of the King of Liao. He himself when in power manifested great hostility to the wealth and power of the imperial clan, and as early as 1549 argued in a memorial that

the imperial clan is proud and dissipated; the mass of officials are neglectful; the style of government is stuck in the mud and does not adapt; the border defences have not been maintained; the treasury is seriously lacking in funds.[3]

Note that of the 'five evils' afflicting the empire, the imperial clan still comes first, receiving formal precedence even in denunciation. On Zhang's death he suffered posthumous disgrace, with the list of his crimes similarly being headed by his hostility to the imperial clan: 'Zhang Juzheng has blackened the name of the princes, he had taken over the tombs and mansions of the kings, controlled the imperial censors by force, kept the emperor in the dark . . .'.[4] The widow of the previously degraded King of Liao accused Zhang of having engineered the king's downfall in order to get hold of his property, and this accusation was used as the reason to confiscate the Zhang's family wealth. There is a particular edge to this charge, as from the princess's point of view Zhang Juzheng was arguably particularly blameworthy for his disloyalty to the 'state' of Liao which his grandfather had served.[5]

Some names still famous today themselves had courtly connections. One of the few Ming writers to be read in translation worldwide today is Wu Cheng'en (*c.* 1506–*c.* 1582), who wrote *Xi you ji*, the novel known in English either as 'Journey to the West' or 'Monkey'; he

was, according to one source, a tutor in the palace of the King of Jing, at Qizhou in Huguang, in the late 1560s. The great doctor and writer on *materia medica* Li Shizhen (1518–1593), one of the most renowned figures today in a lineage of 'great Chinese scientists', received patronage from Zhu Houkun, King of Fushun (*fl.* 1514–1576).[6] The major calligrapher Fu Shan (1607–1685), born in the environs of Taiyuan, had in his ancestry both a tutor in a kingly household *and* a great-grandfather married into a cadet branch of the appanage of Jin.[7]

There is definitely evidence that the degree holding elite was interested in the doings of the imperial clan, whether as a matter of policy or out of an interest in gossip and 'insider' information it does not really matter (and the two are not in any case mutually exclusive). Although theoretically secret, the printed genealogy of the ruling house existed in privately printed editions, 'perhaps reflecting its historical value and the public's fascination with royalty'.[8] Courts could be familiar settings, even if only to those who came as visitors. Lu Shen (1477–1544), who enjoyed both a successful official career and a reputation as a man of letters, was commanded in 1512 to travel to Raozhou in Jiangxi for the investiture of the wife of a King of Huai, and wrote a 'Diary of the Investiture in Huai'.[9] Qian Xiyan's 'Record of Things Heard in the Capital of Liao' is an essay on a visit to the very Hubei

appanage where Zhang Juzheng's grandfather had served, and which he characterizes with relish as a nest of every sort of luxurious vice.[10] In 1589 Xiao Daheng (1532–1612), at that point an official of very high rank, was ordered to escort the new King of Lu to his state in Weihui, Henan. Chen Renxi (1579–1634), rector of the National University, visited Kaifeng in 1631 to confer honours on a King of Zhou.[11] The court was a place both of allure and of danger, and never more so than on those dramatic occasions when individual kings attempted by force to alter the dynastic succession in their own favour (as the King of Yan had so successfully done in the early fifteenth century). The complexities of inter-action are shown in the case of one of the most famous figures of Ming high culture, whose writings were to have a profound influence in his own time and beyond. This was the philosopher, official and general Wang Shouren (1472–1529), often known by his style-name, Wang Yangming.[12] His suppression of the rebellion of the King of Ning, Zhu Chenhao (*d.* 1521), was in some ways the high point of his career, but both in his lifetime and beyond it his reputation was plagued with rumours that he was 'in league with [Chen-] hao'. His numerous political and intellectual enemies, as well as his disciples and adherents, traded accusations against and defences of his conduct though the dynasty.[13] He was supposed to have accepted patronage

and gifts from Zhu Chenhao, sent his disciples to visit his court and made sycophantically energetic efforts to reach Nanchang in time to congratulate the imminently rebellious king on his birthday. He is also supposed to have had a particularly close relationship with Liu Yangzheng, a serial examination failure who was the *éminence grise* of the rebellion and of whom Wang is supposed to have said, 'This is my friend in the study of the Way.' The Ning rebellion was a major and traumatic event, one which led the imperial government, once victorious, to act ruthlessly in its extirpation of all who might be thought to have colluded with it. Later accounts have the king treasonously attempting to build up a network of connections within the bureaucracy and the cultural elite, attempting to ensnare such men as Wen Zhengming (1470–1559) and Tang Yin (1470–1524), both famous by 1519 as calligraphers and painters. A famous passage in the funerary biography of Wen by his son tells how

> The King of Ning sent people with rich gifts to present to him, but my father absolutely refused [to receive] the envoys. At that time people in Suzhou did have some slight relations with him, and my father said, 'If it goes on like this, will it be possible for long to maintain peace in the appanage?', but people strongly disagreed. The king then rebelled, and people began to accept my father's far-sightedness.[14]

Wen's contemporary Lu Wan (1458–1526), also a native of the Jiangnan city of Suzhou, clearly was in some way connected to the kingly interest, and suffered ruination as a result.[15] It may have been unusual for a king whose appanage was situated in Jiangxi to seek to exercise patronage as far away as Suzhou, but what was *not* unusual was that a king should extend his patronage to men of learning and talent more close by. Wang Yangming was *indeed* probably hurrying to offer birthday congratulations to the King of Ning, but so was the bureaucratic elite of the entire province, and it was entirely natural for and expected of them to do so. Only in the retrospective interrogation of motives following the rebellion did this sort of activity become one requiring an explanation or an excuse.

Congratulatory texts written for members of the aristocracy, and often on the occasions of their birthdays, abound in the collected works of certain Ming writers, and even after the debacle of the Ning rebellion the benefits of such a connection clearly outweighed the risks. Certain people seem to have made something of a speciality of supplying the aristocracy with congratulatory texts; there are many in the collected writings of Li Weizhen (1547–1626), although this exceptionally prolific writer may perhaps be seen uncharitably as one of the Ming dynasty's leading brushes for hire.[16] Among his essays of this type are two congratulatory prefaces for

Zhu Chengyao (1550–*c.* 1610), King of Shen (in central Shanxi province), and one for a descendant of a King of Zhao, a King of Shanyin, plus another for a famous Nanjing playboy, Zhu Chengcai, a descendant of the King of Qi.[17] The same King of Shen's 70th birthday was also the subject of two encomia, one entitled 'A birthday preface congratulating his majesty the King of Shen and wishing a thousand years' by the fashionable litterateur and painter Cheng Jiasui (1565–1643).[18] The reader would not know it from Li Weizhen's mellifluously sycophantic prose, but the 'descendants of the King of Qi' were one of the scandals of Nanjing, the empire's secondary capital. They were commented on by Shen Defu at the beginning of the seventeenth century, nearly 200 years after the appanage of Qi, descended from the seventh son of the founder, had been finally abolished, when its first and last holder, 'was imprisoned in Nanjing, and his sons and grandsons were all made commoners, with commoners rations, and no rank or title. Down to the present their branches have gradually increased, and they vagabond about the capital with abusive behaviour.' Shen describes how the lustre of an aristocratic name allows them to take from shops without paying, and to visit the brothels without extending any patronage. 'Even the monasteries fear the harm they bring.' He describes them as people essentially arrogant and ridiculous, dressed in a sort of

parody of royal robes, from unknown sources, and mimicking in their everyday lives the ceremonial of the aristocracy. 'Everyone in the capital had got used to seeing this, and thought it perfectly normal, no longer thinking to make mock of it, but falling into relations with them, which was inexplicable.'[19] The point is that even in Nanjing, and despite Shen Defu's scorn, there was a social cachet to membership of the imperial clan; it is a modern fantasy of Ming China as a meritocratic society of social mobility to imagine even for an instant that there might not be. When Xu Xuemo (1522–1594), 'official, scholar and minor poet' and in 1568 surveillance vice-commissioner in Huguang, stepped forward to defend Zhu Xianjie, King of Liao, a man the *Dictionary of Ming Biography* is happy to characterize as 'greedy, licentious and depraved in many ways', who was degraded for sedition in 1568, and when he included a biography of the disgraced king in his published works, we should perhaps not be too eager to moralize from a safe distance.[20] Perhaps instead we should think about the not inconsiderable body of evidence which exists for bonds of patronage and clientele between the regional aristocracy and the bureaucracy, even if it contradicts long-held but little-examined assumptions about the nature of power and respect in the wider Ming empire.

For it was not just sycophants and hacks who interacted with the imperial clan; in fact, the kingly palace was a major site of interaction

83 Shen Zhou (1427–1509), *Invitation to Reclusion at Chaisang*, hand scroll, ink and colours on paper, 24.8 × 1,094.1 cm.

between aristocratic and bureaucratic elites, often through shared participation in the making and appreciation of cultural forms. We have already seen above how the Crown Prince of Jin in Taiyuan draws attention to an episode of connoisseurship shared between himself and high-ranking officials, in explaining the genesis of the 'Hall for Treasuring Worthies' rubbings collection. We can see just how short the distance is between the Jiangnan literati elite (the central historical actor in most accounts of Ming culture) and the kingly court by considering a work now in the Art Institute of Indianapolis (illus. 83). Entitled *Invitation to Reclusion at Chaisang*, it combines the famous classical poem 'Returning Home' by Tao Yuanming (365–427), executed in the calligraphy of Zhang Bi (1425–1487), with a picture by Shen Zhou (1427–1509). Shen is today one of the most renowned figures of the Ming cultural canon, emblematic of the literati of Suzhou, although his status in this project is perhaps somewhat lower than that of Zhang Bi, since the calligraphy

is the more 'important' part of such joint works, and in fact Shen Zhou does not actually sign the picture. Shen might be the more famous figure today, but Zhang Bi was one of the most renowned calligraphers of the fifteenth century. Indeed it was in this context that six separate works in his hand are included in the 'Hall for Treasuring Worthies' collection of the Crown Prince of Jin (illus. 37).[21]

Another instance of proximity between hitherto rarely connected facets of Ming culture is shown by the reprinting in the Heng appanage of the works of the Jiangnan literatus Yuan Zhi (1502–1547), originally published in Suzhou by his family around the time of his death. Yuan was a close connection of Wen Zhengming, student of Shen Zhou and a man even more emblematic to later ages of the archetypal 'Ming scholar'. This edition published in Shandong has a short biography of Yuan Zhi as well as 'several prefaces and postfaces, one of which mentions that Yuan's sister's son, Zhang Bingzhong, a judicial official (*sili*) in the Heng principality, had

the work reprinted'.[22] Here again it is women, usually invisible in standard accounts, who act to link the separate spheres of the Suzhou gentry and the Shandong imperial aristocracy. The degrees of separation between a Shen Zhou or a Wen Zhengming, in Suzhou, and a Crown Prince of Jin in Taiyuan or a King of Heng in Shandong, might therefore appear to be considerably fewer than our working model of Ming culture would conventionally suppose.

A range of other cultural forms, particularly poetry and music, provided settings where interaction could take place, interaction which we should not assume was entirely in the direction of 'influence' from the literati to the court but which may well have involved participation in a shared and jointly created set of cultural practices. Many kings wrote poetry themselves, even if not all of it survives (or was ever very good).[23] And in the Ming the writing of poetry was crucially a social and not a solitary activity. Again to take Taiyuan as an example, it was there that the famous scholar Kong Tianyin (*jinshi* 1532), who was a son-in-law of the

Commandery King of Qingcheng, took part in poetic gatherings. It was there that the poet Wang Daoxing (*jinshi* 1550), who had previously been prefect of Suzhou (another Shanxi–Jiangnan connection), served as an official, built a famous garden and founded a poetry society which had imperial clan members in it.[24] At the same time as he condemns the court of the louche King of Liao as a scene of gambling, dog and horse racing and dalliance with dancing girls, Qian Xiyan sees it as a place where the practice of poetry was a kingly passion.[25] Where kings existed (and they were absent from the Jiangnan landscape) they were part of an integrated elite culture, often structured on relations, at least rhetorically, of masters and disciples. The scholar He Tang (1474–1543) was acknowledged as the teacher of Zhu Houhuan (1518–1591), King of Zheng, who was in turn the father of one of the most celebrated intellectuals of the Ming imperial clan, the mathematician and musical theorist Zhu Zaiyu (1536–1611), discussed below. He Tang's writings on music and the calendar

were of considerable influence on Zhu Zaiyu's own work, and the prince was in fact married in 1570 to a great-great-granddaughter of He Tang.[26] The philosopher Hu Juren (1424–1484) lectured by invitation in 1483 in front of the King of Huai, a fact which was memorable enough to be recorded in the seventeenth-century collection of biographies, 'Records of the Ming Scholars' (*Ming yi dai fang lu*).[27] The collected works of the 'scholar, dramatist, poet, and bibliophile' Li Kaixian (1502–1568) contain a poem entitled 'Inscribed on [the painting] *Spring Clouds at the Jasper Pond* for the Birthday of the King of Heng', as well as an essay of 1557 congratulating Zhu Houyu, King of Zhao, on his 60th birthday.[28] Heng was an appanage situated in Shandong, the province from which Li Kaixian originated, and it was another branch of this lineage with which Li can be shown to have interacted significantly and over a period of time. The Commandery King of Xinle had a relationship of poetic exchange with Li over a number of years, as he himself states in the preface to his collection of verse, *Shi wai wei jing*, where the king is described as one who

> advocates literary arts and takes joy in things of quality. He is among the most outstanding figures in the royal clan. [He] loves my lyrics, and thus matched them in writing and also put them into print, giving the work the title *Shiwai weijing* ['Gentle Warnings Beyond Poetry']. The sounds and rhymes are harmonious, and the calligraphy is exquisite. The many other [matching] pieces could only admire it in awe, and the various prints became inferior in comparison. My lyrics are therefore transmitted even further. This is my huge and boundless fortune. Now that the book is completed, I respectfully dedicate these few words as a token of my gratitude.[29]

Several other of Li's poems relate to exchanges with the holders of the appanages of Heng and Zhao, or with their cadet branches.[30] Here we see a typical intra-elite format of gentlemanly poetic exchange, 'matching' poems by composing new works which echo the formal features of one another's verse. Li Kaixian and Zhu Zaixi, King of Xinle, are here relating in this way, though Li is suitably deferential, as he might be to any older or higher-ranking patron. He is following a pattern of relations which had begun in the very first decades of the dynasty, and would continue to its end, in contrast to the perception that the 'scholar-elite' and the hereditary aristocracy had nothing to do with one another. As far back as the 1390s Fang Xiaoru (1357–1402), one of the intellectual stars of the new dynasty, had enjoyed a relationship in Chengdu of gift and poetic exchange with Zhu Chun, King of Shu, 'the most literary-minded of the imperial princes . . . a mild-mannered young poet who

recognized literary values and cultivated scholars' and had enjoyed the titular post of tutor to Zhu Yuelian, Crown Prince of Shu (illus. 65).[31] There was a noted circle of writers around Zhu Youdun, King of Zhou, in Kaifeng; the interest of this appanage, situated in the old Northern Song capital, did not die with him, but continued on into the sixteenth century. A set of five poems by Niu Heng (*jinshi* 1535) on life in the Zhou palace, entitled 'Lyrics on the Palace of the Appanage Kings of Zhou' (*Zhou fan wang gong ci*), are appended to Zhu Youdun's own collection of poems on Yuan dynasty palace life, which are included in the seventeenth-century poetry anthology by Qian Qianyi (1582–1664), *Lie chao shi ji*.[32] A much more important poet who shared the same connection is Li Mengyang (1473–1529), who lived in Kaifeng at a low point in his career and came to know the King of Zhou, who later reprinted his writings, as *Kongtong xiansheng ji*. His poetry was edited for the first time by Zhu Mujie (1517–1586), also a cadet member of the appanage of Zhou, before being reprinted in a number of late Ming editions.[33] The 'poet and eccentric man of letters' Lu Nan (*d.* 1560) also had his poetic works printed by a kingly patron, in this case by Zhu Houyu, King of Zhao.[34] And the collection *Yongdong shanren gao*, the poetry of Lü Shi (*fl.* late sixteenth century), 'a writer who found patronage at several of the principalities', was published in 1581 by Zhu Tianjiao, King Xuan of Shen,

in Shanxi.[35] In fact, as in the case of Li Kaixian and Li Mengyang, it was as publishers, patrons of the printed works of scholars, that members of the kingly appanages played one of their most important roles in the promulgation and reproduction of culture in the Ming.

This role has perhaps been the most studied aspect of kingly cultural activity to date, with a number of studies of appanage publishing (*fan ke ben*) to date.[36] Here the aim will not be to replicate the excellent work already done on this topic but to integrate it into a more general attempt to reinstate Ming kings in our broader picture of Ming culture. Kingly palaces were major centres of book culture and often had very large and significant libraries (illus. 84). The Ming bibliographer Huang Yuji was explicit that 'No book collections in the empire surpass those of the appanage households in richness.' Gifts from the imperial centre may have formed a part of these libraries. As Li Kaixian, a writer who himself had his works produced by a kingly press, remarked, 'When kings of the blood proceeded to their states, they first were granted 1,700 volumes of songs and lyrics.' And the seventeenth-century writer Qian Qianyi noted a particular gift of imperially printed titles to the King of Shen in 1531.[37] Kings also spent extensively on their libraries. For example, Zhu Mujie of the Kingdom of Zhou (in Kaifeng) bought the libraries of a Mr Ge of Jiangdu and a Mr Li of Zhangqiu, and built the *Wanjuan tang*, or

'Hall of 10,000 Volumes', to house them.[38] One Ming source asserts that 'The splendour of the books and the art collections of the Zhou household surpassed that of other appanages', while Qing bibliographers comment on the richness of other individual imperial clan libraries.[39] Whether books gifted from the imperial libraries included rare editions of pre-Ming works is a matter of debate. One scholar has claimed,

> Emperors beginning with Ming Taizu (*r.* 1368–98) endowed the princes with copies of precious Song and Yuan editions in order to educate and civilize their kinsmen and sometimes to reward them for their learning and scholarly accomplishments.[40]

These would have gone along with the gifts of paintings and calligraphy already discussed, which certainly are attested by the presence of seals. However, more recently scepticism has been cast on this transmission of early editions from the imperial centre to the kingly courts, one recent study describing it simply as 'a myth'.[41] Either way, just as the appanage of Jin transmitted the calligraphic canon through its production of a rubbings collection, kingly

84 Zhu Zhanji (Ming Xuanzong, *r.* 1426–35), ed., *Wu lun shu* ('Treatise on the Five Relationships'), printed book (dated 1447, imperial edition with seal of the Kings of Lu).

publishing served to transmit earlier and highly regarded modes of book production. The style of Ming appanage editions closely preserves Yuan dynasty practices, including calligraphy in the style of Zhao Mengfu (1254–1322). In at

least one case (that of a version of the literary anthology *Wenxuan* published in the Tang appanage in the Chenghua era, 1465–1487), the later removal of the kingly preface has been sufficient to allow a Ming facsimile to pass as an original Yuan edition in the book market. And by the Jiajing and Wanli eras, what has been called 'the wave of interest in the revival of antiquity' created a trend towards facsimile Song editions, such as a renowned facsimile of *Shiji jijie suoyin zhengyi*, a version of the Han dynasty historical classic *Shiji* with three commentaries, originally edited in the Song by Hang Shanfu (twelfth century) but republished in 1543 in Xi'an by Zhu Weizhuo (*d.* 1544), King Ding of Qin.[42] Here again we see the appanages acting as relay stations for elite and imperial culture, as centres of *reproduction*, with the cultural heritage of the past (whether or not they received it from the imperial centre) being transmitted to the wider empire just as they themselves in their persons reproduced and transmitted the patriline of the founder.

The scholar of Ming printing Lucille Chia has calculated that today we know of slightly over 500 publications from 34 principalities, with some 220 individual members of the imperial clan involved in 'literary' or publishing activities; this will certainly be a minimal figure. The earliest identified edition dates from 1390, the latest from 1640, and the most active appanages are those of Ning and its collateral

branches (with about 105 titles), Zhou (at Kaifeng, in Henan, with about 51) and Shu (at Chengdu, in Sichuan, with about 45).[43] If we look at just one of these centres of publishing, and not the most active, namely the seat of the Kings of Jin at Taiyuan in Shanxi, we see a consistent pattern of kingly engagement there with the anthologizing and transmission of the cultural heritage. This included a number of authored works, including at least one by a consort of an appanage member, the 'Family Instructions of Lady Wang' (*Wang furen jia fan*) by the wife of Zhu Qianqiu.[44] She was replicating on the local level the types of exhortatory authorship which were associated with the women of the imperial clan at the highest levels, with several empresses also being responsible for such morality books.[45]

Zhu Zhiyang (*d.* 1533), King Duan of Jin, and his nephew Zhu Xintian (*d.* 1575), King Jian, published 'nine large literary anthologies, one for each dynasty from the Han through the Ming'. At least three of these were based on rare Song or Yuan period editions.[46] The anthology of Tang literature, *Tang wencui*, describes itself as 'Collated and reprinted in the imperially endowed Yangde Academy of the Jin Household'. The *Yuan wen lei* (illus. 85) was based on a Yuan edition from the West Lake Academy (Xi hu shuyuan) in Hangzhou 'which had probably been bestowed on the Jin principality by an emperor'. The Jin appanage edition of the anthology *Zhen Wenzhong gong*

xu wenzhang zhengzong, compiled in
the Song by Zhen Dexiu (1178–1235),
'was based on a collated version of an
old edition in the Directorate of
Education in Nanjing', while the
Taiyuan 1526 edition of *Wenxuan*,
earliest of the great literary antholo-
gies, was a facsimile version of one
privately printed in Chizhou. Lucille
Chia concludes, 'The Jin princes'
ambitious (re-)printing project clearly
caught the attention of the Jiajing
emperor who showed favour on several
of the publications by writing prefaces
for them.' This is somewhat analogous
to the process by which the calligraphic
canon of the 'Hall for Treasuring
Worthies' collection (illus. 34) is based
on imperial gifts, presented back to
the imperial centre and praised by the
imperial brush. However, it is worth
at least considering the arguments for
parting company with Lucille Chia's
interpretation of the motivation for
kingly engagement in the publishing
of such texts. She sees such publishing
enterprises as being essentially either a form of
vanity publishing or a displacement activity for
those debarred from 'real' power, and operating
under a perpetual cloud of imperial suspicion.
For her, publishing was 'a subtle refuge from
the attentions of an emperor wary of seditious
activities among his relatives . . . an important

85 Su Tianjue (1294–1352), ed., *Yuan wen lei* ('Yuan
Literature Arranged by Genre'), printed book (dated
1537, Jin appanage edition).

aspect of the apolitical pursuit of learning, in
which the princes were free to indulge their
particular interests and to which to devote the
resources of their states'.[47] This sense that kings

turned to culture *faute de mieux* is pervasive in such literature as treats the subject.[48] But the idea that 'power' and 'culture' exist as an antithetical pair, *a priori* (like Charles Hucker's equivalent opposition of 'government' and 'social scene'), is highly problematic in considering the Ming period, or indeed any pre-modern period of Chinese history.

Perhaps we need to consider differently the publishing activities of courts in regional centres normally thought of as far from the centres of cultural activity in the Ming, the great urban centres of the lower Yangtze, where commercial publishing boomed exponentially as the dynasty went on. The rate of publishing in kingly courts stayed relatively stable throughout the length of the dynasty, whereas commercial publishing, which accounted for only 10 per cent of titles in the first half of the Ming and 90 per cent in the second, eventually became numerically dominant.[49] Instead of reading this as evidence of kingly stagnation, we might see here evidence that, as with the production of rubbings collections, the kingly court was a centre of types of cultural production which only later were picked up by the 'literati'. To invert the usual understanding of this relationship may take some effort, but if the evidence is considered as a total picture and not as disconnected fields (history of calligraphy, history of publishing), then the argument is at least worth making.

Also worth making is a counter-argument to the claim that 'The principalities only

occasionally produced (i.e. wrote, compiled or published) works having to do with the areas where they were located.'[50] In strictly numerical terms this might be true, but it is nevertheless possible to trace a strand of interest in things regional, for example, the publishing activities of successive Kings of Shu, at Chengdu in Sichuan province, a region of China which in the Ming as now definitely had a profound sense of itself as having a distinctive history.[51] Under Zhu Chun, first King of Shu, there were published at Chengdu two histories of Shu, the *Shu jian* by Guan Yundao (*fl.* 1236) and *Shu Han benmo*, by Zhao Juxin (*fl.* fourteenth century), while in the sixteenth century a later King of Shu published the collected works of the Yongle era martyr Fang Xiaoru, who had as seen above strong connections to the kingly house.[52] Fang Xiaoru had perished in 1402 for his fidelity to the overthrown grandson of the dynastic founder and second ruler of the Ming, a victim of the King of Yan at the point that the latter established himself as the Yongle emperor. With his whole family extirpated, and the death penalty for any who owned his writings, he was the ultimate 'non-person' of early Ming history. But as time passed he came to be seen even by the imperial government as a paragon of loyalty and uprightness and came to be widely venerated by the bureaucratic elite as a symbol of its most cherished collective virtues. But it was not that elite who constructed the first shrine in his honour, rather it was the

King of Shu, descendant of one of Fang's original patrons, who had built a shrine to his memory in Chengdu in 1532.[53] Here again it was a local version of a universal virtue which kingly agency acted to make concrete and visible. So too in a slightly different form was the case of the 1577 Shu edition of a Northern Song pharmacopoeia, the *Chongxiu Zhenghe jingshi zhenglei beiyao bencao*, by Tang Shenwei. This popular compilation went through at least eleven different Ming editions, more then one of them from a kingly appanage press. But according to a Qing dynasty bibliographer, 'The publication of the Shu edition was prompted partly by the fact that the author, Tian [sic] Shenwei was a Sichuan native.'[54] In the light of this, we might revisit the otherwise exceptional activity of Zhu Mujie, a junior member of the Zhou lineage at Kaifeng who not only wrote and published compilations of biographies of eminent figures from Henan province (including the *Huangchao Zhongzhou renwu zhi*, 'Treatise on Personalities of the Central Realm Under the Reigning Dynasty', 1570), but was a principal editor of the 1555 gazetteer of the province, *Henan tong zhi* and the 1585 prefectural gazetteer *Kaifeng fuzhi*, 'activities in which no other member of any principality seems to have been engaged'.[55] This prolific aristocratic author was also responsible for the writing and publishing of a 'record of the accomplishments of the first Ming emperor' and a set of annals for the Jianwen reign.[56]

Here again we see a common elite culture which, in places like Chengdu and Kaifeng (though *not* in Suzhou or Hangzhou), encompassed aristocratic as well as degree-holding members; the list of Zhu Mujie's fellow editors of the Henan provincial gazetteer is headed by Li Lian (*jinshi* 1514), and distinguished both as an official and a prose stylist.[57] The 'care of text' provided one sort of site for their interaction, but it was not the only one. Historians of music have also noted the prominence of several members of the imperial clan, although typically this fact again remains isolated within the specialist scholarship and has not been integrated into a wider picture of the aristocracy's cultural role. And again the pattern of relay and reproduction as central to the activity of the kingly courts manifests itself. At the very beginning of the dynasty, the Ming founder ordered the bestowal of gifts of librettos of opera and song on the establishments of his sons enfeoffed in appanages, while in 1428 'Xuande granted the princes the privilege of keeping musician-dancers for sacrificial music, and imperial action that contributed to the princely courts' role as regional musical centres.'[58] Kingly courts certainly had extensive establishments of musicians; when the louche Zhengde emperor visited Taiyuan in 1518 he took as his mistress a certain Madame Liu, wife of one of the King of Jin's musicians, which suggests a certain degree of interaction between the kingly and

imperial establishments at this level![59] Several renowned virtuosi of the *pipa* (a lute-like instrument played mainly by professionals) were associated with kingly establishments; these included Zha Nai (active *c.* 1510–1560) and Tang Yingzeng (*b. c.* 1570), both of whom worked for the Zhou court at Kaifeng.[60]

A number of senior Ming aristocrats are themselves significant figures in the history of music, and consequently noticed in the specialist literature on that subject. Among them were figures already encountered above in a range of contexts. The earliest of them is Zhu Quan, King of Ning and son of the Ming founder, whose preface to 'Song Register of Supreme Harmony and Proper Tones' (*Tai he zheng yin pu*) 'attests to the political and social ramifications of imperial musiking', according to the music historian Joseph Lam. In 1425 the king published 'Fantastic and Secret Notations of *Guqin* Music' (*Shen qi mi pu*), 'the earliest known and verifiable anthology of *guqin* music in tablature notation' (the *guqin* being a transverse zither associated with elite and amateur male players; the king was buried with one).[61] Here one might draw an analogy with the project of calligraphy preservation and reproduction being carried out almost simultaneously by Zhu Quan's nephew in Kaifeng, since the preface to *Shen qi mi pu* claims (probably correctly) that sixteen of the 64 tunes it contains are from the Tang or Song periods, or even earlier.[62] In fact, 'Fantastic

and Secret Notations' is only one of a group of *guqin* texts produced by aristocratic authors during the Ming period, with a number of others through the fifteenth, sixteenth and seventeenth centuries forming a distinctive strand within the musical literature of the Ming.[63] One of them, the *Feng xuan xuan pin*, 'Classical and Civilizing *Guqin* Music' (1539), by Zhu Houjue, King Gong of Hui, was the first such text to be annotated with illustrations of performance techniques. A major compilation, the *Qin shu da quan*, 'Great Compendium of *Guqin* Texts', was edited in 1590 by Jiang Keqian, who though not an aristocrat himself came from the same family as the Jiajing emperor's mother (showing incidentally that such connections remained meaningful to contemporaries for decades).[64]

The instruments themselves, often highly valuable antiques, were closely associated with kingly owners, and in some cases makers. Shen Defu tells an illuminating story of how Zhu Houjue was a lover of *guqin*, who came into some sort of conflict with the prefect Chen Ji in making these instruments. He also tells as a footnote to this anecdote of the struggle over a famous *guqin* in the Zhengde reign between the King of Huai, Zhu Youqi, and the ultimately rebellious Zhu Chenhao, King of Ning. The instrument, called (for famous *guqin* all had individual poetic names) *Tian feng huan pei*, 'Jade Pendant in the Heavenly Breeze', was 'a rare treasure transmitted to the

King of Huai by his ancestors'.[65] In fact a number of Ming kings were famous as either players or even as makers of the *guqin*, the most notable probably being Zhu Changfang, King of Lu, active in the very last decades of the Ming dynasty, whose instruments survive in some numbers today (illus. 81).[66]

Perhaps the most renowned Ming aristocrat to be associated with the world of music is Zhu Zaiyu, heir to the King of Zheng, whose modern fame as 'scholar, musician, mathematician' makes him one of very few Ming kings to have their own entry in the *Dictionary of Ming Biography*.[67] As discussed above, he was related both by marriage and by training to the scholar He Tang. The author of a number of works on 'number' (integrating the modern disciplines of music and mathematics), Zhu Zaiyu is particularly significant in modern eyes for his work on the theory of temperament, which he published himself first in 1584 and then incorporated in 1606 into a compendium entitled 'Collected Works on Music History and Theory' (*Yue lü quan shu*).[68] Music was understood by all Ming intellectuals to be central to the right ordering of the state and the world, and so work on pitch can be seen as heavily implicated in what we might at its broadest reach describe as 'power'. Equally or even more significant in his own day, though less regarded in modern times (it has not been transmuted into the 'scientific'), was his work on ritual dance

(illus. 86).[69] Here the attempt to preserve and transmit the steps of the ancients in the correct performance of ritual is deeply associated in Ming terms with good governance; there can be no question that we are dealing here with some detached or autonomous realm of the 'aesthetic'.

This concern for the moral and political aspects of the antique can perhaps be seen as linking two realms of kingly activity as seemingly far from each other as Zhu Zaiyu's concern for correct deportment in ritual dance and the bronzes cast under the auspices of his contemporary the King of Lu. Both the Palace Museum in Beijing and the National Palace Museum in Taipei, the two segments of the imperial collections divided in the 1930s to protect them from Japanese aggression, contain bronze vessels in the style usually described as 'archaistic' (illus. 82), which bear very similar marks attributing them to the agency of the 'Master of Reverence for the Monad', *Jing yi zhu ren*.[70] They additionally bear various dates:

(Taipei): *Da Ming Chongzhen ba nian Lu guo zhi cheng yi qi*, 'Eighth year of Chongzhen of the Great Ming (1635), [for] the State of Lu, vessel one'.
(Beijing): *Da Ming Chongzhen ba nian Lu guo shijiu qi*, 'Eighth year of Chongzhen of the Great Ming (1635), [for] the State of Lu, vessel nineteen'.

(Beijing): *Da Ming Chongzhen jiu nian Lu guo sishi qi*, 'Ninth year of Chongzhen of the Great Ming (1636), [for] the State of Lu, vessel forty'.

The title 'Master of Reverence for the Monad' was borne by two successive holders of the appanage of Lu, situated at Weihui in Henan province; Zhu Yiliu, who died in 1614, cannot be the king in question here and so the relevant person must be his son, Zhu Changfang (1608–1648).[71] He was a man associated with a very wide range of cultural pursuits; we have already encountered him as a maker of *guqin*, and he was the author of a vast collection of biographies of exemplary imperial relatives from the dawn of time down to the Yuan period.[72] This makes it highly likely that he is the author of this project, which must have produced at least 40 such vessels, though only one other example in a Japanese collection is now known to survive. He was himself a calligrapher, a poet and a painter as well as a devotee of Buddhism. A Qing dynasty Weihui gazetteer describes the king as 'practised in literature and calligraphy, a lover of the pleasures of antiquity', while a nineteenth-century history of the Southern Ming says 'Changfang was skilled at calligraphy and painting, a lover

86 'Dance of Four Men', woodblock printed illustration of ritual dance from Zhu Zaiyu (1536–1611), *Yue lü quan shu*, printed book (dated 1573, Zheng appanage edition).

of antiquities, knowledgeable in explication of the canons'.[73] He was certainly the author and publisher, in 1634, of the last of the Ming kingly texts on music, *Gu yin zheng zong*, 'Orthodox Lineage of Antique Tones', and himself a major aficionado as we have seen of the *guqin*, the 'antique zither'.[74] He was the publisher in 1638 of *Lufan xinke shu gu shufa*

zuan ('Compilation of Ancient Calligraphy, An Edition Newly Carved and Annotated by the Lu Princely House').[75] He was a collector of paintings, his seal appearing on a work ascribed (if optimistically) to a major painter of the past (illus. 46). What links a number of these projects is a commitment to the values of the 'antique', values which were shared across the whole range of the Ming elite, and it is therefore fitting that it should have been his court which acted as the production centre for vessels which aim to materialize in the present the values of antiquity, through their eclectic mix of designs and forms drawn from a range of actual types and periods of ancient bronzes (and doubtless from examples in the collection of such things which the king himself almost certainly owned). Like the imperial clan member Zhu Mouyin (already encountered as the author of histories of calligraphy and painting which put that clan at the head of their listings), a man who edited a collection of archaic bronze inscriptions,[76] the King of Lu is here seen as a participant in a shared elite culture in which the forms of the 'antique' had considerably more than a purely aesthetic meaning.

Zhu Changfang fled south as peasant armies engulfed Henan in the turbulent fall of the Ming, and may well have taken his precious vessels with him. He was captured by the Manchus and executed in Beijing in 1646, a probable explanation for the presence in the Qing imperial collections of pieces he owned. By the eighteenth century he had become such a shadowy and forgotten figure that when one of the 'State of Lu' bronzes was published and reproduced in woodblock illustration in one of the great antiquarian collections of the Qing court, it was described as a genuine piece of the Zhou dynasty, despite the manifest evidence of its inscription.[77] No clearer testimony could be given to the way in which the appanage kings of the Ming had become culturally invisible, a status they have held largely unchallenged to the present day.

If the Lu bronzes or the surviving *guqin* give some sense of the kinds of luxury objects which could be manufactured in a kingly palace at the end of the Ming, then a few other examples of material culture with kingly associations hint poignantly at the range of material we might have lost in the wholesale destruction of those palaces at the fall of the Ming. A small vase in the British Museum, decorated in underglaze blue and dated stylistically to the very end of the Ming, bears the inscription *Fu fan zhi zao*, translatable as 'Made for [or 'by'] the Appanage of Fu' (illus. 87).[78] As long ago as 1923 Paul Pelliot identified this mark (which also appears on a piece in the Palace Museum, Beijing) as indicating an association with one or other of the two kings of Fu, an appanage based in Henan province and created in 1601 for Zhu Changxun, third son of the Wanli emperor.[79] Killed in his palace in Luoyang in

87 Porcelain vase painted in underglaze blue, *c.* 1640, *h.* 19 cm.

1640 by the rebel armies of Li Zicheng, he was succeeded by his son Zhu Yousong, elevated after the fall of Beijing to the Manchus to a short and inglorious reign as Southern Ming emperor.[80] Brilliant textual scholar though he was, Pelliot knew or cared less about material evidence, and his assertion that the vase was made in the kingly palace itself is at odds with everything we now know about the ceramics industries of the Ming, and the dominance of Jingdezhen in Jiangxi province as a centre of production. It is highly unlikely that this piece could have been made anywhere else, and certainly not in Henan. The same is true of other late Ming ceramic items bearing marks linking them to the Zhao, Jin, Qin and De appanages.[81] They stand as testimony to kingly ability to commission objects from kilns some distance from their own seats, and hint tantalizingly at possible networks and flows of goods which time and the trauma of Ming defeat have hidden from any more effective scrutiny.

SEVEN

REMEMBERED LANTERNS

Zhang Han (1511–1593) was one of the relatively rare cases proving that the Ming system was on occasion a meritocracy; he was of humble origins (with innkeepers and weavers among his immediate ancestors) but passed the *jinshi* examination in 1535 and rose through a series of offices to become, in effect, governor of Shaanxi province by 1565.[1] He came from Hangzhou, capital of the Southern Song dynasty from 1127 to 1279 and one of the major commercial and cultural centres of the empire, but much of his career was spent further north and further west, in regions of the empire very different from his home one, not least in that they contained appanages of the imperial clan, a type of social structure unknown in Jiangnan. He must have come into contact on a regular basis with 'kings of the blood', since his office required him to pay a monthly courtesy call on the King of Qin in Xi'an, and his perceptive essay recalling visits to the 'First Appanage Under Heaven' was quoted earlier, in chapter Two. However, in another essay entitled 'On the Appanages of the Imperial

Clan' (*Zong fan ji*), he voiced in less positive terms what was probably the pervasive view of the Ming official elite about the extended family to whom they were required to show such deference.[2] He begins by complaining about the proliferation of branches of the family, the ever-growing cost of their stipends to the finances of the province and the damage to tax revenues caused by their exempt status. Forbidden to take up most normal occupations, they suffer hardship and want: 'The impoverished make up 50–60 per cent, some of them even living in old kilns, unable to kindle a fire and with their limbs showing through their clothes, in extreme hardship.' He recalls an incident when several tens of imperial clansmen marched on the provincial capital to demand their salaries, and he was forced to placate them, giving them some firewood and some rice. A number of the ringleaders were subsequently arrested and imprisoned in the clan prison, known as the 'High Walls'. This cannot go on, he says, a situation where 'The imperial clan has increasing [numbers requiring] salaries,

but the world has no increase in fields.'[3] Elsewhere, he is scathing about the social effects of a kingly presence in the region he had come to know so well: 'Today the kingly households of the imperial clan are mostly in the northwest, while bullying arrogance and unfettered pursuit of private advantage are mostly also in the northwest.' He describes the bad moral tone the imperial clan sets and lists the punishments, confiscation and degradations they have received. Such complaints about the imperial aristocracy are multiplied in the memorials of officials struggling to meet tax quotas, and they have very much set the agenda over the past century for historians who perhaps instinctively see 'officials' as being people like themselves. It is the normative view in modern Chinese accounts that 'officials' (often elsewhere seen as oppressors of the people) embody in their conflicts with the aristocracy the reified categories of the State and hence of History. Yet at the same time as he is denouncing their wastefulness and corruption in vivid detail, Zhang Han provides vignettes which, like his nostalgic recall of the splendid entertainments in the gardens of the King of Qin, perhaps give us a different view of some imperial clan members:

> I once passed through Puzhou in Shanxi, and met Xixuan, King of Xiangyuan, now over 70 years old. I met two of his sons, Sanfeng and Sifeng, and at table we talked frankly of current events – they were fully conversant with all aspects of the ancient and the modern, and I regretted that there could be no occupation for them.

He muses that it would be better if the state now abolished the prohibition on them sitting the examinations (which it eventually did, in 1595), since such men have the talent to serve the empire by holding office (as indeed the imperial clan did in the Song period, something a Hangzhou native probably knew). He recalls another such meeting:

> I once met Longtian, King of Huaiyin, of solid abilities and a lover of antiquity, in his dress and manner all just like a scholar. His son Yuanfeng had a bearing out of the ordinary, excellent at the elegant practice of poetry and prose, delighting in disputation . . .[4]

Here we see a tension, which Zhang Han was probably not the only official to feel, between the imperial clan in the abstract as A Bad Thing and the warm personal memories of individual members of that clan.

Something of that ambivalence survived the fall of the Ming dynasty, a catastrophe in which several appanage kings played a starring, if less than glorious, role. It is partly the Ming kingly role in resistance to the Manchus that makes them such negative figures in official

historiography of the Qing dynasty. Could it be that their near success in creating a 'southern Ming' makes them such figures of obloquy? Maybe they came nearer than hindsight would allow? For Ming loyalists like Gu Yanwu (1613–1682), writing in an essay entitled *Zong shi*, 'The Imperial Clan', the enormous and wasteful cost of the upkeep of kingly establishments, alongside their exclusion from any meaningful share in the imperial administration, had been factors which had weakened and imperilled the dynasty. For many, the personal failings of the imperial house rankled as they sought explanations of the catastrophe.[5]

For others, as the decades passed after 1644, the kingly court became something of a *lieu de mémoire* round which nostalgia for the fallen Ming might be structured. At the same time as he reprehended the extravagance of the Ming imperial clan, Gu Yanwu viewed the practice of establishing hereditary jurisdictions (*feng jian*) as a positive thing which guaranteed a degree of local autonomy; his term is the same as that used in the Ming for appanages, even if this native of Kunshan in the Yangtze delta grew up far from any of the regions where the Ming imperial clan was prominent.[6] The 'localist turn', identified as one of the cultural trends of the late Ming era, perhaps lived on into the early Qing through nostalgia for the fallen appanage houses.[7] To one of the great memoirists of the seventeenth century, Zhang Dai, the vanished splendours of the court of

the Kings of Lu at Yanzhou in Shandong province stood for the sadness and chagrin of the entire dynastic collapse. Zhang's father had been appointed in 1627 to the household of the King of Lu, and the two men were in his recollection close, bonded by their shared devotion to Daoist breathing exercises. A great set-piece essay on the gorgeous lanterns paraded by the court and the spectacular fireworks which accompanied them at the New Year festivities in 1629, though not written down until after the dynastic collapse, is suffused with nostalgia for lost happiness.[8] And when the King of Lu fled south in the face of Manchu invasion in 1644, Zhang Dai received him in his home in Shaoxing, describing decades later the crowds, the feasting, the ritual, and the mixture of pride and black humour with which he cast himself in the role of family retainer to the fallen 'state' of Lu.[9]

But Zhang Dai was not the only memorialist of Lu's fallen glories. Yanzhou itself was sacked in the Qing conquest, the royal palace devastated by fire. Yet it was remembered in verse by, among others, the poet Yan Ermei (1603–1662), in 'Passing Again Through Yanzhou', the last line of which evokes the poet's chagrin at the cicadas chirping in the ruins where once there had been convivial drinking parties.[10] One poem by the Qing poet Zhang Tinggui on 'The Palace of the King of Lu' forms part of a set of verses in the genre of *huaigu*, 'remembering the antique', and is

suffused with the genre's typical imagery of vast desolation, with piles of glazed tile fragments among the long autumn grasses.[11] The palace remained a part of the local history (one gate survived as late as the 1950s), recorded in local gazetteers and hymned by local poets long after it had ceased to have a substantial physical presence, its passing evoked by place names to show where it had once stood. In Taiyuan too, a lyric, 'Passing the Old Palace of the Jin Appanage: To the Tune Lanling Wang' by Zhu Yizun (1629–1709), uses the same imagery of desolation.[12] At Jingzhou in Huguang province, seat of the Kings of Liao, the Qing dynasty poet Deng Tingyan wrote 'Singing of Ancient Days in the Liao City'.[13] And in Xi'an, possibly the most densely aristocratic of all Ming cities, gazetteers and other local histories maintained a sense of where the great palace of the Kings of Qin had once been, as the space was successively transformed into the parade ground for the Manchu Banner garrison, then into the site of the new provincial government in the Republican era and then, after 1949, the so-called 'New City'.[14] Gazetteers preserved the memory of kingly burial sites among the learned, for whom they counted as *gu ji*, 'traces of antiquity', while place names often kept alive in the speech of humble people the dim memory of courtly burials, villages having names like 'Village of the Well of King Kang'.[15] And of course there was the living presence of the numerous descendants of the Ming imperial

clan itself. These included two of the most celebrated painters of the seventeenth century, both of whom also at various points in their lives assumed a Buddhist monastic identity: Bada Shanren (1626–1705), a descendant of the Yiyang branch of the Ning appanage in Jiangxi, and Shitao (1642–1707), a member of the Jingjiang linaeage in Guangxi. The memory of kingly origins was part of the complex identity of each of these prominent and lauded figures.[16] But there were also tens of thousands of much more humble people living lives in which remembrance of imperial ancestry may have played private roles of which we remain ignorant.

In peasant communities, folk memory of the kingly lineages of the Ming was preserved in a number of ways, and claims of kinship with the Zhu family remain vital in parts of China today. The lesser members of the household of the appanage of Lu at Yanzhou in Shandong are said in a later gazetteer to have fled into marshy and impenetrable areas, and descendants of imperial clan refugees were said to inhabit one whole village. And in the city of Yanzhou itself there is a local legend that in the late Qing period English missionaries carried out excavations at the site of the former kingly palace, sending away their Chinese workers and digging themselves behind a wooden screen, carrying great quantities of treasure away overseas.[17] Here we find echoes of the many ways in which the vastly ramified imperial clan was knitted

88 The Ninghua Palace vinegar shop and factory site, Taiyuan, Shanxi province.

into local society at a whole range of levels, such that the eradication of its head did not lead to its complete oblivion in memory and in myth.

This popular presence of Ming appanage kings continues to have some meaning in contemporary China. This is so through things like the Ninghua Palace brand of vinegar, a crucial ingredient of the Shanxi style of cooking and a key marker in material culture of a Shanxi identity. The factory and crowded outlet in the heart of modern Taiyuan (illus. 88) proudly claim an origin which was 'Founded in 1377', when the Ninghua branch of the Jin lineage

was first established for Zhu Jihuan, Commandery King of Ninghua. Publicity material for the firm tells how the Yiyuanqing workshop was set up to produce exclusively for the kingly house, and how it became through the Ming and Qing one of the 'famous brands' of Chinese foodstuffs. It claims how the 'broad masses' had always colloquially known this brand as 'Ninghua Palace', in recognition of which this is now used in marketing as the preferred name for this much-lauded and much-appreciated product. This modern sense of kings as 'local heroes'

can also be seen in Zhongxiang, Hubei province, seat of the appanage of Xing. One of the holders of this appanage, Zhu Houcong, was summoned to Beijing when the main imperial line failed and assumed the rule of the Ming empire as the Jiajing emperor (*r.* 1522–66). Scholars visiting Zhongxiang may be treated at lunch to a sort of (very tasty) chicken meatloaf which local knowledge claims as the king's very favourite dish, and they are likely to be taken to a Qing period building which sits somewhere on the site of the vanished kingly palace but which now contains tableaux of the king and emperor's life (illus. 89). Zhu Houcong may have had a rough ride from later historians, for his idleness, his cruelty, his obsession with Daoist mystical and alchemical practices, but in

89 'Palace of the Kings of Xing', diorama from a series showing the life of the Jiajing emperor (*r.* 1522–66), Xiangfan, Hubei province.

90 Site of the tombs of the Kings of Chu, outside Wuhan, Hubei province.

Zhongxiang there is a palpable sense that he is a local figure, whose prominence is worthy of commemoration. And on the outskirts of the rapidly expanding megalopolis of Wuhan, a local community led by a descendant of the Ming dynasty Kings of Chu was in 2009 putting a great deal of effort and a quantity of capital into turning the valley which houses the tombs of the kings of the Chu lineage into a destination spot for day-trippers from the great city (illus. 90). The classification of the mansion and tombs of the Kings of Jingjiang at Guilin as a 'tourist resource', on a par with the region's celebrated and spectacular limestone peaks, and its description as 'undoubtedly possessing effective branding in the cultural historical tourism of the whole country' builds on, rather than precludes, more popular and local appropriations of the Ming kings as local resources allied to a sense of local identities.[18]

Significantly, a lot of the scholarship on which this study is based is work which is itself local, and published in the context of local centres of higher education; thus work on the Kings of Jin appears in 'Studies on the Culture of Jinyang' (*Jinyang wenhua yanjiu*), while that on the appanages of Hubei might be published in the journal 'Jianghan Review' (*Jianghan luntan*), and that on the Kings of Lu at a major conference held at their seat in Xinxiang, Henan province.[19] It would be going too far to suggest that local kings provide a resource for any form of resistance to the homogenizing and centralizing tendencies of official cultural discourse in contemporary China, but they do (rather like the Bronze Age kingdoms after which so many of them are named) provide a way of thinking about the regional which is non-controversial and non-threatening to that discourse. Some of the tensions at play here can perhaps be seen in the coda (rhetorically slightly *retardataire* by the standards of 2004) to an article on the tombs of the appanage kings of Ming Jiangxi, published in the journal *Nanfang wenwu* ('Cultural Relics of the South'), which concludes with an invocation of the tombs as evidence of the rotten decadence of the feudal ruling class, and of the blood and sweat of the labouring masses, their intelligence and great creative powers, 'capable of generating great feelings of national pride, and a determination to make new contributions to the development and progress of a new socialist culture, and the flourishing and prosperity of the motherland'.[20] Here we see an attempt to write the local *into* the national, into the master narrative of Chinese history as it has evolved from the intellectuals of the late Qing, through the Republican era into the People's Republic itself.

For such intellectuals, whether Marxist or not, the appanage kings of the Ming have been an obstacle to history rather than active agents within it. As Prasenjit Duara has so elegantly shown, the process whereby *feng jian*, which in the Ming would have meant 'establishment of appanages', came to mean 'feudal', with all the negative freight of connotations of backwardness which that implies, meant that the Ming kings were at once associated in modern historical scholarship with the worst aspects of *ancien régime* which intellectuals like Kang Youwei (1858–1927) and Liang Qichao (1873–1929) were so eager to jettison.[21] The court, as noted in Chapter One was seen as the antithesis of the modern. Yet there is an irony in that the European power which someone like Liang Qichao most admired, or saw as a model (partly because it lacked the associations with humiliation which attached themselves to its rival the British Empire) was the German Empire, which contemporary scholarship has identified as being in ways the most 'courtly' of European regimes. There was (is) no necessary contradiction between industrial might, or rapidly constructed battle fleets and a fascination with

precise and ceremonious delineation of rank, with gorgeous uniforms, even with decorative 'kings' (Bavaria, Saxony, Württemberg) and a whole plethora of Grand-Dukedoms which, while lacking independent political agency and power, were vital to the functioning of the whole apparatus, and the focus of genuine loyalties on the part of its peoples.[22]

The introduction of a comparative dimension here is deliberate. The willed ignorance of China's past which has sustained the historical enterprise in the West is often answered by a willingness on the part of historians of China, from the intertwined imperatives of sinological and nationalist discourses, to assume that 'the West' is a known and stable entity with which China's difference can be contrasted. This is so whether that difference is being condemned or celebrated. The twin perils of a single, universal, totalizing model (whether it be a model of the 'traditional', the 'modern', the 'feudal') *and* at the same of a radically relativist understanding, are well put by Stephen Greenblatt:

> For thoroughgoing relativism has a curious resemblance to the universalizing that it proposes to displace: both are uncomfortable with histories. Histories threaten relativism, though they seem superficially allied, because the connections and ruptures with which historians are concerned sort ill with the unorganized, value-neutral equivalences that would allow each

moment a perfect independence and autonomy . . . But if we reject both the totalizing of a universal mythology and the radical particularizing of relativism, what are we left with? We are left with a network of lived and narrated stories, practices, strategies, representations, fantasies, negotiations and exchanges that, along with the surviving aural, tactile and visual traces, fashion our experiences of the past, of others, and of ourselves.[23]

Histories are precisely what the Ming regional kings, invisible as actors on a historical stage already crowded with the reified categories of 'peasants' and 'scholar-gentry', have not been granted. This book is therefore an attempt to provide a history of a sort, though a history written around things and representations as much as around the more respectable categories of enquiry such as 'government' or 'power'. Yet even power can be looked at in more than one way:

> To sum up . . . rather than orienting our research into power toward the juridical edifice of sovereignty, State apparatuses, and the ideologies that accompany them, I think we should orient our analysis of power toward material operations, forms of subjugation, and the connections among and the uses made of the local systems of subjugation on the one hand,

and apparatuses of knowledge on the other.[24]

To look at the Ming kingly court and its occupants as 'an apparatus of knowledge' requires that we to a degree reconfigure our sense of what matters. Historians of early medieval Europe are in some cases turning to work done on pre-modern India in order to make subtler their understanding of power, as something which does not simply flow down from a centre, ebbing as it reaches peripheries.[25]

Historians of early modern Europe are increasingly uncomfortable with the Geertzian dichotomy between 'pomp' and 'power', and with purely instrumentalist explanations of ritual and ceremony as propaganda designed to achieve effects in the 'real world'.[26] Perhaps historians of China need to be equally on guard, to not see the practices of calligraphic canon formation, the printing of local histories or the construction of great gardens as simply *either* the displacement activities of those denied access to 'real power' *or* activities designed to further and at the same time to mask 'forms of subjugation'. An attention to the material operations of kingly elites within the Ming empire, attention in which surviving and yet to be discovered aspects of material and visual culture must play a central role, can perhaps unsettle too-long-established ways of thinking about that part of China's past. By

paying attention to the 'fence and screen' which they formed, we can perhaps realize just how little we really still understand about what lay behind.

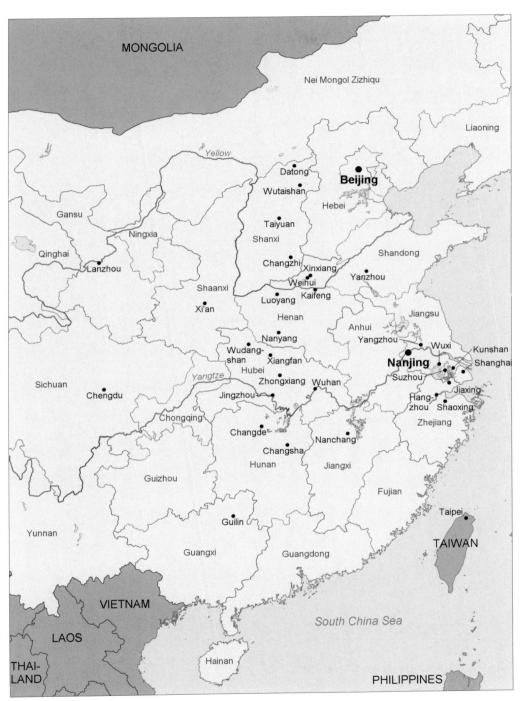

Map illustrating locations mentioned in the text. Michael Athanson, Bodleian Library, Oxford.

REFERENCES

LIST OF ABBREVIATIONS

BXT: Jin ci bowuguan, ed., *Bao xian tang ji gu fa tie* (Beijing, 2002)

DMB: L. Carrington Goodrich and Chaoying Fang, eds, *Dictionary of Ming Biography, 1368–1644*, 2 vols (New York and London, 1976)

ISMH: Wolfgang Franke, *An Introduction to the Sources of Ming History* (Kuala Lumpur, 1968)

MRZJ: Guoli zhongyang tushuguan, *Mingren zhuanji ziliao suoyin*, 2nd edn (Taibei, 1978)

MS: Zhang Tingyu et al., eds, *Ming shi*, 28 vols (Beijing, 1974)

ZGWWDTJ Hubei: Guojia wenwuju, ed., *Zhongguo wenwu dituji: Hubei fence*, 2 vols (Xi'an, 2002)

ZGWWDTJ Shanxi: Guojia wenwuju, ed., *Zhongguo wenwu dituji: Shanxi fence*, 3 vols (Beijing, 2006)

ONE: 'A FENCE AND A SCREEN'

1 Matteo Ricci, *On Friendship: One Hundred Maxims for a Chinese Prince*, trans. Timothy Billings (New York, 2009).

2 Ricci, *On Friendship*, p. 66.

3 Timothy Billings notes of Zhu Duojie, 'Ricci observes that he has "the title of a king", but the more generic translation of "prince" here is customary and probably more accurate.' Ricci, *On Friendship*, p. 66.

4 Julia Ching, *Mysticism and Kingship in China: The Heart of Chinese Wisdom*, Cambridge Studies in Religious Traditions, 11 (Cambridge, 1997), pp. 32–7. Note that Ching refers to a Ming *wang* as a 'prince' (p. 122). Léon Vandermeersch, *Wangdao; ou, La Voie royale: Recherches sur l'esprit des institutions de la Chine archaïque* (Paris, 1977–80), vol. II, pp. 11–12, identifies the traditional etymology of *wang* as '*entièrement fausse*'.

5 Prasenjit Duara, *Rescuing History from the Nation: Questioning Narratives of Modern China* (Chicago and London, 1995), p. 173.

6 *Shi jing*, 'Da Ya: Ban' (Ode 254:7), cited in Lothar von Falkenhausen, *Chinese Society in the Age of Confucius (1000–250 BC): The Archaeological Evidence* (Los Angeles, 2006).

7 *OED* 'Provision for younger children of kings'. The *OED* allows spelling with either one or two 'p's.

8 Wu Hung, *The Double Screen: Medium and Representation in Chinese Painting* (London, 1996), pp. 9–28.

9 Frederic Wakeman Jr, *The Great Enterprise: The Manchu Reconstruction of Imperial Order in Seventeenth-century China* (Berkeley, Los Angeles and London, 1985), vol. I, p. 333.

10 For example, Craig Clunas, *Superfluous Things: Material Culture and Social Status in Early Modern China* (Cambridge, 1991); John Meskill, *Gentlemanly Interests and Wealth on*

the *Yangtze Delta* (Ann Arbor, MI, 1994);
Timothy Brook, *The Confusions of Pleasure:
Commerce and Culture in Ming China*
(Berkeley, Los Angeles and London, 1998);
Craig Clunas, *Empire of Great Brightness:
Visual and Material Cultures of Ming China,
1368–1644* (London, 2007).

11 The classic account is Lynn A. Struve, *The
Southern Ming, 1644–1662* (New Haven, CT,
and London, 1984).

12 Zhang Tingyu et al., eds, *Ming shi*, 28 vols
(Beijing, 1974) [hereafter MS], vol. XII, *juan*
116–120, *Lie zhuan* 4–8, pp. 3557–60. This
source needs to be treated with care, as it can
be inaccurate as to names and dates of imperial
clan members.

13 L. Carrington Goodrich and Chaoying Fang,
eds, *Dictionary of Ming Biography, 1368–1644*,
2 vols (New York and London, 1976) [hereafter
DMB] contains the following entries: Zhu Quan
(1378–1448), DMB I, pp. 305–7, 'prince and man
of letters'; Zhu Gaoxu (c. 1380–c. 1429), DMB,
I, pp. 340–44, 'prince of Han'; Zhu Mouwei
(d. 1624), DMB, I, pp. 345–6, 'scholar and biblio-
phile'; Zhu Su (1361–1425), DMB, I, pp. 350–54,
'first prince of Zhou'; Zhu Zaiyu (1536–1611),
DMB, I, pp. 367–71, 'scholar, musician, math-
ematician'; Zhu Youdun (1379–1439), DMB, I,
pp. 380–81, 'prince and dramatist'.

14 Charles O. Hucker, *A Dictionary of Official
Titles in Imperial China* (Stanford, CA, 1985),
p. 71. Also Charles O. Hucker, 'Ming
Government', in *The Cambridge History of
China*, vol. VII: *The Ming Dynasty, 1368–1644*,
ed. Frederick W. Mote and Denis Twitchett
(Cambridge, 1998), pp. 9–105 (pp. 25–7).
Hucker's term 'nobility' will be avoided in
preference to 'aristocracy', following the

distinction between the former as a 'formal
legal status' and the latter as lineages 'related
to the ruling family by ties of blood and mar-
riage' made in Hamish M. Scott, '"Acts of Time
and Power": The Consolidation of Aristocracy
in Seventeenth-century Europe, c. 580–1720',
*Bulletin of the German Historical Institute
London*, XXX/2 (2008), pp. 3–37 (p. 5).

15 One recent overview of Ming cultural history
devotes 13 pages out of nearly 450 to 'The
Declining Imperial Clan and Aristocratic
Culture'; see Shang Chuan, *Mingdai
wenhuashi* (Shanghai, 2007), pp. 143–55.

16 David M. Robinson, 'Introduction', in
*Culture, Courtiers, and Competition: The
Ming Court (1368–1644)*, ed. David M.
Robinson, Harvard East Asian Monographs,
301 (Cambridge, MA, and London, 2008),
pp. 1–20 (p. 15). Important work on the
Ming imperial court would include Richard
M. Barnhart, *Painters of the Great Ming: The
Imperial Court and the Zhe School* (Dallas,
1993), and the numerous essays in the themed
issue of *Gugong xuekan*, IV (2008); both
largely ignore the kingly courts. An exception
is the comparison between Ming and Qing
systems for the management of imperial
relatives in Zhu Chengru, 'Mingdai de fengfan
yu Qingdai fengjuezhi zhi bijiao yanjiu', in
*Qingdai wangfu ji wangfu wenhua; Guoji
xueshu yantaohui lunwenji*, ed. Gong wangfu
guanli zhongxin (Beijing, 2006), pp. 224–30.

17 Edward L. Farmer, *Early Ming Government:
The Evolution of Dual Capitals* (Cambridge,
MA, and London, 1976), pp. 73–9 and
pp. 90–93; Liu Haiwen, 'Fan wang ji wei –
Mingchao diwang chuanchengzhong de
tuchu tedian', *Xinxiang shifan gaodeng zhuanke*

xuexiao xuebao, xx (2006.3), pp. 2–4 (pp. 2–3).

18 Shen Shixing, ed., *Ming hui dian* (Beijing, 1989), *juan* 55, *Wang guo li* I: *Feng jue*, p. 346.

19 For example Michael Loewe, 'The Structure and Practice of Government', in *The Cambridge History of China*, vol. I: *The Ch'in and Han Empires, 221 BC–AD 220*, ed. Denis Twitchett and John K. Fairbank (Cambridge, 1987), pp. 463–90 (pp. 470–75).

20 John W. Chaffee, *Branches of Heaven: A History of the Imperial Clan of Sung China* (Cambridge, MA, and London, 1999), especially pp. 3–26.

21 Thomas Allsen, 'Sharing out the Empire: Apportioned Lands Under the Mongols', in *Nomads in the Sedentary World*, ed. Anatoly Khazanov and André Wink (Richmond, 2001), pp. 172–90; David Sneath, 'Introduction – Imperial Statecraft: Arts of Power on the Steppe', in *Imperial Statecraft: Political Forms and Techniques of Governance in Inner Asia, Sixth–Twentieth Centuries*, ed. David Sneath (Bellingham, WA, 2006), pp. 1–22 (p. 7); Peter Jackson, 'The Mongol Age in Eastern Inner Asia', in *The Cambridge History of Inner Asia: The Chinggisid Age*, ed. Nicola Di Cosmo, Allen J. Frank and Peter B. Golden (Cambridge, 2009), pp. 26–45 (pp. 37–9).

22 Shen Defu, *Wanli ye huo bian*, Yuan Ming shiliao biji congkan (Beijing, 1980), vol. I, pp. 112–13.

23 Edward L. Farmer, *Zhu Yuanzhang and Early Ming Legislation: The Reordering of Chinese Society Following the Era of Mongol Rule*, Sinica Leidensia, 34 (Leiden, New York and Cologne, 1995), pp. 38–9. A full translation of *Zu xun lu* forms pp. 114–49 of this work. See also Satō Fumiyoshi, *Mindai ōfu no kenkyu* (Tokyo, 1999), pp. 34–85, and John D.

Langlois Jr, 'The Hung-wu Reign, 1368–1398', in *The Cambridge History of China*, vol. VII: *The Ming Dynasty, 1368–1644, Part I*, ed. Frederick W. Mote and Denis Twitchett (Cambridge, 1988), pp. 107–81 (pp. 174–8).

24 Farmer, *Zhu Yuanzhang*, pp. 140–41. These titles, with the exception of my preference for 'king' over 'prince', follow Hucker, *A Dictionary of Official Titles in Imperial China*.

25 Farmer, *Zhu Yuanzhang*, pp. 140–41.

26 Cho-yun Hsu, 'The Spring and Autumn Period', in *The Cambridge History of Ancient China: From the Origins of Civilization to 221 BC*, ed. Michael Loewe and Edward L. Shaughnessy (Cambridge, 1999), pp. 545–86 (pp. 558–60). Tracy Miller, *The Divine Nature of Power: Chinese Ritual Architecture at the Sacred Site of Jinci*, Harvard–Yenching Institute Monograph Series, 62 (Cambridge, MA, and London, 2007), pp. 37–50.

27 One anomaly in the system was the Kings of Jingjiang, with their seat at Guilin. The first holder of the title was a grandson of the Ming founder's brother, and they ranked as *qin wang*, 'kings of the blood'; the two-character name of their state and their posthumous titles caused endless confusion, even to the Qing dynasty editors of the *Ming shi*. It is partially unravelled in Qi Zhaojin, 'Ming Jingjiang wang de jueji', *Shehuikexuejia*, xv/2 (March 2000), pp. 79–85.

28 For examples of such maxims, from the state of Lu in Shandong and Zhou in Kaifeng, see Chen Yong, 'Mingdai Yanzhou Luwang he wangfu', *Shihai gouchen/Zhongzhou Today and Yester-day* (2003.1), pp. 8–16 (p. 11), and Xu Hong, 'Mingdai Kaifeng Zhouwang de xiangguan wenti', *Henan keji daxue xuebao (Shehui kexue*

ban), XXII/4 (2004), pp. 21–4 (p. 22); also Wang Fangyu, Richard M. Barnhart and Judith G. Smith, eds, *Master of the Lotus Garden: The Life and Art of Bada Shanren (1626–1705)* (New Haven, CT, and London, 1990), p. 29.

29 Farmer, *Zhu Yuanzhang*, p. 129. The 'Ceremonial for Kings Coming to Pay Court' is MS, V, *juan* 53, *Zhi* 29: *Li* I, p. 1354.

30 Shen Defu, *Wanli ye huo bian*, I, p. 106.

31 Shen Defu, *Wanli ye huo bian*, I, p. 103.

32 Shen Defu, *Wanli ye huo bian*, I, pp. 106–7.

33 Tracy Miller, *The Divine Nature of Power*, p. 58. See also Wu Hung, *Monumentality in Early Chinese Art and Architecture* (Stanford, CA, 1995), pp. 88–91, and Roger Des Forges, 'Tales of Three City Walls in China's Central Plain', in *Chinese Walls in Time and Space: A Multidisciplinary Perspective*, ed. Roger Des Forges, Minglu Gao, Liu Chiao-mei and Haun Saussy, with Thomas Burkman (Ithaca, NY, 2009), pp. 37–80.

34 Nicholas Bock, 'Patronage, Standards and *Transfert Culturel*: Naples Between Art History and Social Science Theory', *Art History*, XXXI/4 (2008), pp. 574–97 (pp. 588–90).

35 Clifford Geertz, *Negara: The Theatre-State in Nineteenth-century Bali* (Princeton, NJ, 1980), p. 23, cited in Robinson, 'Introduction', p. 28.

36 Ching, *Mysticism and Kingship in China*, p. 48.

37 In addition to the numerous biographies which the 'Ming History' (*Ming shi*) contains (see note 12 above), the imperial clan is highly prominent in this text, in the 'Treatises' (*zhi*). Their ceremonial entourage is described in MS, VI, *juan* 64, *Zhi* 40: *Yi wei*, pp. 1627–31. Their dress is described in MS, VI, *juan* 66, *Zhi* 42: *Yu fu* 2, pp. 1627–31; seals are described in MS, VI, *juan* 68, *Zhi* 44: *Yu fu* 4, p. 1660. Three chapters of the dynastic statutes are taken up with 'Rituals of the Kingly States' (*Wang guo li*), only one place in this text at which they appear. They appear too in the dynastic statutes; Shen Shixing, ed., *Ming hui dian*, *juan* 55–7, pp. 346–60. This in turn is a major source for the prescriptive text *Wang guo dian li*, 'Statutes and Rites of the Kingly States', with a preface dated 1615, by Zhu Qinmei, himself a member of the imperial clan: Zhu Qinmei, *Wang guo dian li*, in *Si ku quan shu cunmu congshu*, vol. CCLXX (Ji'nan, 1995–97). The anonymous *Zong fan tiao li*, 'Precedents of the Imperial Appanages', is a compilation of documents which appears to emanate from a bureaucratic rather than an imperial clan milieu: *Zong fan tiao li*, in *Beijing tushuguan guji zhenben congkan* (Beijing, 1998), vol. LIX. The material on imperial clan members in the 'Veritable Records' (much of it chronicling imperial gifts and grants) has been conveniently collected in Li Qiongying and Zhang Yingzhao, eds, *Ming shi lu lei zuan: Zong fan gui qi lei* (Wuhan, 1995).

38 Ruby Lal, *Domesticity and Power in the Early Mughal World*, Cambridge Studies in Islamic Civilization (Cambridge, 2005), p. 52 and p. 56, drawing on the work of Ranajit Guha and Sanjay Subramanyam.

39 Paul Goldin, 'On the Meaning of the Name Xi Wangmu, Spirit-Mother of the West', *Journal of the American Oriental Society*, CXXII/1 (2002), pp. 83–5, cited in Miller, *The Divine Nature of Power*, p. 85.

40 Ching, *Mysticism and Kingship in China*, pp. 211–12.

41 Julia K. Murray, 'Illustrations of the Life of Confucius: Their Evolution, Functions and

Significance in Late Ming China', *Artibus Asiaei*, LVII.1/2 (1997), pp. 73–134 (p. 76).

42 Weirong Shen, '"Accommodating Barbarians from Afar": Political and Cultural Interactions Between Ming China and Tibet', *Ming Studies*, 56 (Fall 2007), pp. 37–93 (p. 52).

43 Henry Serruys, 'Mongols Ennobled During the Early Ming', *Harvard Journal of Asiatic Studies*, XXII (1959), pp. 209–60 (pp. 256–7).

44 Quoted in Joan-Pau Rubiés, 'Oriental Despotism and European Orientalism: Botero to Montesquieu', *Journal of Early Modern History*, IX/2 (2005), pp. 109–80 (p. 127).

45 Rubiés, 'Oriental Despotism and European Orientalism', p. 133.

46 Charles Boxer, *South China in the Sixteenth Century, Being the Narratives of Galeote Pereira, Fr. Gaspar da Cruz, O.P. [and] Fr. Martin de Rada, O.E.S.A. (1550–1575)* (London, 1953), pp. 40–41.

47 Geertz, *Negara*, p. 13; also p. 45 (on 'despotism').

48 Scott, '"Acts of Time and Power"', p. 5.

49 James Hevia, *Cherishing Men from Afar: Qing Guest Ritual and the Macartney Embassy of 1793* (Durham, NC, and London, 1995), pp. 29–56.

50 Timon Screech, *The Shogun's Painted Culture: Fear and Creativity in the Japanese States, 1760–1829* (London, 2000).

51 Lothar Ledderose, *Ten Thousand Things: Module and Mass Production in Chinese Art* (Princeton, NJ, 2000), and Clunas, *Empire of Great Brightness*, pp. 115–17.

52 Jeroen Duindam, *Vienna and Versailles: The Courts of Europe's Dynastic Rivals, 1550–1780* (Cambridge, 2003), p. 7.

53 Robinson, 'The Ming Court', p. 37, citing Daud Ali, *Courtly Culture and Political Life in Early Medieval India* (Cambridge, 2004), pp. 1–4.

54 Jeroen Duindam, *Myths of Power: Norbert Elias and the Early Modern European Court* (Amsterdam, 1995).

55 Duindam, *Vienna and Versailles*, pp. 8–9.

56 Sheldon Pollock, *The Language of the Gods in the World of Men: Sanskrit, Culture, and Power in Premodern India* (Berkeley, Los Angeles and London, 2006), p. 29.

57 Pollock, *Language of the Gods*, p. 14.

58 Joseph Needham, *Science and Civilisation in China*, vol. I: *Introductory Orientations* (Cambridge, 1954), p. 147.

59 William H. Nienhauser Jr, ed., *The Indiana Companion to Traditional Chinese Literature* (Bloomington, IN, 1986), pp. 344–6; Ren Zunshi, *Zhou Xianwang yanjiu* (Taibei, 1974), and Wilt Idema, *The Dramatic Oeuvre of Chu Yu-tun (1379–1439)*, Sinica Leidensia, 16 (Leiden, 1985).

60 Nienhauser, *Indiana Companion to Traditional Chinese Literature*, pp. 329–30. He has been the subject of a full biography, Yao Pinwen, *Zhu Quan yanjiu* (Nanchang, 1993), which has not been available to me.

61 R. H. van Gulik, *The Lore of the Chinese Lute* (Tokyo, 1968), pp. 213–16.

62 Kenneth Robinson, *A Critical Study of Chu Tsai-yu's Contribution to the Theory of Equal Temperament in Chinese Music*, Sinologica Coloniensa, 9 (Wiesbaden, 1980).

63 Zhao Qian and Zhang Zhiqing, 'Book Publishing by the Princely Households during the Ming Dynasty: A Preliminary Study', *The East Asian Library Journal*, X/1 (Spring 2001), pp. 85–128; Lucille Chia, 'Publications of the Ming Principalities: A Distinct Example of Private Printing', *Ming Studies*, 54 (Fall 2006), pp. 24–70; Jérôme Kerlouégan, 'Printing for

Prestige? Publishing and Publication by Ming Princes', *East Asian Publishing and Society*, I (2011), pp. 39–73.

64 An Jiesheng, *Lishi dili yu Shanxi difangshi xintan* (Taiyuan, 2008), p. 465; Zhang Jianmin, 'Mingdai Lianghu diqu de zongfan yu difang shehui', *Jianghan luntan* (2002.10), pp. 76–81.

65 John Kerrigan, *Archipelagic English: Literature, History and Politics, 1603–1707* (Oxford, 2008), p. 80.

TWO: THE KINGLY LANDSCAPE

1 Wolfgang Franke, *An Introduction to the Sources of Ming History* (Kuala Lumpur, 1968) [hereafter *ISMH*], 8.7.1.

2 Zhang Guoning, 'Ming Jinwang jiqi zongshi zakao', *Jinyang wenhua yanjiu*, I (Taiyuan, 2006), pp. 97–127 (p. 124).

3 Li Weizhen, *Shanxi tong zhi*, 30 *juan* (Wanli period), in *Xijian Zhongguo difangzhi huikan* (Beijing, 1992), vol. IV, *juan* 11, pp. 17a–28b (pp. 120–25 in modern pagination).

4 Li Weizhen, *Shanxi tong zhi*, *juan* 10, pp. 1b–2a (p. 97).

5 Li Weizhen, *Shanxi tong zhi*, *juan* 14, pp. 12b–13a (pp. 174–7) and pp. 25a–25b (p. 181) Kings of Jin and cadet lineages; pp. 30a–30b (p. 183) and p. 36a (p. 186) Kings of Shen and cadet lineages; pp. 41a–41b (p.189) and p. 49a (p. 193) Kings of Dai and cadet lineages.

6 Li Weizhen, *Shanxi tong zhi*, *juan* 26, p. 7a (p. 503); Marsha Weidner, 'Imperial Engagements with Buddhist Art and Architecture: Ming Variations on an Old Theme', in *Cultural Intersections in Later Chinese Buddhism*, ed. Marsha Weidner (Honolulu, 2001), pp. 117–44 (pp. 132–5).

7 *ISMH*, 8.12.2.

8 Xu Xuemo, ed., 'Huguang zong zhi', 98 *juan* (Wanli period), in *Siku quanshu cunmu congshu*, vols CXCIV–CXCVI (Ji'nan, 1995–7), *juan* 8 and 9, pp. 471–84.

9 An Jiesheng, *Lishi dili yu Shanxi difangshi xintan* (Taiyuan, 2008), p. 465.

10 Zhang Guoning, 'Ming Jinwang', p. 106; An Jiesheng, *Lishi dili yu Shanxi difangshi xintan*, p. 480.

11 An Jiesheng, *Lishi dili yu Shanxi difangshi xintan*, p. 487.

12 Zhang Jianmin, 'Mingdai Lianghu diqu de zongfan yu difang shehui', *Jianghan luntan* (2002.10), pp. 76–81.

13 Chen Yong, 'Mingdai Yanzhou Luwang he wangfu', *Shihai gouchen/Zhongzhou Today and Yesterday* (2003.1), pp. 8–16.

14 Wang Jinyan and Liang Jiang, 'Mingchu Yanzhou fucheng xingtai kuangzhan ji Luwangcheng guihua fenxi – Jian lun fanwangcheng guihua', *Guihuashi/Planners* (2001.1), pp. 74–7.

15 Xu Hong, 'Mingdai Kaifeng Zhouwang de xiangguan wenti', *Henan keji daxue xuebao (Shehuikexue ban)*, XXI/4 (2004), pp. 21–4 (p. 24).

16 Kaifeng Song cheng kaogudui, 'Ming Zhou wangfu zijincheng de chubu kantan yu fajue', *Wenwu* (1999.12), pp. 66–73.

17 Zhu Mouwei, *Fan xian ji*, 4 *juan* (Wanli period), in *Beijing tushuguan guji zhenben congkan 19: Shi bu, zhuanji lei* (Beijing, 1998), pp. 745–77 (*juan* 1, p. 8a; p. 752).

18 Shen Defu, *Wanli ye huo bian*, Yuan Ming shiliao biji congkan (Beijing, 1980), vol. I, pp. 109–10.

19 Yang Guoliang and Zhou Zuoming, 'Ming

Jingjiang wangcheng yu Guilin lishi wenhua lüyou jianshe', *Guilin lüyou gaodeng zhuanke xuexiao xuebao*, XIII/3 (2001), pp. 69–71.

20 Charles Boxer, *South China in the Sixteenth Century, Being the Narratives of Galeote Pereira, Fr. Gaspar da Cruz, O.P. [and] Fr. Martín de Rada, O.E.S.A. (1550–1575)* (London, 1953), pp. 41–2.

21 For paintings of Ming cityscapes, see Yu Weichao, ed., *A Journey into China's Antiquity*, vol. IV: *Yuan Dynasty, Ming Dynasty, Qing Dynasty* (Beijing, 1997), discussed in Wang Zhenghua, 'Guoyan fanhua – Wan Ming chengshi tu, chengshi guan, yu wenhua xiaofei de yanjiu', in *Zhongguo de chengshi shenghuo*, ed. Li Xiaodi (Taibei, 2005), pp. 1–57.

22 For the regulations on kingly palaces, see Shen Shixing, ed., *Ming hui dian* (Beijing, 1989), *juan* 181, p. 918, and for a discussion see Ruo Ya, 'Mingdai zhuwangfu guizhi shulüe', *Mingshi yanjiu*, III (1993), pp. 135–8. For imperially ordained names given to the storehouses of individual palaces in 1376 see Li Qiongying and Zhang Yingzhao, eds, *Ming shi lu lei zuan: Zong fan gui qi lei* (Wuhan, 1995), p. 843.

23 Pan Jisheng, *Tian gong kai wu jiaozhu ji yanjiu* (Chengdu, 1989), p. 414; E-tu Zen Sun and Shiou-chuan Sun, trans., *T'ien-kung k'ai-wu: Chinese Technology in the Seventeenth Century* (University Park, PA, 1966), p. 137.

24 Zhu Mouwei, *Fan xian ji, juan* 2, p. 11a (p. 761).

25 Wu Hongqi and Dang Anrong, 'Guanyu Mingdai Xi'an Qin wangfucheng de ruogan wenti', *Zhongguo lishi dili luncong* (1993), pp. 149–64 (p. 156), citing an edict of Hongwu 8 in *Taizu shilu* 87.

26 On the cosmological significance of the number nine, especially in a palace context, see Maggie Bickford, 'Three Rams and Three Friends: The Working Lives of Chinese Auspicious Motifs', *Asia Major*, 3rd ser., XII/1 (1999), pp. 127–58 (pp. 137–42).

27 Guojia wenwuju, ed., *Zhongguo wenwu dituji: Hubei fence*, 2 vols (Xi'an, 2002) [hereafter ZGWWDTI *Hubei*], vol. I, p. 339, and vol. II, pp. 65–6.

28 Illustrated in Kaifeng Song cheng kaogudui, 'Ming Zhou wangfu', p. 68.

29 On eunuchs see Zhao Kesheng, 'Mingdai si yan zhi jin', *Anhui daxue xuebao (Zhexue shehui-kexue ban)*, XXVI/1 (January 2002), pp. 28–33.

30 Shi Hongshi and Wu Hongqi, 'Mingdai Xi'an chengnei huangshi zongzu fuzhai xiangguan wenti yanjiu', *Zhongguo lishi dili luncong*, XVI/1 (March 2001), pp. 69–78.

31 Shi Hongshi and Wu Hongqi, 'Mingdai Xi'an', p. 75.

32 On Zhang Han see L. Carrington Goodrich and Chaoyang Fang, eds, *Dictionary of Ming Biography, 1368–1644*, 2 vols (New York and London, 1976) [hereafter DMB], I, pp. 72–4; Guoli zhongyang tushuguan, *Mingren zhuanji ziliao suoyin*, 2nd edn (Taibei, 1978) [hereafter MRZJ], p. 557.

33 Zhang Han, *Song chuang meng yu*, Ming Qing biji congshu (Shanghai, 1986), p. 35.

34 Zhu Mouwei, *Fan xian ji, juan* 3, pp. 12b–13a (pp. 770–71).

35 Shi Hongshi and Wu Hongqi, 'Mingdai Xi'an', p. 77.

36 *Kaikodo Journal* (2010), pp. 18–19, here the title of the King is read 'Jijin', but no such appanage exists and the reading of Jishan fits the place name.

37 Shen Defu, *Wanli ye huo bian*, vol. I, pp. 113–14.

38 Ren Zunshi, *Zhou Xianwang yanjiu* (Taibei, 1974), pp. 63–71.

39 Ren Zunshi, *Zhou Xianwang yanjiu*, pp. 71–95.

40 Zhu Mouwei, *Fan xian ji, juan* 4, pp. 1a–4b (p. 772–3); MRZJ, p. 136.

41 Zhu Mouwei, *Fan xian ji, juan* 4, pp. 7a–b (p. 775).

42 Zhu Mouwei, *Fan xian ji, juan* 3, pp. 11a–12a (p. 770); MRZJ, p. 142.

43 Julia Ching, *Mysticism and Kingship in China: The Heart of Chinese Wisdom*, Cambridge Studies in Religious Traditions, 11 (Cambridge, 1997), p. 26; Richard G. Wang, 'Ming Princes and Daoist Ritual', *T'oung Pao*, XCV (2009), pp. 51–119 (pp. 65–7). For these altars in Taiyuan see the map in Zhang Guoning, 'Ming Jinwang jiqi zongshi zakao', p. 14.

44 Weidner, 'Imperial Engagements with Buddhist Art and Architecture', pp. 132–5.

45 Guojia wenwuju, ed., *Zhongguo wenwu dituji: Shanxi fence*, 3 vols (Beijing, 2006) [hereafter ZGWWDTJ Shanxi], vol. II, p. 9.

46 Li Yuming, ed., *Shanxi gu jianzhu tonglan* (Taiyuan, 1986), pp. 20–22.

47 Zhang Zhengming, Ke Dawei and Wang Yonghong, eds, *Ming Qing Shanxi beike ziliao xuan (xu yi)* (Taiyuan, 2007), pp. 393–4.

48 Zhang Zhengming et al., eds, *Ming Qing Shanxi beike ziliao xuan (xu yi)*, pp. 394–5.

49 ZGWWDTJ Shanxi, II, p. 9; drawing also on leaflets on sale at the site: Shanxi sheng Taiyuan shi Shuangta si wenwu baoguansuo, *Yongzuo si* (Taiyuan, n.d.), and Taiyuan shi Shuangta si wenwu baoguansuo, *Yongzuo si daoyou* (Taiyuan, n.d.).

50 Zhang Zhengming et al., eds, *Ming Qing Shanxi beike ziliao xuan (xu yi)*, pp. 407–8.

51 Zhang Guoning, 'Ming Jinwang jiqi zongshi zakao', p. 125.

52 Zhang Zhengming et al., eds, *Ming Qing Shanxi beike ziliao xuan (xu yi)*, p. 11.

53 Tracy Miller, *The Divine Nature of Power: Chinese Ritual Architecture at the Sacred Site of Jinci*, Harvard-Yenching Institute Monograph Series, 62 (Cambridge, MA, and London, 2007).

54 Zhang Zhengming et al., eds, *Ming Qing Shanxi beike ziliao xuan (xu yi)*, pp. 181–90.

55 Miller, *Divine Nature of Power*, pp. 129 and 156.

56 Miller, *Divine Nature of Power*, p. 159.

57 Su Siyi, Yang Xiaojie and Liu Liqing, eds, *Shaolin si shike yishu bian* (Beijing, 1985), pp. 40, 48.

58 Zhang Tingyu et al., eds, *Ming shi*, 28 vols (Beijing, 1974) [hereafter MS], vol. XII, *juan* 119, *Liezhuan juan* 7, *Zhuwang* 4, pp. 3637–8.

59 Sun Hongbo and Gao Chunping, *Lu shang wenhua tanjiu* (Tianjin, 2009), p. 136.

60 Yang Zengwu, *Huangjia yu Wutaishan* (Taiyuan, 2005).

61 On Fudeng's career see DMB, I, pp. 462–5.

62 ZGWWDTJ Shanxi, II, p. 582. In the eighteenth century the temple's name was changed to Bishansi, which it still bears today.

63 Zhang Zhengming et al., eds, *Ming Qing Shanxi beike ziliao xuan (xu yi)*, pp. 390–91.

64 ZGWWDTJ Hubei, II, p. 168.

65 Timothy Brook, *Praying for Power: Buddhism and the Formation of Gentry Society in Late-Ming China* (Cambridge, MA, and London, 1993), p. 291.

66 Eskenazi, *Chinese Buddhist Sculpture from Northern Wei to Ming*, exh. cat., Pace

Wildenstein, New York, 18–30 March 2002 (London, 2002), pp. 51–2. Here the date is read as equivalent to 1506, but this is unlikely as the Rong appanage was only established in 1508. MS, XII, *juan* 109, *Lie zhuan* 7, pp. 3642–3.

67 Zhang Jianmin, 'Mingdai Lianghu diqu de zongfan yu difang shehui', p. 76. For patronage of Daoist practitioners by the same lineage see Wang, 'Ming Princes and Daoist Ritual', p. 103.

68 Wang, 'Ming Princes and Daoist Ritual' provides an overview in English, greatly enlarged in Richard G. Wang, *The Ming Prince and Daoism: Institutional Patronage of an Elite* (Oxford, 2012), now the definitive work.

69 DMB, I, pp. 305–7. In general see Pierre-Henry De Bruyn, 'Daoism in the Ming (1368–1644)', in *Daoism Handbook*, ed. Livia Kohn, Handbook of Oriental Studies, Section Four: China, XIV (Leiden, Boston and Cologne, 2000), pp. 594–622.

70 Chen Wenhua, 'Jiangxi Xinjian Ming Zhu Quan mu fajue', *Kaogu* (1962.4), pp. 202–5; Jin Laien and Tian Juan, 'Mingchao Gan di fanwang ji qi muzang', *Nanfang wenwu* (2004.3), pp. 67–71. For pictures see Jiangxi sheng bowuguan et al., eds, *Jiangxi Mingdai fanwang mu* (Beijing, 2010), pp. 2–4.

71 ZGWWDTJ *Hubei*, I, p. 334, and II, p. 161; Wang, 'Ming Princes and Daoist Ritual', p. 88–9.

72 Wang Gang, 'Mingdai wanghou yu Daojiao guanxi tanyan: Yi Lanzhou he Kunming wei li', in *Daojiao yanjiu yu Zhongguo zongjiao wenhua*, ed. Li Zhitian (Xianggang, 2003), pp. 152–212 (p. 165); Wang, 'Ming Princes and Daoist Ritual', pp. 89–91.

73 Wang Gang, 'Mingdai wanghou yu Daojiao guanxi tanyan', pp. 162–9.

74 Shandong sheng bowuguan, 'Fajue Ming Zhu Tan mu jishi', *Wenwu* (1972.5), pp. 25–36.

75 Shen Defu, *Wanli ye huo bian*, vol. I, pp. 120–21 (King of Hui) and pp. 121–2 (King of Liao); Wang, 'Ming Princes and Daoist Ritual', pp. 91–4.

76 Richard G. Wang, 'Four Steles at the Monastery of the Sublime Mystery (Xuanmiao guan): A Study of Daoism and Society on the Ming Frontier', *Asia Major*, 3rd ser., XIII/2 (2000), pp. 37–82 (p. 58).

77 Roger V. Des Forges, *Cultural Centrality and Political Change in Chinese History: Northeast Henan in the Fall of the Ming* (Stanford, CA, 2003), p. 159.

78 DMB, I, p. 988, 'Niccolo Longobardi', and II, p. 1206, 'João Soeiro'.

79 Zhang Guoning, 'Ming Jinwang jiqi zongshi zakao', p. 110.

80 As noted by David Robinson, 'The Ming Court', in *Culture, Courtiers and Competition: The Ming Court (1368–1644)*, ed. David M. Robinson, Harvard East Asian Monographs, 301 (Cambridge, MA, and London, 2008), pp. 21–60 (p. 39). For an example of this discourse see Huang Miantang, *Mingshi guanjian* (Ji'nan, 1985), pp. 159–260 'Aristocratic Estates and Landlord Estates'; also Satō Fumiyoshi, *Mindai ōfu no kenkyu* (Tokyo, 1999), pp. 303–7.

81 Ray Huang, *Taxation and Governmental Finance in Sixteenth-century China*, pp. 106–8, as noted by Robinson, 'The Ming Court', p. 39, n. 70.

82 Chris Wickham, *Framing the Early Middle Ages: Europe and the Mediterranean, 400–800* (Oxford, 2005), pp. 146–7.

83 For example Matthew Innes, *State and Society in the Early Middle Ages: The Middle Rhine Valley, 400–1000*, Cambridge Studies in Medieval Life and Thought (Cambridge, 2000), pp. 72–3.

84 Zhang Jianmin, 'Mingdai Lianghu diqu de zongfan yu difang shehui', p. 81.

85 For a range of examples see Ming shisanling tequ banshichu, ed., *Zhongguo jianzhu yishu quanji: VII, Mingdai lingmu jianzhu* (Beijing 2000), pp. 60–72.

86 For regulations see Liu Yi, *Mingdai diwang lingmu zhidu yanjiu* (Beijing, 2006), pp. 153–317; Wang Jichao, 'Mingdai qinwang zangzhi de jige wenti', *Wenwu* (2003.2), pp. 63–5.

87 *ZGWWDTJ Hubei*, II, p. 399.

88 Zhang Jianmin, 'Mingdai Lianghu diqu de zongfan yu difang shehui', p. 76; *ZGWWDTJ Hubei*, II, p. 399.

89 Hubei sheng wenwu kaogu yanjiusuo and Zhongxiang shi bowuguan, eds, *Liang Zhuangwang mu* (Beijing, 2007).

90 Zhang Zhengming et al., eds, *Ming Qing Shanxi beike ziliao xuan (xu yi)*, p. 309.

91 Zhang Zhengming et al., eds, *Ming Qing Shanxi beike ziliao xuan (xu yi)*, pp. 307–8.

92 Chen Yong, 'Mingdai Yanzhou Luwang he wangfu', p. 11.

THREE: THE WRITING OF THE KING OF JIN

1 Biography in L. Carrington Goodrich and Chaoyang Fang, eds, *Dictionary of Ming Biography, 1368–1644*, 2 vols (New York and London, 1976) [hereafter DMB], I, pp. 345–6, discussed also in Jérôme Kerlouégan, 'Printing for Prestige? Publishing and Publication by Ming Princes', *East Asian Publishing and Society*, I (2011), pp. 39–73.

2 On *Fan xian ji*, see Wolfgang Franke, *An Introduction to the Sources of Ming History* (Kuala Lumpur, 1968) [ISMH], 3.7.2 (p. 93). The full version is now republished as Zhu Mouwei, *Fan xian ji*, 4 *juan* (Wanli period), in *Beijing tushuguan guji zhenben congkan* 19: *Shi bu, zhuanji lei* (Beijing, 1998), pp. 745–77, and all references are to this edition. The abbreviated version in one *juan* appears in Tao Zongyi, *Shuo fu san zhong*, Shanghai guji chubanshe edn (Shanghai, 1988), vol. IX, pp. 345–58.

3 It is, for example, a major source for the imperial clan biographies in Guoli zhongyang tushuguan, *Mingren zhuanji ziliao suoyin*, 2nd edn (Taibei, 1978) [hereafter MRZJ].

4 Zhu Mouwei, *Fan xian ji*, *juan* 1, pp. 8a–8b (p. 752). Biography in DMB, I, pp. 380–81. On Zhu Youdun's full range of activities see Ren Zunshi, *Zhou Xianwang yanjiu* (Taibei, 1974), and Wilt Idema, *The Dramatic Oeuvre of Chu Yu-tun (1379–1439)*, Sinica Leidensia, 16 (Leiden, 1985).

5 Zhu Mouwei, *Fan xian ji*, *juan* 3, pp. 8b–9b (pp. 768–9). On Zhu Zhanji see Wang Chenghua, 'Material Culture and Emperorship: The Shaping of Imperial Roles at the Court of Xuanzong (*r.* 1426–1435)', unpublished PhD dissertation (Yale University, 1998).

6 Zhu Mouwei, *Fan xian ji*, *juan* 1, pp. 4b–5a (pp. 750–1).

7 Zhu Mouwei, *Fan xian ji*, *juan* 4, pp. 1a–4b (pp. 772–73). For his dates see MRZJ, p. 136. This is one of the longest biographies in the full version of 'Offerings from the Appanages', for reasons not clear to me. It is drastically abbreviated in the *Shuo fu* edition.

8 Zhu Mouwei, *Fan xian ji, juan* 3, pp. 4b–5a (pp. 766–67).

9 Zhu Mouwei, *Fan xian ji, juan* 2, pp. 4a–4b (pp. 750–51); MRZJ, p. 124.

10 Zhu Mouwei, *Fan xian ji, juan* 3, p. 10b (p. 769).

11 Zhu Mouwei, *Fan xian ji, juan* 2, pp. 5b–6a (p. 758). This rubbing collection is not apparently extant.

12 Zhu Mouwei, *Fan xian ji, juan* 4, pp. 10b–11a (pp. 776–77); MRZJ, p. 127

13 DMB, II, pp. 1268–72.

14 Zhu Mouyin, *Xu shu shi hui yao*, 1 *juan* (*c.* 1630), in *Jing yin Wenyuange siku quanshu*, 814 (Taibei, 1986).

15 Zhu Mouyin, *Xu shu shi hui yao*, p. 1b (p. 810).

16 Zhu Mouyin, *Xu shu shi hui yao*, pp. 2a–4b (pp. 811–12).

17 Li E, *Yu tai shu shi*, 1 *juan*, in *Meishu congshu*, 4 *ji disan ji*, Jiangsu guji chubanshe reprint edn (Nanjing, 1997), III, pp. 2164–90 (p. 2170). My thanks to Monica Merlin for prompting a search of this text.

18 Christie's Amsterdam, 'The Van Gulik Collection of Fine Chinese, Japanese and Tibetan Paintings and Calligraphy; Oriental Ceramics and Works of Art', 7 December 1983, lot 51. The fact that the calligraphy is illustrated upside down in the catalogue accidentally says something about the perceived status of such objects in the modern art market. The present whereabouts of the scroll are unknown.

19 Zhu Mouwei, *Fan xian ji, juan* 3, p. 13b (p. 771). This is Zhu Zaixi, King Kangxian of Xinle (enfeoffed 1557, *d.* 1593).

20 Zhao Qian and Zhang Zhiqing, 'Book Publishing by the Princely Households during the Ming Dynasty: A Preliminary Survey', *The East Asian Library Journal*, X/1 (Spring 2001), pp. 85–128 (p. 111); Lucille Chia, 'Publications of the Ming Principalities: A Distinct Example of Private Printing', *Ming Studies*, 54 (Fall 2006), pp. 24–70 (p. 35).

21 The Zhu Yilian works are recorded in Liu Jiuan, *Song Yuan Ming Qing shuhuajia chuanshi zuopin nianbiao* (Shanghai 1997), p. 288 and p. 312; for other works by members of the imperial clan see pp. 229, 244, 248.

22 DMB, II, pp. 1191–9. Robert E. Harrist Jr and Wen C. Fong, *The Embodied Image: Chinese Calligraphy from the John B. Elliott Collection* (Princeton, NJ, 1999), pp. 148–9.

23 Yang Chang et al., eds, *Ming shi lu lei zuan: Gongting shiliao juan* (Wuhan, 1992), p. 1419.

24 Qianshen Bai, *Fu Shan's World: The Transformation of Chinese Calligraphy in the Seventeenth Century* (Cambridge, MA, and London, 2003), p. 77.

25 Beijing daxue tushuguan and Xianggang zhongwen daxue wenwuguan, *Zhongguo gudai beitie taben* (Beijing and Xianggang, 2001); Wu Hong, 'On Rubbings: Their Materiality and Historicity', in *Writing and Materiality in China*, ed. Judith Zeitlin and Lydia Liu (Cambridge, MA, 2003), pp. 29–72; Kenneth Starr, *Black Tigers: A Grammar of Chinese Rubbings* (Seattle and London, 2008).

26 On Zhu Su see DMB, I, pp. 350–54.

27 The fullest account in English of the techniques is found in Starr, *Black Tigers*.

28 Amy McNair, 'The Engraved Model-Letters Compendia of the Song Dynasty', *Journal of the American Oriental Society*, CXIV/2 (1994), pp. 209–25 (p. 210). See also Amy McNair, 'Engraved Calligraphy in China: Recension and Reception', *Art Bulletin*, LXXVII/1 (1995), pp. 106–14.

29 Robert E. Harrist Jr, 'Copies, All the Way Down: Notes on the Early Transmission of Calligraphy by Wang Xizhi', *East Asian Library Journal*, x/1 (2001), pp. 176–96;

30 McNair, 'The Engraved Model-Letters Compendia', p. 213.

31 On *fa* see Martin J. Powers, *Pattern and Person: Ornament, Society, and Self in Classical China* (Cambridge, MA, and London, 2006), pp. 140–50.

32 McNair, 'The Engraved Model-Letters Compendia', pp. 211–13.

33 For a list of the contents of *Dong shu tang ji gu fa tie* see Ren Zunshi, *Zhou Xianwang yanjiu*, pp. 115–18.

34 For the full text see Ren Zunshi, *Zhou Xianwang yanjiu*, pp. 130–31.

35 On these three figures see Ren Zunshi, *Zhou Xianwang yanjiu*, pp. 78–95. None has a biography in *MRZJ*.

36 McNair, 'The Engraved Model-Letters Compendia', p. 215–17.

37 Ren Zunshi, *Zhou Xianwang yanjiu*, p. 113.

38 Wen Zhenheng, *Zhang wu zhi jiao zhu* (Nanjing, 1984), p. 185.

39 Wang Hongbin, 'Lun Bao xian tang ji gu fa tie', in *Bao xian tang ji gu fa tie*, ed. Jin ci bowuguan (Beijing, 2002) [hereafter BXT], p. 481. The others were *Bao xian tang ji gu fa tie* and the 'Su palace edition' of *Chunhua ge fa tie*.

40 My understanding of courtly 'newness' is indebted to Sheldon Pollock, *The Language of the Gods in the World of Men: Sanskrit, Culture, and Power in Premodern India* (Berkeley, Los Angeles and London, 2006), p. 333.

41 Ren Zunshi, *Zhou Xianwang yanjiu*, pp. 114–15 and pp. 125–7.

42 Ren Zunshi, *Zhou Xianwang yanjiu*, pp. 118–24; For illustrations see Philip K. Hu, *Visible Traces: Rare Books and Special Collections from the National Library of China* (New York, 2000) pp. 150–54.

43 He Biqi, 'Duandai mima: (Chuan) Guo Zhongshu "Mu Gu Kaizhi Lanting yanji tu" guan hou', *Gugong wenwu yuekan*, CCLXXV (February 2006), pp. 47–59 (p. 56).

44 He Biqi, 'Duandai mima', p. 57. The text also given in Ren Zunshi, *Zhou Xianwang yanjiu*, p. 118.

45 Reproduced in full with transcription and commentary in BXT. See also Wang Zhuanghong, *Tiexue juyao* (Shanghai, 2008), pp. 81–8; Craig Clunas, 'Antiquarian Politics and the Politics of Antiquarianism in Ming Regional Courts', in *Reinventing the Past: Antiquarianism in Chinese Art and Visual Culture*, ed. Wu Hung (Chicago, 2010), pp. 229–54.

46 For Zhu Qiyuan's dates see Zhang Tingyu et al., eds, *Ming shi*, 28 vols (Beijing, 1974) [MS], IX, *juan* 100, *Biao*, p. 2521, and XII, *juan* 116, *Lie zhuan* 4, p. 3564.

47 The Crown Prince's preface is in BXT, p. 12 (original text), p. 364 (transcription).

48 For a simplified genealogical table see Wang Hongbin, 'Lun Bao xian tang ji gu fa tie', p. 484.

49 MRZJ, p. 746. He Liangjun, *Si you zhai cong shuo*, Yuan Ming shiliao biji congkan (Beijing, 1983), p. 135; Zhang Guoning, 'Ming Jinwang jiqi zongshi zakao', *Jinyang wenhua yanjiu*, 1 (Taiyuan, 2006), pp. 97–127 (p. 123) claims that Zhu Gang was also instructed in calligraphy by two other early Ming notables, Song Lian (1310–1381) and Du Huan (MRZJ, p. 189).

50 Xu Bangda, '"Wenhuatang ti" kuan huaba ji

Jinfu qianyin', *Gugong bowuyuan yuankan*, (2005.2), pp. 89–90 (p. 89).

51 Wang Hongbin, 'Lun Bao xian tang ji gu fa tie', p. 481. On these compendia see McNair, 'Engraved Model-Letters Compendia'.

52 Richard Barnhart, '*Streams and Hills Under Fresh Snow* Attributed to Kao K'o-ming', in *Words and Images: Chinese Poetry, Calligraphy and Painting*, ed. Alfreda Murck and Wen C. Fong (New York and Princeton, NJ, 1991), pp. 227–30, on the collection of Zhu Gang. For a note on seals used in the Jin palace see Xu Bangda, '"Wenhuatang ti" kuan huaba ji Jin fu qianyin', pp. 89–90.

53 *BXT*, p. 14 (original text), p. 364 (transcription). Translated in full in Clunas, 'Antiquarian Politics and the Politics of Antiquarianism in Ming Regional Courts', pp. 236–7.

54 Judith Zeitlin, 'The Petrified Heart: Obsession in Chinese Literature, Art and Medicine', *Late Imperial China*, XXI/1 (1991), pp. 1–26.

55 *MRZJ*, p. 550. He has no biography in MS.

56 *MRZJ*, p. 752. He too has no biography in MS.

57 A note on Wang Hongbin, "Lun Bao xian tang ji gu fa tie", p. 365 says: 'Yang Guangpu; from Yishui in Shandong, Chenghua period *jinshi*', his works are *Yichuan ji*. Hu Han, from Yanshan in Jiangxi, *jinshi*. Yang Wenqing; from Yinxian in Zhejiang, *jinshi*. For these three see the Gazetteer of Shanxi: List of Officials, Jiajing edition. From this I take it that Wang Jin (and the two students) are not mentioned in this text.

58 Harrist and Fong, *Embodied Image*, p. 69, example pp. 152–3, which speaks of a distinctive Huating style of cursive calligraphy.

59 *BXT*, p. 303 (original text), p. 445 (transcription). On Juran (active *c.* 960–980),

there is no extant picture of this title in James Cahill, incorporating the work of Osvald Sirén and Ellen Johnston Laing, *An Index of Early Chinese Painters and Paintings: T'ang, Sung, and Yüan* (Berkeley, Los Angeles and London 1980), pp. 30–33. No Wang Shen (work of this title appears in Cahill, *Index*, pp. 183–5. Note that Wang was from Taiyuan, hence a local hero, and his style as 'Minister of Jin' is surely significant).

60 Peter Sturman, *Mi Fu: Style and the Art of Calligraphy in Northern Song China* (New Haven, CT, and London, 1997), p. 74.

61 The piece is Jin Wudi, *Sheng qi tie*, Ren Zunshi, *Zhou Xianwang yanjiu*, p. 115, and *BXT*, p. 36.

62 Charles Holcombe, *In the Shadow of the Han: Literati Thought and Society at the Beginning of the Southern Dynasties* (Honolulu, 1994) remains one of the few accounts of Jin period culture in English.

63 John W. Chaffee, *Branches of Heaven: A History of the Imperial Clan of Sung China* (Cambridge, MA, and London, 1999), pp. 26–7.

64 Gérard Genette, *Paratexts: Thresholds of Interpretation* (Cambridge, 1997).

65 Wang Hongbin, 'Lun Bao xian tang ji gu fa tie', pp. 487–99.

66 Zhu Mouwei, *Fan xian ji*, p. 2b.

67 Wang Hongbin, 'Lun Bao xian tang ji gu fa tie', p. 488.

68 Sir Percival David, *Chinese Connoisseurship: The 'Ko Ku Yao Lun', the Essential Criteria of Antiquities* (London, 1971), pp. 72 and 93.

69 Wang Hongbin, 'Lun Bao xian tang ji gu fa tie', pp. 488–90.

70 Wang Hongbin, 'Lun Bao xian tang ji gu fa tie', pp. 490–96.

71 *BXT*, p. 363 (pp. 8–9). Zhu Youtang, Emperor Xiaozong, was a sixth-generation descendant of Ming Taizu. Zhu Zhongxuan, King of Jin, was four generations removed from the founder, and Zhu Qiyuan, his Crown Prince was five. Hence the respectful language of *shu zu*, 'ancestral uncle'.

72 Pollock, *Language of the Gods in the World of Men*, p. 15.

73 Harrist and Fong, *Embodied Image*, pp. 63–5, on Song Ke's 'juxtaposing and harmonising of different scripts'.

74 Sewall Oertling, *Painting and Calligraphy in the 'Wu-tsa-tsu': Conservative Aesthetics in Seventeenth-century China*, Michigan Monographs in Chinese Studies, 68 (Ann Arbor, MI, 1997), p. 90.

75 *BXT*, p. 481.

76 Wang Zhuanghong, *Tiexue juyao*, pp. 81–2.

77 Wan Yi, *Chunhua he Chunhua ge fatie* (Beijing, 1994), p. 1; Qin Mingzhi, 'Su fu ben Chun hua ge tie kao', *Lanzhou xuekan* (1984.5), pp. 92–101.

78 Wang Zhuanghong, *Tiexue juyao*, p. 16.

79 He Biqi, 'Duandai mima', p. 58. Zhu Yiyin is one of the few Ming kings whose own calligraphy also survives, see Liu Jiuan, *Song Yuan Ming Qing shuhuajia chuanshi zuopin nianbiao*, p. 244.

80 Wang Zhuanghong, *Tiexue juyao*, pp. 89–96.

81 Zhao Qian and Zhang Zhiqing, 'Book Publishing by the Princely Households during the Ming Dynasty', pp. 85–128 (p. 102). On this text (not seen by the present author) see also Jérôme Kerlouégan, 'Printing for Prestige? Publishing and Publication by Ming Princes', *East Asian Publishing and Society*, I (2011), pp. 39–73 (p. 51).

82 Sturman, *Mi Fu*, p. 157.

83 Alfred Gell, *Art and Agency: An Anthropological Theory* (Oxford, 1998), p. 140.

84 Verity Platt, 'Making an Impression: Replication and the Ontology of the Graeco-Roman Seal Stone', in *Art and Replication, Rome and Beyond*, ed. Jennifer Trimble and Jaś Elsner, Special Issue of *Art History*, XXIX/2 (2006), pp. 233–57 (p. 234).

85 Wu Hung, 'On Rubbings', p. 39.

FOUR: THE PAINTING OF THE KING OF ZHOU

1 Craig Clunas, *Pictures and Visuality in Early Modern China* (London, 1997), p. 109.

2 Dora C. Y. Ching, 'Tibetan Buddhism and the Ming Imperial Image', in *Culture, Courtiers, and Competition: The Ming Court (1368–1644)*, ed. David M. Robinson, Harvard East Asian Monographs, 301 (Cambridge, MA, and London, 2008), pp. 321–64 (p. 331), where the translation 'all the princes' is preferred for *zhu wang*.

3 Shandong sheng bowuguan, 'Fajue Ming Zhu Tan mu jishi', *Wenwu* (1972.5), pp. 25–36.

4 On the princess as collector see Shen C. Y. Fu, translated and adapted by Marsha Weidner, 'Princess Sengge Raggi: Collector of Painting and Calligraphy', in *Flowering in the Shadows: Women in the History of Chinese and Japanese Painting*, ed. Marsha Weidner (Honolulu, 1990), pp. 56–80, and Chen Yunru, in Guoli gugong bowuyuan, *Dahan de shiji: Meng Yuan shidai de duoyuan wenhua yu yishu* (Taibei, 2001), pp. 266–85 (pp. 247–8); Jiang Yihan, 'Yuan neifu zhi shoucang (xia)', *Gugong jikan*, XIV/3 (Spring 1980), pp. 1–36.

5 Shandong sheng bowuguan, 'Fajue Ming Zhu

Tan mu jishi', pp. 29–30.

6 Jiang Yihan, 'Yuan neifu zhi shoucang (xia)',
 pp. 29–32; Richard Barnhart, '*Streams and
 Hills Under Fresh Snow* Attributed to Kao
 K'o-ming', in *Words and Images: Chinese
 Poetry, Calligraphy and Painting*, ed. Alfreda
 Murck and Wen C. Fong (New York and
 Princeton, NJ, 1991), pp. 223–46 (pp. 227–30).

7 Heping Liu, '*The Water Mill* and Northern
 Song Imperial Patronage of Art, Commerce
 and Science', *Art Bulletin*, LXXXIV/4 (2002),
 pp. 566–95.

8 Eskenazi, *Seven Classical Chinese Paintings,
 29 October–27 November 2009* (London,
 2009), pp. 20–23. On this seal see Xu Bangda,
 '"Wenhuatang ti" kuan huaba ji Jinfu
 qianyin', *Gugong bowuyuan yuankan*
 (2005.2), pp. 89–90.

9 Unpublished research report, Stephen D.
 Allee, Freer Gallery of Art. Available at
 www.asia.si.edu/SongYuan/F1911.161e/
 F1911-161e.Documentation.pdf.

10 Zhu Mouwei, *Fan xian ji*, 4 *juan* (Wanli
 period), in *Beijing tushuguan guji zhenben
 congkan 19: Shi bu, zhuanji lei* (Beijing, 1998),
 pp. 745–77 (*juan* 2, pp. 8a–8b [p. 759]).

11 L. Carrington Goodrich and Chaoying Fang,
 eds, *Dictionary of Ming Biography, 1368–1644*,
 2 vols (New York and London, 1976) [hereafter
 DMB], II, pp. 1159–61. The paintings are
 illustrated as no. 48 in Kyoto National
 Museum, *Sesshū: botsugo 500-nen, tokubet-
 suten/Sesshū: Master of Ink and Brush* (Kyoto,
 2002), and discussed on p. 255. I am indebted
 to Shi-shan Susan Huang for drawing this
 intriguing case to my attention.

12 Joint Board of Directors of the National
 Palace Museum and National Central
 Museum, eds, *Signatures and Seals on Painting
 and Calligraphy: The Signatures and Seals of
 Artists Connoisseurs and Collectors on Painting
 and Calligraphy since Tsin Dynasty* (Hong
 Kong, 1964), vol. II, pp. 76–8; vol. IV, p. 242.

13 On Xiao Rong see James Cahill, incorpor-
 ating the work of Osvald Sirén and Ellen
 Johnston Laing, *An Index of Early Chinese
 Painters and Paintings: T'ang, Sung, and
 Yüan* (Berkeley, CA, 1980), p. 94. The paint-
 ing is illustrated in Chen Jiejin and Lai Yuzhi,
 *Zhuisuo Zhe pai/Tracing the Che School in
 Chinese painting* (Taibei, 2008), p. 101 and
 discussed p. 177.

14 The Wang Xizhi *Dadao tie* has the National
 Palace Museum registration number *Gu shu*
 000052N000000000. As early as the eighteenth
 century connoisseurs had serious doubts
 about the authenticity of this piece; see Lothar
 Ledderose, *Mi Fu and the Classical Tradition
 of Chinese Calligraphy* (Princeton, NJ, 1979),
 p. 87, n. 137.

15 *Eight Dynasties of Chinese Painting:
 The Collections of the Nelson Gallery-Atkins
 Museum, Kansas City, and The Cleveland
 Museum of Art*, with essays by Wai-kam Ho,
 Sherman E. Lee, Laurence Sickman and Marc
 F. Wilson (Cleveland, OH, 1980), pp. 96–7.

16 Zhang Jianmin, 'Mingdai Lianghu diqu de
 zongfan yu difang shehui', *Jianghan luntan*
 (2002.10), pp. 76–81 (p. 79), quoting the
 Tongzhi period (1862–74) *Wugang zhou zhi*.

17 Zhu Mouwei, *Fan xian ji, juan* 1, pp. 8a–8b
 (p. 752).

18 Zhu Mouwei, *Fan xian ji, juan* 3, pp. 4a–4b
 (p. 766).

19 Zhu Mouwei, *Fan xian ji, juan* 3, pp. 4b–5a
 (pp. 766–7).

20 Zhu Mouwei, *Fan xian ji, juan* 2, p. 12b (p. 761).

21 Zhu Mouwei, *Fan xian ji, juan* 3, p. 11a (p. 770).

22 Zhu Mouyin, *Hua shi hui yao*, 5 *juan* (1631), in *Jing yin Wenyuange siku quanshu*, 816 (Taibei, 1986), *juan* 4, pp. 1a–4a (pp. 515–16).

23 Chart in Frederick W. Mote and Denis Twitchett, eds, *The Cambridge History of China*, vol. VII: *The Ming Dynasty, 1368–1644, Part I* (Cambridge, 1988), p. 171.

24 John W. Chaffee, *Branches of Heaven: A History of the Imperial Clan of Sung China* (Cambridge, MA, and London, 1999), pp. 269–71.

25 Soyoung Lee, JaHyun Kim Haboush, Sunpyo Hong and Chin-Sung Chang, *Arts of the Korean Renaissance, 1400–1600* (New York, 2009), p. 85, 'One of the remarkable characteristics of early Joseon art is the rise of painters of royal descent'.

26 Hin-cheung Lovell, *An Annotated Bibliography of Chinese Painting Catalogues and Related Texts*, Michigan Papers in Chinese Studies, 16 (Ann Arbor, MI, 1973), pp. 107–8; Deborah Del Gais Muller, 'Hsia Wen-yen and His "T'u-hui pao-chien (Precious Mirror of Painting)"', *Ars Orientalis*, XVIII (1988), pp. 131–48.

27 Han Ang, *Tu hui bao jian*, in *Hua shi congshu*, ed. Yu Anjian, 2nd edn (Shanghai, 1982), vol. II (*juan* 6, p. 157).

28 Stephen Little with Shawn Eichman, *Taoism and the Arts of China* (Chicago, 2000), no. 87.

29 For a work by Wuzong, see 'Mynas on a Pine Tree', in Robert L. Thorp, *Son of Heaven: Imperial Arts of China* (Seattle, 1988), p. 158.

30 Xu Qin, *Ming hua lu*, 8 *juan*, in *Hua shi congshu*, ed. Yu Anjian, vol. III, *juan* 1, pp. 1–3.

31 On Ferguson see Lara Jaishree Netting, 'Acquiring Chinese Art and Culture: The Collections and Scholarship of John C. Ferguson (1866–1945)', unpublished PhD dissertation (Princeton University, 2009).

32 These texts are identified and described in Lovell, *An Annotated Bibliography*.

33 Fu Kaisen, *Li dai zhu lu hua mu*, Taiwan zhonghua shuju reprint (Taibei, 1968), II, p. 510a, citing *Nan xun dian zun cang tu xiang mu*, V [Lovell, *Annotated Bibliography*, no. 60].

34 Fu Kaisen, *Li dai zhu lu hua mu*, I, p. 83a, citing Shibaizhai zhuren, *Shi bai zhai shu hua lu*, X/25 [Lovell, *Annotated Bibliography*, no. 69].

35 Fu Kaisen, *Li dai zhu lu hua mu*, I, p. 82b, citing Bian Yongyu, *Shi gu tang shu hua hui kao*, XIV/2 [dated 1682, Lovell, *Annotated Bibliography*, no. 47].

36 Fu Kaisen, *Li dai zhu lu hua mu*, I, p. 83b, citing Zhou Shilin, *Tian shui bing shan lu*, CCXL [Lovell, *Annotated Bibliography*, no. 23].

37 Guo Licheng, 'Zengli hua yanjiu', in *Proceedings of the International Colloquy on Chinese Art History, 1991: Painting and Calligraphy* (Taipei, 1992), II, pp. 749–66. On Yan Song see *DMB*, II, pp. 1586–91.

38 Lovell, *Annotated Bibliography*, no. 21.

39 Fu Kaisen, *Li dai zhu lu hua mu*, I, p. 83a, citing Qin Qian, *Pu hua ji yu*, IX/2 [dated 1929, Lovell, *Annotated Bibliography*, no. 108].

40 Wang Fangyu, Richard M. Barnhart and Judith G. Smith, eds, *Master of the Lotus Garden: The Life and Art of Bada Shanren (1626–1705)* (New Haven, CT, and London, 1990), p. 23.

41 Fu Kaisen, *Li dai zhu lu hua mu*, I, p. 83b, citing Wu Rongguang, *Xin chou xiao xia ji*, IV, XLVIII [dated 1841, Lovell, *Annotated Bibliography*, no. 80].

42 Tang Shuyu, *Yu tai hua shi*, 5 *juan*, in *Hua shi congshu*, ed. Yu Anjian, vol. V, *juan* 1, pp. 7–8.

On this work see Marsha Weidner, Ellen Johnston Laing, Irving Yucheng Lo, Christina Chu and James Robinson, *Views from Jade Terrace: Chinese Women Artists, 1300–1912* (Indianapolis, 1988), pp. 17–21.

43 *DMB*, I, pp. 780–84.

44 Liu Jiuan, *Song Yuan Ming Qing shuhuajia chuanshi zuopin nianbiao* (Shanghai, 1997), p. 238. The same is true of the other work, a landscape hanging scroll date 1617 by Zhu Mou(?); ibid., p. 302.

45 Liu Jiuan, *Song Yuan Ming Qing shuhuajia chuanshi zuopin nianbiao*, p. 133.

46 Wilt Idema, *The Dramatic Oeuvre of Chu Yu-tun (1379–1439)*, Sinica Leidensia, 16 (Leiden, 1985), pp. 9–12.

47 Craig Clunas, *Art in China*, 2nd edn (Oxford, 2009), p. 70.

48 For example Richard Barnhart, *Painters of the Great Ming: The Imperial Court and the Zhe School* (Dallas, 1993), pp. 231 and 313.

49 Ren Zunshi, *Zhou Xian wang yanjiu* (Taibei, 1974), pp. 131–8.

50 Ren Zunshi, *Zhou Xian wang yanjiu*, p. 134. On Hong'er see ibid., p. 60.

51 Guoli zhongyang tushuguan, *Mingren zhuanji ziliao suoyin*, 2nd edn (Taibei, 1978) [hereafter *MRZJ*], p. 202; Ren Zunshi, *Zhou Xian wang yanjiu*, pp. 95–105.

52 Ren Zunshi, *Zhou Xian wang yanjiu*, p. 136.

53 Ren Zunshi, *Zhou Xian wang yanjiu*, p. 137.

54 Cited in Ren Zunshi, *Zhou Xian wang yanjiu*, p. 132.

55 On Zhou see *MRZJ*, p. 315; also Craig Clunas, *Elegant Debts: The Social Art of Wen Zhengming, 1470–1559* (London, 2004), p. 153.

56 Guoli gugong bowuyuan, ed., *Gugong shuhua tulu* (Taibei, 2001), vol. XIX, pp. 281–90.

57 *MRZJ*, p. 127: Joint Board of Directors, eds, *Signatures and Seals on Painting and Calligraphy*, vol. II, p. 73, and vol. IV, p. 241.

58 Neither appears in *MRZJ*. See Joint Board of Directors, eds, *Signatures and Seals on Painting and Calligraphy*, vol. II, pp. 72 and 73, and vol. IV, p. 241.

59 On Li Weizhen see *MRZJ*, p. 220; on Sun Kehong see James Cahill, *The Distant Mountains: Chinese Painting of the Late Ming Dynasty, 1570–1644* (New York and Tokyo, 1982), pp. 66–8; on Zhan Jingfeng see Craig Clunas, *Superfluous Things: Material Culture and Social Status in Early Modern China* (Cambridge, 1991), pp. 123–4; on Ma Shouzhen see Weidner et al., *Views from Jade Terrace*, pp. 72–81.

60 Barnhart, 'Streams and Hills under Fresh Snow', p. 228, referring to Jiang Yihan, 'Yuan neifu zhi shoucang (xia)', *Gugong jikan*, XIV/3 (Spring 1980), p. 30.

61 All three works are illustrated in Guoli gugong bowuyuan, ed., *Gugong shuhua tulu*, vol. V, nos 137, 142, 152.

62 Kathlyn Liscomb, 'Foregrounding the Symbiosis of Power: A Rhetorical Strategy in Some Chinese Commemorative Art', *Art History*, XXV/2 (2002), pp. 135–61 (pp. 140–41).

63 Clunas, *Art in China*, pp. 70–73; Lin Li'na, 'Mingren "Chu jing ru bi tu" zhi zonghe yanjiu', *Gugong wenwu yuekan*, X/7–8 (1993), pp. 58–77, 34–41.

64 Chai Zejun and He Dalong, *Shanxi fosi bihua* (Beijing, 2006), pp. 60–63. Marsha Weidner, 'Imperial Engagements with Buddhist Art and Architecture: Ming Variations on an Old Theme', in *Cultural Intersections in Later Chinese Buddhism*, ed. Marsha Weidner (Honolulu, 2001), pp. 117–44 (pp. 135–6).

65 Chai Zejun and He Dalong, *Shanxi fosi bihua*, pp. 180–84, captions on pp. 239–40.

66 Zhang Jizhong and An Ji, *Taiyuan Chong-shansi wenwu tulu* (Taiyuan, 1987). For the first sequence see also Chai Zejun and He Dalong, *Shanxi fosi bihua*, pp. 58–9, p. 177 (illustrations), p. 238 (captions); and Weidner, 'Imperial Engagements with Buddhist Art and Architecture', pp. 134–5. For the second see also Li Yuming, ed., *Shanxi gu jianzhu tonglan* (Taiyuan, 1986), p. 22. They are discussed in Peng Yuxin, 'Beijing fanke banhua zhu qipa – Ming Hongzhi "Xin kan da zi kui ben quan xiang zeng qi miao zhu shi Xi xiang ji"', unpublished MA dissertation (National Taiwan Normal University, 2009), pp. 73–81.

67 Chai Zejun and He Dalong, *Shanxi fosi bihua*, p. 59.

68 Tracy Miller, *The Divine Nature of Power: Chinese Ritual Architecture at the Sacred Site of Jinci*, Harvard-Yenching Institute Monograph Series, 62 (Cambridge, MA, and London, 2007), pp. 129, 134, 156.

69 Philip K. Hu, *Visible Traces: Rare Books and Special Collections from the National Library of China* (New York, 2000), pp. 150–54; He Biqi, 'Duandai mima: (Chuan) Guo Zhongshu "Mu Gu Kaizhi Lanting yanji tu" guan hou', *Gugong wenwu yuekan*, CCLXXV (February 2006), pp. 47–59 (p. 48).

70 Beijing tushuguan shanbenbu jinshizu, ed., *Beijing tushuguan cang huaxiang taben huibian* ('Pictorial Rubbings in the Collection of the Beijing Library'), (Beijing, 1993), vol. X, pp. 12–13. Maggie Bickford, 'Three Rams and Three Friends: The Working Lives of Chinese Auspicious Motifs', *Asia Major*, 3rd ser., XII/1 (1999), pp. 127–58.

71 Julia K. Murray, 'Illustrations of the Life of Confucius: Their Evolution, Functions and Significance in Late Ming China', *Artibus Asiae*, LVII.I/2 (1997), pp. 73–134; Julia K. Murray, '"Idols" in the Temple: Icons and the Cult of Confucius', *Journal of Asian Studies*, LXVIII/2 (2009), pp. 371–411.

72 Murray, 'Illustrations of the Life of Confucius', p. 89. Zhu Jianjun, King of Ji (enfeoffed 1457, d. 1527), seventh son of Yingzong, has a biography in Zhang Tingyu et al., eds, *Ming shi*, 28 vols (Beijing, 1974) [hereafter MS], XII, *juan* 119, *Liezhuan* 7, p. 3637, where his production of the images of Confucius's life is noted.

73 Zhu Mouwei, *Fan xian ji*, *juan* 3, pp. 2b–3a (pp. 765–6). MS, XII, *juan* 118, *Liezhuan* 6, p. 3606.

74 Murray, 'Illustrations of the Life of Confucius', p. 86.

75 Published in facsimile as Zhu Shouyong and Zhu Yiya, *Ming kan guben Hua fa da cheng* (Beijing, 1996). On this text see Hiromitsu Kobayashi, 'Publishers and their Hua-p'u in the Wan-li Period: The Development of the Comprehensive Painting Manual in the Late Ming', *Gugong xueshu jikan*, XXII/2 (2004), pp. 167–98 (pp. 182–7); Jong Phil Park, 'Ensnaring the Public Eye: Painting Manuals of Late Ming China (1550–1644) and the Negotiation of Taste', unpublished PhD dissertation (University of Michigan, 2007), pp. 78–83.

76 On Zhu Guan'ou, Defender-commander of the State, see MRZJ, p. 153. He had been involved in the publishing of a 1565 edition of the classic Daoist text *Baopuzi*, along with his father, Supporter-general of the State Zhu

Jian'gen; Zhao Qian and Zhang Zhiqing, 'Book Publishing by the Princely Households during the Ming Dynasty: A Preliminary Survey', *The East Asian Library Journal*, x/1 (Spring 2001), pp. 85–128 (p. 91).

FIVE: THE JEWELS OF THE KING OF LIANG

1 On the Hongxi reign see Hok-lam Chan, 'The Chien-wen, Yung-lo, Hung-hsi and Hsüan-te reigns, 1399–1435', in *The Cambridge History of China*, vol. VII: *The Ming Dynasty, 1368–1644, Part I*, ed. Frederick W. Mote and Denis Twitchett (Cambridge, 1988), pp. 182–304 (pp. 276–83). The official record of the brief appanage of Liang can be traced through the 'Veritable Records' in *Ming Shilu lei zuan: Hubei shiliao juan*, ed. Xie Guian (Wuhan, 1991), pp. 1280–84.

2 He does have a very brief biography in Xu Xuemo, ed, *Huguang zong zhi*, 98 *juan* (Wanli period), in *Siku quanshu cunmu congshu*, vols CXCIV–CXCVI (Jinan, 1995–97), CXCIV, *Fan feng*, pp. 18a–18b (p. 479), the text of which forms the basis of his notice in Zhang Tingyu et al., eds, *Ming shi*, 28 vols (Beijing, 1974) [hereafter MS], XII, *juan* 119, *Lie zhuan* 7, *Zhu wang* 4, p. 3634. The shared text notes his lands as formerly those of the defunct appanage of Ying, and tells the affecting tale of his parting from the King of Xiang, 'at which those around all wept'. On the excavation see Hubei sheng wenwu kaogu yanjiusuo et al., 'Hubei Zhongxiang Mingdai Liang Zhuangwang mu fajue jianbao', *Wenwu* (2003.5), pp. 4–23; Hubei sheng wenwu kaogu yanjiusuo and Zhongxiang shi bowuguan, eds, *Liang Zhuangwang mu* (Beijing, 2007).

3 Yang Xiaoneng, 'Ming Art and Culture from an Archaeological Perspective, Part 1: Royal and Elite Tombs', *Orientations* (June 2006), pp. 40–49; Craig Clunas, 'The Other Ming Tombs: Kings and their Burials in Ming China', *Transactions of the Oriental Ceramic Society*, LXX (2005–6), pp. 1–16.

4 Liu Yi, *Mingdai diwang lingmu zhidu yanjiu* (Beijing, 2006), pp. 25–8.

5 Liu Yi, *Mingdai diwang lingmu zhidu yanjiu*, pp. 173–96.

6 For a convenient compilation of photographs of some of the most complete examples see Ming shisanling tequ banshichu, ed., *Zhongguo jianzhu yishu quanji, 7: Mingdai lingmu jianzhu* (Beijing, 2000), pp. 60–72.

7 For example, Zhongguo shehui kexueyuan kaogusuo deng, 'Chengdu Fenghuangshan Ming mu', *Kaogu* (1978.5), pp. 306–13; Ming shisanling tequ banshichu, ed., *Zhongguo jianzhu yishu quanji, 7: Mingdai lingmu jianzhu*, pp. 64–7.

8 Zhu Mouwei, *Fan xian ji*, 4 *juan* (Wanli period), in *Beijing tushuguan guji zhenben congkan* 19: *Shi bu, zhuanji lei* (Beijing, 1998), pp. 745–77 (*juan* 3, pp. 5a–5b [p.767]). The king was from a cadet line of the Tang appanage, and was succeeded by a grandson in 1559.

9 David M. Robinson, 'The Ming Court and the Legacy of the Yuan Mongols', in *Culture, Courtiers, and Competition: The Ming Court (1368–1644)*, ed. David M. Robinson, Harvard East Asian Monographs, 301 (Cambridge, MA, and London, 2008), pp. 365–411 (pp. 396–400).

10 Shandong sheng bowuguan, 'Fajue Ming Zhu Tan mu jishi', *Wenwu* (1972.5), pp. 25–36; Jiangxi sheng bowuguan, 'Jiangxi Nancheng Ming Yiwang Zhu Youbin mu fajue jianbao',

Wenwu (1973.3), pp. 33–45; Jiangxi sheng bowuguan et al., eds, *Jiangxi Mingdai fanwang mu* (Beijing, 2010), pp. 70–86.

11 Xi'an shi wenwu baohu kaogusuo, 'Xi'an nanjiao Huang Ming zongshi Qianyang Duanyiwang Zhu Gongzeng mu qingli jianbao', *Kaogu yu wenwu* (2001.6), pp. 29–45.

12 The other example, also from Hubei, is the tomb of a consort of King Duan of Jing, buried in 1559. Xiao Tun, 'Liuniangjing Ming mu de qingli', *Wenwu cankao ziliao* (1958.5), pp. 55–6.

13 Zhongguo shehui kexueyuan kaogusuo deng, 'Chengdu Fenghuangshan Ming mu', and Chengdu shi wenwu kaogu yanjiusuo, 'Chengdu Mingdai Shu Xiwang fajue jianbao', *Wenwu* (2002.4), pp. 41–54 (1434 tomb of King Xi of Shu, Sichuan province).

14 Chen Wenhua, 'Jiangxi Xinjian Ming Zhu Quan mu fajue', *Kaogu* (1962.4), pp. 202–5; Jiangxi sheng bowuguan et al., eds, *Jiangxi Mingdai fanwang mu*, pp. 5–14.

15 Zhongguo shehui kexueyuan kaogusuo deng, 'Chengdu Fenghuangshan Ming mu'. On iron bows see Sabir Badalkhan, '"Lord of the Iron Bow": The Return Pattern Motif in the Fifteenth-century Buloch Epic Hero Sey Murid', *Oral Tradition*, xix/2 (2004), pp. 253–98. On Turco-Mongolian survivals in Ming kingly culture see David M. Robinson, 'The Ming Court and the Legacy of the Yuan Mongols'.

16 Hubei sheng wenwu kaogu yanjiusuo and Zhongxiang shi bowuguan, eds, *Liang Zhuangwang mu*, I, pp. 100–03, II, pls 106–7.

17 Hubei sheng wenwu kaogu yanjiusuo and Zhongxiang shi bowuguan, eds, *Liang Zhuang-wang mu*, I, pp. 184–6, II, pl. 191. On the court and Tibetan Buddhism see Marsha Weidner, 'Imperial Engagements with Buddhist Art and Architecture: Ming Variations on an Old Theme', in *Cultural Intersections in Later Chinese Buddhism*, ed. Marsha Weidner (Honolulu, 2001), pp. 117–44, and Patricia Berger, 'Miracles in Nanjing: An Imperial Record of the Fifth Karmapa's Visit to the Chinese Capital', in ibid., pp. 145–69.

18 Chen Wenhua, 'Jiangxi Xinjian Ming Zhu Quan mu fajue', p. 205.

19 Xi'an shi wenwu baohu kaogusuo, 'Xi'an nanjiao Huang Ming zongshi Qianyang Duanyiwang Zhu Gongzeng mu qingli jianbao', p. 35.

20 Xiao Tun, 'Liuniangjing Ming mu de qingli'.

21 Jiangxi sheng bowuguan, 'Jiangxi Nancheng Ming Yiwang Zhu Youbin mu fajue jianbao', and Jiangxi sheng bowuguan et al., eds, *Jiangxi Mingdai fanwang mu*, pl. 25; Jiangxi sheng wenwu gongzuodui, 'Jiangxi Nancheng Ming Yi Xuanwang Zhu Yiyin fufu hezang mu', *Wenwu* (1982.8), pp. 16–28.

22 Jiangxi sheng wenwu gongzuodui, 'Jiangxi Nancheng Ming Yi Dingwang Zhu Youmu mu fajue jianbao', *Wenwu* (1983.2), pp. 56–64.

23 Jiangxi sheng wenwu kaogu yanjiusuo, 'Nanchang Mingdai Ning Jingwang furen Wu shi mu fajue jianbao', *Wenwu* (2003.2), pp. 19–34 (p. 24).

24 What follows draws on the 2003 tomb report and the 2007 site monograph, and also on a trip to the site made on 8 April 2009.

25 Hubei sheng wenwu kaogu yanjiusuo et al., 'Wuchang Longquanshan Mingdai Chu Zhaowang mu fajue jianbao', *Wenwu* (2003.2), pp. 4–18.

26 For a more extended comparison of the contents see Craig Clunas, 'The Other Ming Tombs: Kings and their Burials in Ming China'.

27 Hubei sheng wenwu kaogu yanjiusuo and Zhongxiang shi bowuguan, eds, *Liang Zhuangwang mu*, I, pp. 198–201, II, pls 106–7.

28 On the death of Lady Ji see Xie Guian, ed., *Ming Shilu lei zuan: Hubei shiliao juan*, (Wuhan, 1991), p. 1280.

29 On the 'marriage system' of the Ming imperial clan see Satō Fumiyoshi, *Mindai ōfu no kenkyu* (Tokyo, 1999), ch. 3, pp. 178–244, with a listing of all known kingly marriage partners and their backgrounds on pp. 226–39. See also Ellen Soullière, 'The Imperial Marriages of the Ming Dynasty', *Papers on Far Eastern History*, XXVII (1988), pp. 15–42 (which does not mention the kingly houses but concentrates on the main imperial line).

30 For example, a daughter of Fu Youde (*d.* 1394) married a Crown Prince of Jin; F. W. Mote, 'Fu Yu-te', in L. Carrington Goodrich and Chaoying Fang, eds, *Dictionary of Ming Biography, 1368–1644*, 2 vols (New York and London, 1976) [hereafter DMB], I, pp. 466–71 (p. 470). The first King of Lu was married to a daughter of the general Tang He (1326–1395); Chen Yong, 'Mingdai Yanzhou Luwang he wangfu', *Shihai gouchen/Zhongzhou Today and Yesterday* (2003.1), pp. 8–16 (p. 11).

31 Shen Defu, *Wanli ye huo bian*, Yuan Ming shiliao biji congkan (Beijing, 1980), III, pp. 806–7. Also Timothy Brook, *The Confusions of Pleasure: Commerce and Culture in Ming China* (Berkeley, Los Angeles and London, 1998), p. 80 n. 121, for marriages between the former Yuan elite and Ming kings.

32 Zhang Zhengming, Ke Dawei and Wang Yonghong, eds, *Ming Qing Shanxi beike ziliao xuan (xu yi)* (Taiyuan, 2007), pp. 307–8.

33 Gabriel Piterberg, *An Ottoman Tragedy:*

History and Historiography at Play (Berkeley and Los Angeles, 2003), p. 19.

34 Hubei sheng wenwu kaogu yanjiusuo and Zhongxiang shi bowuguan, eds, *Liang Zhuangwang mu*, I, pp. 200–02; II, pls 108–9.

35 Chris Wickham, *Framing the Early Middle Ages: Europe and the Mediterranean, 400–800* (Oxford, 2005), p. 340.

36 Tao Zongyi, *Shuo fu san zhong*, Shanghai guji chubanshe edn (Shanghai, 1988), vol. XIX, pp. 345–58.

37 Ruby Lal, *Domesticity and Power in the Early Mughal World*, Cambridge Studies in Islamic Civilization (Cambridge, 2005).

38 MS, XII, *juan* 166, *Liezhuan* 4, pp. 3566–7; Roger V. Des Forges, *Cultural Centrality and Political Change in Chinese History: Northeast Henan in the Fall of the Ming* (Stanford, CA, 2003), pp. 123–4. However, Ren Zunshi, *Zhou Xian wang yanjiu* (Taibei, 1974), p. 61, sees him as active in persuading Emperor Yingzong (*r.* 1436–49) to prohibit the custom.

39 Ren Zunshi, *Zhou Xian wang yanjiu*, p. 58.

40 Ren Zunshi, *Zhou Xian wang yanjiu*, pp. 59–60.

41 Hubei sheng wenwu kaogu yanjiusuo and Zhongxiang shi bowuguan, eds, *Liang Zhuangwang mu*, I, pp. 36–9; II, pls 26–7.

42 Charles O. Hucker, *A Dictionary of Official Titles in Imperial China* (Stanford, CA, 1985), no. 8,003.

43 For relevant regulations, including lists of the types of jewellery bestowed at betrothal, see Zhu Qinmei, *Wang guo dian li*, in *Si ku quan shu cunmu congshu* (Ji'nan, 1995–7), CCLXX, *juan* 2, pp. 4a–17b (pp. 46–53).

44 Hubei sheng wenwu kaogu yanjiusuo and Zhongxiang shi bowuguan, eds, *Liang Zhuangwang mu*, I, pp. 32–5; II, pls 18–19, 24–5.

45 Hubei sheng wenwu kaogu yanjiusuo and Zhongxiang shi bowuguan, eds, *Liang Zhuangwang mu*, I, pp. 135–6; II, pl. 145.

46 Guo Yuanwei, 'Nanchang Ming Ning Kangwang ci fei Feng shi mu', *Kaogu* (1964.4), pp. 213–14.

47 Jiangxi sheng bowuguan et al., eds, *Jiangxi Mingdai fanwang mu*, pl. 27.

48 Jiangxi sheng bowuguan, 'Jiangxi Nancheng Ming Yiwang Zhu Youbin mu fajue jianbao', pp. 35–6; Jiangxi wenguanhui, 'Jiangxi Nancheng Ming Yi Zhuangwang mu chutu wenwu', *Wenwu* (1959.1), pp. 48–52. For an overview of the Yi tomb excavations see Jin Laien and Tian Juan, 'Mingchao Gan di fanwang ji qi muzang', *Nanfang wenwu* (2004.3), pp. 67–71, and Jiangxi sheng bowuguan et al., eds, *Jiangxi Mingdai fanwang mu*, pp. 60–163.

49 Jiangxi sheng wenwu gongzuodui, 'Jiangxi Nancheng Ming Yi Xuanwang Zhu Yiyin fufu hezang mu', pp. 16–28; Jiangxi sheng bowuguan et al., eds, *Jiangxi Mingdai fanwang mu*, pls 62–3.

50 An idea made very clear in another historical context in Cecily J. Hilsdale, 'The Social Life of the Byzantine Gift: The Royal Crown of Hungary Re-invented', *Art History*, XXXI/5 (2008), pp. 603–31. For a comparative perspective see Marcia Pointon, 'Intriguing Jewellery: Royal Bodies and Luxurious Consumption', *Textual Practice*, XI/3 (1997), pp. 493–516.

51 Hubei sheng wenwu kaogu yanjiusuo and Zhongxiang shi bowuguan, eds, *Liang Zhuangwang mu*, I, p. 44; II, pl. 36. 'Administration Office' (*Cheng feng si*) does not exist as a term in Hucker, *Dictionary of Official Titles*, but it appears in several inscriptions in the tomb.

52 Hubei sheng wenwu kaogu yanjiusuo and Zhongxiang shi bowuguan, eds, *Liang Zhuangwang mu*, I, pp. 76–9; II, pl. 80.

53 Jiangxi sheng wenwu gongzuodui, 'Jiangxi Nancheng Ming Yi Xuanwang Zhu Yiyin fufu hezang mu', pp. 16–28; Jiangxi sheng bowuguan et al., eds, *Jiangxi Mingdai fanwang mu*, pl. 64; for *Dian bao suo* see Hucker, *Dictionary of Official Titles*, no. 6,621.

54 Craig Clunas, 'Some Literary Evidence for Gold and Silver Vessels in the Ming Dynasty (1368–1644)', in *Pots and Pans: A Colloquium on Precious Metals and Ceramics*, ed. Michael Vickers and Julian Raby, Oxford Studies in Islamic Art, 3 (1987), pp. 83–7. For a recent example of new attention to the topic see Nanjing shi bowuguan, *Jin yu yu: Gongyuan 14–17 shiji Zhongguo guizu shoushi* (Shanghai, 2004).

55 Anne Walthall, 'Introducing Palace Women', in *Servants of the Dynasty: Palace Women in World History*, ed. Anne Walthall (Berkeley, Los Angeles and London, 2008), pp. 1–21 (p. 20).

56 F. W. Mote and L. Carrington Goodrich, 'Chu Ti', in *DMB*, I, pp. 355–65.

57 Xu Hong, 'Mingdai Kaifeng Zhouwang de xiangguan wenti', *Henan keji daxue xuebao (Shehui kexue ban)*, XXII/4 (2004), pp. 21–4 (pp. 21–2).

58 Jin Laien and Tian Juan, 'Mingchao Gan di fanwang ji qi muzang', p. 68.

59 Carney T. Fisher, *The Chosen One: Succession and Adoption in the Court of Ming Shizong* (Sydney, Wellington, London and Boston, 1990) remains the fullest account in English.

60 Shen Defu, *Wanli ye huo bian*, I, pp. 111–12.

61 Shen Defu, *Wanli ye huo bian*, I, pp. 112–13.

62 Shen Defu, *Wanli ye huo bian*, I, p. 120.

63 Shen Defu, *Wanli ye huo bian*, I, p. 124.

64 Shen Defu, *Wanli ye huo bian*, I, p. 125.

65 Chaoying Fang and L. Carrington Goodrich, 'Kuo Cheng-yü', in *DMB*, I, pp. 768–70. The dispute is covered in detail in Satō Fumiyoshi, *Mindai ōfu no kenkyu*, pp. 245–302. It can be traced through the 'Veritable Records' account in Xie Guian, ed., *Ming Shilu lei zuan: Hubei shiliao juan*, pp. 1075–166.

66 Cited in Zhang Jianmin, 'Mingdai Lianghu diqu de zongfan yu difang shehui', *Jianghan luntan* (2002.10), pp. 76–81 (p. 79).

67 Jonathan Spence, *Return to Dragon Mountain* (London, 2008), p. 151.

68 Robert. S. Nelson, 'The History of Legends and the Legends of History: The Pilastri Acritani in Venice', in *San Marco, Byzantium, and the Myths of Venice*, ed. Paul Madaglino and Robert Nelson, Dumbarton Oaks Byzantine Symposia and Colloquia (Washington, DC, 2010), pp. 63–90 (p. 90).

SIX: THE BRONZES OF THE KING OF LU

1 Chaoying Fang, 'Ni Ch'ien', in L. Carrington Goodrich and Chaoying Fang, eds, *Dictionary of Ming Biography, 1368–1644*, 2 vols (New York and London, 1976) [hereafter *DMB*], II, pp. 1088–90 (p. 1089).

2 Hok-lam Chan, 'Yang Hsüan', in *DMB*, II, pp. 1510–13 (p. 1511); L. Carrington Goodrich, 'Chiao Fang', in *DMB*, I, pp. 233–4 (p. 233); Chin-tang Lo, 'Li P'an-lung', in *DMB*, I, pp. 845–7 (p. 845); Chaoying Fang and Mingshui Hung, 'Wang Ssu-jen', in *DMB*, II, pp. 1420–25 (p. 1420); Lienche Tu Fang, 'Lu Ping', in *DMB*, I, pp. 998–9 (p. 998).

3 Sun Weiguo, 'Different Types of Scholar-Official in Sixteenth-century China: The Interlaced Careers of Wang Shizhen and Zhang Juzheng', *Ming Studies*, 53/2 (Spring 2006), pp. 4–50, (p. 15).

4 Sun Weiguo, 'Different Types of Scholar-Official', p. 35.

5 Robert B. Crawford and L. Carrington Goodrich, 'Chang Chü-cheng', in *DMB*, I, pp. 53–61 (p. 53); Zhang Jianmin, 'Mingdai Lianghu diqu de zongfan yu difang shehui', *Jianghan luntan* (2002.10), pp. 76–81 (p. 81); for the reception of this event later in the century see Shen Defu, *Wanli ye huo bian*, Yuan Ming shiliao biji congkan (Beijing, 1980), vol. I, pp. 122–3.

6 Liu Ts'un-yan, 'Wu Ch'eng-en', in *DMB*, II, pp. 1479–83 (p. 1481); L. Carrington Goodrich and Chaoying Fang, 'Li Shih-chen', in *DMB*, I, pp. 859–65 (p. 864).

7 Qianshen Bai, *Fu Shan's World: The Transformation of Chinese Calligraphy in the Seventeenth Century* (Cambridge, MA, and London, 2003), p. 73.

8 Scarlett Jang, 'The Eunuch Agency Directorate of Ceremonial and the Ming Imperial Publishing Enterprise', in *Culture, Courtiers, and Competition: The Ming Court (1368–1644)*, ed. David M. Robinson, Harvard East Asian Monographs, 301 (Cambridge, MA, and London, 2008), pp. 116–85 (p. 169).

9 Lu Shen, *Huai feng ri ji*, 1 juan, in *Si ku quan shu cunmu congshu* (Jinan, 1995–7), CXXVII, pp. 622–6. This text is probably incomplete as it stands, since it recounts its author's travels only as far as Suzhou, and does not describe the investiture itself.

10 Qian Xiyan, *Liao di ji wen*, 1 juan, in *Shuo fu xu* (Taibei, 1972), pp. 802–4.

11 Hok-lam Chan, 'Lu Shen', in *DMB*, I,
 pp. 999–1003 (p. 1000); L. Carrington
 Goodrich, 'Hsiao Ta-heng', in *DMB*, I,
 pp. 544–6 (p. 544); Albert Chan, 'Chen
 Renxi', in *DMB*, I, pp. 161–3 (p. 162).

12 Wing-tsit Chan, 'Wang Shou-jen', in *DMB*, II,
 pp. 1408–16.

13 Fang Zhiyuan, 'Yangming shi shi san ti', *Jiangxi
 shifan daxue xuebao (Zhexue shehuikexue ban)*,
 XXXVI/4 (July 2003), pp. 99–106.

14 Quoted in Craig Clunas, *Elegant Debts:
 The Social Art of Wen Zhengming, 1470–1559*
 (London, 2004), p. 49.

15 Clunas, *Elegant Debts*, pp. 49–50.

16 Li Weizhen himself in Guoli zhongyang
 tushuguan, *Mingren zhuanji ziliao suoyin*,
 2nd edn (Taibei, 1978) [hereafter *MRZJ*],
 p. 220.

17 Li Weizhen, 'Shen wang shou xu', 'Shen wang
 shou xu (you)', 'Zhongpei zong hou shou xu',
 'Qi wang sun Guohua shou xu', 'Shanyin wang
 Xiang gong shou xu', *Da mi shan fang ji, juan*
 27, pp. 1a–12b and 22a–23b, in *Si ku quan shu
 cunmu congshu* (Jinan, 1995–97), CLI, pp. 83–8
 and 96–7; other examples are mentioned in
 MRZJ, pp. 127 and 142. An example of a
 funerary text for an aristocratic patron by Li
 is 'Ruichang wang fu fu guo zhong wei Zhenhu
 gong mu zhi ming', *Da mi shan fang ji, juan* 81,
 pp. 1a–12b and 5a, in *Si ku quan shu cunmu
 congshu* (Jinan, 1995–97), vol. CLII, pp. 406–8.

18 *MRZJ*, p. 687. Cheng Jiasui, 'Gong he Shen wang
 dian xia qian qiu jie qi shi shou xu', 'Shen wang
 dian xia qian qiu jie qi shi shou xu', in *Song
 yuan jie an ji, juan* 1, pp. 22b–25b and 46a–48a,
 in *Si ku jin hui shu congkan: Bu bian* (Beijing,
 2005), vol. LXVII, pp. 14–15 and 26–7.

19 Shen Defu, *Wanli ye huo bian*, Yuan Ming

shiliao biji congkan (Beijing, 1980), vol. I,
 p. 127.

20 Lienche Tu Fang, 'Hsü Hsüeh-mo', in *DMB*, I,
 pp. 585–7 (p. 586).

21 Jin ci bowuguan, ed., *Bao xian tang ji gu fa tie*
 (Beijing, 2002), pp. 449–50.

22 Lucille Chia, 'Publications of the Ming
 Principalities: A Distinct Example of Private
 Printing', *Ming Studies*, 54 (Fall 2006), p. 40.

23 As a single example, see the tabulation of
 kingly poets from the province of Henan in
 Wang Rurun and Ma Wei, 'Mingdai Henan
 zongfan shiren kaolun', *Luoyang shifan
 xueyuan xuebao* (2007.1), pp. 82–4.

24 Zhang Guoning, 'Ming Jinwang jiqi zongshi
 zakao', *Jinyang wenhua yanjiu*, 1 (Taiyuan,
 2006), pp. 97–127 (p. 125). On Kong Tianyin
 see *MRZJ*, p. 83; Wang Daoxing is *MRZJ*, p. 61.
 As one of the 'Latter Five Masters' (*Xu wu zi*)
 he was grouped with Zhu Duokui (*MRZJ*,
 p. 127), himself an imperial clan member.

25 Qian Xiyan, *Liao di ji wen*, p. 2b (p. 804).

26 Hok-lam Chan 'Ho T'ang', in *DMB*, I,
 pp. 518–20 (p. 519). See also Chia,
 'Publications of the Ming Principalities', p. 34.

27 Huang Tsung-hsi, *The Records of Ming
 Scholars: A Selected Translation*, ed. Julia
 Ching, with Chaoying Fang (Honolulu, 1987),
 p. 77. On Hu Juren see *DMB*, I, pp. 625–7.

28 'Ti "Yao chi chun xiao tu" shou Heng wang,
 and 'Yao he Zhao wang liu shi sui', in Li
 Kaixian, *Li Kaixian quanji*, ed. Bu Jian (Beijing,
 2004), pp. 73 and 137. I owe this reference, and
 other material that follows, to Tian Yuan Tan.

29 Tian Yuan Tan, 'Qu Writing in Literati
 Communities: Re-discovering Sanqu Songs
 and Drama in Sixteenth-century North
 China', unpublished PhD dissertation

(Harvard University, 2006), p. 160, where the two different possibilities for the identity of the King of Xinle in question are also discussed. The original text is Li Kaixian, *Li Kaixian quanji*, pp. 504–5.

30 Li Kaixian, *Li Kaixian quanji*, p. 131, is a poem of mourning for the King of Duanhui; p. 193 mourns a King of Zhao.

31 F. W. Mote, 'Fang Hsiao-ju', in *DMB*, I, pp. 426–33 (p. 429).

32 D. R. Jonker, 'Chu Yu-dun', in *DMB*, I, pp. 380–81 (p. 381).

33 Chia, 'Publications of the Ming Principalities', pp. 24–70 (p. 35).

34 Lienche Tu Fang, 'Lu Nan', in *DMB*, I, pp. 995–7 (p. 996).

35 Chia, 'Publications of the Ming Principalities', p. 40.

36 Zhao Qian and Zhang Zhiqing, 'Book Publishing by the Princely Households during the Ming Dynasty: A Preliminary Survey', *The East Asian Library Journal*, x/1 (Spring 2001), pp. 85–128; Yu Shuchun, 'Mingdai fanwang de zhushu yu keshu', *Chizhou shizhuan xuebao*, XVII/1 (2003.2), pp. 10–12; Chia, 'Publications of the Ming Principalities'; Jérôme Kerlouégan, 'Printing for Prestige? Publishing and Publication by Ming Princes', *East Asian Publishing and Society*, I (2011), pp. 39–73.

37 Huang Yuji, *Qian qing tang shu mu*, quoted in Yu Shuchun, 'Mingdai fanwang de zhushu yu keshu', p. 12. Zhao Qian and Zhang Zhiqing, 'Book Publishing by the Princely Households during the Ming Dynasty, p. 87. For gifts of books from the imperial court to appanages see also Scarlett Jang, 'The Eunuch Agency Directorate of Ceremonial and the Ming Imperial Publishing Enterprise', p. 117.

38 On Zhu Mujie see *MRZJ*, p. 143. The catalogue of his great library survives as *Wan juan tang shu mu* in 4 *juan*, and is reprinted in Feng Huimin, Li Wanjian et al., eds, *Mingdai shumu tiba congkan* (Beijing, 1994), vol. II, pp. 1065–103.

39 Yu Shuchun, 'Mingdai fanwang de zhushu yu keshu', p. 12. Also Guo Mengliang, 'Shi lun Mingdai zongfan de tushu shiye', *Zhengzhou daxue xuebao* (2002.4), pp. 134–8.

40 Chia, 'Publications of the Ming Principalities', p. 30.

41 Kerlouégan, 'Printing for Prestige?'.

42 Zhao Qian and Zhang Zhiqing, 'Book Publishing by the Princely Households During the Ming Dynasty', p. 101.

43 Chia, 'Publications of the Ming Principalities', pp. 26–8.

44 Zhang Guoning, 'Ming Jinwang jiqi zongshi zakao', p. 126.

45 Susan Mann, 'Grooming a Daughter for Marriage: Brides and Wives in the Mid-Ch'ing Period', in *Marriage and Inequality in Chinese Society*, ed. Rubie S. Watson and Patricia Buckley Ebrey (Berkeley, Los Angeles and London, 1997), pp. 204–30 (p. 214). There the reference is to the Qing grouping of texts known as the *Nü si shu*, one of which was the *Nei xun* 'Womanly Instructions' by Empress Xu (1362–1407; *DMB*, I, pp. 566–9), wife of the Yongle emperor.

46 Chia, 'Publications of the Ming Principalities', p. 36–7.

47 Chia, 'Publications of the Ming Principalities', p. 32.

48 For example, Gu Jinchun and Ye Jianfei, 'Jin ershi nian lai guonei xuejie duiyu Mingdai zongfan de yanjiu zongshu', *Lanzhou jiaoyu xueyuan xuebao* (2006.4), pp. 14–19 (p. 19).

49 Chia, 'Publications of the Ming Principalities', p. 29.

50 Chia, 'Publications of the Ming Principalities', p. 37.

51 An argument also made in Kerlouégan, 'Printing for Prestige?'.

52 Zhao Qian and Zhang Zhiqing, 'Book Publishing by the Princely Households During the Ming Dynasty', p. 102.

53 Peter Ditmanson, 'Death in Fidelity: Mid- and Late-Ming Reconstructions of Fang Xiaoru', *Ming Studies*, 45–46 (2001), pp. 114–43 (p. 129).

54 Chia, 'Publications of the Ming Principalities', p. 38.

55 Chia, 'Publications of the Ming Principalities', p. 37. For *Huangchao Zhongzhou renwu zhi* see Wolfgang Franke, *An Introduction to the Sources of Ming History* (Kuala Lumpur, 1968) [hereafter ISMH], 3.5.2, on which see also Roger V. Des Forges, *Cultural Centrality and Political Change in Chinese History: Northeast Henan in the Fall of the Ming* (Stanford, CA, 2003), p. 16; for *Henan tong zhi* see ISMH, 8.8.1.

56 *Sheng dian*, ISMH, 2.3.15; *Ge chu yi shi*, ISMH, II/42.

57 MRZJ, p. 223.

58 Joseph S.C. Lam, 'Imperial Agency in Ming Music Culture', in *Culture, Courtiers, and Competition: The Ming Court (1368–1644)*, ed. David M. Robinson, Harvard East Asian Monographs, 301 (Cambridge, MA, and London, 2008), pp. 269–320, (pp. 281 and 304).

59 Lam, 'Imperial Agency in Ming Music Culture', p. 295.

60 Eric C. Lai, 'Pipa Artists and their Music in Late Ming China', *Ming Studies*, 58 (Fall 2008), pp. 43–71 (pp. 52–4); Angela Hsi, 'Cha Nai', in DMB, I, pp. 33–4.

61 Lam, 'Imperial Agency in Ming Music Culture', pp. 292–4.

62 Georges Goormaghtigh and Bell Yung, 'Preface of the *Shenqi mipu*: Translation with Commentary', ACMR Reports, *Journal of the Association for Chinese Music Research*, X/1 (1997), pp. 1–13.

63 Zhao Chunting, 'Wu ben Mingdai fanwang qinpu de neizai guanxi ji dui Mingdai qinxue de yingxiang', *Yinyue yanjiu* (2006.3), pp. 29–40.

64 Lam, 'Imperial Agency in Ming Music Culture', pp. 299 and 303.

65 Shen Defu, *Wanli ye huo bian*, I, p. 121.

66 Robert H. van Gulik, *The Lore of the Chinese Lute* (Tokyo, 1968), pp. 214–15. For another example see 'Qin – Ancient Musical Instruments from the Family Collections', Poly Auction, Beijing, 4 June 2010, lot 4253.

67 Kenneth G. Robinson and Chaoying Fang, 'Chu Tsai-yü', in DMB, I, pp. 367–71; Zhang Minfu and Xu Jing, 'Mingdai Henan zongfan qianshu', *Shangqiu shifan xueyuan xuebao*, 18.1/114 (February 2002), pp. 48–51, (p. 114).

68 Kenneth Robinson, *A Critical Study of Chu Tsai-yü's Contribution to the Theory of Equal Temperament in Chinese Music*, Sinologica Coloniensa, 9 (Wiesbaden, 1980), is much more enthusiastic about his achievements than is Fritz A. Kuttner, 'Prince Chu Tsai-yü's Life and Work: A Re-evaluation of His Contribution to Equal Temperament Theory', *Ethnomusicology*, XIX/2 (1975), pp. 163–205; see also Lam, 'Imperial Agency in Ming Music Culture', pp. 301–2.

69 Wang Kefen, *Zhongguo wudao shi: Ming Qing bufen* (Beijing, 1984), pp. 166–84; Nicholas Standaert, 'Ritual Dances and Their Visual

Representations in the Ming and Qing', *The East Asian Library Journal*, XII/1 (2006), pp. 68–181 (pp. 106–30).

70 Wang Guangyao, 'Gugong bowuyuan cang Lu guo tongqi kao', *Wenwu* (1994–6), pp. 72–5; Guoli gugong bowuyuan, ed., *Gu se: Shiliu zhi shiba shiji yishu de fanggufeng* (Taibei, 2003), pp. 97 and 234.

71 Zhang Tingyu et al., eds, *Ming shi*, 28 vols (Beijing, 1974) [MS], XII, *juan* 120, *Liezhuan* 8, pp. 3648–9. Note that some modern scholars prefer the spelling Luh for this appanage of 潞, situated at Weihui in Henan, to distinguish it from 魯, in Shandong.

72 Zhu Changfang, *Gu jin zong fan yi xing kao*, in *Si ku quan shu cunmu congshu* (Ji'nan, 1995), vol. CXVII.

73 Wang Guangyao, 'Gugong bowuyuan cang Lu guo tongqi kao', p. 73.

74 Van Gulik, *Lore of the Chinese Lute*, pp. 214–15; Zhao Chunting, 'Wu ben Mingdai fanwang qinpu', p. 30.

75 Zhao Qian and Zhang Zhiqing, 'Book Publishing by the Princely Households during the Ming Dynasty', p. 102.

76 On Zhu Mouyin, *Li dai zhong ding yi qi kuan shi fa tie*, see Kerlouégan, 'Printing for Prestige?'.

77 Wang Guangyao, 'Gugong bowuyuan cang Lu guo tongqi kao', p. 74.

78 Jessica Harrison-Hall, *Catalogue of Late Yuan and Ming Ceramics in the British Museum* (London, 2001), XII/88.

79 Paul Pelliot, 'Notes sur l'histoire de la céramique chinoise', *T'oung Pao*, XXII (1923), pp. 1–54 (pp. 50–51); Paul Pelliot, 'Sur l'interpretation des marques des porcelaines chinoises', *Artibus Asiae*, II/3 (1927), pp. 179–87 (pp. 182–3).

80 Lynn A. Struve, *The Southern Ming, 1644–1662* (New Haven, CT, and London, 1984), pp. 18–19.

81 Ming Wilson, *Rare Marks on Chinese Ceramics* (London, 1998), p. 9 and pp. 30–31.

SEVEN: REMEMBERED LANTERNS

1 Guoli zhongyang tushuguan, *Mingren zhuanji ziliao suoyin*, 2nd edn (Taibei, 1978) [hereafter MRZJ], p. 557; Lienche Tu Fang, 'Chang Han', in L. Carrington Goodrich and Chaoying Fang, eds, *Dictionary of Ming Biography, 1368–1644*, 2 vols (New York and London, 1976) [DMB], I, pp. 72–4.

2 Zhang Han, *Song chuang meng yu*, Ming Qing biji congshu (Shanghai, 1986), pp. 154–8. On this essay see Guo Chaohui and Zhang Dongdong, '"Song chuang meng yu: Zong fan ji" yanjiu', *Xinxiang jiaoyu xueyuan xuebao*, XX/1 (March 2007), pp. 31–2.

3 Zhang Han, *Song chuang meng yu*, p. 156.

4 Zhang Han, *Song chuang meng yu*, p. 156.

5 John W. Chaffee, *Branches of Heaven: A History of the Imperial Clan of Sung China* (Cambridge, MA, and London, 1999), pp. 272–4.

6 Min Tu-gi, *National Polity and Local Power: The Transformation of Late Imperial China*, ed. Philip A. Kuhn and Timothy Brook (Cambridge, MA, 1989), pp. 89–136; Prasenjit Duara, *Rescuing History from the Nation: Questioning Narratives of Modern China* (Chicago and London, 1995), p. 153; Thomas Bartlett, 'Phonology as Statecraft in Gu Yanwu's Thought', in *The Scholar's Mind: Essays in Honor of Frederic W. Mote*, ed. Perry Link (Hong Kong, 2009), pp. 181–206.

7 Peter Bol, 'The "Localist Turn" and "Local Identity" in Late Imperial China, *Late Imperial China*, XXIV/2 (2003), pp. 1–50.

8 Zhang Dai, *Tao'an meng yi* (Hangzhou, 1982), pp. 17–18, translated in Zhang Dai, *Souvenirs rêvés de Tao'an*, trans. and ed. Brigitte Teboul-Wang (Paris, 1995), and also in Philip A. Kafalas, *In Limpid Dream: Nostalgia and Zhang Dai's Reminsicences of the Ming* (Norwalk, CT, 2003), pp. 115–16, discussed in Jonathan Spence, *Return to Dragon Mountain* (London, 2008), pp. 111–13.

9 Zhang Dai, *Tao'an meng yi*, pp. 111–12; Spence, *Return to Dragon Mountain*, pp. 210–11.

10 Chen Yong, 'Mingdai Yanzhou Luwang he wangfu', *Shihai gouchen/Zhongzhou Today and Yesterday* (2003.1), pp. 8–16 (pp. 14–15).

11 Wang Jinyan and Liang Jiang, 'Mingchu Yanzhou fucheng xingtai kuangzhan ji Luwangcheng guihua fenxi – Jian lun fanwangcheng guihua', *Guihuashi/Planners* (2001.1), pp. 74–7 (p. 76).

12 Zhang Guoning, 'Ming Jinwang jiqi zongshi zakao', *Jinyang wenhua yanjiu*, I (Taiyuan, 2006), pp. 97–127 (p. 116).

13 Zhang Jianmin, 'Mingdai Lianghu diqu de zongfan yu difang shehui', *Jianghan luntan* (2002.10), pp. 76–81 (p. 77).

14 Wu Hongqi and Dang Anrong, 'Guanyu Mingdai Xi'an Qin wangfucheng de ruogan wenti', *Zhongguo lishi dili luncong* (1993), pp. 149–64 (pp. 154–5).

15 Xiao Jianyi, 'Ming Qin fanjia zupuxi ji muzang fenbu chutan', *Kaogu yu wenwu* (2007.2), pp. 93–8 (p. 95).

16 Wang Fangyu, Richard M. Barnhart and Judith G. Smith, eds, *Master of the Lotus Garden: The Life and Art of Bada Shanren (1626–1705)* (New Haven, CT, and London, 1990); Jonathan Hay, *Shitao: Painting and Modernity in Early Qing China* (Cambridge, 2001), p. 84.

17 Chen Yong, 'Mingdai Yanzhou Luwang he wangfu', pp. 14–15.

18 Yang Guoliang and Zhou Zuoming, 'Ming Jingjiang wangcheng yu Guilin lishi wenhua lüyou jianshe', *Guilin lüyou gaodeng zhuanke xuexiao xuebao*, XII/3 (2001), pp. 69–71.

19 Zhang Guoning, 'Ming Jinwang jiqi zongshi zakao', *Jinyang wenhua yanjiu*, I (Taiyuan, 2006), pp. 97–127; Zhang Jianmin, 'Mingdai Lianghu diqu de zongfan yu difang shehui', *Jianghan luntan* (2002.10), pp. 76–81; Su Quanyou and Zhang Yuwei, 'Mingdai fanwangxue de shenghui', *Luohe zhiye shuxueyuan xuebao*, VII/6 (November 2008), pp. 60–62.

20 Jin Laien and Tian Juan, 'Mingchao Gan di fanwang ji qi muzang', *Nanfang wenwu* (2004.3), pp. 67–71 (p. 71).

21 Duara, *Rescuing History from the Nation*, pp. 172–3.

22 John C. G. Röhl, *The Kaiser and His Court: Wilhelm II and the Government of Germany* (Cambridge, 1994), especially pp. 70–106, 'The Kaiser's Court'.

23 Stephen Greenblatt, 'Psychoanalysis and Renaissance Culture', in *The Renaissance: Italy and Abroad*, ed. John Jeffries Martin (London and New York, 2003), pp. 124–38 (p. 132).

24 Michel Foucault, *'Society Must be Defended': Lectures at the Collège de France, 1975–76*, trans. David Macey (London, 2003), p. 34.

25 Matthew Innes, *State and Society in the Early Middle Ages: The Middle Rhine Valley, 400–1000*, Cambridge Studies in Medieval Life and Thought (Cambridge, 2000), p. 261.

26 Dougal Shaw, 'Nothing But Propaganda? Historians and the Study of Early Modern Ritual', *Cultural and Social History*, I (2004), pp. 139–58.

BIBLIOGRAPHY

Daud Ali, *Courtly Culture and Political Life in Early Medieval India* (Cambridge, 2004)

Thomas Allsen, 'Sharing Out the Empire: Apportioned Lands Under the Mongols', in *Nomads in the Sedentary World*, ed. Anatoly Khazanov and André Wink (Richmond, VA, 2001), pp. 172–90

An Jiesheng, *Lishi dili yu Shanxi difangshi xintan* (Taiyuan, 2008)

Sabir Badalkhan, '"Lord of the Iron Bow": The Return Pattern Motif in the Fifteenth-century Baluch Epic Hero Sey Murid', *Oral Tradition*, XIX/2 (2004), pp. 253–98

Qianshen Bai, *Fu Shan's World: The Transformation of Chinese Calligraphy in the Seventeenth Century* (Cambridge, MA, and London, 2003)

Richard Barnhart, '*Streams and Hills Under Fresh Snow* Attributed to Kao K'o-ming', in *Words and Images: Chinese Poetry, Calligraphy and Painting*, ed. Alfreda Murck and Wen C. Fong (New York and Princeton, NJ, 1991), pp. 223–46

——, *Painters of the Great Ming: The Imperial Court and the Zhe School* (Dallas, 1993)

Thomas Bartlett, 'Phonology as Statecraft in Gu Yanwu's Thought', in *The Scholar's Mind: Essays in Honor of Frederic W. Mote*, ed. Perry Link (Hong Kong, 2009), pp. 181–206

Beijing daxue tushuguan and Xianggang zhongwen daxue wenwuguan, *Zhongguo gudai beitie taben* (Beijing and Xianggang, 2001)

Beijing tushuguan shanbenbu jinshizu, ed., *Beijing tushuguan cang huaxiang taben huibian*, 10 vols (Beijing, 1993)

Patricia Berger, 'Miracles in Nanjing: An Imperial Record of the Fifth Karmapa's Visit to the Chinese Capital', in *Cultural Intersections in Later Chinese Buddhism*, ed. Marsha Weidner (Honolulu, 2001), pp. 145–69

Maggie Bickford, 'Three Rams and Three Friends: The Working Lives of Chinese Auspicious Motifs', *Asia Major*, 3rd ser., XII/1 (1999), pp. 127–58

Nicholas Bock, 'Patronage, Standards and *Transfert Culturel*: Naples Between Art History and Social Science Theory', *Art History*, XXXI/4 (2008), pp. 574–97

Peter Bol, 'The "Localist Turn" and "Local Identity" in Late Imperial China', *Late Imperial China*, XXIV/2 (2003), pp. 1–50

Charles Boxer, *South China in the Sixteenth Century, Being the Narratives of Galeote Pereira, Fr.*

Gaspar da Cruz, O.P. [and] Fr. Martn de Rada, O.E.S.A. (1550–1575) (London, 1953)

Timothy Brook, *Praying for Power: Buddhism and the Formation of Gentry Society in Late-Ming China* (Cambridge, MA, and London, 1993)

—, *The Confusions of Pleasure: Commerce and Culture in Ming China* (Berkeley, Los Angeles and London, 1998)

Pierre-Henry de Bruyn, 'Daoism in the Ming (1368–1644)', in *Daoism Handbook*, ed. Livia Kohn, Handbook of Oriental Studies, Section Four: China, XIV (Leiden, Boston and Cologne, 2000), pp. 594–622

James Cahill, incorporating the work of Osvald Sirén and Ellen Johnston Laing, *An Index of Early Chinese Painters and Paintings: T'ang, Sung, and Yüan* (Berkeley, Los Angeles and London 1980)

—, *The Distant Mountains: Chinese Painting of the Late Ming Dynasty, 1570–1644* (New York and Tokyo, 1982)

John W. Chaffee, *Branches of Heaven: A History of the Imperial Clan of Sung China* (Cambridge, MA, and London, 1999)

Chai Zejun and He Dalong, *Shanxi fosi bihua* (Beijing, 2006)

Hok-lam Chan, 'The Chien-wen, Yung-lo, Hung-hsi and Hsüan-te reigns, 1399–1435', in *The Cambridge History of China*, vol. VII: *The Ming Dynasty, 1368–1644, Part I*, ed. Frederick W. Mote and Denis Twitchett (Cambridge, 1988), pp. 182–304

Chen Jiejin and Lai Yuzhi, *Zhuisuo Zhe pai/ Tracing the Che School in Chinese Painting* (Taibei, 2008)

Chen Wenhua, 'Jiangxi Xinjian Ming Zhu Quan mu fajue', *Kaogu* (1962.4), pp. 202–5

Chen Yong, 'Mingdai Yanzhou Luwang he wangfu', *Shihai gouchen/Zhongzhou Today and Yesterday* (2003.1), pp. 8–16

Chen Yunru, 'Meng Yuan huangshi de shuhua yishu fengshang yu shoucang', in *Dahan de shiji: Meng Yuan shidai de duoyuan wenhua yu yishu*, ed. Guoli gugong bowuyuan (Taibei, 2001), pp. 266–85

Cheng Jiasui, *Song yuan jie an ji, 2 juan*, in *Si ku jin hui shu congkan: Bu bian* (Beijing, 2005), vol. LXVII

Chengdu shi wenwu kaogu yanjiusuo, 'Chengdu Mingdai Shu Xiwang fajue jianbao', *Wenwu* (2002.4), pp. 41–54

Lucille Chia, 'Publications of the Ming Principalities: A Distinct Example of Private Printing', *Ming Studies*, 54 (Fall 2006), pp. 24–70

Dora C. Y. Ching, 'Tibetan Buddhism and the Ming Imperial Image', in *Culture, Courtiers and Competition: The Ming Court (1368–1644)*, ed. David M. Robinson, Harvard East Asian Monographs, 301 (Cambridge, MA, and London, 2008), pp. 321–64

Julia Ching, *Mysticism and Kingship in China: The Heart of Chinese Wisdom*, Cambridge Studies in Religious Traditions, 11 (Cambridge, 1997)

Christie's Amsterdam, 'The Van Gulik Collection of Fine Chinese, Japanese and Tibetan Paintings and Calligraphy: Oriental Ceramics and Works of Art' (7 December 1983)

Craig Clunas, 'Some Literary Evidence for Gold and Silver Vessels in the Ming Dynasty (1368–1644)', in *Pots and Pans: A Colloquium on Precious Metals and Ceramics*, ed. Michael Vickers and Julian Raby, Oxford Studies in Islamic Art, 3 (1987), pp. 83–7

—, *Superfluous Things: Material Culture and Social Status in Early Modern China* (Cambridge, 1991)

——, *Pictures and Visuality in Early Modern China* (London, 1997)

——, *Elegant Debts: The Social Art of Wen Zhengming, 1470–1559* (London, 2004)

——, 'The Other Ming Tombs: Kings and Their Burials in Ming China', *Transactions of the Oriental Ceramic Society*, LXX (2005–2006), pp. 1–16

——, *Empire of Great Brightness: Visual and Material Cultures of Ming China, 1368–1644* (London, 2007)

——, *Art in China*, 2nd edn (Oxford, 2009)

——, 'Antiquarian Politics and the Politics of Antiquarianism in Ming Regional Courts', in *Reinventing the Past: Antiquarianism in Chinese Art and Visual Culture*, ed. Wu Hung (Chicago, 2010), pp. 229–54

John Dardess, 'Protesting to the Death: The Fuque in Ming Political History', *Ming Studies*, 47 (Spring 2003), pp. 86–125

Sir Percival David, *Chinese Connoisseurship: The 'Ko Ku Yao Lun', The Essential Criteria of Antiquities* (London, 1971)

Roger V. Des Forges, *Cultural Centrality and Political Change in Chinese History: Northeast Henan in the Fall of the Ming* (Stanford, CA, 2003)

——, 'Tales of Three City Walls in China's Central Plain', in *Chinese Walls in Time and Space: A Multidisciplinary Perspective*, ed. Roger Des Forges, Minglu Gao, Liu Chiao-mei and Haun Saussy, with Thomas Burkman (Ithaca, NY, 2009), pp. 37–80

Nicola Di Cosmo, Allen J. Frank and Peter B. Golden, eds, *The Cambridge History of Inner Asia: The Chinggisid Age* (Cambridge, 2009)

Albert E. Dien, *Six Dynasties Civilization* (New Haven, CT, 2007)

Peter Ditmanson, 'Death in Fidelity: Mid- and Late-Ming Reconstructions of Fang Xiaoru', *Ming Studies*, 45–46 (2001), pp. 114–43

Prasenjit Duara, *Rescuing History from the Nation: Questioning Narratives of Modern China* (Chicago and London, 1995)

Jeroen Duindam, *Myths of Power: Norbert Elias and the Early Modern European Court* (Amsterdam, 1995)

——, *Vienna and Versailles: The Courts of Europe's Dynastic Rivals, 1550–1780* (Cambridge, 2003)

Eight Dynasties of Chinese Painting: The Collections of the Nelson Gallery-Atkins Museum, Kansas City and The Cleveland Museum of Art, with essays by Wai-kam Ho, Sherman E. Lee, Laurence Sickman and Marc F. Wilson (Cleveland, 1980)

Eskenazi, *Chinese Buddhist Sculpture from Northern Wei to Ming*, exh. cat., Pace Wildenstein, New York, 18–30 March 2002 (London, 2002)

——, *Seven Classical Chinese Paintings, 29 October–27 November 2009* (London, 2009)

Fang Zhiyuan, 'Yangming shi shi san ti', *Jiangxi shifan daxue xuebao (Zhexue shehuikexue ban)*, XXXVI/4 (July 2003), pp. 99–106

Edward L. Farmer, *Early Ming Government: The Evolution of Dual Capitals* (Cambridge, MA, and London, 1976)

——, *Zhu Yuanzhang and Early Ming Legislation: The Reordering of Chinese Society Following the Era of Mongol Rule*, Sinica Leidensia, 34 (Leiden, New York and Cologne, 1995)

Feng Huimin, Li Wanjian et al., eds, *Mingdai shumu tiba congkan*, 2 vols (Beijing, 1994)

Carney T. Fisher, *The Chosen One: Succession and Adoption in the Court of Ming Shizong* (Sydney, Wellington, London and Boston, 1990)

Wolfgang Franke, *An Introduction to the Sources of Ming History* (Kuala Lumpur, 1968)

Fu Kaisen, *Li dai zhu lu hua mu*, Taiwan zhonghua shuju reprint (Taibei, 1968)

Shen C. Y. Fu, trans. and adapted by Marsha Weidner, 'Princess Sengge Raggi: Collector of Painting and Calligraphy', in *Flowering in the Shadows: Women in the History of Chinese and Japanese Painting*, ed. Marsha Weidner (Honolulu, 1990), pp. 56–80

Clifford Geertz, *Negara: The Theatre-State in Nineteenth-century Bali* (Princeton, NJ, 1980)

James Geiss, 'The Cheng-te reign, 1506–1521', in *The Cambridge History of China*, vol. VII: *The Ming Dynasty, 1368–1644, Part I*, ed. Frederick W. Mote and Denis Twitchett (Cambridge, 1988), pp. 403–39

Gérard Genette, *Paratexts: Thresholds of Interpretation* (Cambridge, 1997)

Paul Goldin, 'On the Meaning of the Name Xi Wangmu, Spirit-Mother of the West', *Journal of the American Oriental Society*, CXXII/1 (2002), pp. 83–5

L. Carrington Goodrich and Chaoying Fang, eds, *Dictionary of Ming Biography, 1368–1644*, 2 vols (New York and London, 1976)

Georges Goormaghtigh and Bell Yung, 'Preface of the *Shenqi mipu*: Translation with Commentary', *ACMR Reports, Journal of the Association for Chinese Music Research*, X/1 (1997), pp. 1–13

Gu Jinchun and Ye Jianfei, 'Jin ershi nian lai guonei xuejie duiyu Mingdai zongfan de yanjiu zongshu', *Lanzhou jiaoyu xueyuan xuebao* (2006.4), pp. 14–19

Guo Chaohui and Zhang Dongdong, '"Song chuang meng yu: Zong fan ji" yanjiu', *Xinxiang jiaoyu xueyuan xuebao*, XX/1 (March 2007), pp. 31–2

Guo Licheng, 'Zengli hua yanjiu', in *Proceedings of the International Colloquy on Chinese Art History, 1991: Painting and Calligraphy* (Taipei, 1992), vol. II, pp. 749–66

Guo Mengliang, 'Shi lun Mingdai zongfan de tushu shiye', *Zhengzhou daxue xuebao* (2002.4), pp. 134–8

Guo Yuanwei, 'Nanchang Ming Ning Kangwang ci fei Feng shi mu', *Kaogu* (1964.4), pp. 213–14

Guojia wenwuju, ed., *Zhongguo wenwu dituji: Hubei fence*, 2 vols (Xi'an, 2002)

——, *Zhongguo wenwu dituji: Shanxi fence*, 3 vols (Beijing, 2006)

Guoli Gugong bowuyuan, ed., *Gugong shuhua tulu* (Taibei, 2001), vol. XIX

——, *Gu se: Shiliu zhi shiba shiji yishu de fanggufeng* (Taibei, 2003)

Guoli zhongyang tushuguan, *Mingren zhuanji ziliao suoyin*, 2nd edn (Taibei, 1978)

Han Ang, *Tu hui bao jian*, in *Hua shi congshu*, ed. Yu Anjian, 5 vols, 2nd edn (Shanghai, 1982), vol. II

Jessica Harrison-Hall, *Catalogue of Late Yuan and Ming Ceramics in the British Museum* (London, 2001)

Robert E. Harrist Jr, 'Copies, All the Way Down: Notes on the Early Transmission of Calligraphy by Wang Xizhi', *East Asian Library Journal*, X/1 (2001), pp. 176–96

——, and Wen C. Fong, *The Embodied Image: Chinese Calligraphy from the John B. Elliott Collection* (Princeton, NJ, 1999)

Jonathan Hay, *Shitao: Painting and Modernity in Early Qing China* (Cambridge, 2001)

He Biqi, 'Duandai mima: (Chuan) Guo Zhongshu "Mu Gu Kaizhi Lanting yanji tu" guan hou', *Gugong wenwu yuekan*, CCLXXV (February 2006), pp. 47–59

He Liangjun, *Si you zhai cong shuo*, Yuan Ming shiliao biji congkan (Beijing, 1983)

Henan sheng bowuguan deng, 'Xinxiang shi Ming Lu Jianwang mu jiqi shike', *Wenwu* (1979.5), pp. 7–13

James Hevia, *Cherishing Men from Afar: Qing Guest Ritual and the Macartney Embassy of 1793* (Durham, NC, and London, 1995)

Cecily J. Hilsdale, 'The Social Life of the Byzantine Gift: The Royal Crown of Hungary Re-invented', *Art History*, XXXI/5 (2008), pp. 603–31

Charles Holcombe, *In the Shadow of the Han: Literati Thought and Society at the Beginning of the Southern Dynasties* (Honolulu, 1994)

Cho-yun Hsu, 'The Spring and Autumn Period', in *The Cambridge History of Ancient China: From the Origins of Civilization to 221 BC*, ed. Michael Loewe and Edward L. Shaughnessy (Cambridge, 1999), pp. 545–86

Philip K. Hu, *Visible Traces: Rare Books and Special Collections from the National Library of China* (New York, 2000)

Huang Hsing-tsung and Joseph Needham, *Science and Civilisation in China*, vol. VI: *Biology and Biological Technology, Part V: Fermentations and Food Science* (Cambridge, 2000)

Huang Miantang, *Mingshi guanjian* (Ji'nan, 1985)

Ray Huang, *Taxation and Governmental Finance in Sixteenth-century China* (Cambridge, 1974)

Huang Tsung-hsi, *The Records of Ming Scholars: A Selected Translation*, ed. Julia Ching, with the collaboration of Chaoying Fang (Honolulu, 1987)

Hubei sheng wenwu kaogu yanjiusuo et al., 'Hubei Zhongxiang Mingdai Liang Zhuangwang mu fajue jianbao', *Wenwu* (2003.5), pp. 4–23

——, et al., 'Wuchang Longquanshan Mingdai Chu Zhaowang mu fajue jianbao', *Wenwu* (2003.2), pp. 4–18

——, and Zhongxiang shi bowuguan, eds, *Liang Zhuangwang mu*, 2 vols (Beijing, 2007)

Charles O. Hucker, *A Dictionary of Official Titles in Imperial China* (Stanford, CA, 1985)

——, 'Ming Government', in *The Cambridge History of China*, vol. VII: *The Ming Dynasty, 1368–1644, Part II*, ed. Frederick W. Mote and Denis Twitchett (Cambridge, 1998), pp. 9–105

Wilt Idema, 'State and Court in China: The Case of Hung-wu's Imperial Theatre', *Oriens Extremus*, XXIII/2 (1976), pp. 175–89

——, *The Dramatic Oeuvre of Chu Yu-tun (1379–1439)*, Sinica Leidensia, 16 (Leiden, 1985)

Matthew Innes, *State and Society in the Early Middle Ages: The Middle Rhine Valley 400–1000*, Cambridge Studies in Medieval Life and Thought (Cambridge, 2000)

Peter Jackson, 'The Mongol Age in Eastern Inner Asia', in *The Cambridge History of Inner Asia: The Chinggisid Age*, ed. Nicola Di Cosmo, Allen J. Frank and Peter B. Golden (Cambridge, 2009), pp. 26–45

Scarlett Jang, 'The Eunuch Agency Directorate of Ceremonial and the Ming Imperial Publishing Enterprise', in *Culture, Courtiers, and Competition: The Ming Court (1368–1644)*, ed. David M. Robinson, Harvard East Asian Monographs, 301 (Cambridge, MA, and London, 2008), pp. 116–85

Jiang Yihan, 'Yuan neifu zhi shoucang (xia)', *Gugong jikan*, XIV/3 (Spring 1980), pp. 1–36

Jiangxi sheng bowuguan et al., 'Jiangxi Nancheng Ming Yiwang Zhu Youbin mu fajue jianbao', *Wenwu* (1973.3), pp. 33–45

——, eds, *Jiangxi Mingdai fanwang mu* (Beijing, 2010)

Jiangxi sheng wenwu gongzuodui, 'Jiangxi Nancheng Ming Yi Xuanwang Zhu Yiyin fufu hezang mu', *Wenwu* (1982.8), pp. 16–28

—, 'Jiangxi Nancheng Ming Yi Dingwang Zhu Youmu mu fajue jianbao', *Wenwu* (1983.2), pp. 56–64

Jiangxi sheng wenwu kaogu yanjiusuo, 'Nanchang Mingdai Ning Jingwang furen Wu shi mu fajue jianbao', *Wenwu* (2003.2), pp. 19–34

Jie Zhao, 'A Decade of Considerable Significance', *T'oung Pao*, LXXXVIII (2002), pp. 112–50

Jin ci bowuguan, ed., *Bao xian tang ji gu fa tie* ('Antique Model Calligraphy Assembled in the Hall for Treasuring Worthies') (Beijing, 2002)

Jin Laien and Tian Juan, 'Mingchao Gan di fanwang ji qi muzang', *Nanfang wenwu* (2004.3), pp. 67–71

Joint Board of Directors of the National Palace Museum and National Central Museum, eds, *Signatures and Seals on Painting and Calligraphy: The Signatures and Seals of Artists Connoisseurs and Collectors on Painting and Calligraphy since Tsin Dynasty*, 6 vols (Hong Kong, 1964)

Philip A. Kafalas, *In Limpid Dream: Nostalgia and Zhang Dai's Reminiscences of the Ming* (Norwalk, CT, 2003)

Kaifeng Song cheng kaogudui, 'Ming Zhou wangfu zijincheng de chubu kantan yu fajue', *Wenwu* (1999.12), pp. 66–73

Jérôme Kerlouégan, 'Printing for Prestige? Publishing and Publication by Ming Princes', *East Asian Publishing and Society,* I (2011), pp. 39–73

John Kerrigan, *Archipelagic English: Literature, History and Politics, 1603–1707* (Oxford, 2008)

Hiromitsu Kobayashi, 'Publishers and their Hua-p'u in the Wan-li Period: The Development of the Comprehensive Painting Manual in the Late Ming', *Gugong xueshu jikan*, XXII/2 (2004), pp. 167–98

Fritz A. Kuttner, 'Prince Chu Tsai-yü's Life and Work: A Re-Evaluation of His Contribution to Equal Temperament Theory', *Ethnomusicology*, XIX/2 (1975), pp. 163–205

Kyoto National Museum, *Sesshū: Botsugo 500-nen, tokubetsuten/Sesshū: Master of Ink and Brush* (Kyoto, 2002)

Eric C. Lai, 'Pipa Artists and Their Music in Late Ming China', *Ming Studies*, 58 (Fall 2008), pp. 43–71

Ruby Lal, *Domesticity and Power in the Early Mughal World*, Cambridge Studies in Islamic Civilization (Cambridge, 2005)

Joseph S. C. Lam, 'Imperial Agency in Ming Music Culture', in *Culture, Courtiers, and Competition: The Ming Court (1368–1644)*, ed. David M. Robinson, Harvard East Asian Monographs, 301 (Cambridge, MA, and London, 2008) pp. 269–320

John D. Langlois Jr, 'The Hung-wu Reign, 1368–1398', in *The Cambridge History of China*, vol. VII: *The Ming Dynasty, 1368–1644, Part I*, ed. Frederick W. Mote and Denis Twitchett (Cambridge, 1988), pp. 107–81

Lothar Ledderose, *Mi Fu and the Classical Tradition of Chinese Calligraphy* (Princeton, NJ, 1979)

Soyoung Lee, JaHyun Kim Haboush, Sunpyo Hong and Chin-Sung Chang, *Arts of the Korean Renaissance, 1400–1600* (New York, 2009)

Li E, *Yu tai shu shi*, 1 juan, in *Meishu congshu*, 4 ji disan ji, Jiangsu guji chubanshe reprint edn, 3 vols (Nanjing, 1997), vol. III, pp. 2164–90

Li Kaixian, *Li Kaixian quanji*, ed. Bu Jian (Beijing, 2004)

Li Qiongying and Zhang Yingzhao, eds, *Ming shi lu lei zuan: Zong fan gui qi lei* (Wuhan, 1995)

Li Weizhen, *Shanxi tong zhi*, 30 juan (Wanli period), in *Xijian Zhongguo difangzhi huikan* (Beijing, 1992), vol. IV

—, *Da mi shan fang ji*, 134 juan (1611), in *Si ku quan shu cunmu congshu* (Ji'nan, 1995–97), vols CL–CLII

Li Yuming, ed., *Shanxi gu jianzhu tonglan* (Taiyuan, 1986)

Lin Li'na, 'Mingren "Chu jing ru bi tu" zhi zonghe yanjiu', *Gugong wenwu yuekan*, X/7–8 (1993), pp. 58–77, 34–41

Kathlyn Liscomb, 'Foregrounding the Symbiosis of Power: A Rhetorical Strategy in Some Chinese Commemorative Art', *Art History*, XXV/2 (2002), pp. 135–61

Stephen Little with Shawn Eichman, *Taoism and the Arts of China* (Chicago, 2000)

Liu Haiwen, 'Fan wang ji wei: Mingchao diwang chuanchengzhong de tuchu tedian', *Xinxiang shifan gaodeng zhuanke xuexiao xuebao*, XX (2006.3), pp. 2–4

Heping Liu, 'The Water Mill and Northern Song Imperial Patronage of Art, Commerce and Science', *Art Bulletin*, LXXXIV/4 (2002), pp. 566–95

Liu Jiuan, *Song Yuan Ming Qing shuhuajia chuanshi zuopin nianbiao* (Shanghai, 1997)

Liu Yi, *Mingdai diwang lingmu zhidu yanjiu* (Beijing, 2006)

Michael Loewe, 'The Structure and Practice of Government', in *The Cambridge History of China*, vol. I: *The Ch'in and Han Empires, 221 BC–AD 220*, ed. Denis Twitchett and John K. Fairbank (Cambridge, 1987), pp. 463–90

Hin-cheung Lovell, *An Annotated Bibliography of Chinese Painting Catalogues and Related Texts,* Michigan Papers in Chinese Studies, 16 (Ann Arbor, MI, 1973)

Lu Shen, *Huai feng ri ji*, 1 juan, in *Si ku quan shu cunmu congshu* (Jinan, 1995–7), CXXVII, pp. 622–6

Ma Daokuo, 'Zhu Youdun de Lanting taben', *Shufa yanjiu*, I (1984), pp. 73–7

Amy McNair, 'The Engraved Model-Letters Compendia of the Song Dynasty', *Journal of the American Oriental Society*, CXIV/2 (1994), pp. 209–25

—, 'Engraved Calligraphy in China: Recension and Reception', *Art Bulletin*, LXXVII/1 (1995), pp. 106–14

Susan Mann, 'Grooming a Daughter for Marriage: Brides and Wives in the Mid-Ch'ing Period', in *Marriage and Inequality in Chinese Society*, ed. Rubie S. Watson and Patricia Buckley Ebrey (Berkeley, Los Angeles and London, 1997), pp. 204–30

John Meskill, *Gentlemanly Interests and Wealth on the Yangtze Delta* (Ann Arbor, MI, 1994)

Stephen B. Miles, 'Rewriting the Southern Han (917–971): The Production of Local Culture in Nineteenth-century Guangzhou', *Harvard Journal of Asiatic Studies*, LXII/1 (2002), pp. 39–76

Tracy Miller, *The Divine Nature of Power: Chinese Ritual Architecture at the Sacred Site of Jinci*, Harvard Yenching Institute Monograph Series, 62 (Cambridge, MA, and London, 2007)

Min Tu-gi, *National Polity and Local Power: The Transformation of Late Imperial China*, ed. Philip A. Kuhn and Timothy Brook (Cambridge, MA, 1989)

Ming shisanling tequ banshichu, ed., *Zhongguo jianzhu yishu quanji, 7: Mingdai lingmu jianzhu* (Beijing, 2000)

Deborah Del Gais Muller, 'Hsia Wen-yen and His "T'u-hui pao-chien (Precious Mirror of Painting)"', *Ars Orientalis*, XVIII (1988), pp. 131–48

Julia K. Murray, 'Illustrations of the Life of Confucius: Their Evolution, Functions and Significance in Late Ming China', *Artibus Asiae*, CVII.I/2 (1997), pp. 73–134

——, '"Idols" in the Temple: Icons and the Cult of Confucius', *Journal of Asian Studies*, LXVIII/2 (2009), pp. 371–411

Nanjing shi bowuguan, *Jin yu yu: Gongyuan 14–17 shiji Zhongguo guizu shoushi* (Shanghai, 2004)

Joseph Needham, *Science and Civilisation in China*, vol. I: *Introductory Orientations* (Cambridge, 1954)

Robert S. Nelson, 'The History of Legends and the Legends of History: The Pilastri Acritani in Venice', in *San Marco, Byzantium, and the Myths of Venice*, ed. Paul Madaglino and Robert Nelson, Dumbarton Oaks Byzantine Symposia and Colloquia (Washington, DC, 2010), pp. 63–90

Lara Jaishree Netting, 'Acquiring Chinese Art and Culture: The Collections and Scholarship of John C. Ferguson (1866–1945)', unpublished PhD dissertation (Princeton University, 2009)

William H. Nienhauser Jr, ed., *The Indiana Companion to Traditional Chinese Literature* (Bloomington, IN, 1986)

Sewall Oertling, *Painting and Calligraphy in the 'Wu-tsa-tsu': Conservative Aesthetics in Seventeenth-century China*, Michigan Monographs in Chinese Studies, 68 (Ann Arbor, MI, 1997)

Ong Chang Woei, 'Zhang Zai's Lagacy and the Construction of Guanxue in Ming China', *Ming Studies*, 51–52 (Spring and Fall 2005), pp. 58–93

Pan Jisheng, *Tian gong kai wu jiaozhu ji yanjiu* (Chengdu, 1989)

Jong Phil Park, 'Ensnaring the Public Eye: Painting Manuals of Late Ming China (1550–1644) and the Negotiation of Taste', unpublished PhD dissertation (University of Michigan, 2007)

Paul Pelliot, 'Notes sur l'histoire de la céramique chinoise', *T'oung Pao*, XXII (1923), pp. 1–54

——, 'Sur l'interpretation des marques des porcelaines chinoises', *Artibus Asiae*, II/3 (1927), pp. 179–87

Peng Yuxin, 'Beijing fanke banhua zhu qipa – Ming Hongzhi "Xin kan da zi kui ben quan xiang zeng qi miao zhu shi Xi xiang ji"', unpublished MA dissertation (National Taiwan Normal University, 2009)

Gabriel Piterberg, *An Ottoman Tragedy: History and Historiography at Play* (Berkeley and Los Angeles, 2003)

Verity Platt, 'Making an Impression: Replication and the Ontology of the Graeco-Roman Seal Stone', in *Art and Replication, Rome and Beyond*, ed. Jennifer Trimble and Jaś Elsner, Special Issue of *Art History*, XXIX/2 (2006), pp. 233–57

Marcia Pointon, 'Intriguing Jewellery: Royal Bodies and Luxurious Consumption', *Textual Practice*, XI/3 (1997), pp. 493–516

Michael Pollak, *Mandarins, Jews, and Missionaries: The Jewish Experience in the Chinese Empire* (New York, 1998)

Sheldon Pollock, *The Language of the Gods in the World of Men: Sanskrit, Culture, and Power in Premodern India* (Berkeley, Los Angeles and London, 2006)

Martin J. Powers, *Pattern and Person: Ornament, Society, and Self in Classical China* (Cambridge, MA, and London, 2006)

Qi Zhaojin, 'Ming Jingjiang wang de jueji', *Shehuikexuejia*, XV/2 (March 2000), pp. 79–85

Qian Xiyan, *Liao di ji wen*, 1 *juan*, in *Shuo fu xu* (Taibei, 1972), pp. 802–4

Qin Mingzhi, 'Su fu ben Chun hua ge tie kao', *Lanzhou xuekan* (1984.5), pp. 92–101

Ren Zunshi, *Zhou Xianwang yanjiu* (Taibei, 1974)

Matteo Ricci, *On Friendship: One Hundred Maxims for a Chinese Prince*, trans. Timothy Billings (New York, 2009)

David M. Robinson, 'Images of Subject Mongols Under the Ming Dynasty', *Late Imperial China*, XXV/1 (2004), pp. 59–123

——, 'The Ming Court', in *Culture, Courtiers, and Competition: The Ming Court (1368–1644)*, ed. David M. Robinson, Harvard East Asian Monographs, 301 (Cambridge, MA, and London, 2008), pp. 21–60

——, 'The Ming Court and the Legacy of the Yuan Mongols', in *Culture, Courtiers, and Competition: The Ming Court (1368–1644)*, ed. David M. Robinson, Harvard East Asian Monographs, 301 (Cambridge, MA, and London, 2008), pp. 365–411

Kenneth Robinson, *A Critical Study of Chu Tsai-yü's Contribution to the Theory of Equal Temperament in Chinese Music*, Sinologica Coloniensa, 9 (Wiesbaden, 1980)

Joan-Pau Rubiés, 'Oriental Despotism and European Orientalism: Botero to Montesquieu', *Journal of Early Modern History*, IX/2 (2005), pp. 109–80

Ruo Ya, 'Mingdai zhuwangfu guizhi shulüe', *Mingshi yanjiu*, III (1993), pp. 135–8

Satō Fumiyoshi, *Mindai ōfu no kenkyu* (Tokyo, 1999)

Hamish M. Scott, '"Acts of Time and Power": The Consolidation of Aristocracy in Seventeenth-century Europe, *c.* 1580–1720', *Bulletin of the German Historical Institute London*, XXX/2 (2008), pp. 3–37

Timon Screech, *The Shogun's Painted Culture: Fear and Creativity in the Japanese States, 1760–1829* (London, 2000)

Henry Serruys, 'Mongols Ennobled During the Early Ming', *Harvard Journal of Asiatic Studies*, XXII (1959), pp. 209–60

Shang Chuan, *Mingdai wenhuashi* (Shanghai, 2007)

Shandong sheng bowuguan, 'Fajue Ming Zhu Tan mu jishi', *Wenwu* (1972.5), pp. 25–36

Shen Defu, *Wanli ye huo bian*, Yuan Ming shiliao biji congkan (Beijing, 1980)

Shen Shixing, ed., *Ming hui dian* (Beijing, 1989)

Shi Hongshi and Wu Hongqi, 'Mingdai Xi'an chengnei huangshi zongzu fuzhai xiangguan wenti yanjiu', *Zhongguo lishi dili luncong*, XVI/1 (March 2001), pp. 69–78

David Sneath, 'Introduction – Imperial Statecraft: Arts of Power on the Steppe', in *Imperial Statecraft: Political Forms and Techniques of Governance in Inner Asia, Sixth–Twentieth Centuries*, ed. David Sneath (Bellingham, WA, 2006), pp. 1–22

Ellen Soullière, 'The Imperial Marriages of the Ming Dynasty', *Papers on Far Eastern History*, XXXVII (1988), pp. 15–42

Jonathan Spence, *Return to Dragon Mountain* (London, 2008)

Nicholas Standaert, 'Ritual Dances and Their Visual Representations in the Ming and Qing', *The East Asian Library Journal*, XII/1 (2006), pp. 68–181

Kenneth Starr, *Black Tigers: A Grammar of Chinese Rubbings* (Seattle and London, 2008)

Lynn A. Struve, *The Southern Ming, 1644–1662* (New Haven, CT, and London, 1984)

Peter Sturman, *Mi Fu: Style and the Art of Calligraphy in Northern Song China* (New Haven, CT, and London, 1997)

Su Quanyou and Zhang Yuwei, 'Mingdai fanwang xue de shenghui', *Luohe zhiye shuxueyuan xuebao*, VII/6 (November 2008), pp. 60–62

Su Siyi, Yang Xiaojie and Liu Liqing, eds, *Shaolin si shike yishu bian* (Beijing, 1985)

E-tu Zen Sun and Shiou-chuan Sun, trans., *T'ien-kung k'ai-wu: Chinese Technology in the Seventeenth Century* (University Park, PA, 1966)

Sun Hongbo and Gao Chunping, *Lu shang wenhua tanjiu* (Tianjin, 2009)

Sun Weiguo, 'Different Types of Scholar-Official in Sixteenth-century China: The Interlaced Careers of Wang Shizhen and Zhang Juzheng', *Ming Studies*, 53.2 (Spring 2006), pp. 4–50

Tian Yuan Tan, 'Qu Writing in Literati Communities: Re-Discovering Sanqu Songs and Drama in Sixteenth-century North China', unpublished PhD dissertation (Harvard University, 2006)

Romeyn Taylor, 'Ming T'ai-tsu and the Nobility of Merit', *Ming Studies*, 2 (1976), pp. 57–69

Robert L. Thorp, *Son of Heaven: Imperial Arts of China* (Seattle, 1988)

Shih-shan Henry Tsai, *Perpetual Happiness: The Ming Emperor Yongle* (Seattle and London, 2001)

R. H. Van Gulik, *The Lore of the Chinese Lute* (Tokyo, 1968)

Léon Vandermeersch, *Wangdao; ou, La Voie royale: Recherches sur l'esprit des institutions de la Chine archaïque*, 2 vols (Paris, 1977–80)

Lothar von Falkenhausen, *Chinese Society in the Age of Confucius (1000–250 BC): The Archaeological Evidence* (Los Angeles, 2006)

Anne Walthall, 'Introducing Palace Women', in *Servants of the Dynasty: Palace Women in World History*, ed. Anne Walthall (Berkeley, Los Angeles and London, 2008), pp. 1–21

Wan Yi, *Chunhua he Chunhua ge fatie* (Beijing, 1994)

Wang Cheng-hua, 'Material Culture and Emperorship: The Shaping of Imperial Roles at the Court of Xuanzong (r. 1426–1435)', unpublished PhD dissertation (Yale University, 1998)

Wang Fangyu, Richard M. Barnhart and Judith G. Smith, eds, *Master of the Lotus Garden: The Life and Art of Bada Shanren (1626–1705)* (New Haven, CT, and London, 1990)

Wang Gang, 'Mingdai wanghou yu Daojiao guanxi tanyan: Yi Lanzhou he Kunming wei li', in *Daojiao yanjiu yu Zhongguo zongjiao wenhua*, ed. Li Zhitian (Xianggang, 2003), pp. 152–212

Wang Guangyao, 'Gugong bowuyuan cang Lu guo tongqi kao', *Wenwu* (1994–96), pp. 72–5

Wang Jichao, 'Mingdai qinwang zangzhi de jige wenti', *Wenwu* (2003.2), pp. 63–5, 81

Wang Jinyan and Liang Jiang, 'Mingchu Yanzhou fucheng xingtai kuangzhan ji Luwangcheng guihua fenxi – Jian lun fanwangcheng guihua', *Guihuashi/Planners* (2001.1), pp. 74–7

Wang Kefen, *Zhongguo wudao shi: Ming Qing bufen* (Beijing, 1984)

Richard G. Wang, 'Four Steles at the Monastery of the Sublime Mystery (Xuanmiao guan): A Study of Daoism and Society on the Ming Frontier', *Asia Major*, 3rd ser., XIII/2 (2000), pp. 37–82

——, 'Ming Princes and Daoist Ritual', *T'oung Pao*, XCV (2009), pp. 51–119

——, *The Ming Prince and Daoism: Institutional Patronage of an Elite* (Oxford, 2012)

Wang Rurun and Ma Wei, 'Mingdai Henan zongfan shiren kaolun', *Luoyang shifan xueyuan xuebao* (2007.1), pp. 82–4

Wang Yi, 'Mingdai fanfu ke "Lanting tu juan" jiqi bianqian', *Gugong bowuyuan yuankan*, CXXXII (2007.4), pp. 142–55

Wang Zhenghua, 'Guoyan fanhua – Wan Ming chengshi tu, chengshi guan, yu wenhua xiaofei de yanjiu', in *Zhongguo de chengshi shenghuo*, ed. Li Xiaodi (Taibei, 2005), pp. 1–57.

Wang Zhuanghong, *Tiexue juyao* (Shanghai, 2008)

Helen Watanabe-O'Kelly, *Court Culture in Dresden: From Renaissance to Baroque* (Basingstoke, 2002)

Marsha Weidner, 'Imperial Engagements with Buddhist Art and Architecture: Ming Variations on an Old Theme', in *Cultural Intersections in Later Chinese Buddhism*, ed. Marsha Weidner (Honolulu, 2001), pp. 117–44

—, Ellen Johnston Laing, Irving Yucheng Lo, Christina Chu and James Robinson, *Views from Jade Terrace: Chinese Women Artists, 1300–1912* (Indianapolis, 1988)

Wen Zhenheng, *Zhang wu zhi jiao zhu* (Nanjing, 1984), p. 185

Chris Wickham, *Framing the Early Middle Ages: Europe and the Mediterranean, 400–800* (Oxford, 2005)

Ming Wilson, *Rare Marks on Chinese Ceramics* (London, 1998)

Wu Hongqi and Dang Anrong, 'Guanyu Mingdai Xi'an Qin wangfucheng de ruogan wenti', *Zhongguo lishi dili luncong* (1993), pp. 149–64

Wu Hung, *Monumentality in Early Chinese Art and Architecture* (Stanford, CA, 1995)

—, *The Double Screen: Medium and Representation in Chinese Painting* (London, 1996)

—, 'On Rubbings: Their Materiality and Historicity', in *Writing and Materiality in China*, ed. Judith Zeitlin and Lydia Liu (Cambridge, MA, 2003), pp. 29–72

Xi'an shi wenwu baohu kaogusuo, 'Xi'an nanjiao Huang Ming zongshi Qianyang Duanyiwang Zhu Gongzeng mu qingli jianbao', *Kaogu yu wenwu* (2001.6), pp. 29–45

Xiao Jianyi, 'Ming Qin fanjia zupuxi ji muzang fenbu chutan', *Kaogu yu wenwu* (2007.2), pp. 93–8

Xiao Tun, 'Liuniangjing Ming mu de qingli', *Wenwu cankao ziliao* (1958.5), pp. 55–6

Xie Guian, ed., *Ming Shilu lei zuan: Hubei shiliao juan* (Wuhan, 1991)

Xu Bangda, '"Wenhuatang ti" kuan huaba ji Jinfu qianyin', *Gugong bowuyuan yuankan*, (2005.2), pp. 89–90

Xu Hong, 'Mingdai Kaifeng Zhouwang de xiangguan wenti', *Henan keji daxue xuebao (Shehuikexue ban)*, XXII/4 (2004), pp. 21–4

Xu Xuemo, ed. *Huguang zong zhi*, 98 *juan* (Wanli period), in *Siku quanshu cunmu congshu* (Ji'nan, 1995–7), vols CXCIV–CXCVI

Yang Chang et al., eds, *Ming shi lu lei zuan: Gongting shiliao juan* (Wuhan, 1992)

Yang Guoliang and Zhou Zuoming, 'Ming Jingjiang wangcheng yu Guilin lishi wenhua lüyou jianshe', *Guilin lüyou gaodeng zhuanke xuexiao xuebao*, XII/3 (2001), pp. 69–71

Yang Xiaoneng, 'Ming Art and Culture from an Archaeological Perspective, Part 1: Royal and Elite Tombs', *Orientations* (June 2006), pp. 40–49

Yang Zengwu, *Huangjia yu Wutaishan* (Taiyuan, 2005)

Yao Pinwen, *Zhu Quan yanjiu* (Nanchang, 1993)

Yu Shuchun, 'Mingdai fanwang de zhushu yu keshu', *Chizhou shizhuan xuebao*, XVII/1 (2003.2), pp. 10–12

Yu Tongyuan, 'Mingdai Heng wangfu zhuangtian', *Yantai daxue xuebao (Zhexue shehuikexue ban)* (1997.4), pp. 66–8

Yuan Yuhong, 'Beijing tushuguan cang Lantingtu taben qianshuo', *Beijing tushuguan guankan*, I (1998), pp. 60, 94–6

Judith Zeitlin, 'The Petrified Heart: Obsession in Chinese Literature, Art and Medicine', *Late Imperial China*, XXI/1 (1991), pp. 1–26

Zhang Dai, *Tao'an meng yi* (Hangzhou, 1982)

Zhang Guoning, 'Ming Jinwang jiqi zongshi zakao', *Jinyang wenhua yanjiu*, I (Taiyuan, 2006), pp. 97–127

Zhang Han, *Song chuang meng yu*, Ming Qing biji congshu (Shanghai, 1986)

Zhang Jizhong and An Ji, *Taiyuan Chongshansi wenwu tulu* (Taiyuan, 1987)

Zhang Jianmin, 'Mingdai Lianghu diqu de zongfan yu difang shehui', *Jianghan luntan* (2002.10), pp. 76–81

Zhang Minfu and Xu Jing, 'Mingdai Henan zongfan qianshu', *Shangqiu shifan xueyuan xuebao*, XVIII/1 (February 2002), pp. 48–51, 114

Zhang Tingyu et al., eds, *Ming shi*, 28 vols (Beijing, 1974)

Zhang Zhengming, Ke Dawei and Wang Yonghong, eds, *Ming Qing Shanxi beike ziliao xuan (xu yi)* (Taiyuan, 2007)

Zhao Chunting, 'Wu ben Mingdai fanwang qinpu de neizai guanxi ji dui Mingdai qinxue de yingxiang', *Yinyue yanjiu* (2006.3), pp. 29–40

Zhao Kesheng, 'Mingdai si yan zhi jin', *Anhui daxue xuebao (Zhexue shehuikexue ban)*, XXVI/1 (January 2002), pp. 28–33

Zhao Qian and Zhang Zhiqing, 'Book Publishing by the Princely Households during the Ming Dynasty: A Preliminary Survey', *The East Asian Library Journal*, X/1 (Spring 2001), pp. 85–128

Zhao Yi, 'Mingdai zongshi de shangye huodong ji shehui yingxiang', *Zhongguoshi yanjiu*, XLV/1 (1989), pp. 49–54

Zhongguo shehui kexueyuan kaogusuo deng, 'Chengdu Fenghuangshan Ming mu', *Kaogu* (1978.5), pp. 306–13

Zhu Changfang, *Gu jin zong fan yi xing kao*, in *Si ku quan shu cunmu congshu* (Ji'nan, 1995), vol. CXVII

Zhu Chengru, 'Mingdai de fengfan yu Qingdai fengjuezhi zhi bijiao yanjiu', in *Qingdai wangfu ji wangfu wenhua; Guoji xueshu yantaohui lunwenji*, ed. Gong wangfu guanli zhongxin (Beijing, 2006), pp. 224–30

Zhu Mouwei, *Fan xian ji*, 4 juan (Wanli period), in *Beijing tushuguan guji zhenben congkan*, 19: *Shi bu, zhuanji lei* (Beijing, 1998), pp. 745–77

Zhu Mouyin, *Xu shu shi hui yao*, 1 juan (c. 1630), in *Jing yin Wenyuange siku quanshu*, DCCCXIV (Taibei, 1986)

——, *Hua shi hui yao*, 5 juan (1631), in *Jing yin Wenyuange siku quanshu*, DCCCXVI (Taibei, 1986)

Zhu Qinmei, *Wang guo dian li*, in *Si ku quan shu cunmu congshu* (Ji'nan, 1995–7), vol. CCLXX

Zhu Shouyong and Zhu Yiya, *Ming kan guben Hua fa da cheng* (Beijing, 1996)

Zong fan tiao li, in *Beijing tushuguan guji zhenben congkan* (Beijing, 1998), vol. LIX

ACKNOWLEDGEMENTS

Key elements of the research for this book depended on a trip to China in the spring of 2009, made possible through the British Academy/ Chinese Academy of Social Sciences Academic Visitor Programme, and I am very grateful to the staffs of both academies for many kindnesses. In particular I would wish to thank Hou Xiaomin and Gao Chunping of the Shanxi Academy of Social Sciences, Taiyuan, and Li Fei, Director of the Taiyuan Municipal Cultural Relic and Archaeology Research Institute. In Hubei, Yuan Wenqing was the ideal guide and mentor to the riches of Ming kingly culture in that province, and the book owes a great deal to his generosity and willingness to share his profound knowledge. Director Zhou Tianxiang of the Zhongxiang City Museum was equally kind and supportive, while Wang Yi of CASS supplied valuable images and information. In Taipei, Ho Chuan-hsin, Lai Yu-chih, Shih Ching-fei and Wang Ching-Ling all helped me in various ways with ideas and materials, as have Stephen Allee, John Blazejewski, Adam Chau, Peter Ditmanson, Clarence Eng, Vincent Goossaert, Martin Heijdra, David Helliwell, Shih-shan Susan Huang, Jérôme Kerlouégan (who kindly allowed me advance sight of his work on Ming kingly publishing), Luk Yu Ping, Luisa Mengoni, Tracy Miller, John Moffet, Sue Naquin, Lara Netting, Jong Phil Park, Martin Powers, David Robinson, Joan-Pau Rubiés, Tian Yuan Tan, Irene Tsang and Chris Wickham. Vicky Brown, Claire Hills-Nova and Christine Robertson all helped in a range of ways, and I thank them all very sincerely. I am particularly grateful to Michael Athanson of the Bodleian Library for preparation of the map.

An award from the British Academy Small Grants Scheme is gratefully acknowledged as the source of financial support for the acquisition of images and permissions. The John Fell Fund of the University of Oxford provided valuable support for the administration of the image acquisition process, which was carried out with supreme efficiency by Ros Holmes, who also assisted editorially with the endnotes.

For readings of the whole manuscript I am indebted to Peter Ditmanson, Monica Merlin and Verity Wilson. I am thankful for all the good advice I took from them and from all those named above, and thankful too for the good advice I failed to heed, remaining fully responsible for all problems resulting from that failure.

PHOTOGRAPHIC ACKNOWLEDGEMENTS

The author and publishers wish to express their thanks to the following sources of illustrative material and/or permission to reproduce it:

Photographs by the author: 2, 33 (March 2009) and 3, 4, 6, 7, 9, 11, 13, 14, 16, 17, 18, 19, 21, 22, 23, 24, 25, 26, 27, 58, 59, 88, 89, 90 (April 2009); from Beijing tushuguan shanbenbu jinshizu, ed., *Beijing tushuguan cang huaxiang taben huibian*, 10 vols (Beijing, 1993), vol. X: 60; photograph John Blazejewski: 30; Bodleian Library, Oxford: 80 (Backhouse 383/2, *juan* 1), 84 (Backhouse 421/4, *juan* 11), 86 (Backhouse 412/10); The British Museum, London: 44, 87 (Franks Collection OA F.281+); Capital Museum, Beijing: 28, 29, 51; from Chai Zejun and He Dalong, *Shanxi fosi bihua* (Beijing, 2006): 55, 57; from Chengdu shi wenwu kaogu yanjiusuo, 'Chengdu Mingdai Shu Xiwang fajue jianbao', *Wenwu* (2002.4): 66; Chinese University of Hong Kong Art Museum: 35 (gift of the Beishantang Foundation 73.618); © The East Asian Library and the Gest Collection, Princeton University, New Haven (Gest Special Collection Princeton TD 63/286): 85; photograph Clarence Eng: 5; from Eskenazi Ltd, *Chinese Buddhist Sculpture from Northern Wei to Ming*, exhibition in New York at Pace Wildenstein, 18–30 March

2002: 20; after Eskenazi Ltd, *Seven Classical Chinese Paintings, 29 October–27 November 2009* (London, 2009): 44; Freer Gallery of Art, Smithsonian Institution, Washington, DC (gift of Charles Lang Freer, F1911.161e): 45; from Hubei sheng wenwu kaogu yanjiusuo and Zhongxiang shi bowuguan, eds, *Liang Zhuangwang mu*, 2 vols (Beijing, 2007), vol. II: 63, 64, 67, 68, 69, 70, 71, 72, 73, 74, 75, 76, 77, 78, 79; Indianapolis Museum of Art: 83 (purchased to complement the Mr and Mrs Eli Lilly Collection of Chinese Art through the bequest of Mrs Enid Goodrich and the support of Lilly Endowment Inc.; 2004.18); from Jin ci bowuguan, ed., *Bao xian tang ji gu fa tie* (Beijing, 2002): 34, 36, 37, 39, 40, 41; from Li Yuming, ed., *Shanxi gu jianzhu tonglan* (Taiyuan, 1986): 10, 12, 56; Marquand Library of Art and Archaeology, Princeton University, New Haven: 30; Metropolitan Museum of Art, New York: 38 (gift of John M. Crawford Jr., in honour of Professor Wen Fong, 1984 [1984.174] – image © The Metropolitan Museum of Art/Art Resource/Scala, Florence), 81 (purchase, Clara Mertens bequest, in memory of André Mertens, bequest of Dorothy Graham Bennett, The Boston Foundation Gift, and Gift of Elizabeth M. Riley, by exchange, 1999 – 1999.93); Museum of Fine Arts, Boston: 49 (Fenollosa-Weld

Collection, 11.4008); photograph © 2013 Museum of Fine Arts, Boston: 48; National Library of China: 31, 32; National Palace Museum: 1, 43, 46, 48, 50, 53, 54, 82; The Nelson-Atkins Museum of Art, Kansas City, Missouri: 47 (purchase William Rockhill Nelson Trust, 31-135.33 – photography by John Lamberton); from Su Siyi, Yang Xiaojie and Liu Liqing, eds, *Shaolin si shike yishu bian* (Beijing, 1985): 15; Topkapı Palace Museum, Istanbul (H.2154, fol. 18a): 52; photograph 2009 by Wang Yi: 8; from Zheng Zhenduo, ed., *Zhongguo gudai banhua congkan* (Shanghai, 1988): 61; from Zhongguo shehui kexueyuan kaogusuo deng, 'Chengdu Fenghuangshan Ming mu', *Kaogu* (1978.5): 65; from Zhu Shouyong and Zhu Yiya, *Ming kan guben Hua fa da cheng* (Beijing, 1996): 62.

INDEX